Edith Wharton and the Visual Arts

Edith Wharton and the Visual Arts

Emily J. Orlando

THE UNIVERSITY OF ALABAMA PRESS

Tuscaloosa

Typeface: Minion

∞

The paper on which this book is printed meets the minimum requirements of American
National Standard for Information Sciences-Permanence of Paper for Printed Library
Materials, ANSI Z39.48–1984.

Library of Congress Cataloging-in-Publication Data

Orlando, Emily J. (Emily Josephine), 1969–
Edith Wharton and the visual arts / Emily J. Orlando.
p. cm. — (Studies in American literary realism and naturalism)
Includes bibliographical references and index.
ISBN-13: 978-0-8173-1537-5 (alk. paper)
ISBN-10: 0-8173-1537-3 (alk. paper)
1. Wharton, Edith, 1862–1937—Criticism and interpretation. 2. Wharton, Edith, 1862–1937—
Knowledge—Art. 3. Art and literature—United States—History—20th century. 4. Visual
perception in literature. I. Title. II. Series.
PS3545.H16Z756 2006
813'.52—dc22
2006014321

For my parents, Anita Marie Orlando and Frank Paul Orlando,
and for my husband, Nels Pearson

Contents

List of Illustrations ix

Acknowledgments xi

Introduction: Women, Art, and the Sexual Politics of (Mis)representation in Edith Wharton 1

1. Beauty Enshrined: Living Pictures and Still Lifes; or, Her Body Becomes His Art 27

2. Picturing Lily: Body Art in *The House of Mirth* and "The Potboiler"; or, Her Body Becomes Her Art 55

3. "Beauty Enthroned": The Muse's Progress 87

4. Angels at the Grave: Custodial Work in the Palace of Art 126

5. "We'll look, not at visions, but at realities": Women, Art, and Representation in *The Age of Innocence* 170

Notes 201

Works Consulted 229

Index 241

Illustrations

1. Stevens, *The Painter and His Model* 2

2. Millais, *Ophelia* 43

3. Rossetti, *Beata Beatrix* 48

4. Rossetti, *Love's Mirror; or, A Parable of Love* 53

5. Reynolds, *Portrait of Joanna Lloyd of Maryland* 65

6. Van Dyck, *Portrait of a Flemish Lady* 67

7. Goya, *Marie Teresa Cayetana de Silva, Duchess of Alba, 1795* 69

8. Rossetti, *Dante's Dream at the Time of the Death of Beatrice* 75

9. Rossetti, *Sancta Lilias* 77

10. Prud'hon, *Portrait of Josephine at Malmaison, 1805* 92

11. Sargent, *Mrs. Ralph Curtis, 1898* 101

12. Rossetti, *Proserpine* 110

13. Dossi, *Circe and Her Lovers in a Landscape* 140

14. Leonardo, *Ginevra de' Benci (obverse)* 142

15. Bazzi, *Scenes from the Life of Saint Catherine of Siena: The Swooning of the Saint* 144

16. Watson, *The Death of Elaine, 1877 (oil on canvas)* 172

17. Carolus-Duran, *La dame au gant* 180

18. Sargent, *Madame X (Madame Pierre Gautreau)* 182

Acknowledgments

It is with pleasure that I acknowledge the many people who helped bring this book to light. I am grateful to my mentors first at Saint Anselm College (especially Denise Askin, Danielle Blais, and Gary Bouchard) and more recently at the University of Maryland for their guidance and confidence in me. I thank Marilee Lindemann for encouraging me to dwell in the possibilities of Edith Wharton and for inspiring me with her model of scholarly excellence and integrity. Robert S. Levine offered prompt, thorough comments, wise counsel, and collegiality every step of the way. Elizabeth B. Loizeaux generously gave thoughtful, compelling feedback on each chapter and support and good cheer at every turn. Mary Helen Washington consistently embraced my work with enthusiasm, offering moral and intellectual support. I am grateful to Josephine Withers for her invaluable art historical perspective. I owe a special thanks to Louise Greene of the University of Maryland Art Library for graciously guiding me through my tours in the visual arts.

I must thank individually the many persons who assisted me in obtaining permissions and copyrights for much of the material in this book. For assistance with the illustrations, grateful acknowledgment is made to Robert Upstone, Alison Fern, and Claudia Schmid, Tate Britain; Alicia Bradley, Birmingham Museums and Art Gallery; Rebecca Akan and Eileen Sullivan, the Metropolitan Museum of Art; Peter Huestis, the National Gallery of Art; Kathleen Kornell and Elizabeth Lantz, the

Cleveland Museum of Art; Lauren Simonutti, the Walters Art Museum; John Benicewicz, Art Resource; and Caroline Jennings, Bridgeman Art Library. For assistance in securing permission to quote unpublished material, I thank Saundra Taylor, Indiana University's Lilly Library, and Katherine Fausset, Watkins/Loomis Agency. Special thanks are due to Erika Dowell of the Lilly Library who went to great lengths to help with the Wharton manuscripts and to Ngadi Kponou, Stephen C. Jones, and Anne Marie Menta, all of Yale University's Beinecke Rare Book and Manuscript Library, for valued assistance with the Wharton Collection.

Several individuals kindly lent their expertise, support, and enthusiasm to this project: Joelle Biele, Theresa Coletti, Jeana DelRosso, Matt Elliott, James Engell, Daniela Garofalo, Julie Gillis, Tara Hart, Annie Kantar, Jill M. Kress, Shara McCallum, Lynn C. Miller, Nels Pearson, and Merideth Tomlinson. A special thanks goes to Susan Lanser and Brian Richardson for their shrewd advice, unbridled enthusiasm, and confidence in the project. With all my heart I thank Catherine Romagnolo and Jaime Osterman Alves, who tirelessly read my every page. Cathy introduced me to Wharton's gothic fiction and inspired and sustained me with her insight, integrity, and friendship. Jaime encouraged my readings in museum studies and gave generously of her time, wisdom, and friendship. The book would not be half as effective without their intervention.

I also would like to thank the Department of English at the University of Maryland for supporting my scholarship and training me as a writer and teacher. An early version of chapter 5 was generously acknowledged by the English department's Kinnaird Essay Prize. A QCB grant from the graduate school afforded me the rare opportunity to study Edith Wharton's papers at the Beinecke Library.

This project benefited in its earliest stages from an offer of support from two year-long grants at the University of Maryland: the Mabel S. Spencer Dissertation Fellowship and the Mary Savage Snouffer Dissertation Fellowship. The Spencer Fellowship afforded me an uninterrupted year to study Edith Wharton and the visual arts. It is my great hope that the project can do justice to the memory of Dr. Spencer, who devoted much of her life to the advancement of women.

More recently, Tennessee State University lent generous financial and moral support to this project. Drs. Helen Houston and Warren Westcott

and the Department of Languages, Literature, and Philosophy at TSU made possible presentations at the 2003 London conference of the Edith Wharton Society, the 2004 MLA convention in Philadelphia, and the *House of Mirth* centenary conference in Poughkeepsie. Dean William D. Lawson of the College of Arts and Sciences went out of his way to recognize and support my scholarship and to assist in securing funding for the book's illustrations. I thank the TSU Foundation, and particularly Mr. Clinton Gray, chair of the board of trustees, and Dr. Hollis Price, acting executive director, for the foundation's extraordinary award of support for the book plates. I thank also my students, especially the excellent women of my special topics seminar on Wharton, Larsen, and Hurston for their invigorating discussions of many of these works.

Special mention must be made of my remarkable colleagues at Tennessee State University whose ability to balance innovative teaching and research inspires me. I especially thank Erik S. Schmeller and Beverly Whalen-Schmeller, unofficial ambassadors to Nashville, for their collegiality, friendship, and good cheer.

Everyone at the University of Alabama Press has been a pleasure to work with. I wish to thank the editorial staff for its enduring interest and support and to thank especially Robin DuBlanc and the two readers whose excellent suggestions strengthened and enhanced this book.

Finally, a special thanks to my family for its unswerving faith in my abilities as a writer, thinker, and person. I thank my siblings Marianne, Gigi, Francis, Paul, and especially Lisa for her loving support and helpful feedback and for inspiring me professionally, spiritually, and artistically. Thanks are also due to Levi for his dogged loyalty and good humor throughout the revision process. I thank my parents, Anita, the artist, and Frank, the architect, for infusing me with a love for arts and letters. I know that their taking me as a little girl to the Museum of Fine Arts and the Isabella Stewart Gardner Museum helped ignite my interest in women and the visual arts. While to my great sorrow my father did not live to see the book in print, I take comfort in the thought of his spirit musing with Edith's on Italian villas and the decoration of houses. I dedicate the book to Anita and Frank and to my husband, Nels Pearson—true mind, brave heart, and tireless champion of my work on Wharton and the Pre-Raphaelites. To paraphrase another Emily from Massachusetts, Futile the winds, indeed.

Introduction

Women, Art, and the Sexual Politics of (Mis)representation in Edith Wharton

[Y]ou don't know how much of a woman belongs to you after you've painted her.

> —Claydon
> Edith Wharton, "The Moving Finger"

I like her better when she is thus broken. . . . I think that in death she will attain to the supreme expression of her beauty.

> —Giogio
> Gabriele D'Annunzio,
> *Il trionfo della morte*

Embedded in the visual subtext of Alfred Stevens's *The Painter and His Model* (1855) is a paradigm that Edith Wharton skeptically engages throughout her fiction (see figure 1). Stevens's painting depicts an artist languidly gazing at the canvas on which he has represented his female model. The painter's apparent comfort, suggested by his slippers, robe, and posture, and the proximity of the woman's body imply she is both lover and model—a suspicious slippage Wharton frequently calls into question. Indeed, the painter seems to have tilted the easel toward him as if to optimize his viewing pleasure. The Stevens painting provides a visual analogue to several Wharton narratives, especially "The Moving Finger" (1901), in which a painter boasts of having "turned his real woman into a picture" (176) while delighting in what Wharton elsewhere describes as the "joy of possessorship" a man derives from his relation to a beautiful woman.[1] While Stevens's artist, like Wharton's, betrays a wistful admiration of his creation, the model evidently is less pleased with the fruits of his labor. Her somber eyes and frown convey a disenchantment with the artist's rendering. Like Christina Rossetti's chilling sonnet "In an Artist's Studio" written the following year, Ste-

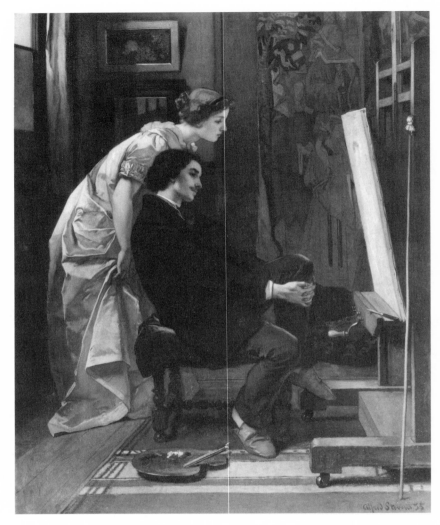

1. Alfred Stevens, *The Painter and His Model* (1855). The Walters Art Museum, Baltimore.

vens's painting unveils a troubling pattern in which the male painter has represented his subject "[n]ot as she is, but as she fills his dream."

The body of Wharton's fiction suggests that, like Stevens's model and Christina Rossetti's speaker, she is similarly frustrated with the problematic relationship between women and art. Her fiction responds to a vital part of her cultural moment as well as our own—the unfortunate

propensity of American culture to appropriate debilitating patterns of representing women, especially creative women. For example, at the close of "Writing a War Story" (1919), which chronicles the thwarted efforts of an American woman writer, Ivy Spang eagerly awaits feedback on her first attempt at fiction. Her male readers are in consensus: "We admire it so much," the soldiers tell her, "that we're going to ask you a most tremendous favor" (367). Assuming it is her story that they want, she is crushed to learn that they in fact seek copies of the portrait accompanying her piece: "[T]hey all forgot to read the story for gazing at its author" (369). When the captain of the troop, himself a man of letters, owns his fixation with her picture, he fails to understand her disappointment: "I didn't admire your story; and now you're angrier still because I do admire your photo. Do you wonder that we novelists find such an inexhaustible field in Woman?" (370). Wharton's women are repeatedly likened to "inexhaustible fields" to be settled, overtaken, and fertilized, not just physically but perpetually, in the male imagination. As this book sets out to demonstrate, her fiction voices a dissatisfaction with the objectification and sexualization of women as objects and not agents—as representations rather than represent*ers*.

"Representation" in this context refers to the act of depicting a body, whether in the visual arts, in fiction, or in our culture at large, though I am primarily concerned with representation both literary and visual—with characters engaged in picturing women according to their whims, wills, and wishes. These acts of representation are, in a sense, a kind of repackaging: that is, acts of re-presenting something or someone. Indeed, those Wharton characters who represent women take bits and pieces of "real" women, infuse them with various ideals or virtues, repackage them, and present them for consumption (for pleasure, gratification, money, power, or success in the marriage market). This examination of representation is thus a study of how different characters combine real and imaginary facets of female physicality, the reasons they do so, and the consequences of their repackaging.

In the cultural study that is her fiction, Wharton proves herself to be particularly invested in acts of *mis*representation. She repeatedly takes issue with the way male artists have imagined women in art or literature—as passive, languid, sexualized, infantilized, dead, or sickly. Wharton interrogates a cultural preference for weak women, analyzing a gaze that,

like the protagonist of D'Annunzio's *Trionfo della morte,* finds female beauty to be "spiritualized in sickness and in weakness." Wharton elucidates the fact that by thus representing women in art and literature, the artist suggests how women are or how they *should* be. Wharton's project resonates powerfully today. Virtually everywhere we turn—the Oscars, the Internet, *American Idol,* the Victoria's Secret catalogue—we are reminded of the power inherent in the act of representation and the messages that are broadcast by way of these images: be beautiful, be thin, be sweet, be simple. This book recognizes Wharton's scathing critique of these misrepresentations of women, as opposed to what some have read as Wharton's disregard of women themselves.

In pursuing this thesis, *Edith Wharton and the Visual Arts* follows a methodology thoroughly concerned with the writer's intertextuality, literary as well as visual. The book points to Wharton's unacknowledged reworkings of texts by artists she deeply admired (Sir Joshua Reynolds, George Eliot, Robert Browning, Honoré de Balzac) and those of whom she was duly suspicious (Edgar Allan Poe, Nathaniel Hawthorne, John Ruskin, and most of all Dante Gabriel Rossetti). As we will see, Wharton's active engagement with these figures enacts a kind of "realist revision" of the gendered image. For instance, in the story "The Duchess at Prayer," Wharton appropriates and rewrites a Balzac tale such that the heroine's fate is less romantic and her tormenter more sinister than the original author had imagined. In so doing, as well as in her clever use of the visual arts as a medium for critiquing the material consequences of a masculine sexual aesthetic, she shows herself to be one of American literature's most gifted intertextual realists. Given its focus and methodology, this study is directed not only to scholars interested in a new context for reading Wharton but also to readers invested in American literature, cultural studies, women's studies, and visual culture.

Surveying the Critical Landscape

More than a century after the birth of her extraordinary career, Wharton is more resonant than ever.[2] The writer's attractiveness to twenty-first-century scholars is seen in the production of more articles, dissertations, and books devoted to her than ever before, and her appeal in

popular culture is evidenced by the appearance of articles addressing her in art, design, and architecture periodicals and in the major women's magazines in the United States and the United Kingdom: she is as much *en vogue* as she is literally in *Vogue*.[3] Her popularity is also evident in the recent transformation of *Ethan Frome, The Age of Innocence,* and *The House of Mirth* into motion pictures featuring major box office stars.[4] The Wharton shelves at Barnes & Noble are rapidly expanding, stocked with new editions of the canonical and less familiar texts.

It is perhaps no coincidence that as Wharton is an increasingly visible presence in our culture, so too is the woman-centered visual art that she interrogates in her fiction. Our modern-day Western culture's interest in these images is confirmed by the number of traveling exhibitions that have toured the United States and United Kingdom in the last decade: the Delaware Art Museum showcased a retrospective on the Pre-Raphaelite Brotherhood in 1995; Washington's National Gallery of Art in 1999 hosted a sweeping exhibition of the paintings of John Singer Sargent; at the turn of the century, the National Gallery of Art opened its doors to "Art Nouveau: 1890–1914"; and in 2002 the Corcoran Gallery offered "The Gilded Cage: Views of Women, 1873–1921." In 2003 London's National Gallery hosted "A Private Passion," which featured nineteenth-century paintings and drawings from the Winthrop Collection at Harvard University; this particular group of Rossettis, Burne-Joneses, Sargents, and Whistlers would have been available to Wharton and her audience, and some of them make their way into her fiction. That same year Liverpool's Walker Art Gallery hosted a Rossetti retrospective. In May 2004 Nashville's Frist Center for the Visual Arts welcomed "The Pre-Raphaelite Dream: Paintings and Drawings from the Tate Collection." In the summer of 2005 Tate Britain hosted its first ever retrospective of the eighteenth-century master Sir Joshua Reynolds, whose work, as we shall see, was central to Wharton's project. These retrospectives, and the crowds they draw, attest to the rediscovery of and revival of interest in (largely nineteenth-century) representations of women in modern visual culture. Furthermore, the countless reproductions on greeting cards, calendars, and Web sites of works by Rossetti, Waterhouse, and their peers speak to our own culture's fascination with these representations of women.

Wharton and Visual Culture

[Americans] have no goddesses or saints, they have forgotten their leg-
ends, they do not read the poets, but something of what goddess, saint,
or heroine represented to other races they find in the idealization of
their womankind.

—Samuel Isham,
The History of American Painting (1905)

Despite the impressive body of scholarship devoted to Wharton in re-
cent years and the fact that she is now acknowledged as a major liter-
ary figure, the attention paid to her interventions in visual culture has
been limited, even though throughout her career Wharton urged us
to recognize the allusions she was tucking into her literary art.[5] While
Judith Fryer has suggested in an otherwise excellent essay that Whar-
ton's "knowledge of painting . . . was not substantial" ("Reading" 34) the
writer left us, in her fiction, ample evidence to the contrary. Wharton's
friend and peer the French writer Paul Bourget aptly said of her that
there was "not a painter or sculptor of whose work she could not com-
pile a catalogue" (Lewis, *Edith Wharton* 69). Such oversights have, in
particular, delayed our recognition of Wharton's career-long engage-
ment with the work of Dante Gabriel Rossetti and the Pre-Raphaelite
Brotherhood (PRB). Until the present study, there has been no critical
account of Wharton's evident suspicion of, distaste for, and critique of
what she understood to be the decidedly antifeminist aesthetic of the
PRB and its peers.

Killoran's thoroughly engaging *Edith Wharton: Art and Allusion* (1996)
attends to the literary and artistic allusions Wharton makes in the nov-
els from *The House of Mirth* to *The Gods Arrive*. Killoran notes that
Wharton "pursued readers tenaciously," urging us to "solve the riddle,
understand its half-hidden messages" (8). In an essay titled "The Vice
of Reading" (1903), Wharton notes that "the born reader" enjoys "the
delights of intellectual vagrancy, of the improvised chase after a fleet-
ing allusion" (*Edith Wharton* xxix). And yet, while Wharton's earliest
short stories are packed with allusions to literary and visual texts, Kil-
loran's study does not examine the stories. A tale like Wharton's "The
House of the Dead Hand" prods us to study its allusions to authentic

works of art that are central to understanding the writer's project, specifically her engagement with turn-of-the-century aestheticism. These intertextual references remain like stones unturned in Wharton criticism, and the stories themselves resemble unfrequented galleries that deserve visitors. This book shows Wharton, then, working in the tradition documented by Murray Krieger known as *ekphrasis,* the practice of invoking actual works of art in literature. Wharton thus positions herself in a predominantly male (and modernist) tradition, some of the most famous practitioners of which were T. S. Eliot, W. H. Auden, Ezra Pound, and W. B. Yeats. This study thus reaches beyond the critical ground surveyed by Killoran's book as well as by Adeline Tintner's inspired *Edith Wharton in Context* (1999), which examines Wharton's invocations of literary and visual works. Tintner notes that while Wharton has always been acknowledged for her excellent taste in fashion and interior decor—her first book, after all, was the well-received co-authored manual titled *The Decoration of Houses*—"little attention has been paid . . . especially in detail, to the role that art played in her fiction or in changing tastes in art in which she, as social historian, was interested" (155).

Beyond celebrating Wharton's curatorial interest in her cultural moment, we also can recognize her as a social critic engaging with how nineteenth- and early twentieth-century American culture was produced and consumed. Critics have not heretofore positioned Wharton alongside the new art historical studies with which her work so profoundly intersects.[6] Additionally, by analyzing Wharton's fiction in relation to the nineteenth-century development of the museum—its functions and the opportunities it presented, or failed to present, women—we can begin to discern a new context for the study of Wharton. This book, then, recognizes Wharton's career-long dialogue with nineteenth-century visual culture, especially the work of the PRB, thereby allowing us to see Wharton enacting a cultural critique that transcends the literary arts, embraces the visual arts, and becomes a part of our shared cultural knowledge.

Never formally trained, Wharton was something of a self-taught art historian. She was well schooled at home. In her father's library she accessed the work of art historians and critics Anna Jameson, Franz Kugler, and John Ruskin. Though Wharton was sympathetic to many of

Ruskin's ideas, she did not share the formidable critic's disregard for the art of the Italian baroque and in fact defended this richly ornamented style of architecture and decoration in *Italian Villas and Their Gardens* and *Italian Backgrounds.* Further, in *The Decoration of Houses,* Wharton and coauthor Ogden Codman, Jr. challenge Ruskin's comparison between artistic integrity and a higher moral imperative. As a young woman, she brought the books of Vernon Lee (Violet Paget) with her on her visits to Italy. In Lee's work, Wharton found an enlightened guide to neoclassical architecture (Sherman 41). When Wharton had the occasion to meet Lee in 1894, she found in her "the first highly cultivated and brilliant woman I had ever known" (*A Backward Glance* 132). Further, Wharton's close friendships with such noteworthy art historians and intellectuals as Charles Eliot Norton, Bernard and Mary Berenson, Kenneth Clark, and Egerton Winthrop increased her access to the visual arts by way of their conversations and their collections.

Wharton's appetite and passion for the arts informed her travels abroad. During an 1893 visit to Florence, she made a day trip to the country with the express goal of investigating religious art about which she had read. She there made a major discovery, refuting the origins of a group of life-sized terra-cottas at the San Vivaldo Monastery near Tuscany. The figures were originally thought by Bernard Berenson and others to have been produced by the seventeenth-century sculptor Gonnelli. Wharton identified them as the work of the fifteenth-century Giovanni della Robbia (Benstock, *No Gifts* 77). Berenson did not appreciate Wharton's correction of his attribution, but with the help of the director of the Royal Museums in Florence, Wharton confirmed della Robbia as the artist and published her findings in an 1895 *Scribner's Magazine* article titled "A Tuscan Shrine." In an 1899 visit to Italy, Wharton journeyed to the village of Cerveno in search of sacred art. There she discovered a group of terra-cottas of Christ's Passion (Benstock, *No Gifts* 105). In her travel books she refers with ease to such Renaissance artists as Bellini, Carpaccio, Botticelli, Botticini, Piero di Cosimo, Signorelli, and Romanino. She admired the Carracci and appreciated Tiepolo, Longhi, and Guardi (Tintner 158). In a letter to Berenson three months before her death, she wrote that she yearned to see the Tintorettos in Venice (*Letters* 604).

While abroad, Wharton pursued sacred images (for example, Christ's Passion, the Nativity) used for devotional purposes, which may partly explain why her fiction takes issue with the perverse secularization of such images in the visual art of her cultural moment.[7] Indeed, her work documents an obsession with art that seeks to turn women's bodies into relics and shrines by literally and figuratively seducing or killing them in art, and it also betrays an awareness of the ways in which art was becoming a sort of "new religion" at the turn into the twentieth century.[8]

In addition to the limited treatment of Wharton's intersections with the visual arts, there remain other considerable gaps in Wharton scholarship to date. First, there has survived a tendency in the criticism to read Wharton as a kind of misogynist. Janet Malcolm's "The Woman Who Hated Women" (1986) is a case in point. Malcolm claims that in *The Custom of the Country*'s Undine Spragg "Wharton takes her cold dislike of women to a height of venomousness previously unknown in American letters and probably never surpassed," and in this remark we hear echoes of what early critics called Wharton's "icy restraint." Malcolm speaks for many when she suggests that the moments in Wharton's fiction in which women are ridiculed are to be taken at face value rather than as Wharton's critique of the lack of power afforded women. Critics continue to read Wharton as outwardly poking fun at aspiring women writers or intellectuals in her fiction. For instance, Josephine Donovan notes that to "be a serious author . . . for Wharton meant to be a patriarch. In numerous stories she puts down the silly, sentimentalist woman author" (*After the Fall* 45).[9] Wharton's fiction clearly subjects artistic and intellectual women to humiliation. But as one of American literature's shrewdest realists, Wharton represents her cultural moment; she exposes and interrogates the way in which women are represented as objects rather than as agents, as voices that are secondary, not primary. The gap Wharton imposes between protagonist and narrator (or reflector through whose eyes we see) makes clear this critique.

Wharton's consistent use of an untrustworthy, condescending male narrator, whose perspective is never neutral, is less a device that reflects the writer's male identification than it is Wharton's method of delivering her social commentary. These often egregiously arrogant male re-

flectors are reliably *un*reliable, and so Wharton compels us to question what she repeatedly calls their "unseeing" gazes. Surprisingly, most critics overlook Wharton's strategic use of narration, an oversight evidenced, for instance, in the critical trend that promotes Newland Archer of *The Age of Innocence* as a hero rather than an untrustworthy reader who misreads the women around him, in effect perpetuating outmoded gender stereotypes.

Smaller Realisms

Some of the best examples of Wharton's critical engagement with the visual arts are found in her short stories. Until recently, Wharton criticism had largely overlooked her work in this form, despite the fact that Wharton was first and foremost a writer of stories.[10] And while a handful of tales have garnered attention, they tend to be addressed in a limited number of contexts. Barbara White has performed a great service to Wharton readers by calling attention to the shorter fiction. The short story is a medium with which Wharton evidently was most comfortable, and it afforded her a place to do things she could not do elsewhere. In a 1907 letter, Wharton speaks of the "smaller realism that I arrive at, I think, better in my short stories. This is the reason why I have always obscurely felt that I didn't know how to write a novel. I feel it more clearly after each attempt, because it is in such sharp contrast to the sense of authority with which I take hold of a short story" (*Letters* 124). In *The Writing of Fiction* (1924), Wharton notes that the short story is particularly adept for recounting "situation" rather than character development, which she considers the task of the novel. Given that Wharton found the short story ideal for representing and describing situation —as in the situation, or predicament, of women—it makes sense to examine the cultural work her stories perform.

Edith Wharton and the Visual Arts examines the stories in tandem with the better-known, as well as the relatively unknown, Wharton novels, thereby allowing us to trace the development of her politics and view the full picture. The general consensus in Wharton scholarship of the last ten years is that the writer's entire body of work merits attention.[11] These underexamined narratives allowed Wharton to work through some of the issues she takes up in the novels for which she is known. For ex-

ample, the story "The Temperate Zone" serves as a fitting companion piece to *The House of Mirth* and *The Custom of the Country*. The present study shows Wharton revisiting, in this clever tale, the themes she addressed a generation before, and it also finds her reaching a kind of closure in her largely unread final novels, *The Gods Arrive* and *The Buccaneers*. Taking into account the entire body of Wharton's work allows us to see how the plot of a woman seeking to memorialize herself in art is a situation common to these narratives. Also consistent is the set of circumstances that prompts each woman to do so—a social system that compels women to sell themselves, rather than be sold, a system that asks them to profit from their "body art." Wharton's women locate power in their bodies, particularly the art they produce with their bodies. That her women manage to find empowerment in a culture of display remains one of Wharton's most intriguing paradoxes.

Wharton's fiction resounds with what must strike some readers as a growing pessimism concerning the possibilities for female artistic agency—an attitude conspicuously counter to the apparent victories of the women's movement and diametrically opposed, also, to the advancements made by women in the fields of museum work and development. The book traces these configurations chronologically in order to account for the development in Wharton's idea of the likelihood of women's resistance to their objectification as muses, as works of art, or as sexualized images and icons. "Progress," of course, need not necessarily be positive, and Wharton at least manages to negotiate a space for female creativity. Yet Wharton, in her life and in her art, finds no place in American culture for the American woman artist. What is more, at the end of her career Wharton seems to suggest with the example of the well-read Halo Tarrant of *The Gods Arrive* that if American women wish to be paired with men, they ought to be ready to forego their creative impulses and settle for the role of inspiring muse and (pro)creator of the male artist's offspring. Wharton thus sounds a cautionary note to the women of the Progressive Era, as if to say they have not, after all, traveled very far. Women continued to be read as "inexhaustible reservoirs," and by promoting their own exploitation—as objects, as muses— they in fact worsened the problem. But Wharton in her art has found a way for women to play Beatrice to their respective Dantes without reclining on the burial bier.

Wharton and the Pre-Raphaelites: Art That Penetrates

One face looks out from all his canvases,
One selfsame figure sits or walks or leans;
We found her hidden just behind those screens,
That mirror gave back all her loveliness.
A queen in opal or in ruby dress,
A nameless girl in freshest summer-greens,
A saint, an angel—every canvas means
That same one meaning, neither more nor less.
He feeds upon her face by day and night,
And she with true kind eyes looks back on him,
Fair as the moon and joyful as the light:
Not wan with waiting, not with sorrow dim;
Not as she is, but was when hope shone bright;
Not as she is, but as she fills his dream.

—Christina Rossetti,
"In an Artist's Studio"

[T]he painter must have been a pre-Raphaelite. . . . No one but a pre-Raphaelite would have so exaggerated every attribute of that delicate face as to give a lurid lightness to the blonde complexion, and a strange, sinister light to the deep blue eyes. No one but a pre-Raphaelite could have given to that pretty pouting mouth the hard and almost wicked look it had in the portrait.

—Mary Elizabeth Braddon,
Lady Audley's Secret

Edith Wharton repeatedly invoked painting as a medium through which to execute her critique of the way women's bodies have been imaged in Western culture, and she did so knowing she had at her disposal a mode of representation that would have been familiar to her reading audience.[12] Paula Gillett's study of painters in Victorian society notes that in the nineteenth century visual artists managed to reach members of virtually every social class—from the wealthy, who were able to purchase costly paintings, to those lower on the social scale, who could buy engraved reproductions of the same works, down to those who could view

contemporary art in inexpensive illustrated books, newspapers, and periodicals (192).[13] In the same way that Wharton's fiction typically looks back to an earlier era—the 1870s through the early twentieth century— so her allusions to paintings are drawn from works produced prior to or coincident with that period: Wharton resisted invoking the new trends, save perhaps a rare allusion to cubism, which she seemed to distrust. Further, Wharton made use of works by the established masters—Leonardo, Raphael, Bernini, Reynolds—in addition to her allusions to works from the nineteenth and early twentieth century.

Wharton cleverly drew from the rhetoric and the repertoire of the highly influential nineteenth-century Pre-Raphaelite Brotherhood, particularly its penchant for replicating not portraits of women but instead icons onto whose bodies male desire is superimposed, to launch her critique of the imaging of women in art. The Pre-Raphaelite Brotherhood, a group of seven young British artists, set out in 1848 to create a new style of painting inspired by Gothic and late medieval art. The original members of the PRB were the Rossetti brothers (Dante Gabriel and William Michael), painters William Holman Hunt, John Everett Millais, Frederick Stephens, and James Collinson, and sculptor Thomas Woolner. Pre-Raphaelitism, considered the first avant-garde movement in British painting, influenced the painters of the symbolist and aesthetic movements in England and France (Bullen 1; Barnes 113). From its inception, the Pre-Raphaelite Brotherhood was united as a reaction against the teaching of the Royal Academy, which advocated an imitation of the Old Masters. Rejecting the art of Raphael, they wanted to retreat to the style of painting produced before him, hence the name "Pre-Raphaelite." These artists were especially critical of Raphael's *Transfiguration* (1518) as, according to William Holman Hunt, "a painting which should be condemned for its grandiose disregard of the simplicity of truth, the pompous posturing of the Apostles, and the unspiritual attitudinizing of the Saviour" (Des Cars 16). The Pre-Raphaelites sought to reinvigorate painting by locating a more authentic origin, which they found in medieval art. The movement was spearheaded in its first generation by Dante Rossetti, Hunt, Millais, and Ford Madox Brown, and, a decade later, by Edward Burne-Jones and William Morris, artists who applied the tenets of the Pre-Raphaelites not only to painting and poetry but also to illustrated books and interior design. Although the original

Brotherhood lasted only until 1853, its influence on British art was pal-
pable through the 1920s (see Bullen). For all the Pre-Raphaelites' talk of
subverting convention, the movement proved to be backward looking
rather than forward thinking.[14] Susan P. Casteras notes the irony that
while the Pre-Raphaelites had set out to right the wrongs of those they
considered to be stilted academic painters—particularly their modes of
representing women—they ultimately committed the very sins they so
vehemently protested: "[I]n the end, part of what the Pre-Raphaelites
initially abhorred in academic art paradoxically reared its ugly head in
their own: repetitive formulas, frivolous representations of women, re-
ductive attitudes and a certain overall slickness" (Watson 145). Further,
Dante Rossetti's renderings of women are less portraits than they are
representations of the sort of "nameless girls" his sister Christina would
describe in her scathing sonnet, and Rossetti's own remarks suggest he
liked it that way. The painter evidently was discouraged to learn that his
Bocca Baciata (The Kissed Mouth)—a painting of a voluptuous, flame-
haired beauty inspired by a Boccaccio sonnet—was read by critics as a
portrait of his model-mistress Fanny Cornforth. Rossetti would have
preferred that the painting, to which Wharton alludes in *The Bucca-
neers,* be appreciated as art for its own sake, an anonymous stunner im-
pervious to our recognition (Wilton and Upstone 97). Wharton has set
to fiction the kind of exposé Christina Rossetti had offered: the same
female face looking out from all the painter's screens, resounding with
"[t]hat same one meaning, neither more nor less."

Wharton, whose library was well stocked with the poems of Christina
and Dante Rossetti, proves herself to be keenly aware of male artists'
wish to use a female model to "fill" their erotic "dreams" and "feed"
upon her "face," and she taps into the way in which, at least for the Pre-
Raphaelites, the artistic process was theorized as a sexual conquest.[15]
The connection between the Pre-Raphaelites and art as seduction is
underscored by the initials "PRB," with which these paintings were
signed. The monogram ostensibly stood for the "Pre-Raphaelite Brother-
hood" shared among the seven male artists who organized a collective
in the mid-nineteenth century, but was playfully translated by their con-
temporaries as "Penis Rather Better" (Barnes 13), an appellation that
startlingly admits that, for these young artists, anatomy was inextricably
linked to the process of artistic creation. Thus the connection between

the paintbrush and the phallus was firmly established, and it could not have been lost on Edith Wharton.[16]

Wharton's audience would have been familiar with the Pre-Raphaelite tradition which, by the turn of the century, was recognized as one of the most influential movements in British art. Pre-Raphaelite art was available for viewing in the United States as early as 1857 by way of a traveling exhibition on British art that visited Boston, New York, and Philadelphia. Collectors Charles Eliot Norton in the mid-1870s and 1880s and later Samuel Bancroft in the 1890s began adding Pre-Raphaelite art to their holdings (Watson 2). Norton, in fact, purchased a watercolor titled *Clerk Saunders* by Elizabeth Siddall, Rossetti's model, muse, and eventual wife; it was one of the only works she ever sold (Daly 60). The Bancroft collection, bequeathed to the Delaware Art Museum in 1935, became one of the largest ensembles of Pre-Raphaelite art outside the United Kingdom. Wharton was a close family friend of Harvard scholar Norton, who in 1874 offered the first formal course in art history in the United States. Wharton would have had access to these paintings, particularly those that comprised the Grenville L. Winthrop collection, which have since been bequeathed to Harvard's Fogg Museum of Art.[17] Among these images is Rossetti's *The Blessed Damozel,* which Wharton invokes in *The Custom of the Country* and *The Buccaneers.* Further, as Bailey Van Hook notes, "There were sections devoted to British art at the 1876 Centennial and the 1893 World's Columbian Exposition in the United States, as well as the 1878, 1889, and 1900 Universal Expositions in Paris" (227n76). The Grosvenor Gallery exhibition of 1877 provided another vital venue for Pre-Raphaelite art. Even if Wharton's readers did not have access to these exhibitions, they would have seen Rossetti's images through their many photographic reproductions, as hundreds of his paintings and drawings were photocopied and distributed before 1915 (*Rossetti Archive*).[18] In 1883, the year after Rossetti's death, three London venues—the Burlington Fine Arts Club, the Royal Academy of Art, and the newly opened Rossetti Gallery, run by Fanny Cornforth and her husband—held exhibitions commemorating Rossetti's achievements (Mancoff 98). Further, the 1897 opening of London's Tate Gallery, which showcased British art and has since become known for its impressive collection of Pre-Raphaelite paintings, helped spread awareness of the Brotherhood.

One way that Americans became aware of the Pre-Raphaelites was through the writings of the internationally famous art critic John Ruskin, whose *Modern Painters,* a text Wharton knew well, was published in the States in 1847 and quickly distinguished him as a leading voice in art. Ruskin identified himself as a staunch advocate of the Pre-Raphaelites in the early 1850s when he wrote two letters to *The Times* defending the young artists from the attacks of critics.[19] In volume 1 of *Modern Painters* (1843), a rather Emersonian Ruskin urges the artist: "Go to Nature in all singleness of heart, and walk with her laboriously and trustingly, having no other thought but how best to penetrate her meaning, and remember her instruction, rejecting nothing, selecting nothing and scorning nothing; believing all things to be right and good, and rejoicing always in the truth" (Des Cars 11).

Ruskin's impulse to "penetrate" Nature carries special poignancy, given the way that Wharton repeatedly critiques the artistic process as a kind of perverse sexual conquest of the female body in art.[20] Unconsummated love recurred as a motif in Pre-Raphaelite art, as Rossetti was fascinated with the story of Dante Alighieri's unrealized love for Beatrice. Rossetti's verse was touched by the theme of penetration: in the sonnet written for his painting *Astarte Syriaca* (1877), which is itself a tribute to his unrequited love for Jane Morris, Rossetti speaks of "Beauty's face" which bears "Love's all-penetrative spell" (*Poetical Works* 359). The connection between Pre-Raphaelite art and the penetration of (a feminine) "Nature" also was drawn by the critic Frederick William Henry Myers, who notes in his essay "Rossetti and the Religion of Beauty" (1887) that "with this newer school—with Rossetti especially—we feel at once that Nature is no more than an accessory. The most direct appeals, the most penetrating reminiscences, come to the worshipper of Beauty from a woman's eyes" (Des Cars 63).

For the Pre-Raphaelite tradition, the slippage between painting a woman and having relations with her was as literal as it was metaphorical. Alison Smith notes that "artists' relationships with their models had not always been conducted on a purely professional basis. Rossetti was far from conventional as was apparent from his relationship with Fanny Cornforth. . . . [Frederick] Sandys's private life was even more erratic; in 1867 he eloped with the model and actress Mary Jones, having earlier (or concurrently) had a relationship with a gipsy woman called Keomi" (Watson 87). Further examples of PRB artists who became in-

volved with, and eventually married, their "stunners" (which was the Pre-Raphaelite term for model) include Ford Madox Brown, who became the husband of Emma Hill, and Frederic Shields, who wed his model Matilda (Marsh, *Pre-Raphaelite Women* 24). William Morris's initial interactions with Jane Burden were as the painter for whom she posed; she would soon become Jane Morris. Dante Rossetti's two great loves served as his models: first Elizabeth Siddall, whom he eventually married, and later Jane Morris, who was already spoken for. Edward Burne-Jones depended on his model and mistress Maria Zambaco, a Greek sculptor, for some of his greatest art (Daly 417). While these liaisons—most of them temporarily or entirely extramarital—would have been condoned in Bohemian circles, most artists worked to keep up an appearance of respectability, often admitting their model-lovers through private entrances (Smith, "The Pre-Raphaelite Nude" 87).

While these women, then, were imagined, in life and in art, as sexual conquests, Wharton shows these conquests to be inherently marked by violence. We see this in her accounts of women who are "kept down,"[21] "blocked in," "imprisoned," or murdered in art. Bram Dijkstra has discussed the misogyny that permeated the visual arts to a degree that was either taken for granted or not thoroughly considered. The work of Dijkstra and other art historians enables us to see Wharton as one who exposes what others seemed to have accepted at face value. With respect to Pre-Raphaelite art in particular, Susan P. Casteras notes that "women were generally distorted as passive visual objects, dominated by the gaze of the men who made and stared at them in real life and on canvas. Such scopic biases are particularly problematic when placed in a social context, for just as English women were striving to gain new rights, more just treatment, and liberalized divorce laws, they were the targets of protracted artistic voyeurism by the Pre-Raphaelites and other artists, who frequently cast them into rigid if beautiful stereotypes" (Watson 146). In spite of the advancements in women's place in modern culture, these images served to reinforce their status as objects of a gaze that would control and commodify.

Women on Display

Several cultural critics have given us the language to talk about the kind of objectification of women that Wharton struggles with and responds

to in her fiction. Feminist and art historical scholars, drawing on Freud-
ian and Lacanian theory, have theorized the common cultural practice
of imagining women as spectacles that titillate and that seem to be in-
variably subject to a male gaze. Feminist film theorist Laura Mulvey has
used the phrase "to-be-looked-at-ness" to describe women's traditional
position as objects d'art (19). Mulvey famously posited that women "are
being turned all the time into objects of display, to be looked at and
gazed at and stared at by men. Yet, in a real sense, women are not there
at all. The parade has nothing to do with woman, everything to do with
man. . . . Women are simply the scenery onto which men project their
narcissistic fantasies" (13). Teresa de Lauretis also has discussed the cul-
tural inclination for men to project their desires onto women, arguing
that "woman" is the very foundation of representation. Western repre-
sentations, de Lauretis notes, work as texts that tell "the story of male
desire by performing the absence of woman and by producing woman
as text, as pure representation" (13). De Lauretis has argued that "the
representation of woman as image (spectacle, object to be looked at, vi-
sion of beauty—and the concurrent representation of the female body
as the locus of sexuality, site of visual pleasure, or lure of the gaze) is so
pervasive in our culture that it necessarily constitutes a starting point
for any understanding of sexual difference and its ideological effects in
the construction of social subjects, its presence in all forms of subjec-
tivity" (37–38). Mulvey in particular has posited that looking has come
to be a male-gendered activity with women positioned at the receiving
end of the gesture—"active/male" versus "passive/female" (19). Peter
Brooks more recently has noted that, in realism, "[w]hile the bodies
viewed are both male and female, vision is a typically male prerogative,
and its object of fascination the woman's body, in a cultural model so
persuasive that many women novelists don't reverse its vectors" (90).
While such theorists as Mulvey and Brooks seem to reject the possibility
of reversing these vectors, Wharton shows women to be appropriating
the gaze for their own purposes, particularly the heroines of the later
fiction who work the system to their advantage and oversee their ob-
jectification as works of art.

The history of the objectification of the female body is surprising,
for, as Brooks notes, the nude in art has not always been female. In
fact, "[t]he female nude appears considerably later than the male—

Kenneth Clark asserts that there are no female nudes in the sixth century B.C., and only rare examples in the fifth century—and is for a long time less common. . . . it is only with the nineteenth century that the female emerges as the very definition of the nude, and censorship of the fully unclothed male body becomes nearly total. . . . Meanwhile, the female nude became the object of connoisseurship, art exhibits, and collecting" (16). Indeed, there is an evident compulsion in the nineteenth century—the period to which Wharton regularly retreats in her fiction—that is given to linking aesthetic tastes and trends to its developments in objectifying the female body. Bailey Van Hook sheds light on this trend, noting that until about 1876, American art concentrated on landscape and genre painting (2). Van Hook notes that American art shifted around the time of the country's centennial due to the influence of European artists.

Images and representations of women are thus intimately bound up with the political landscape, and because Wharton is engaging these issues, her cultural work can be said to be political. In *Visual and Other Pleasures,* Mulvey notes that in the twenty years before she is writing (1989), feminism "emerged as a crucial new cultural and political force" (50). And so it remains. Feminists recognize images and representations to be fundamentally political. Wharton, then, is deeply committed to interrogating and intervening in the sexual politics of representation.

"And yet the earth is over her": Art That Enshrines

This is her picture as she was:
It seems a thing to wonder on,
As though mine image in the glass
Should tarry when myself am gone.
I gaze until she seems to stir,—
Until mine eyes almost aver
That now, even now, the sweet lips part
To breathe the words of the sweet heart:—
And yet the earth is over her.
. .
In painting her I shrined her face.

—Dante Gabriel Rossetti, "The Portrait"

Let this my lady's picture glow
Under my hand to praise her name.

. .

Her face is made her shrine. Let all men note
That in all years . . .
They that would look on her must come to me.

—Dante Gabriel Rossetti,

The House of Life, sonnet 10

The sensational story of Dante Rossetti's burial and recovery of his po-
ems illustrates the nineteenth century's inextricable link between art
and the death of a beautiful woman. In an ill-advised gesture that will
always haunt his biography, Rossetti (grief- or guilt-stricken) placed a
draft of his poems in the coffin of his wife, Elizabeth Siddall, only to
exhume it five years later to retrieve the manuscript and publish it in
1870. While Lizzie Siddall was alive, Rossetti and the Pre-Raphaelites de-
picted her as dead or on the brink of death—as dying Beatrice, drown-
ing Ophelia, martyred Saint Catherine, or ailing Lizzie.[22] (Charles How-
ell, who oversaw the disinterment of Siddall's coffin, assured Rossetti
that Lizzie's beauty remained "perfect" and that her glorious red-gold
hair filled the coffin [Daly 363].) Literally and metaphorically, Rossetti's
art is wrapped up with the body of a beautiful dead woman with whom
he had been intimate. As Carol Christ has observed, "the painted por-
trait is the most frequent vehicle through which nineteenth-century
writers represent the connection of their art to the dead female body"
(134), and countless paintings of dead women by such Victorian artists
as Edward Robert Hughes, William A. Breakspeare, John La Farge, and
John Atkinson Grimshaw, along with the above two Rossetti poems,
certainly suggest as much.

Nineteenth-century literature richly documents the cultural inclina-
tion to use art to dream the deaths of beautiful women. The decadent
poet Arthur Symons participates in this tradition when he writes:

O pale and heavy-lidded woman, why is your cheek
Pale as the dead, and what are your eyes afraid lest they speak?
And the woman answered me: I am pale as the dead

For the dead have loved me, and I dream of the dead. (Marsh,
Pre-Raphaelite Women, 135)

D'Annunzio, in *Trionfo della morte,* has his protagonist, Giogio, make
the following disturbing reflection: "How her beauty becomes spiritual-
ized in sickness and in weakness! I like her better when she is thus bro-
ken. . . . I think that in death she will attain to the supreme expression
of her beauty."[23] A poem titled "Evelyn Hope" by Robert Browning—
who was important to Wharton—with its accompanying illustration of
a female corpse by Sol Eytinge, Jr., stands as testament to the culture's
fascination with this trope.[24] Elisabeth Bronfen has noted that these art-
works emerge at the expense of the death of a beautiful woman, and the
works themselves are treated like female corpses: "Constructed rhetori-
cally like the fetish, the art object works by denying the existence of the
very thing it refers to, by masquerading as entirely self-sufficient, as a
non-referential sign, severed from materiality. Because it is the double,
not the thing itself, it can give the viewer a forbidden sight and shield
from its dangers" (123). This, then, is the kind of art that kills. Rossetti
produces it when his speaker claims that "in painting her I shrined her
face." Wharton critiques it when, in "The Muse's Tragedy," she notes
that Mary Anerton has been "enshrined in some of the noblest English
verse of the nineteenth century" (67)—sonnets written, not coinciden-
tally, by a poet bearing a striking resemblance to Rossetti.

The enshrinement of women surfaced as a popular motif in the
visual art of the period. Abbott Handerson Thayer, known for his exqui-
site female angels, stood as "a paradigm of the male artist who placed
women on a pedestal, believing the innocence of women and children
was superior to men's corrupted nature. [The critic] Ross Anderson has
found in Thayer's writings an artist who saw 'woman as a being who if
not enshrined by art might easily fall into an abyss of materialistic deg-
radations'" (Van Hook 192). Thayer's *Virgin Enthroned,* for which his
daughter modeled, exemplifies his impulse to preserve a woman's purity
by enshrining her in art. But as Dijkstra has noted, elevating a woman
to a pedestal can be understood as a strategy by which men might secure
power: "That, ultimately, was what the mid-nineteenth-century hoist-
ing of woman onto a monumental pedestal of virtue was all about: a

male fantasy of ultimate power, ultimate control—of having the world crawl at his feet" (19). As Wharton shows, the enshrinement of women in art has more to do with a man's power than a woman's.

Wharton demonstrates in the narratives discussed below that enshrinement is inherently intertwined with death. As Griselda Pollock has noted, "a shrine is used to celebrate some usually saintly person, after their death. The word shrine metonymically introduces the trope of death into the field of love, and also of art" (135). So by enshrining Mary as "Silvia" in his poetry, the poet of "The Muse's Tragedy" has at once rendered her immortal by refusing her death—she will always be alive in poetry, perpetually represented as the great muse, "Mrs. A" or "Silvia"—while at the same time he has killed her into art, frozen her in time and place. John William Waterhouse, the popular Victorian artist, provides a visual analogue in his 1895 painting *The Shrine*, which profiles a fair maiden gracefully enjoying a bouquet of flowers. Waterhouse's title alludes to the mantel at which the woman bows while marking the painting's status as a shrine to the porcelain-faced beauty that will endure after her death.

Edith Wharton and the Visual Arts is organized chronologically and thematically, so that each chapter focuses on a particular issue in a set of texts, and also so that the progression of Wharton's heroines, from victims to agents in the visual marketplace, can be highlighted. Chapter 1 examines the early fiction in which female bodies are seduced or "enshrined" in art and turned into portraits, poems, or statuary that men yearn to possess. In such stories as "The Muse's Tragedy" (1899), "The Moving Finger" (1901), and "The Duchess at Prayer" (1900), women are figuratively or literally killed into art. As Wharton instructs, the muse's agency is limited to the ability to empower men. Like Christina Rossetti, Wharton unveils a grim paradigm in which the male artist "feeds upon" the model's "face by day and night."

In these early stories Wharton lays bare her awareness of the way in which, for the Pre-Raphaelite Brotherhood, the creative process was theorized as a sexual conquest. Especially when we read them in the context of her allusions to Poe, Browning, Hawthorne, Balzac, and George Eliot, these critical references to Dante Rossetti and his Pre-Raphaelite peers show Wharton to be thoroughly engaged in a realist revision of

the sexual politics of nineteenth-century literature and visual culture. In fact, we begin to see a pattern whereby her narratives revise a story by a nineteenth-century male writer such that they tell a sobering truth about the state of women with respect to the politics of representation.

Remarkably, then, the women in the middle and later fiction increasingly commission their objectification and manage to find life, rather than death, in art. Lily Bart's tableau vivant in *The House of Mirth* (1905), which is the central focus of the second chapter, is a case in point. Chapter 2 situates this scene within the context of Wharton's attempts not only to expose but also to revise the conventions that would have women seduced or killed in art. Surprisingly, the scholarship to date has not fully reckoned with the meaning of Lily's selection for her "living picture." Lily's alignment with a painting by Sir Joshua Reynolds, the academic painter at whom the Pre-Raphaelites directed their bitterest scorn, ought to be read in keeping with Wharton's argument with, and critique of, the oversexed palette of the PRB. The chapter argues for the importance of situating Lily's tableau within this art historical context and reading it alongside the other "living pictures" Wharton carefully assembles for her pageant. Contextualizing Lily's choice in this way helps us to place her in a continuum of Wharton women and to appreciate Wharton's revisionary work in *The House of Mirth*. By positioning Lily alongside Kate Arran, the heroine of the overlooked Wharton tale "The Potboiler" (1904), the chapter makes it clear why Kate survives and Lily does not. Kate prevails because she understands the intricacies of the (marriage) market and, unlike Lily, she is willing to compromise.

The third chapter charts a new kind of Wharton heroine, the seeds of which are sown in Kate Arran and fully realized in Undine Spragg (*The Custom of the Country*, 1913), who manages to work the system and find power in her objectification, albeit with compromises that seem to be par for the course in the economy Wharton represents. The chapter also examines Wharton's criticism of the so-called New Woman by analyzing her complicity in the patterns of objectification that victimized her predecessors. Wharton depicts purposeful women channeling their objectification to their advantage, by using the power of sex and reproduction that only women have. The chapter combines a discussion of *Custom* with such lesser-known works as "The Temperate Zone" (1924) and Wharton's two-part narrative, *Hudson River Bracketed* (1929) and

The Gods Arrive (1932). Wharton, in this final completed narrative, returns to the trope of the muse with the angelically patient Halo Tarrant, who breathes inspiration into her lover as he struggles to write the Great American Novel. Halo ultimately offers her body as a space for his creativity. With Halo, the wheel has come full circle: she embraces her role as muse, assuming a stance that disturbingly resembles the supplication of the frozen-in-art heroine of "The Duchess at Prayer." Studying these underexamined texts alongside the canonical works provides a window on Wharton's response to, and suspicion of, the work of Progressive Era feminists and a more complete picture of the American writer as social critic.

Chapter 4 further contextualizes Wharton's critical engagement with the roles of women in visual culture by examining her acute, but skeptical, awareness of the then-contemporary advancements of women in museum work. The chapter examines Wharton texts in which women function as caretakers of art: the stories "The House of the Dead Hand" (1904), "The Rembrandt" (1900), "The Angel at the Grave" (1901), and "Mr. Jones" (1928), and the novella *Summer* (1917). Like the Wharton heroines discussed in chapter 3, these women make compromises, securing a relationship to art that is even more removed from its production; they are not even present at its creation. In a sense, they are merely watchwomen. With their "custodial work," these women exemplify what Wharton suggests is another unsatisfying relationship to art. The chapter acknowledges two exceptions, however, where Wharton's women do more than survive. In "The Rembrandt," Wharton finds a way for a woman to dupe a museum curator and make a profit on a painting that is likely a fake. In the masterfully told "Mr. Jones," Wharton acknowledges hope for an autonomous, globe-trotting (Whartonlike) writer-heroine to uncover the story of the silenced women who preceded her and claim and redecorate her house, even if it is haunted by a patriarch's ghost. At the same time, in "Mr. Jones," Wharton makes a key gesture toward revision insofar as she kills off the female custodian who had served as loyal apologist for the patriarch. In writing her out of the story, Wharton poignantly suggests that there is hope for the newer generation, though it comes with the passing of the older guard.

Several threads connect these Wharton narratives: (1) the cultural in-

clination to present women as objects for possession or exhibition; (2) the inextricable link between art and necrophilia; (3) the fact that painting women has been theorized as a sexual conquest marked by violence; (4) the tendency of the world of art and letters to embrace women willing to perform roles that are "feminine"/secondary/marginal; and (5) the notion that self-directed circulation of women's own bodies can be a means for survival, and a source for agency, in a world that would otherwise disempower them by turning them into objects to be plundered or entombed.

The fifth and final chapter presents Wharton's *The Age of Innocence* (1920) as a cautionary tale about the dangers of misguided reading and, in particular, of interpreting real women through the idealizing, mythologizing lens of the painter or poet. Indeed, multiple levels of Wharton's revisionary project come together in this novel and, as such, the chapter connects the fabrics that have been woven throughout the book: the unseeing gaze that disables Newland Archer and other of Wharton's male reflectors, Wharton's career-long engagement with Rossetti and the PRB, and Wharton's investment in locating a space for the creative American woman. The chapter closes with a brief discussion of *The Buccaneers,* the novel Wharton left unfinished at her death. Like *The Age of Innocence,* the final novel retreats to the old New York of Wharton's youth and weaves into the plot Rossetti's painting and poetry. In fact, the Pre-Raphaelite himself appears, rather worn and drug addicted, thus speaking to the Victorian artist's palpable presence throughout the body of Wharton's work. *The Age of Innocence* and *The Buccaneers,* which engage Rossetti and the Pre-Raphaelites, afford us an occasion to revisit with Wharton some of the ways that her male characters misread creative women, purposefully misconstruing them to the point that anything—even a marriage marked by "cold celibacy"—is better than having to share (creative) power with women. And yet, in *The Age of Innocence* Wharton offers the promising possibility of the American woman artist in Ellen Olenska, a woman who—although told, like many Wharton heroines, that she "ought to be painted"—secures for herself a more empowering and satisfying relationship to art. In this last chapter, and specifically in the example of the Countess Olenska, Wharton is revealed to have reached a conclusion. *Edith Wharton and the Visual*

Arts, then, offers an interdisciplinary approach to Wharton's engagement with issues of agency and representation that pervade American culture a century after the birth of her career.

When read in the context of Wharton's narratives on women, art, and representation, a moment from the short story "The Quicksand" (1904) resonates particularly powerfully.[25] Appropriately enough, the scene is played out against the backdrop of an art museum, and it depicts a seasoned woman advising her prospective daughter-in-law on the (decidedly unromantic) ways of the world. It is as if Wharton's voice is channeled through Mrs. Quentin: "I wanted to show you how little, as the years go on, theories, ideas, abstract conceptions of life, weigh against the actual, against the particular way in which life presents itself to us—to women especially. . . . Life is made up of compromises: that is what youth refuses to understand" (403). Wharton's fiction is rarely subtle in its articulation of what "youth refuses to understand," and it is there that she makes clear her awareness that life is marked by compromise, for "women especially." Her narratives nevertheless find ways for women to negotiate power and secure agency in light of the sexual politics of misrepresentation.

1

Beauty Enshrined
Living Pictures and Still Lifes; or,
Her Body Becomes His Art

Women and works of art are related creatures. . . . What is really
wanted of them is possession or exhibition.
—Hippolyte Taine, *Notes on Paris* (1901)

[M]en say of women, let them be idols, useless absorbents of previous
things, provided we are not obliged to admit them to be strictly fellow-
beings.
—George Eliot, "Margaret Fuller and
Mary Wollstonecraft" (1855)

Terence Davies admits he cast Gillian Anderson in his recent film of *The
House of Mirth* (2000) because she reminded him of a Sargent paint-
ing, a point that Wharton would have appreciated.[1] Davies had never
seen Anderson act—and at the film's release, he had yet to watch *The
X-Files*—but he selected his Lily because she looked like she stepped
from a canvas by the premier portraitist of Wharton's set. Wharton
clearly knew how it felt to be compared to a painting: her friend, the
writer Paul Bourget, called her "le Velasquez" after a child princess by
the Spanish artist (Lubbock 95).[2] As an adult, Wharton was painted
once, by her husband's friend Julian Story; thinking the portrait a fail-
ure, she refused to sit for another. Wharton also was averse to being pho-
tographed, as is clear from a 1902 letter to her publisher.[3] Such resistance
to being represented in visual culture suggests that Wharton keenly un-
derstood the power of images. And while both Gillian Anderson and
Edith Wharton, auburn-haired women rising to prominence at the start
of a century, established themselves as successful artists in their own
right, the men in their respective fields seem inclined to position them
as living portraits.

This chapter concerns moments in Wharton's fiction in which women are "enshrined" in art as poems, pictures, or statues—idols intended, as Taine[4] and Eliot suggest, for possession or exhibition. The chapter addresses Wharton's lesser-known early tales "The Muse's Tragedy," "The Moving Finger," and "The Duchess at Prayer" in context with the well-known *The House of Mirth*, while drawing connections to other texts by Wharton and those whose work her fiction invokes—Browning, Hawthorne, Poe, Balzac, George Eliot, Christina Rossetti, and especially Dante Rossetti. These Wharton tales embrace a number of shared themes: an awareness of the cultural predilection for imaging women as objects of display for possession or exhibition; a recognition of the period's inextricable link between art and the death of a beautiful woman; and a consciousness of the way in which the representation of women has been theorized as akin to sexually overpowering them and/or appropriating their "fertile gardens" and that this conquest is marked by violence.

These Wharton narratives, and the ones that would follow, offer a limited set of options for women. Among them are: disappointment and loneliness, death (after which one becomes an object d'art), acceptance of one's status as artwork for circulation in the marketplace, or self-directed circulation of one's own body on the marriage market. That is, Wharton's women can be circulated as works of art or they can beat men in their own game and elect to circulate themselves as marriageable commodities (Kate Arran, "The Potboiler") or as works of art (Lily Bart, *The House of Mirth;* Undine Spragg, *The Custom of the Country*) or both. Increasingly in Wharton's fiction, her women learn, as a survival tactic, to barter their bodies for their benefit. In fact, the women in Wharton's middle to late fiction turn the tables and locate agency in their objectification in a way that the early heroines could not: they direct and produce a kind of "body art." While Sandra Gilbert and Susan Gubar have astutely noted that "[m]id-Victorian writers of both sexes tended to dramatize a defeat of the female, while turn-of-the-century authors began to envision the possibility of women's triumph" (1:4), Wharton's case is more complicated. Indeed, what distinguishes Wharton is her contention that not much had truly changed for women by the early years of the twentieth century; and this, of course, was not a terribly popular message to broadcast. If Wharton is able to locate possi-

bility in these narratives, it is through her heroine's objectification and indeed the cross-marketing of her own body. This is not to suggest Wharton promotes or celebrates the strategy. On the contrary, she laments the choices available to American women. But at least Wharton manages to identify some options. This book's discussion of women who turn up disappointed or dead at the narrative's end (Mary Anerton, Mrs. Grancy, the duchess at prayer, Lily Bart) anticipates the striking example of Undine Spragg, discussed at the start of chapter 3, who carves out a space for her own agency. In the later years of her career, Edith Wharton negotiates a way for her heroines to survive in a system that would otherwise relentlessly objectify them in art. She allows the women of her later fiction to find ways to make the system work for them by overseeing and directing their body art.

The objectification of women must have struck a personal note for Edith Wharton, who was compared not only to a painting but also to a piece of furniture. At the height of her career, Wharton was described by a critic as being "finished as a Sheraton sideboard" (Parrington 393). The analogy resonates on many levels. Bram Dijkstra in *Idols of Perversity: Fantasies of Feminine Evil in Fin-de-Siècle Culture* describes a disturbing trend in the visual arts of the turn of the century that figures women as furniture. He points for example to drawings of women who offer their backs for the support of a chair. Such images, he claims, signify "the twisted turn-of-the-century dream of masculine mastery which insisted on seeing woman as merely a piece of household furniture" (118). And yet many of Wharton's women are ambivalent about the "dream of masculine mastery" to which Dijkstra refers—ambivalent because, although they may be objectified and sexualized, there are advantages to being likened to a work of art and thought so aesthetically pleasing that, like Ellen Olenska, they "ought to be painted." As Wharton repeatedly shows, upper-class women of leisure, and particularly the women of the later fiction, in effect support and reinforce the cultural codes and benefit from the pernicious tradition that objectifies them.

The comparison between Wharton and furniture further invokes Laura Mulvey's discussion of a more contemporary London exhibition of Allen Jones's work: "The sculptures formed a series, called 'Women as Furniture,' in which life-size effigies of women, slave-like and sexually provocative, double as hat-stands, tables and chairs. Not surprisingly,

members of Women's Liberation noticed the exhibition and denounced it as supremely exploitative of women's already exploited image" (6). Response to the 1970 Jones show makes it clear why a critic's likening of Wharton to a piece of furniture might offend women, and especially creative women. The comparison of Wharton to a work of art remained with her after death, when she was described by a scholar and sometime friend as though she were a novel by Henry James: "[S]he was all that only his [Henry James's] eloquence could depict . . . clear-cut, finely finished and trimmed and edged. . . . If she was a novel of his own she did him credit. . . . All this was much more than her pretty little literary talent, the handful of clever little fictions of her own" (Lubbock 21). Perhaps anticipating the dismissal of her "pretty little . . . talent" and "clever little fictions" and the will of others to render her, as they would the heroine of "The Muse's Tragedy," a "pretty little essay with a margin" (78), Wharton's own fiction takes up with special urgency the problem of the objectification of women in art and culture.

Turn-of-the-century America, which finds Wharton defining herself as a fiction writer, evidently expended a lot of energy dreaming of portraits of dead, beloved females coming to life, if only for an instant. We might consider the example of the popular magician Herrmann who in 1894 staged a scene titled *The Artist's Dream*. The *New York Herald* described it on November 18 as "a pathetic little sketch telling the story of an old French artist who had painted the portrait of his little daughter, who has died." The stage re-created the artist's studio: "[A]t one side stands the young girl's portrait. . . . the artist comes in, and after adding a few touches to the picture [of his daughter] with his brush, sits down in front of it. He gazes at it awhile, and then apparently drops off to sleep. In a twinkling a fairy appears in one of the empty frames, and as she waves her wand the portrait of the child literally comes to life before the eyes of the spectators. She steps down from the frame and dances and sings around her father's chair. Suddenly he awakes and—presto! the child is back in the frame, a picture once more." This fragment from the turn-of-the-century New York stage demonstrates the culture's attraction to art that captures dead female bodies, resurrects them for a moment in the fashion of Pygmalion, and restores them to the canvas, "a picture once more." Christina Rossetti's sonnet "In an Artist's Studio"

anticipates the work of the magician Herrmann, whose female model is alive only in the artist's dream.

"The Muse's Tragedy" (1899) remains a touchstone for Wharton's commentary on the enshrinement of women in art by men. Wharton's Mary Anerton, a forty-something American woman who has spent most of her life in Europe, has been canonized as the "Silvia" and "Mrs. A" of the celebrated sonnets by the late Vincent Rendle, a poet whom she loved in a way he could not reciprocate. Rendle in fact begs a comparison to Dante Rossetti, whose sonnet sequence *The House of Life* (1870) celebrates the second of his great loves—the inaccessible model-muse Jane Morris. Rendle's protégé, an aspiring young critic named Danyers, has long been intrigued with the mythical Mrs. A: "Ever since his Harvard days . . . Danyers had dreamed of Mrs. Anerton, the Silvia of Vincent Rendle's immortal sonnet cycle, the Mrs. A of the *Life and Letters.* Her name was enshrined in some of the noblest English verse of the nineteenth century" (67). Wharton here invokes the Anglo-Italian Rossetti's 1870 poem "The Portrait," in which the speaker celebrates his enshrinement of a woman's beauty: "In painting her I shrined her face" (l. 19). The tenth sonnet of *The House of Life,* also titled "The Portrait," similarly speaks in the voice of a male painter, who boasts

Her face is made her shrine. Let all men note
That in all years (O Love, thy gift is this!)
They that would look on her must come to me.

Like Rossetti's speaker, Wharton's Rendle has enshrined his muse in art such that the reader must go through him to get to her.

Mary Anerton and other Wharton heroines challenge the assumption that a muse is more active than passive. At the story's end, Mary says of Rendle's sonnets: "I am supposed to have 'inspired' them, and in a sense I did" (74). But the reader knows, if not from Wharton's own career then from the cautionary example of Emily Morland, the late accomplished poet of "The Temperate Zone" (1924), that it is not enough to "inspire" great art: it is said of Mrs. Morland that she "had been inspired, which, on the whole, is more worth-while than to inspire" (455).

Wharton borrows Danyers's perspective to deliver a commentary on

the sexually charged relationship between women, art, and inspiration: "Posterity is apt to regard the women whom poets have sung as chance pegs on which they hung their garlands; but Mrs. Anerton's mind was like some fertile garden wherein, inevitably, Rendle's imagination had rooted itself and flowered. Danyers began to see how many threads of his complex mental tissue the poet had owed to the blending of her temperament with his; in a certain sense Silvia had herself created the *Sonnets to Silvia*" (72). While the passage suggests Danyers's acknowledgment of the muse's involvement in literary production, it is "Silvia," not Mary, to whom credit is given. In rechristening Mary "Silvia" in art, Vincent Rendle aligns himself with Dante Rossetti, another Victorian sonneteer who renamed his muse: as his brother William noted, Dante Rossetti insisted on spelling Lizzie's last name with one "l" (Siddal), even though her family name was Siddall (*Dante Gabriel Rossetti: His Family Letters with a Memoir* 1:171). (He thought the change rendered it more refined.) Like Rendle, Rossetti effectively controlled how history would remember his muse, not just in image but also in name, given that Rossetti's spelling has generally been accepted as standard.[5]

Danyers's image renders Mary Anerton a "fertile ground" to be "inevitably" penetrated by the male genius—a paradigm that suggests the kind of Pre-Raphaelite art that would penetrate. In fact, Danyers seems to want to let his own imagination roam in "Silvia": "[H]e now thrilled to the close-packed significance of each line, the allusiveness of each word—his imagination lured hither and thither on fresh trails of thought, and perpetually spurred by the sense that, beyond what he had already discovered, more marvelous regions lay waiting to be explored" (67). So for both Rendle and Danyers, a woman enshrined in art remains a fertile ground waiting to be conquered by a male explorer who will linger *hither* and *thither,* drawing *thrills* from the process of unveiling the meaning of the text/garden/woman. But Wharton critiques this impulse first by having Mary survive Rendle and escape the "enforced immortality" of her enshrinement in art and also by having her reject the marriage proposal made by Danyers, a man who seems eager to fill Rendle's shoes (73).

The image of the male writer's imagination flowering in Mary Anerton's mind looks forward to a problematic remark Henry James would make in speaking about Wharton's fiction. James suggests in a 1902 let-

ter to Mary Cadwalader Jones, his longtime friend and Wharton's sister-in-law, that he evidently wanted to plant his own imagination in the aspiring writer's "fertile ground." While expressing approval of two volumes of Wharton stories, James nevertheless would like "to get hold of the little lady and pump the pure essence of my wisdom and experience into her. . . . If a work of imagination, of fiction, interests me at all . . . I always want to write it over in my own way. . . . *That* I always find a pleasure in, and I found it extremely in the "Vanished Hand" (Bell, *Edith Wharton and Henry James* 247). Apparently referring to "The Moving Finger," James's comment is instructive to Wharton readers not only for the way it reduces Wharton to "the little lady" but also for its undeniably sexual implications, suggesting a kind of intellectual ravishment that is decidedly violent.

Mary Anerton critiques the construction of woman-as-muse in the Dear John letter to Danyers with which the story closes, and she in fact proposes a solution to the muse's quandary. Of her failed romance with Rendle, who was more in love with his image of her than with her flesh-and-blood counterpart, she writes: "He had never made love to me; it was no fault of his if I wanted more than he could give me. The *Sonnets to Silvia,* you say? But what are they? A cosmic philosophy, not a love poem; addressed to Woman, not to a woman!" (75). The facts that Wharton's story is interrupted by the intrusion of Mary's voice (her letter to Danyers comprises the story's final section), that we more than once see her engaged in the act of writing, and that she speaks the words that close the narrative, suggest a kind of resistance to the way in which art and poetry enshrine women. Indeed, she speaks for herself at the close of a story that had otherwise been more Danyers's than her own. So while Wharton's Mary is empowered by the way in which she closes the narrative, it is useful to remember that her fate, signaled by the story's title, is far from happy: one of Wharton's tragic muses, she describes herself, finally, as "a disappointed woman" (73). But at least Mary escapes the narrative alive, and with a voice, which is more than can be said for the other tragic muses and enshrined beauties that constellate the pages of Wharton's early fiction.

Wharton's "The Moving Finger" reflects the nineteenth-century tendency to commingle art and necrophilia. The writer's investment in the theme is enunciated in her borrowings from two stories by Poe, who was

famously entranced by the topic of the death of a beautiful woman and who was hailed by Rossetti and his Pre-Raphaelite brothers as one of the great "Immortals" (Wildman 90).[6] In fact, Rossetti produced such drawings from Poe as *Ulalume* (1848), *The Sleeper* (1847), and *The Raven* (1847) (Nicoll 33). Rossetti's *The Blessed Damozel* was inspired by Poe's treatment of the bereaved lover in "The Raven" (Wilton and Upstone 192). (In the 1860s Rossetti even kept a raven as a pet [Daly 346].) "The Moving Finger" reverses the Pygmalion myth and documents a woman's transformation into art—she is indeed "imprisoned" by it—at the hands of two men.[7] The woman in this narrative has comparably less agency than Wharton's Mary Anerton. Here, the protagonist is most empowered when dead, and it is only when she has acquired the status of a benevolent phantom and piece of art, instead of a woman with a voice and will, that she can lay claim to a measure of power, having been frozen into art by the able, "moving fingers" of more than one man.

"The Moving Finger" centers on a painting of a Mrs. Grancy who, like many Wharton heroines, is dead before the start of the narrative, and thus her story comes to us by way of a secondary source.[8] And while "The Muse's Tragedy" invites us inside Mary Anerton's consciousness, we have no such access to Mrs. Grancy's inner life: she is as one-dimensional as her portrait. In this story, Claydon, a portraitist, had been commissioned by his friend Ralph Grancy to paint his beloved wife. A great success, the painting is admired by all, but its subject dies three years later, and as he ages, Grancy comes to think the painted woman mocks him with her flawless youth. Grancy asks Claydon to alter the portrait so the image of Mrs. Grancy ages with him, but Claydon, appalled by the suggestion—which he likens to murder—refuses (177). He eventually consents and is horrified by the result; the picture no longer embodies perfection. A decade later the male narrator happens upon Grancy, realizing, to his dismay, that the portrait has been adulterated.[9] When Grancy dies, Claydon acquires the picture, restoring it to its original perfection. Claydon believes he now possesses Mrs. Grancy by way of her portrait.

Like "The Muse's Tragedy," this story casts the heroine in the role of muse. For instance, Mrs. Grancy inspires and drives Claydon to produce "his masterpiece"—enabling him, as he puts it, to paint as he "shall never paint again" (156, 176). But Wharton here, in her later story, pre-

sents an even bleaker picture, given her emphasis on a muse rendered a silent, immobile object of art—the kind of "pretty little essay" from which Mary Anerton escapes. While in "The Muse's Tragedy," Mary Anerton is allowed a certain measure of resistance to her objectification and lives to tell her story, Mrs. Grancy cannot escape burial in art. What's more, hers is barely a speaking part, as she remains relatively voiceless in this text.

Mrs. Grancy's portrait invokes turn-of-the-century images of women enthroned. As a piece of inanimate art, the woman holds court in her husband's library, "illuminating its studious walls" (157). When Claydon finally acquires the portrait, he makes it the centerpiece of a kind of shrine. The narrator observes the painting "throned alone on the panelled wall, asserting a brilliant supremacy over its carefully-chosen surroundings. . . . the whole room was tributary to it" (175). In *Angels of Art: Women and Art in American Society, 1876–1914*, Bailey Van Hook discusses (European-trained) American artists' interest in enthroning women. The painter Abbott Handerson Thayer, known for his ethereal depictions of angels, "strove for transcendent beauty by purging the contemporary material facts of existence from his compositions. . . . he abstracted out of reality only those pleasing and unthreatening qualities— by keeping the background plain, simplifying the complexity of clothing, arranging the pose and expression so it was passive and contented, accentuating the youth and innocence of his models—and by adding wings to his figures or placing them on elevated thrones, to produce an image read as embodying a spare and elegant spirituality" (163). Thayer, then, manages to elevate women to a higher level literally, by seating them on thrones, and figuratively, by eliminating earthly imperfections. In the Thayer images as well as the painting of Mrs. Grancy, placement atop a throne suggests at once power and entrapment. As a work of art, Mrs. Grancy will be worshiped, adored as an integral part of her surroundings, but she remains a woman framed.

Mrs. Grancy's status as art is anticipated by the narrator. He promotes the idea of Mrs. Grancy as a text to be analyzed: "Mrs. Grancy acquired the charm which makes some women's faces like a book of which the last page is never turned. There was always something new to read in her eyes" (156). As such the woman becomes a text that never will be completely contained or fully understood, as she remains inexhaustible. De-

spite the fact that her face never will be fully readable—there always will
be a final "page" unturned and inaccessible—Wharton assures us that
Claydon will try to unravel her in his rendering: "What Claydon read
there [in her eyes] . . . his portrait in due course declared to us" (156).
Wharton's narrator elucidates the notion that the painting will docu-
ment *what Claydon reads* in Mrs. Grancy's eyes, not what Mrs. Grancy's
eyes are saying. Further, as the narrator describes Mrs. Grancy, he notes
that "[s]o many people are like badly-composed statues, over-lapping
their niches at one point and leaving them vacant at another" (153). Yet
only Mrs. Grancy is overtly compared to such a "statue," and she seems
to know her place, as "her unique distinction was that of filling to per-
fection her special place in the world" (153).

Even more than a book or a statue, Mrs. Grancy is compared to a
flower planted by her husband: "If, to carry on the metaphor, Grancy's
life was a sedulously-cultivated enclosure, his wife was the flower he had
planted in its midst—the embowering tree, rather, which gave him rest
and shade at its foot and the wind of dreams in its upper branches" (153–
54). The narrator's metaphor likens the woman to an accommodating
article of nature into which the husband breathes life. As such, she ren-
ders him a service, offering the comfort of shade and "the wind of
dreams"—the kind of inspiration a muse might lend. With this meta-
phor, Wharton draws a link to the image of Rendle planting seeds that
flourish in Mary Anerton's "fertile garden." The subtle difference is that
while in "The Muse's Tragedy" the man's imagination spreads in the
woman's mind, here the woman has less agency for she is, as the flower
or tree he planted, dependent upon him for her existence.

Prevalent in the mid-nineteenth century was a line of thinking that
posited women as flowers planted by men. The proper husband was ex-
pected to "regard himself as the gardener and his wife as his flower. As
a matter of fact, in her very essence, her fragility, her physical beauty,
her passivity and lack of aptitude for practical matters, woman was vir-
tually a flower herself" (Dijkstra 15). Ruskin's observation that the "path
of a good woman is indeed strewn with flowers; but they rise behind her
steps, not before them" (Ruskin, "Sesame and Lilies" 93) suggests that a
"good," "true" woman would leave flowers in her wake rather than the
indelicate footprints made by one who walks with firm steps. Replacing
female footsteps with flowers denies women groundedness and stability.

Dijkstra notes that in the second half of the nineteenth century, women frequently were equated with flowers in the visual arts: "Robert Reid, in his *Fleur de Lys*[,] . . . dramatically suggested the unity of woman and flower by making her, as it were, 'grow' among the flowers she is contemplating, the elegant curves of her body and dress serving as the stem and leaves of this delicate representative of the static existence of woman as flower" (15). The photographer Gregory Crewdson's 1999 piece titled "woman in flowers," which positions an apparently disillusioned woman seated in a garden that is also her kitchen, seems to critique the (still resonant) conception of woman as flower. And because we cannot see their feet, the suggestion that these women have taken root in the soil is all the more pronounced.

If, according to this reasoning, women are creations engendered by men, Wharton shows that these men fancy a woman's primary wish is to please, and she thus represents the kind of fantasy of shaping women into what men "wish" that we have seen in Hawthorne's "The Birth Mark" (1846) and such modern-day narratives as *The Stepford Wives* and *M. Butterfly*. In the Wharton tale, men see this desire to please them as utterly inexhaustible. Claydon recounts to the narrator the story of how Grancy asked him to adjust the painting—a request he initially refused. But the artist later has a change of heart: "At first I told him I couldn't do it—but afterward, when he left me alone with the picture, something queer happened. . . . as I sat looking up at her, she seemed to say, 'I'm not yours but his, and I want you to make me what he wishes.' And so I did it" (177). When Wharton's narrator learns that the husband had the portrait doctored to give the impression that Mrs. Grancy has aged, Grancy insists he is privy to his wife's desires: "It's what she would have wished. . . . That we should grow old together" (164). But it has more to do with what *he* wishes, for he "like[s] her better so."

In Hawthorne's "The Birth Mark," Aylmer muses that the crimson mark on his (otherwise beautiful) wife's face might well be removed. When she returns that the mark has been deemed a "charm" by some, he notes: "Ah, upon another face, perhaps it might. . . . But never on yours! . . . you came so nearly perfect from the hand of Nature, that this slightest possible defect—which we hesitate whether to term a defect or a beauty—shocks me, as being the visible mark of earthly imperfection" (764–65). Hawthorne's story, of course, shows the husband's correc-

tional impulses to be destructive, as his efforts to remove the mark trigger his wife's death. But in the Wharton tale, the man's zeal seems to go unpunished.

In her depiction of male power gone awry, Wharton looks forward to the film *The Stepford Wives* (1975), based on the Ira Levin novel, in which members of a secretive "men's association" conspire to transform their wives into unfeeling robots programmed to please them. One by one they kill the women, replacing them with bigger-breasted, apron-wearing clones who thrive on performing "the little domestic things" men admittedly love to "watch." When Joanna, the resisting feminist protagonist, asks why the men carry on this way, the ringleader chillingly responds "*Because we can.*" David Henry Hwang's play *M. Butterfly* (1988) represents a similar cultural tendency for a man to fall in love with his image of a woman, and for that image to replace the reality (even when, in this case, the ideal "woman" is a male spy in drag).[10] Wharton, then, anticipates Hwang's play in documenting the impulse to become enamored with an image one has mistaken for reality.

Not only does Wharton's Mrs. Grancy become an aesthetically pleasing work of art but her portrait becomes more "real" to men than the woman who inspired it. Claydon remarks that "the portrait *was* Mrs. Grancy," in response to which the narrator confesses "there were moments when the statement seemed unanswerable" (157). That the gap between the real and the painted becomes blurred is evidenced by a remark made by Grancy: "[G]radually the distinction between the two was effaced and the mere thought of her grew warm as flesh and blood" (167). Thus, the man's vision of the woman is as good as "flesh and blood." Wharton's narrative thus resonates with Christina Rossetti's "In an Artist's Studio," in which the male painter represents the female subject "not as she is, but as she fills his dream." In Wharton's tale, the painting and the woman also are interchangeable for the portraitist: the narrator recounts that "often, when Mrs. Grancy was in the room, . . . Claydon, averted from the real woman, would sit as it were listening to the picture" (158). Wharton's language in "The Moving Finger" anticipates *The House of Mirth:* with such phrases as "flesh and blood" and "real self," Wharton looks forward to the tableaux vivants scene in which the spectators are mesmerized by "the flesh and blood loveliness of Lily Bart" as she impersonates a Reynolds painting. In this same

scene, Lily's admirer, Lawrence Selden, recognizes in her imitation of a painting "the real Lily" (134–35). Wharton, then, is acutely aware of men who mistake visual representations of women for their real selves; the image seems to be even better than the real thing.

Recalling the way in which Mary Anerton has been romanced in art, Claydon falls in love with his portrait in a reenactment of the Pygmalion myth. According to Wharton's narrator, it was said that "Claydon had been saved from falling in love with Mrs. Grancy only by falling in love with his picture of her" (158). (As such, he anticipates *The Age of Innocence*'s Newland Archer, who considers his "vision" of Ellen Olenska "more real" than the woman herself.) Wharton thus critiques the cultural myopia that perpetuates women as images and icons—as constructions so desirable that men become enamored with them. Wharton inverts the Pygmalion myth, a story Linda Nochlin recognizes as particularly popular in nineteenth-century visual culture—"stone beauty made flesh by the warming glow of masculine desire" (*Women, Art, and Power* 19).[11] The artist Claydon chillingly compares himself to the mythological figure: "Pygmalion . . . turned his statue into a real woman; *I* turned my real woman into a picture. Small compensation, you think— but you don't know how much of a woman belongs to you after you've painted her! . . . I gave her the best I had in me; and she gave me in return what such a woman gives by merely being. . . . There was one side of her, though, that was mine alone, and that was her beauty; for no one else understood it" (176).

In boasting that he has turned his "real woman into a picture," Claydon speaks of his rendering of Mrs. Grancy in the language of sexual conquest (*I gave her the best I had in me*), as though ownership of the woman is consecrated by this clearly sexually charged act: "[Y]ou don't know how much of a woman belongs to you after you've painted her"; "There was one side of her . . . that was mine alone . . . for no one else understood it." It is as if no one can "know" her in the way that he seems to think he does. With such a claim, we can read "painted her" as a euphemism for "had sex with her" or, better put, wishes he had. As such, Wharton's artist recalls the speaker of Rossetti's poem "The Portrait" who, after finishing his painting of his beloved, challenges "all men" to "note" that "[t]hey that would look on her must come to me." And for Claydon, the act of painting is likened to a transaction in which

the "compensation" is his ownership of the woman and, especially, her sexuality. The painter, then, fancies himself a kind of gatekeeper to her beauty, erecting a power structure that harkens back to Browning's "My Last Duchess" and anticipates Wharton's "Duchess at Prayer."

In his comparison between painting a woman and sexually conquering her, Claydon anticipates such painters as Mungold ("The Potboiler"), Popple (*Custom of the Country*), and Jolyesse ("The Temperate Zone"), who surface later in Wharton's fiction. Popple's art grants him license to "do" women, while Jolyesse hopes to "have" them by way of portraiture. But as for possession of the woman in the portrait—which Claydon claims—it seems the painter has some competition. For Grancy feels the portrait allows him to declare his wife his property. He habitually told his wife the picture serves as a way to imprison her: "I used to say to her, 'You're my prisoner now—I shall never lose you'" (166). But alas, by the narrative's end, the painting falls back into the hands of Claydon, who joyfully claims that "now she belongs to me" (178).

Wharton's allusion to the Pygmalion myth resonates in other important ways that undermine the power of female creativity. A significant yet overlooked detail is that Pygmalion was created without the intervention of a woman (Kestner 61). Wharton's command of mythology suggests she planted the allusion deliberately. The invocation of this myth not only objectifies and fetishizes the female body but also undermines and dispenses with women's creative capacities. Claydon's use of the myth itself suggests men's insecurity in the face of women's power to reproduce or, more generally speaking, to create (that is, create life or art). Wharton here highlights what Kestner has called an intersection of mythology and misogyny. Further, what Elisabeth Bronfen says about the male artist's narcissistic impulse rings true for Wharton's tale: "[T]he artist's narcissism is supported by his creation. . . . If security and empowerment is connected with the gaze in that something is made present to sight, then what remains absent from sight perturbs and questions power—notably woman's sexuality . . . and the body absent in death. In the case of the feminine corpse and the portrait of a deceased woman, the non-visible is given figure, visual presence" (122–23). And that "visual presence" takes the place of the dead woman it represents.

In the struggle between the two men, portraitist and husband, Wharton's story begs the question of who, finally, has more power over the

woman—or who *believes* he does. Is it the producer or the owner of the image? When the husband acquires the portrait, he can keep the woman as a "prisoner" of his gaze and he likewise can monitor who has access to her image. As the keeper and guardian of his dead wife's image, Grancy broadcasts a message to all men that resonates with that of the speaker of Rossetti's "The Portrait."[12] But the power over the portrait is ultimately restored to the painter by the narrative's end: he boasts that by painting her, he was the only one who truly "understood" her, and thus her image belonged to him (176). And he undermines Grancy's "possession" of his wife when he claims: "Even when he saw the picture he didn't guess my secret—he was so sure she was all his! As though a man should think he owned the moon because it was reflected in the pool at his door—" (176–77).

With the claim that the husband "didn't guess" his "secret," Claydon suggests there is something adulterous about his act of painting the married woman, which looks forward to those male painters in Wharton's repertoire who imagine the act of painting a woman as a stand-in for the sex he is not having with her. And yet Wharton clearly ridicules the idea of men having exclusive rights to a woman's body by way of painting her. After all, Claydon is living in a kind of fantasy world at the end of the story, flanked by his shrine erected in Mrs. Grancy's name.

The connection between Wharton's tale and female enshrinement is underscored by her invocation of two tales by Poe. First, Wharton alludes to "The Fall of the House of Usher" (1839) in her description of a woman imprisoned by art and thus further draws on the connection between art and necrophilia. In a very Edgar Allan Poe moment, Wharton's Grancy describes the extent to which his wife is oppressed in art. At this point his wife has been dead five years: "[T]he idea came to me: 'It's the picture that stands between us; the picture that is dead, and not my wife. To sit in this room is to keep watch beside a corpse.' . . . As this feeling grew on me the portrait became like a beautiful mausoleum in which she had been buried alive: I could hear her beating against the painted walls and crying to me faintly for help" (169; Wharton's ellipsis).[13] The painting not only displaces his wife's corpse (the *portrait* is dead); it also becomes a tomb where the woman has been buried alive—as if in having her painted he had her killed. Again we hear echoes of Rossetti: *In painting her I shrined her face.*[14] Wharton here invokes Poe's

image of a woman similarly beating against walls, protesting her premature burial. The allusion to the grisly Poe story—which practices his theory that the death of a beautiful woman is the most poetic subject—bleakly forecasts the unlikely possibilities for female agency, given the image of a woman as a passive object, to be gazed on and admired. Her terror, then, is either ignored or eroticized. Bronfen's remarks on Rossetti's poem "The Portrait" help us unpack Wharton's use of the painting of Mrs. Grancy: "It self-reflexively doubles the uncanny position of its object of depiction—a woman made relic before her decease; the desired body always already lost before and beyond any material absence" (119). Indeed, Wharton's Mrs. Grancy became a relic before her decease. And her painting becomes a shrine after her death, as Grancy removes it to a private sanctuary where he gazes at it alone (170).

Wharton also draws from a lesser-known Poe tale titled "The Oval Portrait" (1842), which similarly concerns the enshrinement in art of a beautiful woman and foregrounds the link between art and necrophilia as well as the notion that painting a woman substitutes for the sexual act. In the Poe story, which, like Wharton's "Moving Finger," comes to us via a third male party who is intrigued by the story behind a portrait, a young bride obliges her painter-husband's request to sit for him. As he paints her, she falls ill—unbeknownst to him she withers away from poor conditions in the dark turret where she sits.[15] Indeed, he has drawn from her very life force to make his portrait complete: "[H]e *would* not see that the tints which he spread upon the canvas were drawn from the cheeks of her who sate beside him" (106). Poe's artist, then, sucks the life force from his subject in a way that invokes Pygmalion's anxiety in the face of women's reproductive powers. At the same time, it is clear that Poe's artist fails to see the real woman—and thus detect her rapid decline—and instead can only see his picture of her. As such, he looks forward to Wharton's men who prefer image to reality. At the moment Poe's artist completes his painting, he beholds his masterpiece, crying, "This is indeed *Life* itself!" But evidently he has "finished" not only the portrait but also his wife, for he turns to her to find her dead. (Poe's original title, "Life in Death," points to a perverse need to kill a woman in order to create life in art.) So perfection of art and death are inextricably linked in the Poe story as they are in the Wharton tale.

A male painter's all-consuming absorption in his work at the expense

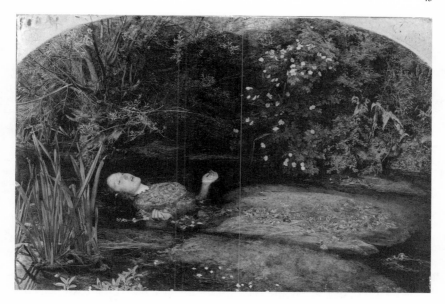

2. John Everett Millais, *Ophelia* (1851–52). © Tate, London 2005.

of the model's health also marks the story behind the making of John Everett Millais's *Ophelia* (figure 2), for which Elizabeth Siddall posed. Only nineteen years old and admired for her "red, coppery hair and bright consumptive complexion," Siddall modeled for the hauntingly gorgeous painting of Shakespeare's drowning tragedienne in a tub full of water, kept warm by oil lamps. As legend has it, the flames went out, Siddall took ill, and Millais, so hypnotized by the creative process, failed to notice. Siddall acquired pneumonia and seems never to have quite regained her health (Millais). Millais's picture, now a masterwork at Tate Britain, inaugurated for Lizzie Siddall a career bookended by aesthetically beautiful deaths.

Poe's "Oval Portrait" also highlights a trope that Wharton appropriates in "The Moving Finger" and elsewhere: painting a woman as a substitution for having sex with her.[16] In the Poe tale, the painter's act of capturing his wife on canvas displaces the sexual act. Poe's narrator tells us that the dutiful, virginal bride, though faithful and meek, acknowledges that her husband "already [had] a bride in his Art" and as such she grows to hate "the Art which was her rival" (105). In the Poe

tale, we immediately see the painter's lust for art taking the place of what would be a healthy, normal attraction to his wife. The painter's libido is projected onto his artwork: we learn of his "wild," "passionate" "desire to portray his young bride" with a yearning that endured "from hour to hour, and from day to day" as if to substitute for the sex that normally would occur during a couple's newlywed hours (106). And though the bride is uncomfortable sitting for him, "[y]et she smiled on and still on, uncomplainingly, because she saw that the painter (who had high renown) took a fervid and burning pleasure in his task, and wrought day and night to depict her who so loved him." Poe's story anticipates Christina Rossetti's sonnet insofar as the male painter "feeds upon" the model's "face by day and night," while "she with true kind eyes looks back on him." Again, Poe has used a rhetoric of sex—the sort of nineteenth-century sex that a husband is expected to enjoy and a wife should not—to describe the process of representing a woman in art.

Why, then, did Wharton appropriate the Poe tale? One reason seems to be its shared emphasis on the slippage between painting a woman and having sex with her, though the Poe tale lacks the natural, analogous sexual passion. While we cannot know whether or not Mrs. Grancy resisted having her portrait done (Wharton grants her one speaking line), the wife in the Poe tale did hesitate to sit for him, for "[i]t was . . . a terrible thing for this lady to hear the painter speak of his desire to portray even his young bride" (105). In both tales, the woman dies after the painting is complete and the painter mistakes the picture for "Life itself": the canvas replaces her. But in Poe the woman dies as a result of the husband's painting her, whereas in Wharton the woman expires a few years after the husband commissions the portrait. So Wharton's heroine lingers long enough to show the men's misguided identification of the painting as reality. Wharton's narrative, unlike the Poe tale, emphasizes men's desire to control the image, seen in Grancy's and Claydon's wish to correct the imperfections found in the portrait. Both tales focus on the "spell of the picture" (Poe 105).

If Wharton's Mrs. Grancy has any power, it comes at the cost of her death.[17] Once Mrs. Grancy is dead and Grancy himself is dying, he attributes a supernatural agency to his wife's portrait: as he puts it, she "knows" he is dying (173). Further, Mrs. Grancy, as a kind of phantom, is more powerful and influential than when mortal; the narrator senses the

dead woman's presence throughout Grancy's home: "I found how inextricably his wife was interwoven with my remembrance of the place: how the whole scene was but an extension of that vivid presence" (162). She is most "vividly" present when absent. Diane Price Herndl's discussion of Poe's "The Oval Portrait" and Hawthorne's "The Birth Mark" offers a way of understanding the empowerment that might come from the death of a woman who had been trapped in an otherwise victimizing narrative: "[N]either wife can assert her power, first, because the husband in each story has relegated her to the status of material for his work and, finally, because he kills her. In so doing, he unequivocally returns her to a state of nature, for she has ceased being human. . . . These women do not leave the legacy of faith and good works that female characters in women's fiction so often do, but they do leave behind men who are finally defeated by woman's ultimate supernatural power" (90). The fact that the men in these stories are defeated does not necessarily mean the women are victorious. Wharton's Mrs. Grancy is a case in point. At the end of Wharton's story, it is the painter who has survived and now possesses the woman by way of her image. It is true that as a portrait the woman has power—Claydon says that he could read a message in her painted image: "[W]hen I turned to the picture . . . I swear it was *her* face that told me he was dying. . . . She had a message for him and she made me deliver it" (177–78). But Wharton's story deconstructs the notion that the painter can read a woman, for in truth he reads her image made by his hand, and the meaning he has imposed onto her body, and so his sense of reality collapses on itself. True, the men are ultimately defeated in the Wharton tale, but so too is the woman who has served as a muse and ultimately as a work of art. Like Wharton's duchess, whose story also comes to us secondhand, this woman has been frozen into art by male gazes that wish to contain her body and her sexuality. These women are subject to a visual vector—woman as object of a gaze that sexualizes, objectifies, and enshrines—that only Wharton's later heroines will have the savvy and survivor instincts necessary to reverse.

In Wharton's more macabre "The Duchess at Prayer" (1900), a woman literally becomes a statue chiseled in marble at her husband's command. Here the woman's transformation into art is less a tribute to her beauty and virtue, as is the purported intention of the picture of Mrs. Grancy,

and more an effort to curtail the sexual recklessness of an allegedly way-ward woman. In both instances, the work of art is a means to freeze and control the wife of the man who commissioned it; each husband acquires power over whose eyes gaze on the enshrined beauty. Further, as in "The Moving Finger," Wharton shows that, for men, art can be a means of controlling a woman's sexual behavior—either by imprisoning a faithful, virtuous woman (Mrs. Grancy) or punishing a faithless woman for her indiscretions (the duchess). In this tale, the settling of the female body is comparably more violent.

Wharton's "The Duchess at Prayer" reflects back to the seventeenth-century marriage of a cold, Casaubonlike[18] Italian duke and his unfortunate Duchess Violante, whose name (resembling the French *violer,* to rape) accentuates the decidedly sexual nature of the harm inflicted by her duke. The duke suspects his wife of cheating on him with his charming cousin (and the narrative lends support to his assumption).[19] Presumably by order of the duke, the cousin never returns—not publicly—and the duchess takes up a devout life, which seems a front to mask her dalliances during her supposed devotions.[20] As what he poignantly calls a "tribute to [her] extraordinary piety" (22)—a gesture oozing with irony, given that he seems well aware her piety is a pretext—the duke arranges for the Italian baroque sculptor Bernini to produce a statue of the duchess kneeling in prayer. The duke presents the work to his wife and the members of their community in an apparent effort to exert supremacy over her body.

Wharton's narrator describes the statue in terms so provocative it is surprising that critics have all but ignored the tale's sexual implications. The Bernini depicts

> a woman in furred robes and spreading fraise, her hand lifted, her face addressed to the tabernacle. There was a strangeness in the sight of that immovable presence locked in prayer before an abandoned shrine. Her face was hidden, and I wondered whether it were grief or gratitude that raised her hands and drew her eyes to the altar, where no living prayer joined her marble invocation. . . . The Duchess's attitude was one of transport, as though heavenly airs fluttered her laces and the love-locks escaping from her coif. I saw how admirably the sculptor had caught the

poise of her head, the tender slope of the shoulder; then I crossed over and looked into her face—it was a frozen horror. (5–6)

Wharton's description of the Bernini is fertile. The figure's "love-locks" and "attitude of transport," as well as the double entendre of "abandoned," suggest a slippage—or at least the duke's suspicion of a slippage —between the woman's spiritual ecstasy (addressed to her saint) and her sexual abandon (directed at her lover).[21] The reference to the "strangeness" of "grief or gratitude" suggests orgasmic ecstasy. There is something pointedly sexual in the image of "furred robes" and "spreading fraise," which suggest the illicit "spreading" of the woman's legs. The reference to the Duchess's "love-locks escaping from her coif" further suggests sexuality. That the locks are attempting to "escape" her coif— the skullcap worn by nuns beneath a veil—suggests a repressed sexuality yearning for liberation from the conventions of a devout life, given that loose hair is often a symbol of female sexuality.[22] The attempted escape of the duchess's locks reflects her resistance to her husband's efforts to contain her sexuality. Her resistance, and her efforts to channel her sexual energies where she might, are, of course, in vain. Her body becomes his art.

With the description of the statue of the duchess, Wharton invokes Dante Rossetti's painting *Beata Beatrix* (Blessed Beatrice) (1864–70), a painting Wharton knew well, in which the artist captures his wife, Elizabeth Siddall, as Dante's Beatrice in an ecstatic state that is both spiritual and sexual (figure 3). In fact, Rossetti, born Gabriel Charles Dante Rossetti, so identified with Dante Alighieri that in 1850 he changed his name to Dante Gabriel (dropping Charles altogether) to draw attention to his literary forebear. *Beata Beatrix* is one of several images in which Rossetti depicts Siddall either dead or on the brink of death. Rossetti began the painting while she was alive and returned to it after her death, ultimately producing six copies (Wilton and Upstone 157). Like the statue of Wharton's duchess, the painting captures the female subject in an attitude of ecstatic transport and, also like the Bernini, the subject's hands are clasped together. Lizzie Siddall is depicted in a scene from Dante's *Purgatorio* as Beatrice at the moment of her death. In a letter, Rossetti described the painting thus: "[T]he picture . . . is not at

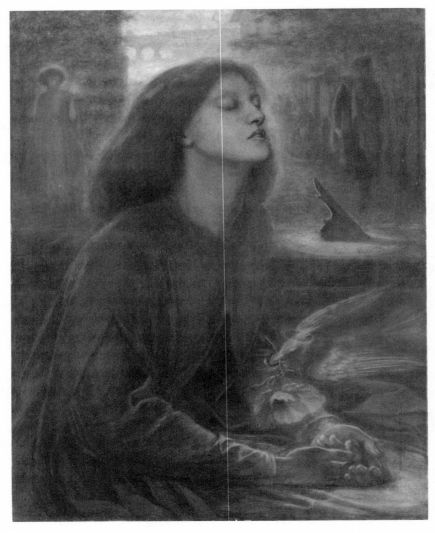

3. Dante Gabriel Rossetti, *Beata Beatrix* (1864–70). © Tate, London 2005.

all intended to represent Death . . . but to render it under the resem-
blance of a trance, in which Beatrice . . . is suddenly rapt from Earth to
Heaven" (Wilton and Upstone 155). As Andrew Wilton and Robert Up-
stone have noted, Rossetti's Beatrice "is frankly depicted in a way that
resembles sexual ecstasy. Her facial expression, raised head, straining

throat and parted lips are overtly sensual, and Rossetti evidently intends to suggest a connection between the sexual and the divine, between orgasm and revelation" (156). Rossetti's image, then, like Wharton's, conflates spiritual ecstasy with sexual rapture, similarly drawing a troubling link between sex and death.

If Wharton's image suggests sexuality, that sexuality is contained, for the statue serves to reinforce the code of conduct that the duke wants his duchess to emulate. The figure is "immovable," recalling the code that women remain "immovable as idols" (*The Age of Innocence* 63). Further, the statue's "hidden" face reflects a woman's proper degree of modesty, even shame. The prayer position implies the supplication appropriate to her sex, and it is a stance that Wharton revisits in the example of the (submissive) heroine of *The Gods Arrive,* discussed in chapter 3. Finally, the sculpture is confined, suggesting the woman's status as "locked" in place. Ultimately, the duke poisons and replaces his wife because he has suspected her of sexually "spreading" herself around. In a supernatural twist, the statue's face takes on a look of horror once installed in the chapel, reflecting the duchess's final moments of tortured angst.

In her description of the Bernini statue, and particularly its expression of "frozen horror" that is at once rapturous, Wharton demonstrates her familiarity with the work of Gian Lorenzo Bernini, master of seventeenth-century baroque sculpture. Wharton's statue of the duchess invokes Bernini's erotically charged *Ecstasy of Saint Theresa* (1645–52), which depicts in marble the swooning saint in a way that marries the sexual and the spiritual. Bernini's Theresa has in fact been wounded by the arrow of an angel of divine love; though his weapon has pierced her heart, he seems to aim it toward her pelvis. The dart's position reminds us of the duke's interest in punishing his duchess for her out-of-wedlock ecstasies. Wharton's statue blends the features of Bernini's Theresa of Avila with the frozen horror and tortured angst of his *Damned Soul* (1619) which, like Wharton's sculpture, projects "hate, revolt, and agony" (6).

Wharton's statue also invokes George Eliot, one of her most admired literary models. In Eliot's *Daniel Deronda* (1876), from which Wharton also draws for Lily Bart's tableau in *The House of Mirth,* the lovely, spirited Gwendolen Harleth aligns herself with a statue in a moment that looks forward to Wharton's story. In a particularly rich scene, Gwendolen

enacts a tableau vivant of the tragic Hermione from Shakespeare's *The Winter's Tale.* In her living picture, Gwendolen transforms herself into Shakespeare's unjustly persecuted Hermione, who pretends to be a statue that comes to life. But more than simply acting as Hermione, Gwendolen poses as the actress Sarah Siddons posing as Hermione posing as a statue. So Eliot's heroine emulates an actress who emulates a character who emulates a statue. As David Marshall notes, "at the moment that she plays a woman who is playing a statue that comes to life—in a tableau that poses all of its actors like statues or characters in a painting— Gwendolen really looks and acts like a statue, as if she were reversing the Pygmalion myth rather than following it as Shakespeare's characters appear to do" (*Figure of Theater* 199). In Eliot's novel, it is Gwendolen's facial expression, not her bodily "attitude," that is most striking, and this expression anticipates Wharton's duchess: "Gwendolen . . . stood without change of attitude, but with a change of expression that was terrifying in its terror. She looked like a statue into which a soul of Fear had entered: her pallid lips were parted; her eyes, usually narrowed under their long lashes, were dilated and fixed" (91). Like Wharton's duchess, Eliot's heroine (and Shakespeare's Hermione), a spirited, attractive, self-confident woman, makes an unfortunate marriage to a cold, arrogant man. (Like Hermione, Wharton's duchess is accused by her husband of adultery.) But at least Eliot's and Shakespeare's heroines escape the narrative alive. Wharton's duchess is less fortunate and instead of the privilege of turning herself, for a playful moment, into a statue, Wharton inverts the storyline and has her unfortunate lady turned to art. Her body becomes her shrine.

Wharton's emphasis on the statue of the duchess kneeling as if at an "abandoned shrine" invokes the link between art and necrophilia basic to female enshrinement, and it also resonates with the enshrinement in art enacted by the speaker of Rossetti's "The Portrait." Whereas in "The Muse's Tragedy" and "The Moving Finger," art is a means to enshrine and ostensibly glorify a woman—Mary Anerton is enshrined in verse as "Silvia" while Mrs. Grancy, a True Woman and wife, is immortalized in a portrait—here a statue of a woman stands as an homage to her misplaced sexual abandon. Art, in this tale, serves as a vehicle with which to discipline a wayward female and use her example to teach other women where best to channel their sexual energies. That is, they

should be *kneeling at prayer* in humble supplication and not kneeling before a lover in the performance of a sexual act. Like the portrait painted by Rossetti's speaker, the Bernini statue stands as a (metaphorical) killing of the duchess in that the statue replaces her body with a sign and it anticipates her own (literal) death at the hands of her duke. He kills her twice. And particularly poignant is the fact that while the duchess had been "affecting" a fervent devotion to the relics of Saint Blandina, the duke turns the duchess into a relic before her death.

With its emphasis on a supposedly faithless, vivacious duchess killed into art by her husband, Wharton's tale draws obvious links to Browning's "My Last Duchess,"[23] as critics have noted, but equally important is Wharton's invocation and revision of Balzac's "La grande bretèche." In *The Writing of Fiction,* Wharton praises the Balzac tale as "that most perfectly-composed of all short stories" (67). Whereas Balzac also presents a framed narrative of a cloistered, suffocated woman, Wharton rewrites the tale such that the woman has even less agency. For instance, in Balzac, although Madame de Merret is caught in a compromising position by her husband, her life is spared, while Wharton's duchess is killed and, in effect, turned to marble. In both tales, the woman is suspected of adultery by her jealous husband, though the Balzac story offers hard evidence of her betrayal and Wharton merely suggests the duchess hides something from her husband. Wharton implies, then, that in the culture she represents, guilt by suspicion is grounds for incrimination. Wharton's duchess transgresses the code of wifely behavior and turns up dead. And while both tales imply that the male lover is sealed up in a wall—suffocated by order of the husband—in the Balzac story, the wife has more voice and is able to manipulate her husband into trusting her. (She warns a duly suspicious husband that opening a cupboard door in search of her lover is tantamount to ending their marriage.) The voicelessness of Wharton's duchess is underscored by the fact that her story is told by a man, generations later, far removed by differences of time, gender, and culture. Wharton does a bit of appropriating of her own: she draws from Balzac in a gesture of realist revision, painting a world that punishes women for exerting agency over their bodies. Wharton's revision distinguishes her from the twentieth-century women writers Gilbert and Gubar see envisioning the possibility of female empowerment.

Nancy A. Walker's work on women and narrative tradition is instructive to readers of Wharton's tale. Though Walker does not treat Wharton in her 1995 study, her discussion of appropriation and revision resonates powerfully with "The Duchess at Prayer." Walker notes that "[b]ecause of the way in which Western literary traditions have been formulated, . . . most male writers who have appropriated and revised previous texts have worked within a tradition that included them and their experience, whereas women writers have more commonly addressed such texts from the position of outsider, altering them either to point up the biases they encode or to make them into narratives that women can more comfortably inhabit" (3). Wharton is distinguished by her gesture of appropriating and revising the Balzac tale and transforming it into a narrative that women inhabit to a *less* comfortable degree.

The fact that these two early tales—"The Moving Finger" and "The Duchess at Prayer"—invite a comparison to Browning's "My Last Duchess" suggests Wharton encourages us to align these men with Browning's analogously uncomfortable duke who is so threatened by his wife he must kill her and turn her into art to be tucked behind curtains that he opens and shuts at will. The work of art itself stands as a reminder of the husband's insecurities that drive him to freeze a woman into art in the first place.

In the narratives discussed in the following chapters, Wharton represents women subjected to the same kind of compulsion to seduce them in art. Male artists repeatedly want to "enshrine" them in art and, as we have seen, enshrinement is a euphemism for murder. Wharton thus paints a picture of a kind of art that would penetrate women, kill them, or both. As a sort of antidote, Wharton finds a way for women to locate agency and it comes in a surprising venue: the objectification of their own bodies. She will highlight this first in the curious cases of Lily Bart and Kate Arran ("The Potboiler") and increasingly in the examples of her modern women. Wharton's heroines find ways to counteract a male impulse to "enshrine" them in art. They oversee, direct, and coproduce their body art, and their beauty is less "enshrined" than it is *enthroned*. Rather than being seduced or killed into art, these heroines find life and power in representation. Although the options may not always satisfy or gratify, they at least endow women with a means of survival and a way

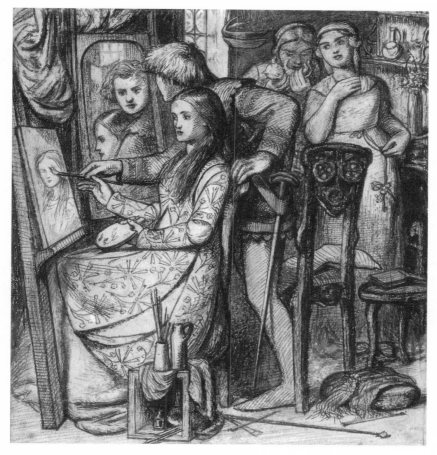

4. Dante Gabriel Rossetti, *Love's Mirror; or, A Parable of Love* (1850). © Birmingham Museums & Art Gallery.

to overturn the perversely sexist, markedly necrophilic model of creativity presented in the early narratives.

We might say that Wharton revises, in the later narratives, the model of creativity presented in a Dante Rossetti drawing from 1850 titled *Love's Mirror; or, A Parable of Love* (figure 4). Rossetti may as well have named the sketch "A Parable of *Art*," as it serves as an allegory for the way in which the process of artistic creation, and the extent to which women's bodies ought to be involved, was conceived in the nineteenth century.

Rossetti depicts a male artist guiding the hand of a female pupil who is also the model for the painting he coaches her to produce. The drawing, whose title identifies the woman at the easel as the artist's beloved and which apparently is a picture of Rossetti and Elizabeth Siddall, whom he would later marry, also suggests the way in which painting a woman and having relations with her often went hand in hand in the nineteenth century. The Rossetti sketch underscores the mentor-artist's intimate involvement in the process of representing this woman, signaled, for instance, by his steady hand atop hers: his hand, not hers, holds the brush. Further, his gaze in the mirror captures her image and shows him to be watching her. The woman's position as model and object of art is underscored by the fact that he is guiding her to create a painting that is *his* image of her. In fact, the paintbrush appears to be blotting out the eyes of the woman on the canvas: as if to render useless her own artistic vision. But Wharton would update this fragment of nineteenth-century visual culture by letting the female subject seize the paintbrush and tactfully oversee her own representation. Wharton's modern women are far removed from the heroines thus far examined, and removed, too, from the obvious discomfort of the female captured in Rossetti's seemingly harmless, but in fact rather insidious, little art parable. And where better to turn for inspired and empowered body art than the picture-perfect loveliness of Miss Lily Bart?

2

Picturing Lily

Body Art in *The House of Mirth* and "The Potboiler"; or, Her Body Becomes Her Art

By Jove, Lily, you do look a stunner!
—Gus Trenor to Lily Bart
Edith Wharton, *The House of Mirth*

[S]he is the canvas, isn't she?
—Baz Lurman, speaking of
Nicole Kidman

In *The House of Mirth* (1905), as in much of her earlier fiction, Edith Wharton pays considerable attention to the voyeuristic imaging of women as objects that inspire and arouse male desire. Wharton's novel, however, marks an important turning point in her fiction because of its response to the way that "pictures" of women have been used in the popular imagination, and one of these surely was for sexual titillation.[1] Lawrence Selden, the most devoted spectator of Wharton's Lily, invests considerable energy in enjoying and consuming his own pictures of Lily. *The House of Mirth* opens and closes, after all, with Selden gazing at the beautiful Lily Bart. And although the better part of the narrative is viewed through Lily's perspective, the novel favors Selden's gaze in the beginning, middle, and end. He is, in Wharton's words, a "spectator" with a proclivity for "vision-making" who "had always enjoyed Lily Bart" (4, 133, 4). But Wharton's response to the role that spectacular pictures of women played in her culture—a response most clearly articulated in the tableaux vivants scene of book 1—suggests a function that extends beyond titillation. That is, Wharton lets *her* Lily manipulate the power of imaging to her advantage by overseeing her objectification as a work of art.

While in the early tales female protagonists are literally and meta-phorically "enshrined" in art—and enshrining is a euphemism for killing—Wharton's Lily is neither enshrined nor entombed by art. (Lily's body does, of course, become a shrine by the novel's end, in part because of a refusal to compromise, and this is a point to which we will return.) Wharton draws from a different vocabulary to describe Lily's living pic-ture. In fact, unlike in Wharton's earlier fiction, the word "shrine" (or its derivative) does not appear in the 1905 novel. Rather than be "shrined" in the way female bodies are captured in the art of Dante Gabriel Ros-setti and his Pre-Raphaelite brothers, Lily Bart willingly "step[s], not out of, but into" (134) art, and while Wharton's earlier women find death in art, it is there that Lily finds life.[2] After the curtain falls on her tableau, Lily is struck by "the precise note of approval" sounded by her audi-ence, and she feels "the completeness of her triumph" and "an intoxi-cating sense of recovered power" (136). But, as Wharton demonstrates, Lily's power is nevertheless unsatisfying in the grand scheme of things. Wharton thus identifies and critiques a rather unfortunate undercurrent in her culture that would have women eagerly become art for the amuse-ment of their peers as well as for their own personal profit.

This chapter arranges a dialogue between two narratives from the early phase of Wharton's fiction—*The House of Mirth* and the relatively unknown tale "The Potboiler" (1904)—which focus on women who use art to their advantage. Lily Bart locates power in turning herself into art, particularly in the tableaux scene, which is the central focus of this dis-cussion. Nowhere in the novel is Lily more powerful than when she poses as Sir Joshua Reynolds's Mrs. Lloyd and thereby oversees her own objectification. In that sense, Lily has control over the imaging of her body: her body becomes her art. She attempts to barter her body with the goal of marriage in mind but her conscience interferes and, ulti-mately, she becomes a beautiful corpse. In this way, Lily is not terribly far removed from the ill-fated ladies of the early tales. Turning to Kate Arran of "The Potboiler" allows us to see some of the choices available to women of Lily's day. In the example of Kate, as well as the women discussed in chapter 3, Wharton illustrates a kind of *compromise* by which the woman complies with the bartering of her body, within the world of art, to the end of securing a means for living and avoiding (a beautiful) death.

These Wharton narratives collectively address the troubled topic of prostitution—that is, the bartering of one's body for profit. Lily Bart prostitutes her body when she transforms herself into a work of art: she displays her beauty on the marriage market in hopes of procuring a husband. The double entendre of "painted lady" is especially apt to Lily's case, for in her tableau vivant she at once transforms herself into a painting of a lady (living picture) and a sort of painted lady (prostitute). Maureen Montgomery acknowledges the link between prostitution and the display of the female body: "The problem for society women was that the notion of a woman displaying herself was firmly associated with the world of prostitution. The *demimondaine* made herself into an object of desire and of luxury in order to appeal to a high-class male clientele, appearing like an actress in the marketplace and, as Saisselin has explained, 'exhibiting herself to advantage' in the same way that commodities were 'shown to advantage in the boutiques.' How then, did society women step out onto the public stage—into the fashionable streets, the Park and the opera—and exhibit themselves *without* running the risk of being misrecognized?" (120). Modeling and prostitution in the nineteenth century were, in fact, considered interchangeable activities, and the parallels between the professions were enunciated by the facts that (1) both were construed as operating outside of marriage, in private secreted spaces, for financial reward; (2) the terms "procure" and "hire" were used; and (3) girls were often supplied by older women.[3] Although Lily prostitutes her body in the tableaux scene, in the final analysis she is unwilling to compromise. Unlike the women of the later fiction, Lily refuses to adhere to the rules of the marriage market. For example, she will not accept marriage to a man she finds undesirable in order to put food on her table, at the very least, and to maintain the society life for which she has been bred, at the very best. Lily's unwillingness to compromise precipitates her tragedy.

Wharton's Kate Arran "prostitutes" her body in order to support herself financially. Her prostitution is a survival tactic, and in her example Wharton offers a way to seize control of one's objectification. Kate at least manages to take charge of her body and put it into circulation—making a profitable marriage to a financially secure artist in order to feed herself and her starving-artist brother. Rather than be "enshrined" in art, Kate barters her body for "a mess of pottage." To be sure, hers is

at once a kind of prostitution and a business decision. She makes a so-cially acceptable marriage, which is one reason she survives and Lily does not. What is more, Kate Arran manages to avoid enshrinement in art by backing out of a commitment to pose for the painter who wor-ships her. It is perhaps because of her resistance to the male artist's act of enshrinement that she escapes the narrative alive and does not make her exit as a beautiful corpse. She lets art—as a commodity that brings in revenue—work *for,* not against, her. Kate signals a new kind of Whar-ton heroine invested with a survival instinct. With the examples of these women, Wharton would increasingly suggest that women can strategi-cally use their bodies to survive. And yet, by letting her Lily expire, Wharton at once spares her the fate of a Kate Arran while making the uncomfortable suggestion that, for women, having a conscience—as Lily surely does—proves self-defeating.

Kate Arran distinguishes herself as one of Wharton's compromis-ing women—those who, like the seasoned heroine of "The Quicksand" (1904), are painfully aware that "life is made up of compromises," for "women especially" (403). In the early "The Muse's Tragedy," the hero-ine breaks free of her objectification in art only to live a disappointed life. Undine Spragg of *The Custom of the Country* (1913) takes charge of her objectification but remains restless and dissatisfied by the time we leave her. In Wharton's novella *New Year's Day* (1924), Lizzie Hazeldean literally sells her body, accepting the title of "expensive prostitute" in order to support herself and her dying husband (*Old New York* 292). Like more than one Wharton heroine, Lizzie is relegated to a life of "cold celibacy."[4] In *The Gods Arrive* (1932), her last completed novel, Wharton presents us with another compromising (and compromised) woman: Halo Tarrant would willingly serve her lover as a muse and subsume her identity for his professional gain. And while Ellen Olenska of *The Age of Innocence* escapes alive the oppression of old New York, moves to France, and establishes there an autonomous, artistic life, she, too, makes sacri-fices in the name of freedom. Wharton thus critiques a culture that af-fords women so few opportunities for independence and satisfaction that they are compelled to compromise their virtue, their freedom, their self-respect, or all of the above. But at the same time Wharton interro-gates and explores the possibilities for women—the ways in which they might, at the very least, escape being killed into art and secure for them-

selves some kind of power. One thing seems fairly certain: the reason a Kate Arran, and, for that matter, an Undine Spragg or Halo Tarrant, survives and a Lily Bart does not is because of a willingness, in the final hour, to compromise one's virtue, one's body, one's beauty, or even one's freedom, all in the name of survival.

Tableaux Vivants and Still Lifes in *The House of Mirth*

Beauty like hers is genius. Not the call
Of Homer's or of Dante's heart sublime,—
Not Michael's hand furrowing the zones of time,—
Is more with compassed mysteries musical;
Nay, not in Spring's or Summer's sweet footfall
More gathered gifts exuberant Life bequeaths
Than doth this sovereign face, whose love-spell breathes
Even from its shadowed contour on the wall.

—Dante Gabriel Rossetti,
"Genius in Beauty"

It already has been extensively shown that Lily Bart offers herself, and is read by others, as a work of art.[5] Lily, after all, has been trained to believe that her beauty is the kind of "genius" Rossetti celebrates in *The House of Life*, and that it can and will take her places. Wharton makes it clear that Lily "had been fashioned to adorn and to delight" (301) and, as she knows well, she is destined to barter her beauty on the marriage market. As Judith Fetterley has observed, the "movement from her mother's indoctrination to Lily's presentation of herself in the Wellington Brys tableaux as a living art object is as inevitable as it is frightening" (201). It hardly surprises us that Wharton's Lily would seek and locate power in the one field for which she has been outfitted. Her body becomes her art.

This chapter adds to the discussion of the novel a contextualization of Lily's tableau vivant within the tradition of the drawing-room convention, and it situates the moment within the context of those episodes in Wharton's fiction, discussed above, in which women are seduced or enshrined in art. Furthermore, the chapter encourages a careful reading of Lily's selection for her tableau vivant. Surprisingly, the scholarship to

date has not fully reckoned with the meaning of Lily's choice. Lily's alignment with a painting by the quintessential academic painter for whom the Pre-Raphaelite Brotherhood reserved its bitterest scorn ought to be read in keeping with Wharton's career-long argument with, and critique of, the oversexed palette of the PRB. I argue for the importance of situating Lily's tableau within this art historical context and reading it alongside the other "living pictures" Wharton has carefully lined up for her pageant. Further, I suggest that Wharton has again drawn from her literary model, George Eliot, as a source for this key scene. Contextualizing Lily's choice in this way helps us to place her in a continuum of Wharton women and to appreciate the revisionary work of *The House of Mirth* and the later fiction.

The tableau vivant or "living picture," which enjoyed a revival in the nineteenth century as a kind of parlor game for the leisure class, has a colorful history that precedes Wharton's day. Its origins can be found in the pageants and royal processions of the Renaissance and in the eighteenth-century example of Emma, Lady Hamilton, who was known for her "attitudes" impersonating such women of mythology as Helen, Cassandra, and Niobe (Altick 344; McCullough 7, 25). Tableaux vivants have a historical connection to the theater: they were staged between the acts of eighteenth-century Parisian theatrical performances (Fryer, "Reading" 29), and they made their New York debut during the 1831–32 theater season (McCullough 12). Mrs. Ada Adams Barrymore, for instance, enacted "a new form of art, the reproduction of famous pictures in living tableaux" (McCullough 11). The players who enacted tableaux were called "model artists," a term that points to their dual identification as both models (still, frozen figures) and artists (makers of art).[6]

Rather coincidentally, one of the ways in which American culture was introduced to these model artists and their tableaux vivants was through a theater company overseen by a Madame Warton. An 1840s playbill for the London-based company lists the reenactment of paintings by such artists as Sir Joshua Reynolds, Angelica Kauffman, Nicolas Poussin, and Correggio, all of whose works make appearances in Wharton's fiction. In fact, paintings by Reynolds and Kauffman are brought to life in the tableaux scene in *The House of Mirth*. The performances listed on the playbill for Madame Warton's troupe embrace such classical themes as the Judgment of Paris and re-create such figures as Diana and Venus

Rising from the Sea, both of which were impersonated by Madame Warton herself.[7] Diana of the chase and Venus rising from the foam make cameos in Wharton's novels—for example, May Welland of *The Age of Innocence* is repeatedly likened to Diana and Norma Hatch of *The House of Mirth* is described as rising "like Venus from her shell" (273). Madame Warton's troupe of performers came to New York's Franklin Theatre (later the Franklin Museum) in 1851 (McCullough 38). An 1858 playbill for the Franklin Museum advertises Madame Warton's "New Troupe of Model Artistes" in a series of tableaux and boasts the presentation of "living statuary" devoted to such topics as "Innocence," "The Three Graces," and "Diana preparing for the Chase" (McCullough 47). It is worth noting that the London-based Madame Warton was re-creating, in the 1840s, the very sort of art against which the Pre-Raphaelite Brotherhood was rebelling in the same city at the same time. Turning to this historical precedent helps us to position Wharton as director of a kind of stage show for her readers, and it also suggests the writer likely was both aware of her British predecessor and amused by the thought of casting herself, half a century later, as the American Madame W[h]arton, mistress of the tableau vivant.

Most tableaux vivants were sensational in nature and designed to titillate. But controversy did not surround these performances until women's bodies entered the scene. One observer noted in 1850 that "[u]p to this time these exhibitions had been composed exclusively of men, and we never heard of their being immodest; but the moment ladies made their appearance, an outcry of outraged pubic decency rose on all sides" (McCullough 19). As soon as the viewer's gaze shifted to female bodies on display—and scantily clad bodies at that—the tradition became associated with indecency. Judith Fryer has noted the risqué nature of these performances: "These presentations drew a mixed public reaction in the latter half of the nineteenth century: on the one hand, respectable audiences . . . [were] given 'permission' to stare at women in a state of semi-nudity (often the only covering would be paint sprayed on the body) under the guise of viewing 'great art' . . . ; on the other hand, certain segments of the population, such as the WCTU [Women's Christian Temperance Union], were outraged by the indecent displays" ("Reading" 30).[8] A late 1840s movement that sought to suppress this trend was unsuccessful, as tableaux vivants were resurrected when Bartholdi's Statue

of Liberty, an ideal subject for a living picture, arrived in New York in the 1880s (McCullough 98).

In nineteenth- and early-twentieth-century America, tableaux vivants thrived in both the private and public sphere. Between 1860 and 1890 middle-class evening parties were structured around the depiction of tableaux, many of them inspired by John Rogers's sentimental statuettes. In the 1890s theater scene the convention reached new heights and was dominated by Edward Kilianyi, whose living pictures, titled "Queen Isabella's Art Gallery," drew crowds to the show *1492*, and whose career was built on his mastery of this genre (McCullough 101). As the artist William Merritt Chase noted, tableaux vivants "took the country by storm" in the 1890s[9]—the culture's affinity for spectacle makes it easy to see why—but their appeal (and necessity) eventually was eclipsed by the advent of motion pictures.

By virtue of invoking the drawing-room version of the tableau vivant, Wharton looks back to George Eliot's *Daniel Deronda* (1876), whose heroine, Gwendolen Harleth, strikes a pose as Saint Cecilia, a martyr so pure and beautiful that when her body was uncovered after some eighteen hundred years in a Roman grave, it was allegedly "still fresh and sweet and beautiful as if she were asleep."[10] One of Eliot's greatest admirers, Wharton likely is responding to the earlier writer's use of tableaux. But Lily does not choose, for her "living picture," to embody a virgin or martyr like Saint Cecilia who, as patron saint of music, repeatedly is depicted in the visual arts and poetry as sleeping or swooning. Further, Lily resists aligning herself with the kind of frozen terror personified in Gwendolen's tableau of Hermione. Lily certainly had at her disposal many a passive, disempowered beauty to impersonate: she might, for example, align herself with John William Waterhouse's 1895 painting of the pale, sleeping Cecilia or Rossetti's renderings of the swooning saint produced for the Moxon Tennyson volume. Whether asleep or unconscious, the female subject's eyes are closed, which invites the spectator's to linger all the more, confident her gaze will not answer back.

Sleeping women saturated nineteenth-century visual culture.[11] Painters were obsessed with depicting women as beautiful, unmoving bodies reclined in passive purity, presumably waiting for their suitors to awaken them. In such sumptuous works as Paul Baudry's *The Pearl*

and the Wave, Cabanel's *The Birth of Venus,* Leighton's *Flaming June,* and Albert Moore's *Beads,* the languid female body and "the absence of male figures within the painting facilitated the viewer's fantasy of making himself the woman's lover" (Van Hook 44–45). The depiction of sleep became a dominant theme of the aesthetic movement. Sleeping women appear in late nineteenth- and early-twentieth-century paintings by Frederick Sandys, Alfred George Stevens, Sir Edward Poynter, J. M. Strudwick, Alma-Tadema, and Sir Edward Burne-Jones. Lionel Lambourne notes that "[o]n the whole, women are more often portrayed asleep than men. . . . In sleep, problems of the relationships between men and women are postponed, so that the sleeping person for the viewer becomes an object of admiration or worship and physical involvement is sublimated" (195). The *Briar Rose* series by Burne-Jones, the most prominent painter of what Robert Upstone calls "the second wave of 'High' Pre-Raphaelitism," captures many a sleeping beauty (26). In one image, a chaste princess lies waiting for her suitor. Another image produced for the series, Burne-Jones's more somber *The Garden Court,* depicts a woman with hidden face and body coiled in anguish. In both Burne-Jones images, the maiden's restful pose delays her wakefulness and confirms the (imagined) male as the active, moving body in contrast to her beautiful passivity.

Rather than identifying with the kind of sleeping virgin memorialized by the PRB, Lily embodies a painting far more "awake" and empowering: a portrait of a lady by the academic painter the Pre-Raphaelite circle most vehemently denounced. Rossetti and his artistic brothers ridiculed Sir Joshua Reynolds, first president of the Royal Academy of Art and the artist who dominated the late-eighteenth-century British art scene, dubbing him "Sir Sloshua" for his "sloshy" artistic technique (Des Cars 15).[12] In fact, one might think of Rossetti, founding father of the PRB, as a kind of *anti*-Reynolds, diametrically opposed to the "first father" of the Royal Academy. Reynolds is perhaps best known for fusing the "grand style" of the Italian masters—especially Raphael, Michelangelo, and the Venetian painters—into his portraits of the British aristocracy. The *Discourses on Art* (1769–90), a series of Reynolds lectures later published in book form, was for Wharton a formative influence, and she alludes to it with familiarity in her fiction.[13] His emphasis on order and decorum informed Wharton's preference for a neo-

classical style, evidenced in *The Decoration of Houses,* her well-received coauthored interior-decorating guide. Reynolds, after all, is the artist whose painting *The Age of Innocence* inspired the title of Wharton's 1920 novel.[14] However the PRB might condemn the "sloshy" brushstrokes of Reynolds's canvases, the artist cannot be accused of performing the kind of figurative seduction and enshrinement of the female subject Wharton obviously found to be a signature of the Pre-Raphaelites and their nineteenth-century heirs.

The farthest thing from a Rossetti or a Waterhouse, Lily's tableau forms the literal and figurative center of Wharton's novel, and the painting with which she aligns herself sets her apart from her peers as well as the women of the early fiction. At the home of the Wellington Brys, Lily embodies Reynolds's portrait of Mrs. Joanna Lloyd (figure 5).[15] Lily's tableau is very unlike the sort of melancholy maiden memorialized by the Pre-Raphaelites, who were quite fashionable at Lily's fin-de-siècle moment, given the 1897 opening and immediate success of London's Tate Gallery, which showcased British art and in the early years of the new century became known for its expansive collection of Pre-Raphaelite paintings. The unseemly Gus Trenor in fact encourages the identification of Lily with a Pre-Raphaelite goddess when he says, all too familiarly, "By Jove, Lily, you do look a stunner!"—*stunner* being the Pre-Raphaelite term for a strikingly beautiful woman (91).[16] Nor is Lily's tableau inspired by a portrait of a female consumptive, a trope pervading nineteenth-century representations of women. Witness, by contrast, the images of pale, wan ladies disseminated by the PRB and by J. M. Whistler, who painted his ailing wife, as well as his model-mistress, laid up in bed.[17] Representing women as convalescents in effect suspends them in time as female invalids. Reynolds's Mrs. Lloyd is not sleepily stretched out for the hungry voyeur: her body is vertical and grounded. She is the very picture of health and liberation. That the painting's date of completion, 1776, coincides with American independence only emphasizes its spirit of emancipation. It matters, too, that Reynolds's female subject flourishes in her natural setting. By contrast, women depicted outdoors in Pre-Raphaelite paintings tend to find themselves expiring or ensnared. Consider, for example, the alarmingly popular paintings of the drowning Ophelia (figure 2), Lady of Shalott, and Elaine,[18] or the claustrophobic female of Rossetti's *The Day Dream* (1880)—a slouching, despondent woman entangled in a tree. The liberation ex-

5. Sir Joshua Reynolds, *Portrait of Joanna Lloyd of Maryland* (c. 1775–76). Bridgeman-Giraudon/Art Resource, NY.

pressed in Reynolds's Mrs. Lloyd is amplified by the fact that she does not wear a crinoline, as a proper woman of Lily's day would do: rather, Reynolds has clothed his subject in a simple, free-flowing dress that accentuates her body. Her legs are provocatively crossed, her feet are sandaled, and her figure is abundant and voluptuous. She is far removed from the pale maiden replicated across Victorian visual culture.

Lily's tableau also stands in sharp contrast to the other "living pictures" on display at the Wellington Brys' soirée. Several tableaux, inspired by "old pictures" and enacted by "fashionable women," precede Lily's performance (133, 131). Wharton's playbill looks something like this: two ensembles of nymphs inspired by Botticelli and Angelica Kauffman, a "supper" drawn from Paolo Veronese, a playful group of "flute-playing comedians" by Watteau, a lady by Goya, Titian's painting of his daughter, and a "characteristic Vandyck [sic], in black satin" (133–34). These pictures, some of which are discussed below, differ from Lily's insofar as they are generally the products of an earlier artistic tradition. Additionally, unlike the troupe of nymphs or musicians or the partakers of the supper by Veronese, Lily's tableau is notable for its depiction of a woman standing alone; rather than sharing the spotlight, she commands center stage. And unlike the other "one-woman shows"—for example, Titian's daughter and the "typical Goya"—Lily does not rely on such props or accouterments as the tray of fruit proffered by Titian's girl or the "exaggerated" and "frankly-painted" make-up worn by Carry Fisher as Goya's lady (133). Lily opts for elegant simplicity in her tableau. Further, those tableaux that do capture a woman alone—the Goya, the Van Dyck—do so in a way that is far less liberating and empowering than Lily's Mrs. Lloyd.

Lily's reincarnation of Mrs. Lloyd could not be further removed from the Van Dyck tableau. Wharton notes that young Mrs. Van Alstyne's tableau "showed the frailer Dutch type, with high blue-veined forehead and pale eyes and lashes," making "a characteristic Vandyck, in black satin, against a curtained archway" (134). Wharton invokes Van Dyck's *Portrait of a Flemish Lady* (1618), a picture of a noblewoman bearing the high forehead, black satin, and "frailer Dutch type" described, and whose ornate dress (elaborate jewelry, gold embroidery, lace cuffs, millstone collar) stands in striking contrast to Lily as Mrs. Lloyd (figure 6). The difference is even more pronounced when we note the bodily stiff-

6. Sir Anthony Van Dyck, *Portrait of a Flemish Lady* (1618). Andrew W. Mellon Collection, Image © 2005 Board of Trustees, National Gallery of Art, Washington, DC.

ness and sense of entrapment depicted in this Van Dyck.[19] Where the Van Dyck suggests immobility, Lily's Mrs. Lloyd is all about mobility.

Wharton's juxtaposition of Lily's living picture alongside Carry Fisher's Goya-inspired tableau also speaks volumes. Wharton invokes Goya's 1790s portraits of the Duchess of Alba, the dark-haired Spanish beauty with whom he allegedly was romantically involved. In his 1795 image of the duchess, Goya curiously positions her standing stiffly, pointing downward in the direction of his signature (figure 7). A 1797 portrait, in fact, shows the duchess gesticulating toward the phrase "Solo Goya," etched upside down in sand by her feet, which at once suggests her heart is spoken for, while intimating, too, that what matters here is the artist's identity: *Only Goya.*[20] While the Goya painting thus emphasizes the male artist's authorship as well as the female subject's status as "taken," Lily's tableau draws attention to Lily as artist and broadcasts her status as "available."

In contrast to the other living pictures, Wharton emphasizes the un-adulterated beauty of Lily's tableau and in so doing again invokes George Eliot. Gerty Farish remarks on the appeal of Lily's "simple dress" (135), and Wharton's narrator notes that Lily "had purposely chosen a picture without distracting accessories of dress or surroundings," relying in-stead on her "unassisted beauty" (134). As Diane Price Herndl notes, "She does not need decoration; she is decoration" (134). Wharton seems to have found a source in Eliot's *Daniel Deronda,* for in the earlier novel Gwendolen Harleth, dressed for an archery meeting in Brackenshaw Park, is described in terms that anticipate Lily Bart's elegantly simple tableau: "[I]t was the fashion to dance in the archery dress, throwing off the jacket; and *the simplicity* of [Gwendolen's] white cashmere with its border of pale green *set off her form to the utmost.* A thin line of gold round her neck, and the gold star on her breast, were *her only ornaments.* Her smooth soft hair piled up into a grand crown made a clear line about her brow. *Sir Joshua would have been glad to take her portrait*" (151; emphasis added). Gwendolen's white cashmere with pale green border is echoed in Lily's "pale draperies, and the background of foliage against which she stood" (134). And if, as Eliot notes, no less than the Royal Academy president would have vied to paint Miss Harleth, Wharton's Lily is pleased to offer her body as a Reynolds.[21]

Just as Gwendolen Harleth's unassisted tableau had "set off her form

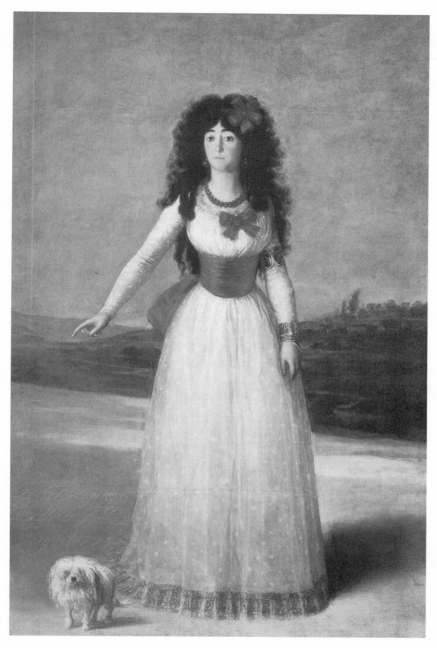

7. Francisco de Goya y Lucientes, *Marie Teresa Cayetana de Silva, Duchess of Alba*, 1795. Scala/Art Resource, NY.

to the utmost," the simplicity of Lily's tableau affords her male specta-
tors "an exceptional opportunity for the study of the female outline,"
thus making hers the most provocative living picture in Wharton's gal-
lery of human art (135). Even though the image Lily chooses for her tab-
leau would not reveal as much flesh as the Botticelli or Kauffmann tab-
leaux, it is hers that attracts the most notice. As Fryer notes, "What is
different in this tableau is the frank presentation of Lily's *body*, an ac-
knowledgment of an erotic nature that is never mentioned in her so-
ciety, though its currents run deep beneath the surface" (*Felicitous Space*
77). So Lily, then, is putting her body into circulation—seemingly using
her awareness of that undercurrent and trying to appeal to it in her
viewers. Lily is markedly in control of what others see, for the lewd Ned
Van Alstyne—whose wife poses as the heavily robed Van Dyck—remarks
that while Lily had the nerve to "show herself in that get-up," she pre-
sumably "wanted [her viewers] to know" just how good she looked (135).

Quite paradoxically, Lily's tableau manages to represent Lily Bart
more than Joanna Lloyd. Although Lily's tableau is a reincarnation of a
Reynolds lady, it fails to eclipse her character: "Indeed, so skillfully had
the personality of the actors been subdued to the scenes they figured in
that even the least imaginative of the audience must have felt a thrill of
contrast when the curtain suddenly parted on a picture which was sim-
ply and undisguisedly the portrait of Miss Bart" (134). Lily's tableau,
then, truly is a "picture of Lily" rather than a portrait of Mrs. Lloyd:
"She had shown her artistic intelligence in selecting a type so like her
own that she could embody the person represented without ceasing to
be herself." This is more than a little problematic. Lily seems to be wres-
tling with the image of Reynolds's Mrs. Lloyd, and we have to wonder
which will win. Will she be seen as an original ("the real Lily Bart" [135]
Selden identifies in her tableau) or as a reproduction of an eighteenth-
century betrothed beauty? Can she at once embody Mrs. Lloyd and be
herself?

Lily's tableau fails to eclipse her character because it is not her char-
acter but her *body* that is at stake here. Lily objectifies herself and seems
to understand that her aim is not so much to embody art as it is to
use this occasion to sell herself as a marriageable commodity. Her ob-
jectification calls to mind what John Berger, in *Ways of Seeing* (1972),
says of women's relationship to the gaze. Berger famously posited that

"men act and women appear. Men look at women. Women watch them-
selves being looked at. . . . The surveyor of woman in herself is male: the
surveyed female. Thus she turns herself into an object—and most par-
ticularly an object of vision. . . . the 'ideal' spectator is always assumed
to be male and the image of woman is designed to flatter him" (47).
Surely Wharton's Lily is all appearance, embodying what Mulvey has
called "to-be-looked-at-ness." And the other women in tableaux are cer-
tainly watching themselves being looked at. Yet Lily complicates Berger's
point, insofar as she at once appears ("women appear") *and* acts ("men
act"): she is appearing and performing. To be sure, Lily is being looked
at, relishing in the "triumph" (137) of her tableau and her status as the
chief object of Selden's gaze.[22] But a key distinction of Lily's tableau is
that she uses the medium to display her wares on the marriage market.
Lily's tableau is more complex than the scenario Berger paints, insofar
as Wharton, as author, is also a watcher, an orchestrator, a director of
the scene she stages—as the American Madame W[h]arton. So Wharton
watches Lily watching men (and women) watch her. Evidently the "ideal
spectator" is not always male. There is power in both spectating and
speculating. Wharton's text, then, poses important questions: How does
Lily manage to achieve this power, however limited? How does she or-
chestrate the scene of her own objectification?

Although Lily ultimately becomes a figure in the service of art, for an
art in the service of men, she draws power from the interactions she ini-
tiates with art, and particularly with a portrait painter. Although Lily
invokes the "organizing hand" of the portraitist Paul Morpeth, she man-
ages the project of her objectification (133): "Under Morpeth's guid-
ance her vivid plastic sense . . . found eager expression in the disposal of
draperies, the study of attitudes, the shifting of lights and shadows. Her
dramatic instinct was roused by the choice of subjects, and the gorgeous
reproductions of historic dress stirred an imagination which only visual
impressions could reach. But keenest of all was the exhilaration of dis-
playing her own beauty under a new aspect: of showing that her loveli-
ness was no more fixed quality, but an element shaping all emotions to
fresh forms of grace" (131). While Lily is eager to channel her "vivid
plastic sense" for her tableau, she rejects the invitation to be painted by
Morpeth, who had marveled on Lily's "plastic possibilities," declaring,
"[G]ad, what a model she'd make!" (237). When Carry Fisher asks Lily

why she won't sit to Morpeth, Lily examines her face in the mirror with a "critical glance" and returns "with a slight touch of irritation: 'I don't care to accept a portrait from Paul Morpeth'" (251). Lily seems to recognize the power that comes from representation—a power she evidently is unwilling to relinquish.[23]

There is even more at stake in Lily's tableau. The narrative suggests that in selecting the Reynolds portrait for her tableau, Lily enacts a kind of exorcism of the "dead beauties" that precede her in Wharton's fiction: "It was as though she had stepped, not out of, but into, Reynolds's canvas, *banishing the phantom of his dead beauty* by the beams of her living grace. The impulse to show herself in a splendid setting—she had thought for a moment of representing Tiepolo's Cleopatra—had yielded to the truer instinct of trusting to her unassisted beauty, and she had purposely chosen a picture without distracting accessories of dress or surroundings" (134; emphasis added). The importance of Lily's having "banish[ed] the phantom" of Reynolds's "dead beauty" should not be underestimated. For while dead beauties are strewn about the early pages of Wharton's fiction, Lily chooses, in her tableau, to embody a different kind of beauty. Lily had decided against representing Tiepolo's painting of Cleopatra, a woman who, like Lily, displays powerful charm and allure, and, significantly, takes her own life.[24] Cleopatra thus stands as a tragic—and not terrifically empowering—heroine to emulate. Had Lily chosen to embody the Egyptian queen, her living picture would have been more in keeping with the agenda of the PRB than the progressive representative act that it is. Lily is fully alive in her living picture, and with her example Wharton also has exorcised the phantoms of the "dead beauties" killed into art in the early fiction.

Lily's tableau invites a series of complicated questions. How, for instance, does Wharton reconcile the central tension in Lily's tableau—the heroine's use of self-display as self-authorship vis-à-vis her complicity with a pernicious tradition that feverishly objectifies women? Jack Stepney likens Lily's tableau to "a girl standing there as if she was up at auction" (157), and Rosedale responds to Lily's living picture with "My God, . . . if I could get Paul Morpeth to paint her like that, the picture'd appreciate a hundred per cent in ten years" (158). Lily works toward a kind of self-authorship by means of her living picture. But Lily has at least two strikes against her. First, Selden, through whose eyes Lily is

most often presented, exposes himself as an untrustworthy reader and thus proves ill equipped to see the full "picture" of Lily Bart. Second, Lily is unwilling to make the ultimate compromise—sell her body on the marriage market—in order to remain alive. These two circumstances precipitate her defeat.

Carefully revisiting Wharton's description of Lily's tableau allows us to see an important way in which Selden fails to get the full picture of Lily. In her account of Lily's living picture, which is filtered through Selden's gaze, Wharton withholds a crucial detail of the Reynolds painting. Reynolds's Mrs. Lloyd is engaged in the act of writing, and this has encouraged readers to envision Lily as a kind of woman writer.[25] Sir Joshua's Mrs. Lloyd carves her married name on the trunk of a tree, in keeping with a trope found in Shakespeare and popularized in eighteenth-century visual culture. Reynolds's interpretation of the tree-writing motif is all the more progressive when we consider that, traditionally, the figures are depicted as reclining or seated (Mannings 309). His Mrs. Lloyd seems more interested in her creative act than in the implied audience's gaze, suggested by the fact that her face appears in profile. Wharton's account makes no mention of a carving utensil in Lily's hand; her readers would have to be familiar with the Reynolds—and likely many of them were—to appreciate the reference to a woman writing. Although we cannot be sure Lily holds the instrument, we also cannot be sure she does not. What matters is that Selden's gaze fails to record it. The image, after all, is filtered through a narrative lens that was moments before described as informed by Selden's predilection for "vision-making" (133) and "vision-building," which "lead him so far down the vistas of fancy" (134). As she later would do in *The Custom of the Country* and *The Age of Innocence,* Wharton compels us to mind the gap between the female subject and the male narrative gaze through which she is presented.

Despite the fact that Lily is perfectly alive in her tableau, Selden identifies in her a disempowering posture that harkens back to Wharton's kneeling, suppliant duchess at prayer. Gazing at Lily's living picture, Selden "feel[s] . . . the whole tragedy of her life" (135) in a way that aligns Lily with the "frozen horror" of the silenced heroine of "The Duchess at Prayer" (6). Reading Lily's tableau, Selden imagines that "*her beauty* . . . thus detached from all that cheapened and vulgarized it, *had*

held out suppliant hands to him from the world in which he and she had once met for a moment" (135; emphasis added). Wharton again rewards us for reading Lily alongside her predecessors, for no matter how much agency Lily achieves in her artistic re-creation, Selden sees in her a helpless pose that strikingly recalls the suppliant, clasped hands of the doomed duchess "locked in prayer before an abandoned shrine" (6). Indeed, one might infer from Selden's reading that Lily had chosen for her tableau not Reynolds's *Mrs. Lloyd* but something more akin to Rossetti's *Beata Beatrix,* a painting that aestheticizes and sexualizes the death of Dante Alighieri's beloved (figure 3). And Selden's morbid reading of Lily anticipates her own status as a body-made-shrine at the narrative's end. While the reader may wish to credit Selden for his ability to penetrate the vision of Lily's tableau and see there "the whole tragedy of her life," his awareness does not pardon him for failing to come to Lily's aid in her most critical hours. In fact, considering his gift of insight into her predicament, his failure to act on her behalf is all the more indefensible.

The novel's closing scene captures Selden at the deathbed of his (would-be) beloved, and Wharton's use of this trope allows her to critique a tradition, manifest in the work of Rossetti and his Pre-Raphaelite brothers, that positions dead beautiful women as subject to the gazes of men who fail to rise to their occasion. Visual images of this sort freeze an aesthetically appealing woman into a posture that is disempowering, passive, and forever to-be-looked-at while immortalizing the male in the active position as gazing consumer. Wharton invokes such images as Rossetti's *Dante's Dream at the Time of the Death of Beatrice.* The painting shows Dante Alighieri, for whom Rossetti was named, approaching the deceased Beatrice laid out on her burial bier. Rossetti in this image adapts a theme from Dante in which the poet "is led by [the god of] love . . . to see the dead Beatrice laid on a bier. Attendants lower a pall laden with symbolic mayflowers, while poppies symbolizing death litter the floor" (Nicoll 149). Rossetti painted two versions of this scene, one in 1856 and another in 1871; in each he has imposed onto the face of Beatrice the features of the object of his affection. In the 1871 image, we recognize Jane Morris, the inaccessible raven-haired beauty memorialized in such Rossetti paintings as *Proserpine* (1874) and *The Day-Dream* and in the sonnet sequence *The House of Life* (1870). In the 1856 image, we find Rossetti's wife, Elizabeth Siddall, who died in 1862 (figure 8).[26]

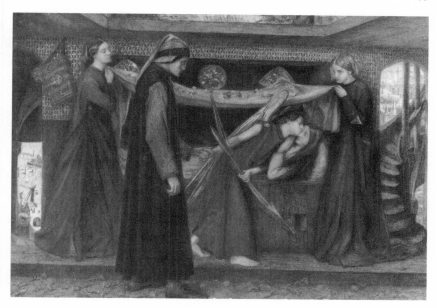

8. Dante Gabriel Rossetti, *Dante's Dream at the Time of the Death of Beatrice* (1856). © Tate, London 2005.

Wharton may have found a source for Lily's untimely death in the apparent suicide of Elizabeth Siddall. Lizzie Siddall is perhaps best known for her aesthetically beautiful deaths, having famously posed for Millais's *Ophelia* (figure 2). The similarities between Rossetti's muse and Wharton's heroine are striking. Both Lily and Lizzie were transformed, in life, into works of art, and both died after a gradual physical decline: Lily departs the novel slighter and less voluptuous than when we met her, while Lizzie apparently suffered from pulmonary consumption and was thought lovelier for her "raggedness." Both women endured sleeplessness, dying, at around age thirty, of an overdose that may have been accidental. (Lily's drops were chloral while Lizzie's were laudanum; both acquired a dependence on the drug in hopes of escaping an unbearable consciousness.) Each woman served as a beautiful corpse offered up to the gaze of what Rossetti, in *The House of Life,* calls "a belated worshipper." Of Siddall's death, John Nicoll writes: "The evidence is confusing, but it seems more likely than not that she killed herself as a result of her melancholia and the increasing pain of her illness. Whether by accident or design the cause of death was an overdose of laudanum. In spite

(or perhaps because) of the personal devastation which Rossetti suf-
fered, and the remorse with which he never ceased to reproach himself,
Elizabeth Siddal[l]'s death provided the personal impetus that was per-
haps necessary if the impending changes in his art were to become fully
worked out" (127–32). Siddall's death fueled Rossetti's relentlessly necro-
philic painting and poetry. And Rossetti's now legendary burial of his
poems in his wife's coffin, and subsequent recovery of the manuscript
by disinterment (an act that perhaps explains his worship of Poe), em-
phasizes his blurring of the lines between art and necrophilia. Rossetti's
numerous renderings of Lizzie as dead, dying, or martyred (Beatrice,
Ophelia, Saint Catherine) permanently enshrine her as an eroticized
beautiful corpse laid out for our visual consumption. Turning to the
example of the Rossetti-Siddall connection helps us step outside *The
House of Mirth* and appreciate Wharton's concern with something much
larger than the tragedy of a fictional Lily Bart. She is commenting on
a historical reality of women who, despite the fact that they may be as-
piring artists—Siddall, a gifted poet and painter, is a case in point—
are nevertheless fetishized, sexualized, worshiped in art, and ultimately
driven to their tragic deaths by a culture that prefers to imagine them as
beautiful corpses.

Lilies played an important role in Rossetti's iconography, which Whar-
ton invokes in *The House of Mirth*. Rossetti's 1870 poem "Love-Lily" ap-
peared in *The Collected Works,* which Wharton owned, and in 1884 was
set to music by the celebrated musicologist Edward Dannreuther. "Love-
Lily" is spoken in the voice of an admirer who equates a woman (and
particularly her body parts) with a lily, marveling at her physical virtues
with his "gazing eyes." Rossetti's 1874 painting titled *Sancta Lilias* (Holy
Lily) features the central female figure of *The Blessed Damozel* holding
irises (figure 9). Rossetti produced a chalk drawing by the same name
(1879) depicting a haloed woman holding a stemmed lily in her left
hand. A ribbon inscribed with the phrase "Aspice Lilias" (gaze at the lily)
extends from the lily, which it enwraps. Wharton shares a verbal as well
as a visual lexicon with Rossetti. He begins his sonnet sequence, *The
House of Life*—whose title Wharton echoes with *The House of Mirth*—
thus: "A Sonnet is a moment's monument"; Wharton's working title for
The House of Mirth was "A Moment's Ornament."

Wharton's final scene, which is at once monumental and ornamen-

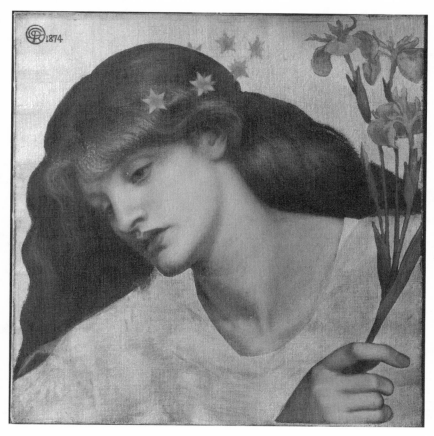

9. Dante Gabriel Rossetti, *Sancta Lilias* (1874). © Tate, London 2005.

tal, responds to the visual precedent of Rossetti's *Dante's Dream at the Time of the Death of Beatrice*. Like Dante Alighieri in Rossetti's painting, Selden is "led by love" to see his beautiful, dead beloved—if not by love, then at least by hope. Selden had awoken to a "promise in the summer air" that reflected his own sense of "intoxication" and "youthful . . . adventure" (324). But this, of course, is a day after he fails to rise to the occasion and abandons Lily in a state of despair; as they part, he finds himself "still groping for the word to break the spell" (310). And now, a day late, he rushes to her boardinghouse with "the word he meant to say to her," which "could not wait another moment to be said" (324). Wharton's description of Selden beholding the deceased Lily poignantly con-

jures up the Rossetti painting: "He stood looking down on the sleeping
face which seemed . . . like a delicate impalpable mask over the living
lineaments he had known. . . . he stood alone with the motionless sleeper
on the bed. . . . he felt himself drawn downward into the strange mys-
terious depths of her tranquility" (326). Dante Alighieri's *Vita nuova*,
which served as the source for Rossetti's painting, records the poet's vi-
sion of the death of Beatrice with a macabre voyeurism that looks for-
ward to Wharton's finale:

> Then Love said, "Now shall all things be made clear
> Come and behold our lady where she lies."
> These 'wildering phantasies
> Then carried me to see my lady dead.
> Even as I there was led,
> Her ladies with a veil were covering her;
> And with her was such very humbleness
> That she appeared to say, "I am at peace." (Upstone 79)

Dante's assurance that, with Beatrice's death, "shall all things be made
clear" is eerily echoed in the last line of *The House of Mirth*, which
observes that between Selden and the departed Lily "there passed . . .
the word which made all clear" (329). Selden, studying "the mute lips
on the pillow," had been drawn "penitent and reconciled to her side,"
aware of "his cowardice," which cost him his love and accounts for his
"having failed to reach the heights of his opportunity" (329, 328, 329).
This closing moment poignantly recalls Wharton's opening scene, which
describes Selden's recognition of a similar "mask" on Lily's face: "She
stood apart from the crowd, . . . wearing an air of irresolution which
might, as he surmised, be the mask of a very definite purpose" (3). But,
sadly, Lily ultimately will wear the mask of death subjected to Selden's
wistful gaze as the lady has become a beautiful corpse. Terence Davies's
film amplifies Wharton's link between art and necrophilia by having his
camera dwell on Gillian Anderson's dead Lily Bart laid out on her bed,
with Eric Stolz's remorsefully gazing Selden grasping her motionless
hand. The image furnishes the backdrop on which the credits roll and
as such invites us to participate in the act of objectifying a beautiful
corpse.

How, then, do we reconcile Lily's vibrant, Reynolds-inspired "living picture" with her final presentation as a still life? If Lily so seamlessly frames herself as a liberated, empowered Reynolds lady, why then does "Madame Wharton" lay her body out as a corpse, subject not only to Selden's gaze but to our own? Lily achieves agency in her objectification in a way her predecessors could not. Her problem, however, seems to be her unwillingness to compromise. But what, after all, is a girl to do? Lily might use Bertha Dorset's incriminating letters to restore her reputation and financial situation. Further, Lily could accept the other options available to her (for example, Rosedale, George Dorset, even Gus Trenor) which, however distasteful, would spare her from utter destitution. Lily chooses not to stoop and this costs her her life.

If it is impossible for Lily to remain alive in this narrative, Wharton finds a way for Lily's younger literary sisters—the women of the new century—to thrive in the later narratives by feeding and rewarding their desire to display themselves as objects d'art. In the later pages of Wharton's oeuvre, which are not decorated with the "dead beauties" that crowd the early fiction, Wharton thus sets the stage for what we might call the anti-Lily: Undine Spragg, the shameless material girl of *The Custom of the Country* who will bend and ply the portraitist's hand to her own marketing purposes. Like Lily, these modern women enact a kind of body art and oversee the way in which they are represented in visual culture, but they reach further and in so doing manage to escape the nineteenth-century conflation of art and necrophilia. Perhaps better than Lily, these women understand the politics of representation. Their survival, of course, will continue to involve compromise, a spectre that looms wherever Wharton interrogates the sexual politics of representation.

Boiling the Pot

Yet, Jenny, looking long at you,
The woman almost fades from view.
A cipher of man's changeless sum
Of lust, past, present, and to come,
Is left.

—Dante Gabriel Rossetti, "Jenny"

With the overlooked tale "The Potboiler" (1904), Wharton offers one alternative to the woman who might otherwise be enshrined in art. She shows a woman beating men in their own game—eluding the male impulse, documented in the early fiction, to capture or enshrine her in the kind of art in which "[t]he woman almost fades from view," becoming a "cipher of man's changeless sum / Of lust, past, present, and to come." In fact, Rossetti's "Jenny," embracing as it does the topic of prostitution, is a fitting segue into a discussion of this curious Wharton tale, for the story's female protagonist prostitutes herself as a means of survival.[27] In this sense, her choice represents a kind of antidote, as unattractive as it may be, to the predicament of a Lily Bart, who fails to compromise and, of course, makes the ultimate sacrifice. Wharton paints the heroine of "The Potboiler" as complicit in the prostitution of her own body—a kind of prostitution the writer addresses in such later narratives as *The Custom of the Country, New Year's Day,* "The Temperate Zone," and *Twilight Sleep.* In "The Potboiler," a woman barters her body for the betterment of a man's art as much as for her own survival; it is a business decision and a survival tactic. Prostitution, while unquestionably oppressive to women, carries with it a kind of agency: it suggests using the body for female profit and male pleasure, using it in the moment, disconnected from productivity, marriage, and motherhood.[28] Prostitution here becomes a means by which a woman can use her body for her own profit as a commodity in a market that would inherently treat it as an object of exchange.

Wharton's tale, set in New York, centers on the creative pursuits of two male artists—the painter Ned Stanwell and the asthmatic sculptor Caspar Arran. Important to both of them is the sculptor's sister Kate, who is described by Wharton's narrator as "a strapping girl, fresh from the country, who had installed herself in the little room off her brother's studio, keeping house for him with a chafing dish and a coffee machine, to the mirth and envy of the other young men in the building. . . . Kate Arran took his complaints with unfailing good-humor, darned his socks, brushed his clothes, fed him with steaming broths and foaming milk punches, and listened with reverential assent to his interminable disquisitions on art" (663–64). Notwithstanding that the man's "talk was a bore," Kate presides as a domestic goddess—indeed, the dream of every

man in the building—who seems at ease with her station as a nurturer
and promoter of the creative output of her artist-brother (664).

Like the Wharton heroines discussed thus far, Kate is imagined as a
kind of muse for male poetic production, but what sets her apart is her
inability to be pinned down in art. That is not to say the men do not try.
Kate serves as the inspiration for Ned Stanwell's portrait, which the nar-
rator describes as "a canvas on which a young woman's head had been
blocked in. It was just in that state of semievocation when a picture
seems to detach itself from the grossness of its medium and live a won-
drous moment in the actual; and the quality of the head—a vigorous
dusky youthfulness, a kind of virgin majesty—lent itself to this illusion
of life" (665). The description of Kate's head as "blocked in" resonates
with the imprisonment in art of Wharton's Mrs. Grancy and her duch-
ess at prayer. But Kate's story is different. The unfinished picture of Kate
has the ability to "live . . . in the actual"—to cross over into the real
and assume a life of its own, despite the "grossness of its medium." As
such, Wharton suggests there is something in Kate that does not al-
low her to be killed into art. This is unlike the cases of Mrs. Grancy and
the hapless duchess at prayer—whose bodies are displaced by works of
art—or Mary Anerton, who, as "Silvia," has been enshrined and sen-
tenced to "enforced immortality." Kate manages to find a way to elude
the male impulse to enshrine her in art and she avoids having her body
superimposed onto the kind of masturbatory "pictures" in which male
artists capture women. Stanwell's painting of her remains unfinished.

Although Kate becomes the object of Stanwell's affection, she rejects
him because he "prostitutes" his talent by producing work that is be-
neath him in order to make money. And Stanwell admits that though his
society portraits are "as good" as those of Mungold, the commercially
successful portraitist, they are "the work of a man who knew it was bad
art" (673). To Kate's mind, the artist ought to resist the temptation to
turn out the kind of work that would "boil the pot"—that is, put food
on the table.[29] She tells Stanwell he has "sold his talent" by producing
commercial art in the style of Mungold, which she considers unforgiv-
able (683).

Everybody of consequence vies to be "done" by the John Singer Sar-
gentesque Mungold, the older, established society portraitist who con-

siders it "the purpose of all true art" to please the consumer (667, 674).
Mungold "devote[s] himself to the portrayal of the other sex, paint-
ing ladies in syrup . . . with marshmallow children against their knees"
(671). Wharton thus mocks the artist's sugary style of representing
women in art as if they are edible morsels for the viewer's consumption.
The painter is described as "a small dapperly dressed man with a silky
mustache and mildly-bulging eyes" who is "esteemed for painting pearls
better, and making unsuggestive children look lovelier, than any of his
fellow craftsmen" (671, 672). His studio is likened by the resentful Stan-
well to "a manicure's parlor—or a beauty doctor's" (665). The reference
to the silky mustache and bulging eyes suggests a kind of licentiousness
that links him to the other male artists in Wharton's repertoire. Mun-
gold stands as a satirical portrait of John Singer Sargent, who was dis-
tinguished by his curled mustache and bulging eyes (Ormond 18), and
who appears elsewhere in Wharton's fiction as Paul Morpeth (*House of
Mirth*) and Claud Walsingham Popple (*Custom of The Country*).[30] (Like
Morpeth, Mungold oversees the staging of tableaux vivants for the well
connected [674]; and in his gift for painting women's pearls, he antici-
pates Popple, who "was the only man who could 'do pearls'" [*Custom of
the Country* 117].) The women who populate Mungold's canvases—and
they are always women—are subject to the painter's sickly sweet, saccha-
rine brushstrokes. Mungold's work, then, stands as an example of the
kind of art beneath Stanwell's talent.

Prostituting one's talent is, of course, altogether different from pros-
tituting one's body. A gifted man might compromise his talent in order
to meet the demands of his consumers. If he sells out or, as Caspar Ar-
ran puts it, "barter[s]" his "birthright for a mess of pottage," he has a
conscience to answer to in the name of feeding himself (at the very
least) and living a life of luxury (at the very best) (678). Further, he may
forfeit a chance to be romantically paired with the object of his esteem.
A woman, however, who is imagined as a muse has a body to offer as
exchange: she can sell out in the name of survival. As such, her body, not
her talent, can make her a commodity. She can prostitute her body but
the returns seem comparably diminishing: she might set up for herself
a comfortable life—by, for example, marrying a man who can financially
support her—but there is no guarantee that hers will be a life of satis-

faction. As Wharton's fiction repeatedly suggests, marriage seems for women to be a kind of prolonged prostitution.

While prostituting one's talent by painting like Mungold is frowned upon, Wharton's story illustrates the kind of prostitution society will tolerate. If Stanwell can be accused of selling his talent, it is certainly fair to say that Kate sells her body. At the end of Wharton's story, Kate reveals to the disappointed Stanwell, in the same breath in which she scolds him for making concessions in the name of commerce, that she has agreed to marry Mungold in order to support her brother's artistic pursuits and, in turn, herself. In a stilted delivery, Kate utters the following to Stanwell: "[S]ince an artist cannot sacrifice his convictions, the sacrifice must—I mean—I wanted you to know that I have promised to marry Mr. Mungold" (684). The abrupt break in Kate's delivery suggests hesitation and discomfort, which implies an awareness of her compromised position. "I can take money earned [by Mungold] in good faith—," she tells Stanwell, "I can let Caspar live on it. I can marry Mr. Mungold because, though his pictures are bad, he does not prostitute his art" (684). As she sees it, Mungold's commercial success is excusable, given that he does not seem to know how to paint as well (or as realistically) as Stanwell. So while Kate Arran reprimands Stanwell for his prostitution, her *own*—the bartering of her body on the marriage market—is neither challenged nor questioned by the men in this story. And Wharton doesn't openly criticize it either. She leaves it up to the reader to recognize the skewed logic of it all, in the irony of the situation, and in the fact that the word "prostitution" is used not with regard to the woman's body as currency but rather with respect to the man's sale of his talent.[31] What distinguishes Kate Arran is that she prostitutes herself on the marriage market and remains alive.

Kate Arran, then, is no Lily Bart. Kate seems to understand how the market works. While Lily has seized control over the circulation of her image—in the way in which she identifies with a liberated, fully alive Reynolds heroine—she is unwilling to make the compromises basic to survival. Lily Bart fails to prostitute herself on the marriage market and thus becomes a casualty of a system set up against her. It seems safe to conjecture that Kate finds (metaphorical) prostitution to be her best option. This woman's agency is limited to the ability to volunteer herself

as an object of exchange, the goal of which is to promote the artistic career of her brother and her own livelihood. She has the ability to put her body into circulation. Perhaps Kate Arran is the true "potboiler" of the story's title: she finds a way to boil her pot and butter her bread.

We might ask whether or not Wharton offers a remedy here, as she did in "The Muse's Tragedy," to the problem of women as muses or women as art. One solution is for the woman to take charge of her fate by making a business decision and thereby surviving. Granted, in Kate's case, marriage does not necessarily mean escape from objectification—Mungold, after all, makes a living painting syrupy portraits of women—but there is something to the fact that Kate is not enshrined in art in this story.

Not, however, for lack of trying. The final moment of the narrative reinscribes the male artist's impulse to commodify the female body in the art world. We watch the rejected Stanwell return to his studio and redirect his energies toward the objectification of Kate Arran: "[H]e dragged out his unfinished head of Kate Arran, replaced it on the easel, and sat down before it with a grim smile" (684). The story closes, then, with the image of a male artist in his dimly lit studio smiling grimly at his incomplete rendering of his would-be beloved—a representation that he is in the process of producing, underscoring his role as creator and hers as inspiring muse. But what matters is that the portrait remains incomplete because Kate backed out of a promise to sit for him: earlier on, she stopped in to say she "could not sit" (669). So in this sense Kate resists his objectification of her. The imperfect image remains all he has left of her, and it is all he ever had of her from the start.[32] Wharton's Kate Arran will not offer her body in the service of (masturbatory) visual art, nor can she be pinned down and frozen onto a canvas. Kate literally and metaphorically resists the status of the kind of "still life" that Lily Bart ultimately becomes.

That Stanwell is determined to see Kate Arran as an image that ought to be killed into art to achieve perfection is underscored by Wharton's clever allusion to *La Bohème* (1896). In the opening scene of "The Potboiler," Stanwell inwardly compares his dingy room to "the last act of *Bohème*. . . . Exactly like *Bohème*, really—that crack in the wall is much more like a stage crack than a real one. . . . It only needs Kate Arran to be borne in dying" (663). This comment, which offers the first men-

tion of Kate, helps us unpack Stanwell's reading of her. In the final act of Puccini's opera, Mimi, the frail, pretty seamstress loved by the poet Rudolfo, dies onstage of consumption. Stanwell presumably fancies himself a Rudolfo to Kate's Mimi, another female body that makes its mark in death and is "borne in dying."

More recently, Baz Lurman's lively musical film *Moulin Rouge* set in fin-de-siècle Paris—itself a reworking of *La Bohème*—speaks to a turn-of-the-century audience's fascination with the death of a beautiful, consumptive woman. In the final scene, Nicole Kidman's tragic Satine dies onstage, in the arms of her poet-lover. Seemingly unaware that Satine has actually died, the Parisian audience vigorously applauds, thereby confirming the entertainment value of her death. At the same time, we too are implicated by our act of gazing at her beautiful corpse. When interviewed for a July 2005 *Vanity Fair* feature on Kidman's film career, Lurman rhetorically asked, "[S]he is the canvas, isn't she?," a comment that Wharton's fiction proves to be more problematic than the director might have imagined (139). Lurman's *Moulin Rouge* and Davies's *The House of Mirth*—closing as they do with the spectre of a beautiful dead woman—read in context with the stop-motion animated film *Tim Burton's Corpse Bride* (2005), unsettlingly suggest that the link between art and necrophilia is alive and well at the dawn of the twenty-first century, despite the fact that more than a hundred years have passed since Wilde's Lord Henry quipped, "There is something to me quite beautiful about [Sibyl Vane's] death. I am glad I am living in a century when such wonders happen" (Wilde 99). Our own century, it seems, similarly enables such wonders. George Lucas's *Star Wars: Episode III—Revenge of the Sith* further engages this trope in presenting the exquisite corpse of Natalie Portman's Padmé, laid out in a sumptuous robe bedecked with flowers, a tableau that perhaps deliberately pays homage to Millais' Ophelia drowning (figure 2). This continued predilection for the spectacle of the female corpse is anticipated in the decadent writer D'Annunzio, whose protagonist, musing on a beautiful, ailing woman, chillingly reflects that "in death she will attain to the supreme expression of her beauty" (*Trionfo della morte*).

In "The Potboiler," Wharton invokes, then, the trope of the female corpse and the cultural inclination to wed art to necrophilia so prevalent in her turn-of-the-century moment and, it seems, our own. And while

Wharton would revisit the themes of objectification and necrophilia in *The House of Mirth*, published one year later, in "The Potboiler" she manages to find a way out for the woman, even if it is not the most glamorous. Lily and Kate are of a kind insofar as they are fairly likable young women: they seem to have consciences and they reveal none of the avarice or backbiting of Wharton's later heroines—Undine Spragg chief among them. Wharton implies that, as the Progressive Era settles in, women must increasingly toughen up and renounce their consciences if they want to have power and survive the literary precedents of Flaubert's Emma Bovary, Hardy's Tess of the d'Urbervilles, Crane's Maggie, and Chopin's Edna Pontellier. Indeed, one way to reconcile Wharton's elimination of Lily Bart is to understand that she spares her the fate of a Kate Arran: Wharton suggests that having a conscience proves fatal. And like most of Wharton's messages about female possibility, this is not an especially popular one to broadcast. And yet there is another way to look at the picture. When we consider the figure of the quintessential survivor—the indelicate, zealous, and perfectly alive Undine Spragg— and the Wharton women who follow on her heels, we see Wharton not only letting her heroines survive but better still: they have power, they are alive, and they are well. These compromising, and at times *compromised*, women represent for us the kinds of conditions women were compelled to accept in the name of power and survival. And these compromises will continue to resonate across the pages of Wharton's fiction about women, art, and representation.

3

"Beauty Enthroned"

The Muse's Progress

Under the arch of Life, where love and death,
Terror and mystery, guard her shrine, I saw
Beauty enthroned; and though her gaze struck awe,
I drew it in as simply as my breath.

—Dante Gabriel Rossetti, "Soul's Beauty"

[T]he success of the picture obscured all other impressions. She saw herself throning in a central panel at the spring exhibition, with the crowd pushing about the picture, repeating her name.

—Edith Wharton,
The Custom of the Country

Howard Chandler Christy's *The American Girl* (1912) depicts a young woman poised like an empress atop her throne, apparently happy to be worshiped. She bears the tiara and scepter that mark her as an untouchable, her eyes cast downward with the condescension of a queen. She resembles the kind of civic virtue associated with femininity at the turn into the twentieth century. To borrow a phrase from Rossetti, Christy's lady is "beauty enthroned"—regal, statuesque, iconic. The image, like so many of its kind, was produced at the time Wharton drafted one of the novels that made her most proud: *The Custom of the Country* (1913).[1] Christy's picture suggests the kind of ambiguous power associated with American women that Wharton represents in that novel and the fiction that would follow on its heels. That is, Christy's rendering, like Wharton's, suggests female power—an unassailable, formidable power—at the same time that it implies objectification: the woman is on display; she *is* display. The lady depicted in *The American Girl* represents an idea or an ideal and thus, as Martha Banta's landmark study suggests, she is the subject of our own projections, our own values tied up with "American-

ness." Edith Wharton provocatively illustrates, in the fiction produced at the time Christy's illustrations graced the pages of *Harper's, Scribner's,* and *McClure's,* the means by which American women might negotiate a space where they can be objectified while at the same time wield power, profiting from their exploitation in a culture of display.

This chapter examines Wharton's enthroned beauties, addressing *The Custom of the Country* (1913), "The Temperate Zone" (1924), and the two-part narrative *Hudson River Bracketed* (1929) and *The Gods Arrive* (1932). The discussion tracks a development in Wharton's thinking about the relationship between women, art, and representation and the empowerment women might secure in a culture of display. The chapter looks at women who either commission their objectification as works of art or who acquiesce to their objectification and embrace, with what Wharton calls "anxious joy," their role as muse of their artist-lover. These representative women are the impossibly materialistic Undine Spragg (*Custom of the Country*) and Bessy Paul ("Temperate Zone") and the intellectually enlightened, ultimately submissive Halo Tarrant (*Hudson River Bracketed* and *Gods Arrive*). For Wharton, a woman enthroned in art is not the same as a woman *enshrined*. As chapter 1 has shown, "enshrining" women becomes a means to kill them metaphorically in and through art. Wharton documents this impulse with the examples of Mary Anerton ("The Muse's Tragedy") who laments, but ultimately escapes, her live enshrinement, and Mrs. Grancy ("The Moving Finger") and the duchess at prayer, who cannot avoid being buried in and by art.

The women of Wharton's later fiction are neither frozen nor static: they are mobile, they are moving. Like the preternatural beauty described in the Rossetti sonnet with which this chapter begins, these women represent "beauty enthroned" and their gazes strike awe. Accordingly, they are found to be threatening. However, if they share a survival instinct they also share the distinction that they appear to lack consciences. Undine Spragg is a case in point: she might, in fact, be considered a revised Lily Bart. As chapter 2 demonstrates, although Wharton's Lily manages to find power in her objectification, her conscience gets the best of her and prevents her from compromising and thus surviving. Wharton controversially suggests, then, that the new generation of female survivors must abandon their consciences if they want to survive and have power. In Wharton's later fiction, enthronement at

once suggests empowerment and disempowerment, for women are arguably hoisted atop pedestals as a means of denying them power. Society women at the turn of the twentieth century found themselves trapped in a pernicious double bind: "[B]oth the culture of display and newspaper publicity brought with them the disadvantages of sexual objectification and external surveillance and extended discourses of control aimed at disciplining the sexuality of young women. Modernization held out the promise of certain social freedoms to both men and women, a redefinition of gender relations even, but in the end it reinscribed patriarchal values" (Montgomery 167–68). Wharton's women of the middle and late fiction show us the advantages and disadvantages of a culture of display.[2] These women of the new generation remain alive and manage to find empowerment and a certain degree of satisfaction in their enthronement. In fact, it is not so much that these women are hoisted atop pedestals, but rather that they manage to climb their thrones themselves.

Whereas in *The House of Mirth* Wharton identifies a way for women to locate life and agency in art, in the later narratives she enables them to insert themselves within the context of an art system that would objectify them and ultimately prevail. These women manage to have the last word, which is literally the case with Bessy Paul of "The Temperate Zone." In fact, with Bessy's example, Wharton invokes the real-life figures of Rossetti's two great muses—Elizabeth Siddall and Jane Morris—and manages to give voice to these women whom visual culture has immortalized as silent bodies, despondently staring out blankly from the canvas. Lynne Pearce helps us understand how a new generation of twentieth-century women like Undine Spragg and Bessy Paul are able to gain access to (nineteenth-century) images of women and insert themselves into the picture, so to speak: "Although it is impossible to prove that the exclusively male production and dissemination of nineteenth-century art works excluded the female viewer in any absolute sense, . . . the institutions in which those texts were manufactured and viewed (e.g., the Royal Academy) were so intrinsically patriarchal that it would have been extremely difficult for women to participate significantly in the processes" (2–3). Because of the great extent to which nineteenth-century paintings became available by way of mass reproduction, modern women like Undine and her sisters were able to consume these images

more readily. And their consumption is more than a little conspicuous, as Wharton's latter-day women are able to grab hold of the reins and find pleasure and power in objectification. Wharton offers an exemplary illustration of this kind of female empowerment in the figure of the coolly calculating Undine Spragg.

The Painted Lady and the "Ironic Grasp of Celibacy" in *The Custom of the Country*

And still she sits, young while the earth is old,
And, subtly of herself contemplative,
Draws men to watch the bright web she can weave,
Till heart and body and life are in its hold.
. .
Lo! as that youth's eyes burned at thine, so went
Thy spell through him, and left his straight neck bent
And round his heart one strangling golden hair.

—Dante Gabriel Rossetti,
"Body's Beauty"

Wharton suggests in *The Custom of the Country* (1913) that a surefire way for women to secure power in a culture of display is to act as architects of their own construction as marketable works of art. In Undine Spragg, Wharton unleashes a protagonist who possesses far more agency than the hapless heroines of "The Duchess at Prayer" and "The Moving Finger" or the more recent *House of Mirth*. Undine commands serious attention, increasingly developing "a clearer measure of her power" (249) and manipulating it to her every advantage. Like the Pre-Raphaelite siren described in the sonnet above, Undine lures men to the bright web she weaves. Wharton's novel traces Undine's twelve-year social-climbing campaign, fueled by a "defiant desire to make herself seen" (233), moving from her marriage to old New York's Ralph Marvell and affair with the nouveau riche Peter Van Degen, on to her union with a French nobleman, ultimately returning her to the vulgar billionaire to whom she was once secretly married. While in the early stories, images of women are passed from one male owner to the next, here a live woman puts herself in circulation. Not only does she circulate her own body, she also dis-

seminates her image by commissioning her portrait and promoting its visibility. As a much-married woman, Undine uses her body art to accomplish a goal very different from Lily Bart's. Maureen Montgomery has noted that for married women, self-display was no longer used to attract a husband but instead "was intended to provoke in other men envy of the woman's 'possessor'—the man who paid for her clothes and jewelry" (127–28). Undine overturns this model: she would have people envy *her*—specifically her beauty and the rewards it brings—rather than her possessor. She is tickled by the notion that "[t]heir admiration was all for herself, and her beauty deepened under it" (142). Wharton paints Undine as the aggressive agent of her objectification and also a consumer—a dynamic increasingly represented in the middle and late fiction. The crucial difference is that Undine commissions and oversees her own representation, in the form of her full-length portrait. Undine anticipates the heroine of "The Temperate Zone" who aggressively chases the most fashionable painter of the hour, insisting he has "got" to "do" her, and to make it a "full-length" (472). It is as if these women want to beat men to the punch by capturing their beauty in art. Perhaps because of the male artist's impulse to use art to sexually conquer them, there is empowerment for these women in controlling their objectification.

Wharton shows Undine encouraging others to acknowledge the power she draws from her relationship to art in a poignant scene that aligns her with a portrait of Josephine Bonaparte. Undine attends a costume ball as Josephine "after the Prudhon portrait in the Louvre" (124) and so becomes a living picture. Pierre-Paul Prud'hon's *Portrait of Josephine at Malmaison, 1805,* painted shortly after Napoleon's coronation, depicts a thoughtful Josephine positioned in poetic, pastoral splendor, resting on a rocky glade (figure 10). In this painting, Josephine looks romantic and mysterious, in the style of portraiture for which Prud'hon was known. Undine has done well to choose this likeness of Josephine, for the painting captures the subject at the height of her powers, having recently attained the status of empress. Like Undine, Josephine captivated, flirted, and charmed and was romantically linked to several men before, during, and after marriage. Further, both women relished the accouterments of wealth: fashion, jewelry, a life of luxury.

Undine's alignment with Josephine also speaks to the inherent complexities of a beauty enthroned, for Undine resembles Josephine in ways

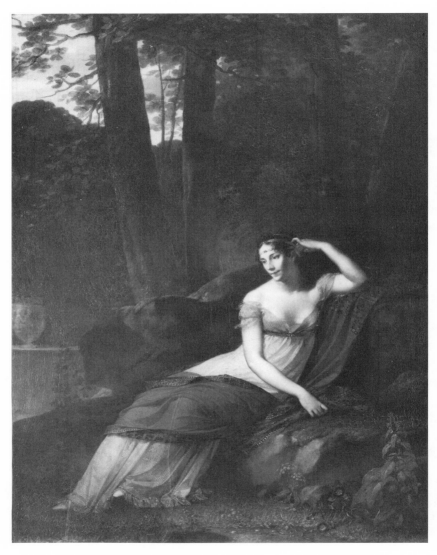

10. Pierre-Paul Prud'hon, *Portrait of Josephine at Malmaison, 1805*. Bridgeman-Giraudon/Art Resource, NY.

that highlight Wharton's ambivalence toward this power. Like Undine, Josephine was compelled to engage in passionate but pragmatic relationships with men in order to ensure financial support (Erickson 82).[3] Although she assumed the throne, Josephine's power would not, of course, endure, as Napoleon ultimately renounced her for her failure to produce an heir.[4] Undine shrewdly avoided modeling her costume after the 1809 painting titled *Napoleon's Farewell to Josephine* (artist unknown), which depicts the empress forsaken and abandoned. Undine's identification with Josephine anticipates much about her that is central to Wharton's narrative: she is imitative yet in control of her image and her representation, she flaunts her love of money and power, and she revels in her role as a living spectacle.

In her efforts to promote herself as a beautiful object, Undine recalls Wharton's Lily Bart, who similarly has been raised to trust her beauty to "carr[y] her through every ordeal" (*Custom* 56), but Wharton highlights an important distinction: Undine is a survivor. Lily's market-savvy literary cousin swiftly acquires an "ability to protect herself" and a killer "instinct of self-preservation" (102) that makes all the difference. Surviving, of course, does not necessarily mean thriving. Wharton is markedly ambivalent about Undine's power: she shows her in control of her own objectification, but that control comes at a price. In the example of Undine, Wharton critiques a system that compels women to comply not only with their own objectification but also with the oppression that ensues. (In this sense she shows women to be part of the problem.) But Wharton directs her critique at the source of the problem: a culture that compels women to objectify themselves feverishly in the name of survival. Though she spares her heroine's life, Wharton does not reward Undine at the novel's end: she is not, finally, a satisfied woman. Wharton drops several hints suggesting she would not admire a woman like Undine—whom "allusions to pictures and books escaped" (22)—given her egregious inadequacies of taste and intellect (24). Undine is neither well read nor worldly wise, and given that Wharton herself prized, above all, the virtues of intelligence and sophistication, it is unlikely she would applaud a woman like Undine.[5] As we approach the final chapter, we find Undine, despite her considerable agency, feeling little more than a sort of waxen woman on display: in conversation with Elmer Moffatt, the goal of which is to close a deal both marital and financial, "she felt,

under his cool eye, no more compelling than a woman of wax in a show-case" (359). By comparing Undine to a wax figure, Wharton suggests the heroine may well follow in the footsteps of her mother, who is described as displaying "as complete an air of detachment as if she had been a wax figure in a show-window" (3). In so doing, Wharton questions the notion of progress from one generation to the next. In fact, she suggests a kind of throwback to an earlier day—the old New York of Wharton's youth—where a woman is expected to be silent, still, and "immovable as an idol" (*The Age of Innocence* 63). Wharton, then, in this twentieth-century novel, finds a way to reconcile the contradiction of muse as both inspiration and agent, but this is not to say she celebrates, or even likes, the compromise.

Undine Spragg evidently was made to be in pictures, and everyone around her knows it. In the novel's opening scene, Wharton's heroine has recently met the well-connected society painter Claud Walsingham Popple, who has expressed his desire to paint her (4).[6] To Elmer Moffatt, there are "few women as well worth looking at" (68) as Undine, and he tells her so in a move that aligns him with the sickly Ralph Touchett of James's *Portrait of a Lady* (1881), who finds Isabel Archer "better worth looking at than most works of art" (46). (Undine, by contrast, has far more control over her destiny than James's heroine.) After spotting Undine at an art gallery, Peter Van Degen insists, "You ought to be painted yourself . . . you ought to get old Popp to do you. He'd do your hair rippingly" (42).[7] Such an exhortation to "be painted" suggests art's function as a means to document a woman's transitory beauty before its inevitable departure.

For Popple, as is typical of Wharton's male painters, capturing women in art becomes a substitute for sexual conquest. All the society matrons want to be "done" by "old Popp"—the painter who serves as a stand-in for Sargent and updated version of Mungold from the early story "The Potboiler."[8] "He's doing everybody this year, you know," remarks Mrs. Van Degen to an envious Undine. He apparently wants to "do" Undine, the implications of which are patently sexual. Wharton underscores the sexually charged nature of the transaction between painter and subject when Undine notes Popple's "masterly manner, his domineering yet caressing address" (15). Further, Popple's teasing remark to Undine in the presence of her fiancé, Ralph, elucidates the analogy be-

tween painting a woman and having relations with her: "I can paint you! He [Ralph] can't forbid that, can he? Not before marriage, anyhow" (62). In the same exchange, Popple congratulates Ralph for landing such a great catch, offering him "the ironic grasp of celibacy" (62). Popple's grasp of celibacy is ironic, Wharton suggests, for while the artist is, as Sargent was, unmarried, he seems to gratify his sexual appetite by painting women. To drive home the link between painting and romancing a woman, Popple's sittings are more than once described as seductions.[9]

In the early moments of the novel, Undine and Popple engage in a kind of courtship: he wants to paint her, she pursues his suit, and each recognizes the "win-win" situation that it is. The critical difference is that Undine, unlike Mary Anerton, Mrs. Grancy, or the duchess at prayer, commissions the work of art that will immortalize her. The distinction clearly marks Undine as an agent in her own objectification.[10] Popple recognizes what Undine would bring to a canvas, and he muses that she would "show up splendidly as a *pendant* to [his] Mrs. Van Degen —Blonde and Brunette . . . Night and Morning" (45). Popple, then, would like to repackage (the decidedly auburn-haired) Undine as an attitude or an idea, much like the nameless, languid beauties adorning the posters of art nouveau.

Images of women at the turn into the twentieth century assumed a wide variety of meanings, ranging from Venus and Diana to the four seasons. Women were imaged as "allegorical or quasi-mythological subjects. . . . Evocative titles, such as *Sleep and Poetry* and *In Arcadia*, defined the women as occupying an otherworldly, symbolic, or 'ideal' realm" (Van Hook 2). This preponderance of female imagery was not, however, always prevalent in American art; in fact, until about 1876, American artists concentrated on landscape and genre painting. (Consider, for example, the work of Thomas Cole and the Hudson River School.) The focus of American art shifted around the time of the country's centennial due to the influence of European artists. "Young artists flocked abroad in increasing numbers, drawn by the promise of a superior (and sometimes free) art education in some of the most famous ateliers and schools of Europe" (2). Because these painters—among them William Merritt Chase, Thomas Dewing, Frank Millet, Abbott Handerson Thayer—studied in Europe during their formative years, their work

reflected the European influence more than the art of the older artists
(Thomas Cole, Daniel Huntington, George Caleb Bingham) who stud-
ied abroad (3). The majority of these younger artists developed into fig-
ure painters as a result of the influence of their European teachers, who
were themselves masters of the female figure (4). And yet, the female
body in *American* art came to mean something altogether different: "In
France, where . . . many of the salon paintings in the last half of the
nineteenth century also imaged women, female figures conveyed a dif-
ferent message. Since art and culture were regarded intrinsically as na-
tional treasures, it wasn't necessary for French artists to image women to
signify the higher, rarefied realm of Art. In America, culture was margi-
nalized and alienated" (145). The apparent commodification of the fe-
male body in American art thus helps us appreciate why Wharton was
more drawn to French culture than to that of her native land.

Popple is the kind of American artist who would willingly produce
these allegorical or quasi-mythological renderings. And yet Undine ma-
nipulates him to her advantage: Popple's painting represents neither
"Night" nor "Morning." It is unmistakably a portrait of Undine—a
woman, not an idea—and Popple flatteringly concedes that in the case
of Undine "there has been no need to idealize—nature herself has out-
done the artist's dream" (122). Popple's reference to "the artist's dream"
echoes Christina Rossetti's "In an Artist's Studio," which critiques a
paradigm by which the painter uses art to represent his sitter "as she fills
his dream." With Undine's portrait, Wharton has given the sitter a good
degree of power in her transaction with the artist such that the "artist's
dream"—which is colored by a desire to seduce or enshrine—remains a
dream deferred.

"Old Popp," with the ironically celibate grasp of his painterly hand,
delivers to his fans the kind of "pleasing" picture they expect from a
woman's portrait. With his example, Wharton pokes fun at the type of
the academic painter. One of his male fans remarks that "the great thing
in a man's portrait is to catch the likeness—we all know that; but with a
woman's it's different—a woman's picture has got to be pleasing. Who
wants it about if it isn't?" (122). Popple satisfies the demands of his con-
sumers, serving up idealized renderings of women: "[A]ll they asked of
a portrait was that the costume should be sufficiently 'life-like,' and the
face not too much so; and a long experience in idealizing flesh and real-

izing dress fabrics had enabled Mr. Popple to meet both demands" (122). Wharton here suggests the artist's impulse to idealize women in art.

Popple, then, is far from the realist artist that Wharton was. Mrs. Fairford notes that Popple's portraits are "not pictures of Mrs. or Miss So-and-so, but simply the impression Popple thinks he's made on them" (23), a remark that undermines Popple's effect on women—he *thinks* he impresses—and identifies him as a painter who wants to leave his mark on the female body in art. As such he recalls Rendle's *Rendl*ing of Mary Anerton ("Muse's Tragedy"), Claydon's remaking of Mrs. Grancy ("Moving Finger"), and the duke's refashioning of his duchess into a pious woman in marble ("Duchess at Prayer"): each artistic endeavor seeks to improve upon an imperfect woman.[11]

With the example of Popple, Wharton taps into a debate about whether artists ought to faithfully represent or improve upon the beauty of their subjects. At the turn of the twentieth century, exhibitions in New York and London

> raised issues in the contemporary press regarding the relation and responsibility of the artist to the sitter: how much a woman's beauty is important to the success of the portrait, whether a portrait painter should idealize her in order to improve the portrait's appearance, whether she could be used as element in a decorative design, and so forth. In each case women were the raw material to be modeled and manipulated by (male) artists. The painter Frank Fowler . . . arrogantly claimed that portraits could bring out features of a woman's beauty "sometimes never brought to light unless the practiced hand directed by the cultured mind of a master painter interprets them." (Van Hook 166)

Wharton's Popple is of the mind that the artist must flatter at the expense of faithfully representing.

In his interest in pleasing his public, Popple recalls the French academic painter William-Adolphe Bougeureau. Bougeureau is the prototype of the artist who, with his polished and waxen images, cared more about painting to the tastes of the public. While critics generally dismissed his art as too polished, photographic, and artificial, the public loved him. He enjoyed great success with American collectors, shamelessly admitting that he "found that the humble, the frenzied, the heroic,

does not pay; and as the public of today prefers Venuses and Cupids, and I paint to please them, to Venus and her Cupid I chiefly devote myself" (Van Hook 32). Bougeureau became known for his sensual Venuses, Cupids, and nymphlike nudes. His *Nymphs Bathing,* for instance, showcased at the 1878 Paris International Exposition, displays languid, voluptuous nudes who play, relax, and recline before the presumably male spectator.

Wharton invites us into the artist's studio to witness Undine's reincarnation at the hands of Popple, and this reading is conveyed through the untrustworthy gaze of Peter Van Degen, whose eyes, marked by their "bulging stare," catalogue and sexualize Undine (118). In a novel for which portraiture is central, it is perhaps disappointing that Wharton does not devote more space to the description of Popple's painting of Undine. And yet her choice of filtering the image through this lens makes clear her investment in exposing and critiquing a voyeuristic male gaze. The man's surname, Van *Degen,* identifies him as something of a degenerate. After Van Degen remarks on Popple's luck for having "the privilege of painting" Undine, our heroine is thus described "in her shimmering dress" through Van Degen's gaze: "She was dressed for the sitting in something faint and shining, above which the long curves of her neck looked dead white in the cold light of the studio; and her hair, all a shadowless rosy gold, was starred with a hard glitter of diamonds" (118). Van Degen's image of Undine, with its emphasis on coldness and dead whiteness, resembles the waxen beauties for which Bouguereau was known.

Bram Dijkstra has tracked in the work of Bouguereau and other artists of the mid- to late-nineteenth century a theme he identifies as "women of moonlight and wax": "The dulled, passive whiteness of moonlight and the sterile glazing of wax were the perfect textures with which to create the ideal women of the later nineteenth century. The woman of moonlight and wax came to exude, through the pasty texture of her skin, the virtuous pliability of the wife as household virgin" (123). While Undine's alliance with these (painted) women of moonlight and wax underscores her objectification as art—captured in dulled, passive, waxen whiteness—she is far removed from the type of the "wife as household virgin" and she fails to suggest "virtuous pliability." The connection between painted ladies and waxen women invokes the cultural institution

of the wax museum, brought to its full potential in Madame Tussaud's famous collection. Marina Warner discusses the birth and flowering of this phenomenon: "In spite of its powers to seal and preserve, wax is a deliquescent substance, and while it does not decay, it can melt. It thus offered a metaphor for the deliquescence of flesh" ("Waxworks and Wonderlands" 192). Warner thus reminds us of wax's associations with impermanence and the desire to control, even halt, the passage of time and the mechanism of aging. But Undine finds a way to make waxworks serve her: she locates power in her waxen enthronement in art, in being immortalized in her resplendent beauty.

In addition to aligning Undine with a waxen woman, Van Degen reads her as the sort of long-necked Pre-Raphaelite "stunner" we would find in a painting by Rossetti or Millais. The rosy-gold hair dressed with diamonds invokes Rossetti's painting *The Blessed Damozel,* which features an ethereal beauty with seven stars in her auburn hair looking down from heaven upon her love-struck swain. Envisioning Undine in "cold light" with her neck "long" and "dead white" undermines her power, for it aligns her with the archetypal Pre-Raphaelite heroine (Beatrice, Persephone, Pandora): a languid, pale, melancholy damsel who is decidedly doomed. (Rossetti's preference for ladies with long white necks is evident in his painting and his translations.)[12] Illustrative examples of claustrophobic Pre-Raphaelite ladies are found in Waterhouse's *Lady of Shalott* and Millais' *Ophelia* (figure 2), for which Elizabeth Siddall famously posed. Both sumptuous images depict an auburn-haired, ethereal woman meeting her death in water. Rossetti's somber *La Pia de' Tolomei* and Millais' exquisite *Mariana in the Moated Grange* are similarly representative of female entrapment.[13] This predilection for imagining in art the demise or destruction of beautiful women perhaps explains the Pre-Raphaelites's reverence of Poe, while looking forward to a sentiment voiced by the decadent D'Annunzio, whose protagonist prefers a woman "in sickness and in weakness," liking her "better when she is thus broken."

But Undine does not strike a pose as a broken, dead, or dying Pre-Raphaelite heroine. The portrait Undine commissions is closer to the kind of full-length for which Sargent was known. Popple's picture is a large-scale portrait of Undine that he strategically positions "fac[ing] the doorway with the air of having been invited to 'receive'" for him

(117). Wharton may have had in mind Sargent's 1898 *Mrs. Ralph Curtis* when she envisioned Undine's portrait (figure 11). Like Undine, Mrs. Curtis, a striking beauty with hair "all . . . rosy gold," similarly costumed in a "shimmering dress," "faint and shining" and exposing a beautifully sculpted neck and shoulders, is captured in glistening whites and reds. And like Mrs. Curtis, who also was married to a man named Ralph at the time of the sitting, Undine poses commandingly, the very picture of self-possession. That Mrs. Curtis assumes nearly the same stance as Sargent's more famous *Madame X* (1884; see figure 18 in chapter 5)—the striking Europeanized American beauty standing proud, shoulders exposed, hands leaning behind her on a round table—underscores the woman's command of her surroundings and, by association, identifies Undine as a woman empowered.

Undine draws great pleasure and power from the thought of her enthronement, and she does what she can to keep her name and image in circulation. Musing on the anticipated triumph of Popple's portrait, Undine "saw herself throning in a central panel at the spring exhibition, with the crowd pushing about the picture, repeating her name," and she dutifully rings up her press agent "to do a paragraph" about her portrait (124). Turn-of-the-century society women "enacted a spectacle both for viewers and for those who wrote about them; their performance was recorded in detail. . . . The more the press made a point of writing about fashionable society, giving attention to what women wore and did, the more women played to the press gallery" (Montgomery 130). For Wharton's Undine, "the success of the picture obscured all other impressions" (124). And while the thought of throning in a central panel strikes Undine as delicious, Wharton's diction puts us in mind of the late Mrs. Grancy's portrait, which finally "*throned* alone on the panel wall, asserting a brilliant supremacy" and similarly occupying center stage ("Moving Finger," 175; emphasis added).

By using language that conjures up one of the "dead beauties" of the early fiction, Wharton asks us to consider what makes Undine different. While Mrs. Grancy has to die in order to achieve a degree of power, Undine manages to live and reap the benefits of her exploitation. Indeed, throning gives Undine power: as in the case of Lily Bart, Wharton refrains from describing Undine as "enshrined," and that amounts to progress, then, from Mrs. Grancy and her sisters, given that enshrinement in effect means death.

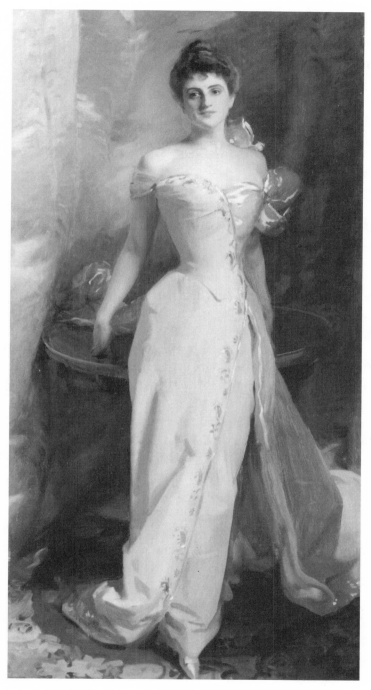

11. John Singer Sargent, *Mrs. Ralph Curtis, 1898*. American, 1856–1925. Oil on canvas, 219.3 × 104.8 cm. © The Cleveland Museum of Art.

The power Undine derives from her enthronement is haunting to her cuckolded husband, once she leaves him. It is only when the numerous photographs of Undine, including a reproduction of Popple's picture, are removed from his room that Ralph can feel free to "look about him without meeting Undine's eyes" (213). For while the pathetically poetic Ralph Marvell would willingly have Undine as his muse, she devours him alive.[14] (Ultimately abandoned by her, his health and finances dwindle, provoking him to end his misery by taking his life.) Beauty enthroned means power for Undine in a way it could not for Wharton's early heroines because she has overseen and orchestrated her objectification and served as the architect of her own commodification.[15] So because Undine has exerted enough control over her painted image, she gains power over the portraitist and anyone else who gazes upon it.

Wharton encourages us to compare Undine Spragg's "living picture" to that of Lily Bart. As chapter 2 has shown, the heroine of *The House of Mirth* finds life and power when she poses as the vibrant, voluptuous Joanna Lloyd as painted by Sir Joshua Reynolds. And her act of selecting a Reynolds stands as a shrewd critical gesture on Wharton's part, for the artist represented the very kind of art that repulsed the professedly revisionary, but ultimately retro, Pre-Raphaelite Brotherhood which, like the earlier artists in Wharton's canon, favored the kind of art that enshrines women. While Lily's identification with Mrs. Lloyd, a betrothed beauty at the height of her powers, is rather forward thinking, she seems drawn to the Reynolds as a symbol of matrimony—a woman no longer suspended in time as a *jeune fille à marier*—and hopes to co-opt her image as a way to find a husband. And yet Lily is ultimately unwilling to make the compromises required to make a killing on the marriage market and keep herself alive. Undine Spragg, on the other hand, commissions a portrait by a Sargentesque painter who figures her as a beauty enthroned. Although Van Degen's gaze would image her as a dead-white stunner of the Pre-Raphaelite variety, Undine Spragg is no entrapped beauty frozen on a canvas like Mrs. Grancy or entombed in stone like the duchess at prayer. Undine guides the artist—indeed commissions and pays for her portrait—and she uses it to give herself press, thus circulating her image for her own gain. She manipulates the system of objectification in a way that accords her power.

That power, of course, comes at a price. Wharton provides ample evi-

dence to suggest Undine is not completely at ease with the compromises she has made in order to live through art. The narrative makes repeated references to the weight of Peter Van Degen's "bulging stare" (39), which recalls the "bulging" eyes of the painter Mungold in "The Potboiler," while suggesting that there is something sexually predatory about these men. Undine wonders if he "might become a 'bother' less negligible than those he had relieved her of" (142), and his habit of leering at her at dinner "had made it plain that the [financial] favour she had accepted would necessitate her being more conspicuously in his company" (142). Van Degen reminds us of Gus Trenor, whose financial aid to Lily carries with it the unspoken expectation of a sexual favor. The chief difference is that Undine—along with Wharton's later heroines—seems to understand that there is always a tax on these "gifts," and it is Lily's ignorance on that score that gets her in trouble when she accepts Trenor's money. While Wharton records her heroine's displeasure at her compromises, Undine proves herself willing to pay a hefty price in order to live through art and enjoy power, however limited.

Wharton points to other ways in which Undine lacks power. Though it may seem to Undine that it is enough to be beautiful, Wharton suggests otherwise. Undine eventually discerns that she needs more than her looks to get by, at least in France, where she resides for part of the narrative; a woman, she learns, must keep herself abreast of current events and be able to contribute to discussions. Her confidante, Madame de Trézac, warns her: "It's not that they [the members of her husband's set] don't admire you—your looks, I mean; they think you beautiful; they're delighted to bring you out at their big dinners. . . . But a woman has got to be something more than good-looking to have a chance to be intimate with them: she's got to know what's being said about things" (338). Wharton suggests here that—more important than having an opinion of her own—Undine has got to familiarize herself with the opinions of others (*what's being said about things*) in order to imitate them. Accordingly, Undine resolves to pick up the right amount of "culture" to get by. Toward the novel's end, she hopes to impress (the "vulgar") Moffatt and win him back, now that his financial picture renders him attractive: "She even acquired as much of the jargon as a pretty woman needs to produce the impression of being well-informed" (350). But Undine's is an artful attempt to make an impression, and her insin-

cerity gives her away. She is a poseur, and it seems nobody, not even her confidante, wants her to be an original.

By the time we leave her, Undine is poised to take Manhattan, drumming up her most valuable resources, chief among them Mr. Popple: she will retain his services as a kind of public relations agent in her career as a billionaire's wife (368). So while Wharton paints a picture of a woman empowered, she at the same time shows that woman to be exacerbating the problem of women's powerlessness by promoting herself and other women as objects, which would seem to turn back the clock more than a few years. Undine herself conceptualizes women as works of art. For instance, she reads the "large," "blond" Mabel Lipscomb as a picture lacking symmetry. At the theater, "Undine had already become aware that Mabel, planted, blond and brimming, too near the edge of the box, was somehow out of scale and out of drawing; and the freedom of her demonstrations increased the effect of disproportion" (40). So Undine not only complies with her own objectification but also aligns other women with works of art: the disproportionate Mabel becomes a sketch off scale. The only American female in the novel who is accorded the title of "artist" is a " 'society' manicure and masseuse" (4) named Mrs. Heeny who styles Undine's hair (54). Undine's "loose locks . . . spread and sparkled under Mrs. Heeny's touch," to the extent that a "new quality seemed added to Undine's beauty" (54). Mrs. Heeny helps primp Undine to meet men and win them over. When her mother notes that Undine surely will "know how to talk" to a gentleman she hopes to impress, Mrs. Heeny returns, "She'll know how to *look* at him, anyhow" (54). Mrs. Heeny is an artist, perhaps—and her patrons admire "the result of [her] manipulations" (54)—but only inasmuch as she makes women into objects. As such, she practices a craft not far removed from that of Popple: transforming women into art and, more to the point, a kind of *artifice*. Like Undine, she contributes to the problem, retarding any progress that may have been attained in the early years of the twentieth century.

Wharton implies, then, that with the example of Undine she has looked back at her earlier incarnations of objectified women—relentlessly fetishized, turned to relics, seduced or "enshrined" in art—and at last proposed a solution to the problem of women as art. Undine serves as a harbinger for Wharton's purposeful women of the twentieth century

who can and do survive, notwithstanding the fact that they increasingly lack consciences, and their lives are colored by compromise. Undine signals a new generation of Wharton heroines who create, produce, and direct their body art, overseeing the way in which they are represented in visual culture, and they manage to escape the nineteenth-century conflation of art and necrophilia. Rather than allowing art to depict them not as they are, but as they fill a painter's dream, Wharton's modern women use art to fill their own dreams of self-possession.

Exhausting Beauty: The Avenging Muse in "The Temperate Zone"

> It seemed a face to fire his [Dante Rossetti's] imagination, and to quicken his powers—a face of arcane and inexhaustible meaning.
>
> —William Michael Rossetti,
> on Jane Morris

> It was like an inexhaustible reservoir of beauty, a still pool into which the imagination could perpetually dip and draw up new treasure.
>
> —Edith Wharton,
> "The Temperate Zone"

In "The Temperate Zone" (1924), a neglected tale that serves as a follow-up to *The Custom of the Country* and *The House of Mirth,* Wharton accomplishes at least two big things: she shows a woman securing agency by using art to her advantage, and she revises the Pre-Raphaelite script of male creativity, invoking real-life women and rewriting their stories. For the revision alone the story deserves attention. Though the tale features one of Wharton's few women artists, the writer Emily Morland, what matters is that the woman's polar opposite—a female muse and Jazz Age supermodel—outlives her. This model-muse survives not only the woman artist but also the male painter whose work she fueled. Indeed, she secures power in a superficial culture of display, manipulating the rules of representation and masterminding her objectification. Wharton again engages the model of creativity set forth by the Pre-Raphaelites: a young starlet is discovered by a male painter and becomes his model and muse, furnishing him with "an inexhaustible reservoir of

beauty" into which his imagination might "perpetually dip and draw up new treasure" (462). It is a plot Wharton recognized in the Pre-Raphaelite Brotherhood—especially Dante Rossetti's rapport with the two great model-lovers who peopled his canvases, Elizabeth Siddall (1829–62) and Jane Morris (1839–1914). Wharton's heroine is in fact an amalgamation of Siddall and Morris. But Wharton takes liberties with the plot: she revises it such that the muse comes out on top—she is far from the ultimately consumptive Lizzie Siddall or the melancholy, misunderstood Jane Morris—and as such Wharton offers a kind of revisionary tale. Rather than letting her beauty be "exhausted" by the male artist—as if it were a sort of reservoir at his disposal—Wharton's new heroine will exhaust, as in make use of, her own beauty to her own end. At the same time, this latter-day heroine will use her beauty to exhaust others—that is, wear them out. Wharton makes another gesture, then, toward realist revision—a reworking of a script that, in this case, is romantic to the detriment of the women it casts.

With the example of Bessy Paul, Wharton draws recognizable parallels to Elizabeth Siddall, the woman who eventually married Rossetti and, for the first part of his career, ignited his art.[16] ("Bessy," after all, is an Americanized, countrified version of Siddall's given name.) Though she had ostensibly meant to study art, Bessy quickly found a new calling: she was "a little American waif sent out [to Paris] from some prairie burrow to 'learn art'. . . . And suddenly she met Fingall, and found out what she was really made for" (455). That this "waif" was sent abroad to "learn art" suggests less that this woman intended to be an artist and more, that she was enrolled in one of the enormously popular art academies, many of which, like *l'Academie colarrosi,* catered to young women and had little to do with the practice of art.[17] Wharton reminds us of the relationship between Elizabeth Siddall and Rossetti, who seems to have inspired the name Horace Fingall, given that Dante Rossetti also signed his paintings with the first name of a writer from antiquity (even though his Christian name was properly "Gabriel"). As we have seen, Rossetti served as an art tutor to (the apparently consumptive) Siddall at the same time that he courted her, making her his muse and romanticizing her in his painting and poetry as Beatrice and other archetypal women entrapped, dead, or on the brink of death. The artist-model relationship between Rossetti and Siddall inspired his sister Christina's

"In an Artist's Studio"; Lizzie is the "nameless" beauty "hidden just behind those screens," upon whose face the artist "feeds . . . by day and night."[18]

Siddall's presence dominated Rossetti's art for over a decade, and after her death the role of muse transferred to Jane Morris (Marsh, *Pre-Raphaelite Women* 21).[19] Like Lizzie and later Jane, Wharton's Bessy Paul evidently was "really made" to serve an artist as a model and muse. As Horace Fingall's generous muse—"the woman who had been the preponderating influence" in his art—Bessy Paul performed an important service, awakening him from a creative slumber: "[T]he sight of her had suddenly drawn the painter's genius from its long eclipse" (451, 455). But there is something different about Bessy's role as muse, and that difference is highlighted in a comment made by her new husband: "She's always been an inspiration; it's come to be a sort of obligation to her" (463). Her function as obligatory "inspiration" is different from the inspiring role enacted by Siddall or Jane Morris. That is, Bessy Paul channels her "inspiration" for her personal gain. She uses her appeal to painters to secure power for herself, not the portraitist.

The story of Bessy Paul and the painter who made her famous also invokes the relation between Rossetti and Jane Morris.[20] Of the rapport between Rossetti and his second great love—the woman whose face haunted the poetry and painting of the latter part of his career, particularly *The House of Life*—Debra Mancoff writes: "In discovering Jane, Rossetti recognized a rare beauty in her startling appearance, but he also seized the opportunity to display the power of his own creativity. Through art, he could transform a poor, ungainly, and odd-looking girl into a queen" (21). Wharton, then, directly evokes the Rossetti–Jane Morris link when she describes the connection between Fingall and the similarly poor and ungainly young woman named "Miss Bessy Reck" whom he met and transformed into his model, muse, lover, and wife. (Like Bessy Reck, Jane Burden gained access to a higher social class when she married William Morris, for whom she had modeled. In fact, Morris "could not get his painting right; according to legend, one day in desperation he scrawled on the back of th[e] canvas, 'I can't paint you, but I love you'" [Daly 334].) According to Lady Brankhurst, a gossipmonger friend of Mr. French (the male reflector), Fingall "transformed" Bessy: "[F]or one thing he made her do her hair differently. . . . And

when we went to the studio she was always dressed in the most marvel-
ous Eastern things" (456). Here Wharton summons the image of Jane
Morris, who was known for her exotic, flowing garments, which were
often suggestive of medieval gowns (Mancoff 34–35). Jane's "distinctive
taste in clothing had been exerting an influence on Victorian fashion. . . .
Although other women in her circle favored unusual and eye-catching at-
tire, Jane became the avatar of a style that seemed to bring Pre-Raphaelite
art to life" (85, 86). Jane Morris was something of a trendsetter in wom-
en's fashion, and the coverage she got as Rossetti's ubermodel brought
fame and a kind of cult status to a woman otherwise rather reserved.

Henry James, Wharton's longtime literary friend and peer, had the
opportunity to meet the real-life Jane Morris and recorded his impres-
sions in a letter to his sister Alice: "Imagine a tall lean woman in a long
dress of some *dead* purple stuff, guiltless of hoops (or anything else, I
should say), with a mass of crisp black hair heaped into great wavy pro-
jections on each side of her temples, a *thin pale face,* a pair of strange
sad, deep, dark Swinburnian eyes, with great thick black oblique brows,
. . . a mouth like the 'Oriana' in our illustrated Tennyson, a *long neck,*
without any collar, and in lieu thereof some dozen strings of outlandish
beads" (Mancoff 61–62; emphasis added).[21] Rossetti, then, would have
found a sympathizer in James, who similarly promoted Jane Morris as a
beauty enshrined—the pale and wan maiden basic to such Victorian
narratives as the early Tennyson ballad (illustrated by Rossetti) to which
he compares her. James's description of a dress made of "dead purple
stuff" amplifies the connection between art and necrophilia that Whar-
ton recognized in the Pre-Raphaelites. When we consider the parentheti-
cal attention James pays to what is obviously to him Jane's provocative
absence of restrictive underclothes—"guiltless of hoops (*or anything
else, I should say)*"—we are reminded of the period's inextricable link
between sex (loose, revealing clothing) and death (thin, pale, dead).
The fact that James had experienced firsthand the woman whose "thin
pale face" and exaggeratedly long neck were replicated across Rossetti's
canvases—and that James and Wharton shared many acquaintances, lit-
erary and professional—accentuates Wharton's nod to Jane Morris in
this tale.[22]

With Fingall's portrait of Bessy Paul, Wharton sustains her critique
of the idealism and distortion basic to Pre-Raphaelite representations of

women as well as the peculiar slippage between painting a woman and having relations with her that pervades the Pre-Raphaelite tradition. (Rossetti and his artistic brothers regularly seduced and slept with their models, with little regard to the fact that they were married to other men [Pollock 110].)[23] Fingall's portrait of Bessy Paul transforms her into a household name. The woman is very like the sort of "stunner" immortalized by Rossetti and the members of his brotherhood, and her portrait bears the Pre-Raphaelite stamp of the heavy-tressed, languid beauty. Wharton's description, which comes to us through the male reflector's gaze, is articulated in the language of Pre-Raphaelite verse— "so frail, so pale under the gloom and glory of her hair" (455)—as if it were drawn straight from the pages of Rossetti's *House of Life*. The line smacks of Rossetti's representations of Jane Morris, who was known for her dense, wavy, glorious hair. Wharton in fact puts us in mind of Rossetti's *Proserpine* (1873–77), for which Morris posed as the gloomily glorious goddess condemned to spend the darker months in the underworld for having eaten the seed of a pomegranate (figure 12). The Persephone myth was important to Wharton—she invokes it, for instance, in the stories "Pomegranate Seed" and "Copy" and in *The Touchstone*—and she may have seen this Rossetti firsthand when it was exhibited at the Royal Academy of Art in 1883.[24] Jan Marsh has remarked that "[l]oose, luxuriant hair was an emblem of female sexuality in Pre-Raphaelite painting, just as it is today the chief signifier of the term 'Pre-Raphaelite'" and further that, in reality, "loose hair was worn only by children; in womanhood it was braided or pinned up and thereafter visible only when retiring or rising. Its appearance in art has therefore an intimate, erotic significance" (*Pre-Raphaelite Women* 23, 48). Thus, the attention Fingall's portrait pays to Bessy Paul's hair, and the association with Rossetti's goddess who has tasted the forbidden fruit, marks her as sexualized.

Wharton's critique in "The Temperate Zone" of the Pre-Raphaelite Brotherhood may have been inspired by Violet Paget, one of the few women writers whose work Wharton admired.[25] In 1884 Paget pseudonymously published *Miss Brown,* a novel that centers on a poor but exquisitely beautiful young woman who is discovered by the poet-painter Walter Hamlin. On a visit to Italy Hamlin meets Anne Brown, employed as a children's nurse. He is struck by her exotic countenance, finding her "a strange type, neither Latin nor Greek, but with something Jewish

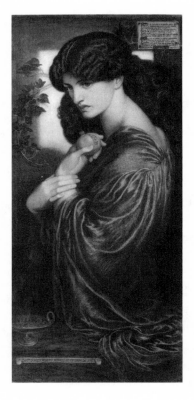

12. Dante Gabriel Rossetti, *Proserpine* (1873–77).
© Tate, London 2005.

and something of Ethiopian subdued into a statuesque but most un-
Hellenic beauty" (11). As Mancoff notes, "Although Paget borrowed as-
pects of Rossetti's career and character to create Hamlin, she used Jane
[Morris] as a precise template for Miss Brown. . . . Anne becomes Ham-
lin's model, his muse, and . . . his salvation. While the novel was anti-
aesthetic, highly critical of the pretensions of the Aesthetic Movement,
it also was an attack on Rossetti. In *Miss Brown*, Paget cast a mirror im-
age of Jane to expose what she regarded as the superficiality of Ros-
setti's art as well as his sensuous self-indulgence" (92). Wharton, then,
carries out a project similar to Paget's, the chief difference lying in the
fact that Wharton's narrative accords the female muse a kind of dan-
gerous power that allows her to manipulate those who represent her
in art.

Bessy Paul, as she is represented in her late husband's picture of her,

is poignantly compared to a vampire, which opens up a conversation about the way in which the figure of the New Woman was read in the early years of the twentieth century. Bessy Paul's story was published at the height of the Jazz Age and she clearly bears the stamp of the New Woman. The marked paleness and lack of vibrance in Fingall's rendering of his wife is noted by André Jolyesse, the fashionable portraitist who irreverently describes the portrait as "that consumptive witch in the Luxembourg," adding that "she looks like a vegetarian vampire" (458). Bram Dijkstra has discussed the trope of the vampire and its relevance to the New Woman: "[Bram] Stoker's *Dracula* [1897] is a very carefully constructed cautionary tale directed to men of the modern temper, warning them not to yield to the bloodlust of the feminist, the New Woman embodied [in Stoker's novel] by Lucy" (348). Dijkstra further notes that by the start of the twentieth century, "the vampire had come to represent woman as the personification of everything negative that linked sex, ownership, and money. She symbolized the sterile hunger for seed of the brainless, instinctively polyandrous—even if still virginal—child-woman. She also came to represent the equally sterile lust for gold of woman as the eternal polyandrous prostitute" (351). Bessy Paul is nothing if not a figure of the New Woman, about which Wharton had much ambivalence. Wharton's latter-day heroines are linked to the figure of the vampire not only by the fact that they represent the New Woman but also in the sense that, like Stoker's Lucy, they appear to lack souls. Wharton, then, taps into the way in which the New Woman is represented in both the visual and the literary arts as metaphorically enervating and blood sucking.

With the allusion to a "consumptive" beauty immortalized in art, Wharton invokes Elizabeth Siddall, a real-life consumptive whose tragic fate, as we have seen, uncannily parallels that of Lily Bart. Siddall apparently suffered from pulmonary consumption, which William Michael Rossetti describes in his account of his brother's life as a kind of feminine weakness. On seeing Lizzie's frail corpse, William thought to himself, "The poor thing looks wonderfully calm now and beautiful" (Doughty 294). That Siddall's consumption amplified her desirability is made clear in a remark made by the Pre-Raphaelite Ford Madox Brown, who once described Rossetti's wife as "looking more ragged and more beautiful than ever," a statement that betrays the Brotherhood's predilection for

sickly, frail women (Pearce 53).[26] Comments like this beg the question of what the gazing consumer considers attractive, appealing, even sexy in women.[27] With such an allusion, Wharton asks what artists like Fingall or Rossetti do to women, and specifically to their wives, through art. Wharton also strongly suggests Fingall as a stand-in for Rossetti and, as such, she reverses the dynamic by having the consumptively rendered wife survive. (Rossetti outlived Siddall by two decades; Fingall, on the other hand, is survived by his remarried wife.) Thus, with the examples of Bessy Paul and Undine Spragg, Wharton shows that objectified women can survive and find some measure of fulfillment. They are not sentenced to the fates of the beautiful, tubercular Lizzie Siddall, the tragically decorative Lily Bart, or the "dead beauties" of the early Wharton tales. And yet the survival of this new generation comes at the cost of women selling out, giving in, exploiting their bodies. Although modern-day readers may be tempted to oversimplify Wharton as either feminist or antifeminist, it is never quite that simple.[28] Women can survive in the narratives of Wharton's later years, but that survival comes at a dear price.

Jolyesse, the painter who had compared Bessy Paul, in her portrait, to a "consumptive witch," reminds us of Wharton's earlier male artists in more than one way. Like the other painters in Wharton's repertoire—for example, Claydon, Mungold, Popple—he detects a gap between the woman and her painted image and conflates painting a woman with bedding her. When Jolyesse sees in the flesh the woman who inspired the painting and his own disdainful commentary, he fails to recognize her as the lifeless beauty of Fingall's picture, which suggests the work is less a representation of the real woman than a manifestation of the artist's vision of her. Jolyesse is so taken with the woman in person that he insists he must paint her: "You'll see, I'll have her in the next Salon!" (459), he assures Mr. French. The double entendre inherent in the verb *to have* recalls Popple's urge to *do* Undine, similarly aligning painting with sexual conquest.

Mr. French, the man through whose eyes we experience the narrative, appreciates the appropriateness of immortalizing Bessy Paul in art, acknowledging that "at least as *a moment's ornament,* the lady was worth all the trouble spent on her. She seemed, in truth, framed by nature to bloom from one of Monsieur Jolyesse's canvases, so completely did she embody the kind of beauty it was his mission to immortalize. It was

annoying that eyes like forest pools and a mouth like a tropical flower should so fit into that particular type" (458; emphasis added). French evidently buys into the idea that the woman was destined to come to life through the brushstrokes of a male artist ("to bloom from one of Monsieur Jolyesse's canvases") and that the painter's task is to "immortalize" her, recalling the way Rendle relegates Mary Anerton to the kind of "enforced immortality" she critiques. The fact that French's gaze catalogues the woman's body according to trite romantic conventions (eyes/forest pools, mouth/tropical flower) does little to suggest that he sees her as anything more than a "type."[29] And the comparison to a "type" reminds us of the way in which Jane Morris's face was read as "one of the few World Faces, unique, yet each representative of a great type of which it is the supreme summary: . . . the Sphinx, [Mona] Lisa Gherardini and Napoleon, but to the list, however short, must certainly be added the name of Jane Morris" (Robertson 93–95).

Wharton's Bessy Paul recalls other of Wharton's women who become living pictures, most notably Lily Bart. Like the heroine of *The House of Mirth*, Bessy Paul draws power from her association with art and is compared to "a moment's ornament," which was a working title for Wharton's 1905 novel.[30] As discussed in chapter 2, the phrase draws compelling links to Rossetti's *House of Life*. It also invokes the Wordsworth lyric "She was a Phantom of Delight" (1804), in which the male speaker praises his beloved as a kind of otherworldly image of perfection: "A lovely Apparition, sent / To be a moment's ornament" (ll. 3–4). The focus, then, is on the woman's decorative qualities. To be associated with but a "moment"—in a way that recalls Kate Arran's portrait, which lives a "wondrous moment in the actual" (665)—suggests an even greater sense of impermanence. She is to him "[a] dancing Shape, an Image gay, / To haunt, to startle, and way-lay" (ll. 9–10). (Being compared to such a fleeting, if distracting, entity directly contrasts with the idea of the masculine "moving finger" alluded to in Wharton's early tale: the hand of the male artist can produce art that cannot be undone, but the woman's beauty provides but a moment's delight.) Comparing the woman to a phantom, shape, and image relegates her to the imaginary. Further, like the woman in the poem, Bessy Paul's "inner state" is considered by Mr. French to be "less complicated" than her "lovely exterior" (458).

Bessy Paul's "lovely exterior" is described in the way that Wharton's

early tragic muses and the Pre-Raphaelite stunners were imagined by
their painters: as repositories where the male imagination might take
root and expand. Here is French, in a passage invoked in my epigraph,
observing Fingall's portrait of the woman he eventually married: "Every-
thing she was said to have done for Fingall's genius seemed to burn in
the depths of that quiet face. It was like *an inexhaustible reservoir of
beauty,* a *still pool* into which the imagination could *perpetually dip and
draw up new treasure*" (462; emphasis added). The "inexhaustible reser-
voir" French reads in the female subject resonates in more than one
way. First, Wharton directly invokes the figure of Jane Morris, who was
described by Rossetti's brother, William Michael, in these very terms.
William Rossetti articulated what Jane's beauty did for Rossetti's imagi-
nation: "It seemed a face to fire his imagination, and to quicken his
powers—a *face of arcane and inexhaustible meaning.* . . . For idealizing
there was but one process—to realize. I will not conceal my opinion that
my brother succeeded where few painters would have done other than
fail; he did some genuine justice to this astonishing countenance" (Man-
coff 52–53; emphasis added). Second, the "reservoir" recalls the "fertile
garden" to which Mary Anerton's mind is compared, wherein "Rendle's
imagination had rooted itself and flowered"—as if the woman is meant
to serve as an accommodating host to the male imagination.[31] Further
resembling the image in "The Muse's Tragedy," French's reading of the
painting is startlingly sexual, given the suggestion of Fingall's genius
burning in the woman's depths and his imagination continually dipping
for treasure in her still pool. The "still pool" suggests the kind of necro-
philic impulse Wharton showed us in her earlier tales: the equation
that posits the woman as a silent, still body to be overtaken by a territo-
rial male artist. At the same time, Wharton recalls the hand of Undine
Spragg that her admirer, Ralph Marvell, expects can passively receive
"whatever [his] imagination" might "pour into it" and Henry James's
impulse to "pump the pure essence" of his "wisdom and experience"
into the beginning writer Edith Wharton in order to spread his intellec-
tual and artistic seed. But as we saw with Undine, and as Wharton shows
us with Bessy Paul, it is possible to reverse the vectors of power.

 Wharton's Bessy Paul proves herself a shrewd businesswoman, the
likes of which we have seen in Undine Spragg. Wharton encourages the
comparison by situating Bessy Paul at the fictional "Nouveau Luxe"—

the very Paris hotel where Undine had taken up. (It is also the residence of another modern woman, the pretentious Mrs. Joyce Wheater of Wharton's *The Children*.) In a final conversation with Mr. French, in which she voices her desire for Jolyesse to "do" her, the narrator tells us that although Bessy "held him playfully[,] her long fine fingers seemed as strong as steel" (471). Bessy Paul means business and she tells him so: in exchange for her cooperation as he writes a life of her late husband, she proposes a kind of quid pro quo: "After all, business is business, isn't it? . . . In return for the equally immense favor I'm going to do you . . . what are you going to give *me*? Have you ever thought about *that*?" (471; Wharton's emphasis). Bessy Paul then holds out "both her shining hands to him" (472) in an aggressive manner that recalls Undine Spragg: Bessy's shining fingers resonate with the description of Undine as "faint and shining," and the extended hands remind us of Undine's outstretched, beckoning open palm—a palm that asks for money, jewels, and power. Bessy has chosen Jolyesse as the painter to sponsor her campaign because, she explains, "[n]o one has been more of a success than Jolyesse—I hear his prices have doubled again. Well, that's proof, in a way" (471). Further, she admits that Jolyesse does not produce the kind of "wild things poor Horace" used to "do" of her (471). Bessy evidently cares less for the kind of Pre-Raphaelitesque, oversexed vixen Fingall made of her; she seems to prefer the sort of dignified, opulent oil painting in the manner of a Jolyesse or a Sargent.

Bessy Paul's story marks a significant departure from Wharton's earlier narratives of tragic muses and women of wax in that, despite the conventional way in which Fingall had painted her, she is a modern woman—specifically a flapper—and she is, like Undine, an agent of her objectification. Bessy's status as a flapper is reinforced by the illustrations that accompanied "The Temperate Zone" in its *Pictorial Review* publication (February 1924, illustrations by J. E. Allen).[32] All three images center on Bessy, dressed to the nines in flapper couture. The first depicts the late Fingall and his elegant wife (now known as Mrs. Paul) seated in his studio, surrounded by three similarly dressed women and numerous cats. The cats suggest the archetype of the "feline" female. Further, the women's reclining postures and dazed countenances underscore the languor of the flapper. All three pictures, in fact, depict women slouching, suggesting a kind of exhaustion from the life of excess asso-

ciated with the Jazz Age—from partying, dancing, sexual promiscuity, and the rituals involved with maintaining one's beauty.[33] The second illustration, in particular, imagines Bessy Paul as an apparition. She appears to be floating; there are traces, then, of the ethereal, abstract beauty imaged in the art and literature of the earlier period of Wharton's career. Bessy wears the short, bobbed hair and low-waist dress of the flapper, as if she has stepped from a *Vogue* fashion plate, and the third image shows her to be a woman who dictates style. The caption speaks to her ability to influence fashion by how an outfit works on her: "[L]ots of things succeed or fail as they happen to look on *her.*"[34]

Wharton thus suggests in her 1924 narrative that women have not come terribly far, for Bessy Paul is but an updated version of Lily Bart, and a far less likable one at that. The difference, of course, is that Bessy Paul survives. If her endurance indicates Wharton's sense of a survival of the fittest—it is key that she outlives the artist who made her famous—then it is worth noting who else has not survived: the woman artist, Emily Morland. Indeed, her very place has been usurped by Bessy Paul, and Wharton confirms her displacement by having Bessy marry the beloved of the late Emily Morland. To add insult to injury, the desk once owned by the woman poet now boasts a framed picture of the modern muse. And that woman is described in particularly unsympathetic terms: more Undine Spragg than Lily Bart, Bessy Paul is pretentious, absentminded, materialistic, and knows nothing—and cares little—about art. She is considered by French to embody the "artlessness" of a child (461). Perhaps most unsettling to Wharton, she seems content with her role of inspiring art. And yet this woman wields power. Like Undine before her, Bessy Paul has commissioned her own objectification: as if to seal her fate as a sexualized object, Bessy wants French to help her get Jolyesse, the best-selling artist, to "do" her: "[W]hat I want is to beg and implore you to ask Jolyesse if he'll do me. . . . And mind, he's got to make it a full-length!" (471–72). In fact, in their first encounter, she is struck by French's association with Jolyesse, and with a "random sweetness [that] grew more concentrated," she betrays her interest in getting close to anyone who has an "in" with the portrait painter: "You were talking to a dark man with a beard—André Jolyesse, wasn't it? I *told* my husband it was Jolyesse. How awfully interesting that you should know him!" (461). This woman knows what she wants and she

works the system to her advantage: like Undine, she finds agency in her objectification. She will invoke the assistance of the painter as a kind of public relations agent to represent her in the public consciousness. This negotiation invigorates her. Wharton suggests that Bessy Paul's is the best way for women to seize and retain power in the Progressive Era. The muse has more power than the dead woman artist who, granted, did not choose to sell out and, perhaps consequently, does not survive. And by establishing so obvious a link to Jane Morris, the queen of the Pre-Raphaelite stunners, Wharton begs the question of what is different about Bessy's narrative. If we consider where Wharton leaves Bessy Paul —in the midst of closing a deal to have Jolyesse paint her—and compare that to the ending of Jane Morris's story, the differences speak volumes. Here is Wilfred Scawen Blunt, one of Jane's suitors late in life, describing the aging, misunderstood muse years after the death of the artist who immortalized her: "Poor woman, the troubles of life and death are closing in on her, and there she sits under the portraits of her youth by Rossetti . . . merely a tomb" (Mancoff 99). Wharton's Bessy Paul— unlike Jane Morris, Lizzie Siddall, or the doomed damsels of Wharton's early fiction—is neither "beauty enshrined" nor the sort of living "tomb" to which the seasoned Jane Morris is compared. Wharton's heroine is alive and well and rather than surrendering her beauty as an inexhaustible reservoir or fertile garden, she exhausts her beauty to her own end. Bessy Paul is beauty enthroned, and with her example Wharton allows us to rethink the sexist model of creativity offered by the brothers Pre-Raphaelite.

"Stale Old Images" and "Anxious Joy" in *Hudson River Bracketed* and *The Gods Arrive*

To be his Muse, his inspiration—then there really was some meaning in the stale old image!

—Edith Wharton, *The Gods Arrive*

Wharton's last completed novels, *Hudson River Bracketed* (1929) and its sequel *The Gods Arrive* (1932), further question women's progress by offering a heroine who serves her lover as a tireless muse, secretary, homemaker, and mother of his child. Halo Tarrant, Wharton's new, revised

heroine—like Undine and Bessy before her—beats men to the proverbial punch and embraces her role as a muse. Wharton suggests there is for women empowerment in willingly assuming this role instead of having it thrust upon them, notwithstanding the fact that it remains a "stale old image" (*Gods Arrive* 485). Rather than dying in art like the duchess at prayer or Mrs. Grancy, Wharton's modern women learn ways to work the system to their advantage, even if it means compromise.

Wharton's *Hudson River Bracketed* traces Vance Weston's development as a writer who marries the frail Laura Lou Tracy and falls in love with Halo Spear Tarrant, an intelligent woman trapped in a loveless marriage. At the end of *Hudson River Bracketed,* Vance's wife dies, and the beginning of *The Gods Arrive* finds Vance and Halo, who has left her husband, living together unmarried in Europe.[35] The self-absorbed Vance (short for "Advance") soon tires of Halo—he had solicited her opinion on his work only to find it threatening[36]—and takes up with an old flame, the fickle, "indolent" Floss Delaney, who is introduced as "the inspirer of [his] poems" (*Gods Arrive* 212; *Hudson River Bracketed* 3). Rejected by Floss, Vance sheepishly returns to Halo, who greets him with open arms and the news that she is expecting his child. They decide to start anew in America.

Wharton's final completed narrative shares with such works as *The Custom of the Country* and "The Temperate Zone" the sense that women are, at least in part, enablers in their own subjugation. To make this point, Wharton employs as a device the trope of the "unseeing eye." Increasingly in Wharton's later fiction women are marked by "unseeing eyes" or "short-sighted" gazes, suggesting that their vision is impaired. Halo, for instance, is described as such,[37] as are women in the novel *Twilight Sleep.* But in Wharton's earlier fiction, such nearsightedness is generally reserved for men. Wharton uses this instrument in her later fiction to convey her sense that women have grown blind to their own objectification and subjugation. It is especially poignant that Wharton would take up this issue at a time where she is simultaneously concerned with the objectification of female bodies in the figure of the flapper and film queen: women, then, are increasingly *seen,* while their own power to see has been compromised.

Though the first chapter of *Gods Arrive* finds Halo feeling like "a new woman in a new world," full of promise and possibility, she retreats,

perhaps because of her shortsightedness, to a rather old-fashioned role (10). Halo conforms to the stereotype of the deferential, marginalized helpmeet. She considers herself "weak" and Vance "strong and decided" and, moreover, she delights in her submission: the narrator observes that "she thought, with a little thrill of feminine submission: 'How strong and decided he seems! He tells me what to do—he takes everything for granted. I'm the weak inexperienced one, after all'" (6). And yet this would seem to contradict Wharton's frequent assertions of Vance's weak will and *in*decisiveness (for example, his inability to resist the flighty Floss) and, in general, Wharton's tendency, as Elizabeth Ammons has noted, to consider men as "weakly affairs" (*Edith Wharton's Argument with America* 194). The fact that Halo is moments earlier described as having eyes "unseeing" and "short-sighted" compels us to question her judgment and vision. Further, her shortsightedness suggests a lack of insight into the future and the possible ramifications of female submission.

Wharton's Halo Tarrant seems to delight in her role as Vance's Beatrice. Halo is far removed from Wharton's Mary Anerton: unlike the outspoken heroine of "The Muse's Tragedy," who resists her "enforced immortality" in verse and bears "no trace of the Egeria in her pose" (72), Halo seems comfortable in her role as Vance's patient muse. She is described as Beatrice to Vance's Dante, and she appears to enjoy the role; as she explains to her mother: "He needs me for his work . . . I can help him, I know I can . . . " (33; Wharton's ellipses). The comparison to Beatrice invokes Rossetti, who was preoccupied with the story of Dante and Beatrice to such an extent that he modified his name, Gabriel Charles Dante Rossetti, to optimize the identification with Dante and enshrined his inaccessible loves—Lizzie Siddall, Jane Morris—as Beatrice in his painting and poetry. With the example of Halo Tarrant, Wharton offers a way for a woman to be Beatrice without the bier—to be the faithful guide sans the beautiful death.

Halo also is seen as Eurydice to Vance's Orpheus.[38] The legend of Orpheus has historically served as a metaphor for the relationship between (male) poet and (female) muse. Eurydice functions as the enabling, generous muse who breathes life into Orpheus's songs: "The male is singer-creator whose potent song moves the gods of Hades, the mountain nymphs and goddesses, nature herself. The reason behind his

song, on the other hand, is a woman, Eurydice, who in the myth becomes universal Woman: that distant, detached love object whom the poet longs to possess, but who remains unattainable. Traditionally, then, woman serves the male poet as an objectified muse, a catalyst stimulating male creativity. As such, she, like Eurydice, is often overlooked" (DeShazer 8). In her function as Eurydice and as objectified muse, Halo is clearly overlooked by her Orpheus.

In Wharton's narrative, one of the primary functions of a muse is to serve as loyal listener. While in *Hudson River Bracketed,* Vance would regularly rely on Halo for her listening skills—reaching for what she refers to as her "intellectual help" (340)—increasingly in *The Gods Arrive,* he resists doing so, and her response is regret and sorrow: "[S]he suffered acutely from the fact that, for the first time, he had not sought her intellectual collaboration" (102). But to Halo, "intellectual collaboration" means listening, not speaking. Vance consistently sees Halo as more a generous ear than a critical voice: "Even when he was writing [his novel] *The Puritan in Spain* . . . , he had used her as an ear to listen, not as an intelligence to criticize" (339). And when the wandering, unfaithful Vance returns to Halo, she inwardly rejoices: "'He's come back to me—he's come back to me!' . . . as if this need of her intellectual help were a surer token of his return to her than any revival of passion. . . . At any rate, she thought with secret triumph, he hasn't found any one to replace me as a listener" (340). While a Mary Anerton would not consider it enough to serve her mate as a listener, Halo deems it a "secret triumph" to have secured her role as Vance's sounding board. Her secrecy suggests the victory is not to be celebrated publicly.

The distance between Halo Tarrant and Wharton's early tragic muse is further enunciated in a poignant exchange between Halo and Vance. Vance makes clear his interest in reading Halo not only as a muse but also as a work of art: during their tour of Spain, he compares her to a statue: "Do you know, you've got just the shape of the head of one of those statues of the Virgin they carry in the processions. . . . A little face, long, and narrowing down softly to the chin—like a fruit or a violin. . . . What's the use of sight-seeing, anyhow, when I've got you to look at?" (36–37).[39] Halo's response sets her apart from a Mary Anerton. While the heroine of "The Muse's Tragedy" would have resisted the male writer's propensity to read her as a work of art, Halo, with "a sudden shyness,"

wonders if he will soon tire of his muse: privately she reflects, "'Shall I have to content myself with being a peg to hang a book on?' and [she] found an anxious joy in the idea" (37). Wharton's narrative here draws a direct link to the early "Muse's Tragedy," in which Danyers observes, "Posterity is apt to regard the women whom poets have sung as chance pegs on which they hung their garlands" (72). By contrast, Halo experiences joy at the thought of being regarded as such a "chance peg" on which Vance might hang his literary accolades.[40] That her joy is characterized as "anxious" suggests Halo's ambivalence, as if to concede that her pleasure should remain another of her "secret triumphs."[41]

What further distinguishes Halo from earlier Wharton heroines is her willingness to offer herself as a life-sustaining space where the male artist might metaphorically spread his creative seed. She tells Vance, for instance, that "what I want is just to be like the air you breathe" (31). As such, Wharton invokes such early narratives as "The Moving Finger," in which Mrs. Grancy becomes the "climate" in which her husband feels "meant to live" (166) and after death remains "the very air [he] breathe[s]" (167). Like the male artists featured in Wharton's earlier narratives, Vance relies on the opportunity to let his imagination roam in Halo as a repository. This dependence is clear as he struggles to write a novel: "[H]e could not write. What he needed was not her critical aid but her nearness. . . . what he craved was the one medium in which his imagination could expand, and that was Halo herself" (16). Vance's desire to allow his "imagination" to expand and flower in Halo harkens back to Rendle and his literary descendants. Once Halo has returned to his side, he rests assured that "his imagination would have room to range in" (24).

Not only does Halo serve Vance as a fertile garden where his imagination can blossom, she literally renders him the ultimate service by providing a space to plant his seed. By the end of *The Gods Arrive*, Halo has become the quintessential nurturer. After sowing his proverbial wild oats and undergoing a journey into himself, Vance crawls back to Halo, admitting his weakness: "I'm not fit for you yet, Halo; I'm only just learning to walk" (439). To this she joyfully responds, "But then I shall have two children to take care of instead of one," thereby informing him of her pregnancy (439). Admittedly at peace, Halo embraces Vance with "a kind of tranquil gravity" (439), accepting the notion that "[h]ouse-

making and housekeeping were her escape, she supposed: she must build up a home for her son" (431). Wharton's identification of the child's sex as male is a commentary in itself. Unlike, for instance, Louisa May Alcott's *Work* (1872) or Willa Cather's contemporaneous "Old Mrs. Harris" (1932)—both of which conclude by ushering in a new era with women at the helm—Wharton directs her attention to the support of a new generation that is decidedly male.[42] In more ways than one she shows her heroine nurturing the present and future male generations. And perhaps the most comfortable way to rationalize this is to label Wharton an uncompromising conservative, which would be easier to do had she not repeatedly painted her Halo as unseeing and shortsighted.

The Muse Arrives

> I wanted to show you how little, as the years go on, theories, ideas, abstract conceptions of life, weigh against the actual, against the particular way in which life presents itself to us—to women especially. . . . Life is made up of compromises: that is what youth refuses to understand. . . . Do I seem casuistical? I don't know—there may be losses either way . . . but the love of the man one loves . . . of the child one loves . . . that makes up for everything.
>
> —Mrs. Quentin to Hope Fenno
> Edith Wharton, "The Quicksand"

How, then, do we move from Wharton's reluctantly enshrined beauties to Halo Tarrant's compliant muse? Wharton's muse narratives consistently foreground the male artist's desire to spread his artistic seed in the female's "fertile garden" and lay bare the notion that representing a woman in art is tantamount to sexually overpowering her. The language Wharton uses to describe the conquest is decidedly violent: women are "kept down" (*The Reef*), "blocked in" ("Potboiler"), "imprisoned" ("Moving Finger"), and their hair is rendered "rippingly" (*Custom of the Country*). The rhetoric is in keeping with James's desire to "get hold of" Wharton and "pump the pure essence of my wisdom and experience into her," which in turn eerily resonates with Ralph Marvell's wish to "pour" his imagination into Undine Spragg's vessel and the male gazer's impulse to dip into the "inexhaustible reservoir" of

Bessy Paul's beauty ("Temperate Zone"). Consistent throughout is the idea that capturing a woman in art makes men powerful. Wharton suggests that turning to a muse for support is a gesture that would empower man more than muse, as Ralph Marvell (foolishly) thinks Undine might grant him the "power to write a great poem" (89). By the time we get to Wharton's final (completed) novels, the male artist still hopes to spread his seed in his adoring muse, and he succeeds metaphorically and literally. In critiquing the notion of literary creation as a sexually charged act, Wharton participates in a tradition documented by Gilbert and Gubar, who famously asked, a generation ago, if the pen were "a metaphorical penis." Wharton answers that the pen, brush, and chisel facilitate the male imagination's mastery of the female body and deny women agency by imprisoning them in art. Furthermore, Wharton suggests a female consent to motherhood that is perhaps a kind of selling out: as if to concede that if a woman cannot be an artist, she might at least create in another very significant way—reproduction—and this, of course, is a creative act that men cannot experience firsthand.

What, we must ask, is the muse's progress? Or, to put the question another way: what is her compromise, if—as Wharton's early heroine, Mrs. Quentin, puts it—"life is made up of compromises," for "women especially"? And what can the muse teach us? Several lessons can be gleaned from Wharton's female muses. Wharton's early muse, Mary Anerton, suggests the impossibility of realizing a romantic union with a man who considers her an intellectual equal. Because she was part of Rendle's imaginary life, Mary never could cross over into the actual, even if she was courted in verse. Recognizing that art is a means to objectify her, Mary breaks free, her freedom translating to solitude. In Kate Arran of "The Potboiler," Wharton shows women to be complicit in the objectification of their bodies, which comes to be a survival tactic that she would further take up in such works as *The Custom of the Country, Twilight Sleep, The Children,* and "The Temperate Zone." Rather than "progress," Wharton points to the muse's *compromise,* a compromise that does not seem to delight Wharton. In *The Gods Arrive,* the (unseeing, shortsighted) muse evidently has made some concessions. That Halo Tarrant is a younger cousin of Kate Arran is enunciated by their surnames' close proximity. Additionally, Halo's last name seems an overt allusion to James's initially feminist, finally "divinely docile" Verena Tar-

rant of *The Bostonians* who is, like Halo, ultimately subsumed into the identity of her male lover who hopes to make her his wife and exorcise her feminist sensibilities.[43] With Halo's first name, Heloise, Wharton also makes a nod to Rousseau's *La nouvelle Heloise,* and we might turn to Rousseau's unfortunate remarks on women's intellect and education, specifically in *Emile,* to understand Wharton's allusion.[44] The lesson seems to be that if an intelligent woman like Halo—who, as an enlightened soul, is far removed from the sort of woman Wharton dismisses in *French Ways and Their Meaning*[45]—wishes to be partnered with a man, her best bet is to be his supportive, acquiescent muse, who, like Halo, cares more for "*his* freedom" than her own (*Gods Arrive* 318; Wharton's emphasis). An early Wharton heroine would be more concerned with her own freedom; she also would have eyes more "seeing" than "unseeing." Whereas in "The Muse's Tragedy," women resist their status as objectified bodies, by the time we reach *The Gods Arrive,* they appear to have given up the fight. They are perhaps duped by the power that flapper culture had promised. Vance Weston seems to speak for all of Wharton's male artists when he reflects, "Intellectual comradeship between lovers [is] unattainable; that [is] not the service women could render to men" (390). Indeed, Vance seeks from Halo an altogether different service, and she obliges him with open arms. Wharton suggests that Halo's predicament (as muse, as childbearer) is the most an intelligent American woman can expect if she wishes to be with a man and, at the same time, to enjoy a relationship to art. Perhaps this is the only power Wharton can ascribe to the intellectual woman, at least in America—a place she describes, from the vantage point of France, as "supposedly the country of the greatest sex-freedom," and a land where women aggressively commodify their own bodies (as flappers, as film queens) with the misguided assertion that they are "emancipated" (*French Ways* 114).

Halo Tarrant's position of utter supplication is brought home by Wharton's final image of her: "With a kind of tranquil gravity she lifted up her arms in the ancient attitude of prayer" (439). Wharton's image is all the more chilling when we read it in tandem with "The Duchess at Prayer," who similarly assumes a primordial prayer position. But the critical difference is that Halo raises her own arms in her act of supplication. Wharton's final novel ends thus: "'You see we belong to each

other after all,' she said; but as her arms sank about [Vance's] neck he bent his head and put his lips to a fold of her loose dress" (439). It is as if Halo has become the Galatean statue on which Vance leans, offering her the Pygmalion kiss. Wharton thus sounds a cautionary note to the women of the Progressive Era, as if to respond to that old Virginia Slims ad with the retort we *haven't*, after all, come a long way, baby. Blindness—that is, to the damaging effect of the ways women are imaged in culture—will get us nowhere. Women continue to be read as "inexhaustible reservoirs" and, by promoting their exploitation—as objects, as muses—they in fact worsen the problem. But at least Wharton has found a way for women to play Beatrice to their respective Dantes without having to recline on the burial bier.

It is fitting, then, that Poussin's *The Inspiration of the Poet* would be dear to the male protagonist of Wharton's last completed novel (117).[46] The painting depicts Apollo, a muse, and a poet, with whom Vance Weston apparently aligns himself. Charged by the divine intervention of the god of poetry beside him, Poussin's poet holds a pen in one hand and a tablet in the other, poised to embark on the creative process. One of two hovering putti suspends above him a laurel wreath with which to crown him. The poet and the god occupy center stage in this rendering; the painting directs the eye first to the laurel-crowned, lyre-bearing Apollo and then, following his gaze, to the poet. Poussin's muse—like Sappho in Raphael's *Parnassus* and like Halo in Wharton's *The Gods Arrive*—is relegated to the margins. No laurel adorns her head. Though the muse bears a flute, she does not raise it to her lips. Like Halo, she stands as a faithful listener, and she, too, might convince herself of her part in the creative process. Perhaps the most to which she can aspire is to be a kind of "chance peg" on which the poet might hang his garland. She may also, in the dress of a muse, earn a spot amid the congregation of artists and scholars atop Parnassus. But it seems unlikely that she will raise her flute to make her own music. As chapter 4 will show, Wharton's women who forego the role of muse—and instead aspire to scale Parnassus's rugged heights—often find the smoothest path to the mountain top is to serve as careful custodian of the master's Great Books.

4

Angels at the Grave
Custodial Work in the Palace of Art

Don't you see that it's your love that's kept him alive? If you'd aban-
doned your post for an instant—let things pass into other hands—if
your wonderful tenderness hadn't perpetually kept guard—this might
have been—must have been—irretrievably lost.

—Edith Wharton,
"The Angel at the Grave"

"Don't you think the blue pin's better?" he suggested, and immediately
she saw that the lily of the valley was mere trumpery compared to the
small round stone, blue as a mountain lake. . . . She coloured at her
want of discrimination.

—Edith Wharton, *Summer*

The criticism to date has not acknowledged the compelling connection
between Edith Wharton and women's role in the development of the
museum. Because a number of Wharton's narratives concern women's
relationship to art, specifically women performing "custodial work,"
they can usefully be contextualized within the framework of this im-
portant part of American cultural history. It is more than a little ironic
that at a time when women are making serious headway as authorities
with respect to art, and specifically within the museum world, Whar-
ton, in her fiction, manages to find only a limited amount of power for
her women. In the narratives discussed below, Wharton challenges the
idea that women have gained significant authority within this sacred
sphere. In fact, she shows women enacting traditionally "feminine" roles
engendered by the birth of the museum—nurturer, caretaker, keeper,
guardian—and deferring, and at times relinquishing power, to authori-
ties who are consistently male.

The history of women's involvement in the establishment and man-
agement of the art museum runs parallel to the rise and progress of

various educational and social reform movements in the United States. In the first part of the nineteenth century, when art, under the influence of Ruskin, was thought to have a civilizing influence on society, museums were considered to be necessary institutions in social education. Museums have thus been thought of as sites of moral education and, given the nineteenth-century social construction of "woman," it follows that women would be connected to this instrument of education. In the first half of the century, women were involved in developing museums as a reflection of the philanthropy they were expected to practice, such as abolition, temperance, and prison reform. But by 1860, various influences compelled the museum to focus more on entertainment than education. At this time, women retreated from the development of museums, as the institution no longer was connected to a moralizing social purpose. It was not until the late nineteenth and early twentieth century—the period of progressive reform and the years spanning Wharton's career—that women resumed their efforts: "Under the impact of progressive interest in improving the environment and expanding educational opportunities, women [again] began to become active in the widespread movement to establish museums in communities throughout the country and to bring the people the best they could find in art, science, and history" (Miller 10).

Since the early twentieth century, women have played a pivotal role in founding and directing art museums. As collectors and benefactors, women helped establish some of the country's most prestigious art institutions, including the Isabella Stewart Gardner Museum in Boston and the Havermeyer wing at the Metropolitan Museum in New York. Nearly all the major museums started by women in the twentieth century are art related: the Museum of Modern Art (MoMA) in New York, the Whitney Museum of American Art of New York, and the Folk Art Museum at Colonial Williamsburg (Taylor 13). Many of these museums were led by female directors.[1] Women established collections and developed education departments for community outreach; many of these departments are now overseen by women. Women's commitment to education and their willingness to volunteer their time on boards, in fund-raising, and as docents and gallery assistants were major factors in the increase in their involvement in museums (Weber 34). The emphasis on women's traditional interests, which led to their involvement in mu-

seum work in the first place, links museum stewardship to education, which itself might be seen as an extension of mothering.

Before women were assuming leadership roles within the art museum, they found ways to trickle into the field of art history as well. And they did this, arguably, by capitalizing on the principle of women as guardians of culture that prevailed in America for most of the nineteenth century: "Although [women] had no professional status in either museums or academia, they did contribute vastly to scholarship in art history by translating scholarly texts and producing popular histories, guidebooks, and monographs on individual artists, as well as working on collections or documents and studies in iconography, architectural history, and criticism" (Downs 93). So while women were largely excluded from employment in museums and universities from around 1820 to 1890, their activity was directed to writing on art for a general reading audience (Sherman 8). In fact, Wharton would have seen this firsthand in the example of Mary Berenson (née Mary Pearsall Smith), a close confidante whose reputation as a respected art historian was eventually eclipsed by that of her husband, the formidable Bernard Berenson, whose career she helped launch.

The impressive achievements of women writing on the arts during this early period compels us to ask how women could accomplish so much while remaining shut outside the gates of professional advancement in the field. Claire Sherman and Adele Holcomb offer as explanation the fact that "authorship, the only professional avenue open to them, was a socially accepted occupation for middle-class women" (17).[2] In contrast to law or medicine, which required contact with the public and training and admission by institutions, "women writers on the arts, working in private, could by various means acquire enough skills to make their work eligible for publication" (16–17).

At the beginning of the twentieth century, women gradually began entering the art museum profession at the junior level. In the academy, women's colleges led the way in designing and offering courses in the visual arts to women, though these courses were less often available at universities. At Wellesley College, for instance, Myrtella Avery offered such a course, as did Sara Yorke Stevenson at the Pennsylvania Museum (later the Philadelphia Museum of Art). Courses like these trained women who became professionally involved in museum studies and the

development of the American art museum. When women did enter the art museum profession during the period from the 1890s to the 1930s, it was on unequal terms with their male peers. They accepted inferior positions and earned smaller incomes. As Linda Downs notes, "Their contributions continued to be in art historical and critical texts, the results of solitary endeavors. There was no institutional structure that would help women progress in the museum environment. From 1905 to 1945 only ten women attained full curatorial status at major U.S. art museums, and nearly all of them were single or married without children" (93). Thus, while women were remarkably active in establishing museum collections, they were themselves largely invisible, operating behind the scenes.

The establishment of the museum called for a new kind of professional: the museum curator, or "keeper." As Ralph Rugoff notes, "The word curator derives from the Latin to 'care for,' and here caretaking extends not simply to objects, but to our relationship with the past, particularly those portions that have been overlooked, dismissed, forgotten, or destroyed" (80). Like museum directors, museum curators were initially predominantly men. The gathering of art for galleries was an exclusively male privilege, despite the fact that nurturing, keeping, and tending were socially inscribed as "feminine." Consider the remarks of Jane Mitchell Thompson Walters, mother to William T. Walters, whose collection served as the foundation for Baltimore's Walters Art Gallery (now the Walters Art Museum). Mrs. Walters celebrates the (male) ritual of acquiring and appreciating good art: "The busy portions of a young man's life . . . are taken up full enough to keep him out of mischief or contamination. It is his leisure time and surplus money that must be provided for, and a young man can employ his time and money in no better way than by devoting them to accumulating and appreciating the noble works of literature and of art."[3] So the act of gathering and collecting great literature and art not only had an ennobling influence available to those who were blessed with "leisure time" and "surplus money," but it also seems to have been socially inscribed as a "masculine" endeavor.[4]

While curators had for the most part been men, things slowly started to change in the early years of the twentieth century, when Wharton's literary career was taking off. At this time, women began pursuing ad-

vanced degrees to secure the same professional status as men with similar
education (Taylor 21). Female curators in the scientific fields—specifically
anthropology, ethnology, paleontology—set the stage for this progress.
Curators in the liberal arts soon followed, having been aided by circum-
stances brought on by World War II. Among the earliest female curators
was Dorothy Miner, a member of the first wave of American women
professionals who received advanced academic training in art history.
Miner's career endured almost forty years, in which she served as cura-
tor of manuscripts and rare books as well as curator of Islamic and Near
Eastern art at the Walters Art Gallery in Baltimore (Taylor 21). Three
other well-known and respected art curators and supervisors, spanning
three generations in the twentieth century, are Emily Millard at Wash-
ington's Corcoran Gallery of Art and Dorothy Canning Miller and Riva
Castleman at New York's Museum of Modern Art. In 1943 Miller be-
came curator of painting and sculpture at the MoMA, making her one
of the first women art curators in the United States (25). And yet, one
could argue that the majority of the women acquiring the status of cu-
rator were nonetheless relegated to the "lesser arts"—decorative arts,
lace, textiles, prints (Sherman 50). The realm of the so-called minor arts
is where women like Florence Paull Berger and Frances Morris found
their niches; Berger, for instance, was general curator (an administrative
position) at the Wadsworth Atheneum in Hartford, Connecticut.

Wharton's fiction is clear on the gender division between curator and
custodian: the curator is male, the custodian female. Over and again she
casts men in the role of connoisseur who serves as collector and au-
thority. The pages of Wharton's fiction project an accepted understand-
ing that upper-class men of leisure were to tour the world, gather art,
and become experts. Women, on the other hand, serve as custodians
who keep watch over a work of art but are not involved in establishing
a collection or appraising art. The question, then, becomes why does
Wharton seem unable to imagine women in these positions of authority
within the art world? Why does she assume the troubling position of the
weaver of stories that set women back with respect to the history of the
museum and women's role in relation to art? Throughout the body of
her fiction, Wharton challenges the idea that women have traveled far by
the Progressive Era. She complicates a reading of women as fully devel-
oped authorities within the realm of art by pointing to the ways that

they continue to exhibit traditionally "feminine" behaviors. These behaviors are perhaps best illustrated in the example of Wharton's Paulina of "The Angel at the Grave" who is applauded for dutifully preserving the papers of a dead patriarch, thus ensuring his immortality. Wharton suggests that the art world has created a new kind of limited sphere for women, a place where, like Paulina, they are secreted away, hidden from the public, spectacular nature of the museum, yet championed for their "wonderful tenderness" and for using their "love" to "keep . . . alive" great men.

Gilded Cages and Palaces of Art

She felt a desperate longing to escape into the outer air. . . . It was the sense of wasted labor that oppressed her; of two lives consumed in that ruthless process that uses generations of effort to build a single cell.

—Edith Wharton,
"The Angel at the Grave"

I lock my door upon myself,
And bar them out; but who shall wall
Self from myself, most loathed of all?
Myself, arch-traitor to myself;
My hollowest friend, my deadliest foe,
My clog whatever road I go.

—Christina Rossetti,
"Who Shall Deliver Me?"

The Gilded Cage (1919), by the Pre-Raphaelite artist Evelyn de Morgan, depicts a restless, despondent woman in period dress evidently trapped in a marriage to a gentleman of considerable age and wealth.[5] The painting gives one the feel of the similarly lifeless union between the bookish Casaubon and the spirited Dorothea of George Eliot's *Middlemarch*. Like Casaubon, the man in the picture seems more the age of the woman's father than husband. The lady's predicament is reflected in the caged songbird off to the right, which would have stood as an obvious signifier for the woman, specifically the creative woman, who finds herself imprisoned in a domesticity that limits, entraps, and ensnares. Her body

language—she is literally clawing at the window—suggests a yearning for the outer world. Outside a bird soars happily, emblematic of the freedom this woman, and her caged bird, cannot know. Indoors, a book and various strands of jewels lie scattered about the floor, cast aside by the young wife. And yet she continues to wear a bracelet, reminiscent of the links of Lily Bart's jewels, which "seemed like manacles chaining her to her fate" (*The House of Mirth* 7). The wife depicted in this visual narrative, produced by a Pre-Raphaelite woman artist who, unlike her peers, managed to make a name for herself as an artist and not a model, reflects the domestic entrapment represented in the Wharton tales this chapter examines.[6] Additionally, the book thrown to the floor speaks to the kind of unhappy confinement to a "Palace of Art" that Wharton documents.

The Palace of Art, a nineteenth-century concept, comes to us by way of England's Poet Laureate, Alfred, Lord Tennyson. In the 1833 poem by that name, a human soul resides for years in isolation, locked up in a hermetically sealed "Palace of Art." Its halls are splendidly decorated with exquisite art—"full of great rooms . . . / All various, each a perfect whole / From living Nature." But soon enough, overwhelmed with "[d]eep dread and loathing of her solitude," and feeling "[s]hut up as in a crumbling tomb, girt round / With blackness as a solid wall," the soul recognizes the folly of living for art alone and abandons the palace to live in the world. The phrase "Palace of Art" was adapted during the latter part of the century as a term for the homes of merchants that boasted the finest works of art (Lambourne 20). As we shall see, the Palace of Art is an unhealthy space for Wharton's women; it suffocates, depresses, and enervates her heroines. Like Tennyson's allegorical female soul, and like de Morgan's painted heroine, they yearn to experience the outside world.

The Wharton narratives discussed in this chapter feature characters who serve as allegorical female artists or women whose "custodial work" connects them to the art world. In each case, the women are entrapped—sometimes by their own devices, like the speaker of Christina Rossetti's poem who locks her door upon herself, wondering who will set her free. A dominant chord throughout these narratives is that the art these women keep feels dead to them. The chapter discusses

Wharton's relatively neglected short stories "The House of the Dead Hand" (1904), "The Angel at the Grave" (1901), "The Rembrandt" (1900), and "Mr. Jones" (1928) as well as the novella *Summer* (1917). These narratives concern a woman's preservation and/or guardianship of art in the form of books, paintings, or letters. With the exception of "The Rembrandt," which is played against the backdrop of the Metropolitan Museum, the houses and libraries in these texts function as museums: they are more than simply the private space of the home, given the fact that the woman plays the role of a custodian or caretaker, a role that forces her to interact with the outside world that is interested in the art or letters locked within. And yet, within these Palaces of Art, women are positioned in domestic roles—nurturing, protecting, guarding, tending. They are tending material goods in a sphere largely cut off from the outside world, which is not quite the same as the more traditional kind of domesticity; tending goods is also different from producing them. If their roles are an extension of mothering, these women are more akin to nannies and nursemaids than mothers. The stories consider how the woman responds to her role as a custodian, how she secures or surrenders power therein—a surrender, that is, to outside forces that compel her to acknowledge that the power she might secure for herself is minimal at best. The narratives concern how to free one's self from the past, how to make the past relevant, and how to profit from one's relationship to art.

Wharton offers these narratives as cautionary tales for her female readers. The texts advise women on the limits of power within the art world, despite the contemporaneous advancements for women in the profession. The female protagonists of these narratives have troubled relationships to their Palaces of Art. In "The Angel at the Grave," Wharton's Paulina is metaphorically walled alive in a tomb, and as such she instantly summons up the early stories "The Duchess at Prayer" and "The Moving Finger" and, in turn, the Poe tales those stories invoke. But the difference here is that the woman has a hand in her own imprisonment. Like the purposeful women discussed in chapter 3, these women make compromises but not by submitting to their objectification as muses or as objects for display; they compromise within the art world by performing tasks that have been undermined as secondary

and marginal. While they exemplify another unsatisfying relationship to art, their choices allow them to remain alive, and that surely stands for something.

The chapter acknowledges two important exceptions where Wharton's women do more than stay alive: they secure a kind of agency. Wharton revises the script presented in the narratives discussed in the first portion of this chapter in a clever tale called "The Rembrandt" as well as in her late ghost story, "Mr. Jones," which lays out fresh possibilities for a new generation of women. In "The Rembrandt," Wharton finds a way for a seemingly naive elderly widow to pull the proverbial wool over the eyes of an art curator and ultimately secure money in exchange for a painting that is likely a fake. In the masterfully told "Mr. Jones," Wharton acknowledges hope for the autonomous, independent heroine to uncover the story of the silenced women who preceded her and claim and redecorate her own house, even if it is haunted by a patriarch's ghost. At the same time, Wharton in this story makes a key gesture toward revision insofar as she writes out of the script the female custodian who had obediently enforced the master's rules. As is often the case with Edith Wharton, power for one woman comes with the departure of another.

Dead Hands

Wharton's richly allusive "The House of the Dead Hand" (1904) engages the visual arts in order to draw attention to women's compromised relationships to art. Wharton opens her story in Siena, Italy, where Wyant, a young Englishman, has been sent to meet Dr. Lombard, an English dilettante and "devout student of the Italian Renaissance" (507). As a favor to his friend, Wyant hopes to catch a glimpse of the supposed Leonardo painting known to be kept at Lombard's home. The doctor lives with his wife, his daughter Sybilla, and the tightly secured Leonardo in "the House of the Dead Hand," a structure named for the "antique hand of marble which for many hundred years" has hung above the door (508). As Wyant approaches the entrance, he observes the "sallow marble hand" mounted above the doorway: "The hand was a woman's—a dead drooping hand, which hung there convulsed and helpless, as though it had been thrust forth in denunciation of some evil mystery within the house, and had sunk struggling into death" (509). In heavy-handed

fashion, Wharton describes the "dead hand" that "reached out like the cry of an imprisoned anguish" and "drooped tragically . . . ; in the waning light it seemed to have relaxed into the passiveness of despair" (526, 517).[7] Wyant is confounded by the hand's "hidden meaning" which, Wharton suggests, is tied to suppressed female power in this text and specifically to the "passive submission" attributed to Sybilla: "[S]he was horribly afraid of her father, and would never venture openly to oppose him" (517, 520). Sybilla's obedience to her father stands in stark contrast to the "fierce individualism" (509) basic to the Italian Renaissance with which her father is enamored.

In this narrative, Wharton paints a world in which women find themselves trapped in suffocating relationships to art. Sybilla, for instance, is unhappily tied to the Leonardo painting. Knowing that her father coveted, but could not afford, the masterpiece, she purchased it with her grandmother's inheritance. By virtue of investing her money in the Leonardo she has denied herself the dowry necessary to marry the man she loves. The suggestion, made by her suitor's parents, that she sell the Leonardo had been quickly dismissed by Lombard (520). Even after his death, Sybilla finds herself unable to dispense with the painting, given her father's cold grasp upon her life: "[H]e wouldn't let me [part with it]—he will never let me now" (529). Consequently, Sybilla remains trapped, living a life of cold celibacy in her father's Palace of Art.

To Dr. Lombard, the young woman's tie to the Leonardo painting is both a blessing and a privilege, and his reading of the picture betrays a conception of art that conflates the spiritual with the secular: "[M]y daughter is indeed fortunate. . . . Think of the happiness of being always under the influence of such a creation; of living *into* it; of partaking of it in daily and hourly communion! This room is a chapel; the sight of that picture is a sacrament" (513). As he sees it, his daughter is among the elect: "What other private person enjoys the same opportunity of understanding the master? Who else lives under the same roof with an untouched masterpiece of Leonardo?" (513). Lombard envisions Sybilla as "a votary of the arts" (511); indeed, the house itself becomes for the daughter and mother a kind of nunnery. And yet, it is the father who worships art, having "given [his] life to the study of the Renaissance" (514). Dr. Lombard's all-consuming commitment to the arts and his troubling relationship with his daughter align him with the (in-

cestuous) father of Wharton's "Beatrice Palmato" fragment, who is a wealthy art collector living in "an agreeable artistic-literary house." Further, Lombard conceptualizes art as a kind of sacrament, and the rhetoric employed by the narrative suggests a suspicious conflation of art and religion, specifically Christianity (for example, "communion," "votary," "sacrament," "chapel"). Dr. Lombard is even concerned that an "unworthy eye" might "desecrate" the picture, implying that the painting is inherently sacred and vulnerable to the gaze of the wrong pair of eyes (511). And the fact that the Latin for "light of the world" appears on a canvas that features various pagan symbols further underscores the suspicious blend of sacred and profane. Wharton's use of this rhetoric begs the question: Is it not a *sacrilege* to think of art as a sacrament?

Wharton here puts us in mind of a key concern of the turn-of-the-century aesthetic movement—the transformation of art into a kind of cult: "With the increasing secularization of late Victorian society, . . . art worship became a substitute for religion" (Treuherz 155). This is quite different from Ruskin's mid-nineteenth-century notion that art ought to be infused with a moral purpose. Art in this story is a kind of secular religion, blending Christianity with classical mythology; the Leonardo, for instance, juxtaposes a crucifixion with the figure of Dionysus. Wharton here critiques the mystification of art. Dr. Lombard himself seems to speak for the aesthetic movement—he might even be said to serve as a stand-in for Algernon Charles Swinburne—when he discourages Wyant from trying to pinpoint the meaning of the painting's rich symbols: "I stand abashed and ignorant before the mystery of this picture. It means nothing—it means all things. . . . Don't ask what it means, young man, but bow your head in thankfulness for having seen it!" (514).[8] In other words, celebrate art for art's sake.

For Sybilla, stewardship of the Leonardo painting is anything but happy. She grows to despise the painting and the walls built up around it. The house, with its "gray-brown tints of decaying vegetation," represents to her a "dungeon" (509, 521). In response to Wyant's insistence that she is lucky "to be the possessor of anything so perfect," Sybilla remarks, "coldly," that the painting "is *considered* very beautiful" (513; emphasis added). She confesses, at the story's end, that she has "never thought it beautiful" (528). Indeed, after the death of her father, Sybilla

reveals to Wyant her utter disdain for the painting: "I hate it; I've always hated it" (529).

Like Sybilla, Mrs. Lombard finds little appealing in the Leonardo, which is a beguiling portrait of a lady. Mrs. Lombard prefers the sort of "animated picture" one finds in William Powell Frith's *Railway Station* (512), an image full of commotion, which makes sense, given her enjoyment of dancing and other carefree activities when she was young (523). Wharton here suggests a female resistance to a kind of deadness in art. The resentment Sybilla and her mother feel for the painting recalls the hostility that Mary Anerton of Wharton's "The Muse's Tragedy" feels for what "literature" or, generally speaking, art, does to women. These women care little for works that, like the Lombard Leonardo, freeze women in art.

In her story, Wharton makes use of what John Hollander has called "notional ekphrasis"—a verbal description of a visual representation that is in fact an "imaginary" or lost work of art. Because Wharton is so generous in her description of the supposed Leonardo, the story invites a close reading of its intertextual implications, but it is crucial to realize that this description comes to us by way of Wyant:

> The central figure of the foreground . . . was that of a woman seated in an antique chair of marble with bas-reliefs of dancing maenads. . . . her attitude of smiling majesty recalled that of Dosso Dossi's *Circe*. . . . one hand drooped on the arm of her chair; the other held up an inverted human skull, into which a young Dionysus, smooth, brown and sidelong as the *St. John* of the Louvre, poured a stream of wine from a high-poised flagon. At the lady's feet lay the symbols of art and luxury: a flute and a roll of music, a platter heaped with grapes and roses, the torso of a Greek statuette, and a bowl overflowing with coins and jewels; behind her . . . hung the crucified Christ. (512–13)

The woman described in the portrait, with her "smiling majesty," reminds us of the flirtatious duchess of Robert Browning's famous dramatic monologue. As such, she is linked, in turn, to Wharton's hapless duchess at prayer. And like the painting in Browning's monologue, this woman's likeness is enshrouded—"concealed by a curtain of faded vel-

vet" (512)—as if to keep the lady tucked away while controlling whose eyes consume her.

Wharton directly engages aestheticism in her description of the Leonardo painting. First, she twice compares the figure of the young Dionysus to Leonardo's *St. John* of the Louvre (513), which invokes the work of the art critic Walter Pater, vocal champion of Rossetti and reluctant leader of the aesthetic movement that climaxed in the example of Oscar Wilde. (Wyant and Sybilla each allude to the *St. John* in describing the Lombard Leonardo.) In the essay "Notes on Leonardo da Vinci" (1869) by Pater, whose work Wharton knew well and invokes elsewhere, the critic calls attention to Leonardo's painting of Saint John the Baptist, "whose delicate brown flesh and woman's hair no one would go out into the wilderness to seek, and whose treacherous smile would have us understand something far beyond the outward gesture or circumstance. . . . we are no longer surprised by Saint John's strange likeness to the Bacchus [also by Leonardo] which hangs near it, and which set Theophile Gautier thinking of Heine's notion of decayed gods, who, to maintain themselves, after the fall of paganism, took employment in the new religion" (quoted in Prettejohn, *After the Pre-Raphaelites* 45).[9] Wharton also has planted various emblems of aestheticism—what she calls the "symbols of art and luxury"—in her description of the Leonardo. The grapes and roses, torso of a Greek statuette, and bowl overflowing with riches all would have called to mind aestheticism's suspicious conflation of the spiritual and the secular, its understanding of art as a new religion, and its appreciation of beauty as an end in itself. This emphasis on *l'art pour l'art* is perhaps best articulated by Pater, when he writes in his conclusion to *The Renaissance* (1873): "Of such wisdom, the poetic passion, the desire of beauty, the love of art for its own sake, has most. For art comes to you proposing frankly to give nothing but the highest quality to your moments as they pass, and simply for those moments' sake" (553). The description of the Lombard Leonardo, as well as the figure of Dr. Lombard who, like Pater, has devoted his life to the study of the Renaissance, would have struck Wharton's readers as indicative of her interrogation of the principles of aestheticism that were espoused at the story's turn-of-the-century moment.

The comparison made by Wyant to Dosso Dossi's depiction of the enchantress who turns men to swine also begs analysis. Dossi's *Circe and*

Her Lovers in a Landscape (1514–16) captures the nude sorceress in an idyllic setting, surrounded by the animals that were once her lovers; she appears to have cast a spell on them and transformed them into beasts (though they seem more friendly than beastly) (figure 13). The partially draped, seated female nude hardly bears the "smiling majesty" with which Wyant associates her, and so we have to question the credibility of this male reflector. He looks at a painting of a woman and sees Circe. Dossi's Circe in fact looks rather ill at ease, and it is telling that Wharton has Wyant invoke one of the less empowered renderings of Circe, unlike such contemporary depictions of the sorceress as the enchantress of Waterhouse's *Circe Offering the Cup to Ulysses* (1891) or the self-possessed temptress of Arthur Hacker's *Circe* (1893). In the Dossi rendering, Circe supports in her hands a large inscribed tablet, while by her feet rests an open book; inscribed on both texts are what appear to be the incantations used to turn men to swine.[10] The Dossi rendering of Circe—which would seem to depict a powerful female but in fact suggests a woman uncomfortable with her exposure and, perhaps, her authority—reflects Sybilla's position as an ostensibly empowered woman (she owns the Leonardo) who is in fact an unwilling and unhappy custodian of a masterwork.

Wharton encourages us to see Sybilla's story reflected in the Leonardo painting which, like her, is kept under lock and key within the claustrophobic walls of the Lombard Palace of Art. The canvas features a mysterious woman whose hand, like that of marble above the house's entrance, is lifeless. The lady's "golden hair" is contrasted with Sybilla's "dull fair" tresses, thus tying the heroine to the portrait (513, 510), with the important difference, of course, between golden (implying liveliness) and dull (signifying lifelessness). In spite of the comparison to Circe, and notwithstanding the elaborate red garb that suggests vitality and regality, the woman framed in the Lombard Leonardo fails to suggest power. Indeed, the painting everywhere bespeaks passivity. The crucifixion in the background, though foregrounded by symbols of indulgence and hedonism, looms large as a sign of defeat. And yet the crucifixion is also a symbol of Christ's power and victory over death. The skull held by the lady stands as a symbol of the fate she holds in her hands.

Leonardo's lady sits in a chair made of the same material as the fa-

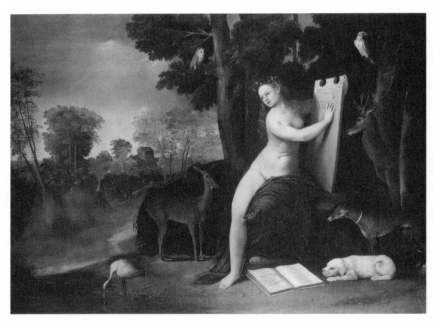

13. Dosso Dossi, *Circe and Her Lovers in a Landscape* (1514–16). Samuel H. Kress Collection, Image © 2005 Board of Trustees, National Gallery of Art, Washington, DC.

mous dead hand—which further points to the woman's disempowerment —but even more suggestive are the "dancing maenads" inscribed on it. The classically informed Wharton would have known that in Greek mythology, the maenads were women frenzied with wine who belonged to the cult of Dionysus—a figure representing excess—which explains the presence of this young god of vegetation, wine, and ecstasy in the Leonardo. Among the most negative images of women presented in nineteenth-century painting were those juxtaposing women and Dionysus: "The idea of the mad woman, in the figure of the worshipers of Dionysus, appears in works by Watts . . . Alma-Tadema, [et al.] . . . Men particularly feared the Maenad and Bacchante because Dionysus, as the son of Semele (moon, femaleness), represented a worship . . . believed [to be] essentially 'matriarchal' " (Kestner 43). And yet in Wharton's Leonardo, the crucifixion in the backdrop complicates the notion of a matriarchal worship. Wharton, conversant in several languages, also surely knew that "maenad" derives from the Greek *mainas,* for raving mad-

woman. The reference to a madwoman anticipates the insanity that en-
sues when women—Sybilla, her mother—are consigned to the house of
a patriarch (consider the narrator of Gilman's "The Yellow Wallpaper"
or Bertha Mason Rochester of Brontë's *Jane Eyre*). Mrs. Lombard's fond-
ness for dancing further links her to the maenads. Perhaps most signifi-
cant is that the maenads were driven to lunacy by drinking the very sort
of wine that Wharton's Dionysus seems to pour Leonardo's lady.

The painting Wharton describes invokes a similarly haunting por-
trait of a lady attributed to Leonardo. The Leonardo that most closely
resembles the Lombard painting—and stands as a possible source for
Wharton's tale—is titled *Ginevra de' Benci* (1474) (figure 14). The por-
trait of Ginevra de' Benci—whose authenticity, like that of the Lombard
Leonardo, was disputed for some time—bears many of the features
Wharton describes: a young woman with "high forehead," "crinkled
golden hair," and red dress against a backdrop of landscape with water
and vegetation. Also like Wharton's Leonardo, the picture of Ginevra
de' Benci displays a Latin-inscribed scroll: the painted reverse side of
the Benci portrait bears the motto "virtutem forma decorat" ("beauty
adorns virtue"). Scholars discussing the Benci picture have surmised
that "the lower part of the bust, with the hands, had remained unfin-
ished and was therefore taken off" (Ettlinger, 89.)[11] So the crucial dif-
ference consists in the absence, in the Benci portrait, of the drooping
hand that distinguishes Wharton's Leonardo. Wharton seems to have
added the detail of the hand to emphasize women's failed agency in this
narrative. What further encourages a link between the Benci portrait
and Wharton's painting is the involvement of her good friend, the art
scholar Bernard Berenson, in confirming the authenticity of the Benci.
A devout student of the Italian Renaissance, Wharton likely kept herself
up to speed on these findings. Further, the woman in the Benci portrait
projects a vacant stare that captures the mood of the Lombard painting
and the paralysis of Sybilla herself.

In the Leonardo painting Wharton describes, and throughout the
tale, drooping, inanimate hands function as reminders of female disem-
powerment. The hand of Leonardo's lady droops in a way that begs com-
parison to the mysterious "dead hand." Sybilla's mouth also droops (510,
513), which disturbingly likens her to a corpse, given that the muscles of
the mouth are among the first to bear the signs of rigor mortis. The

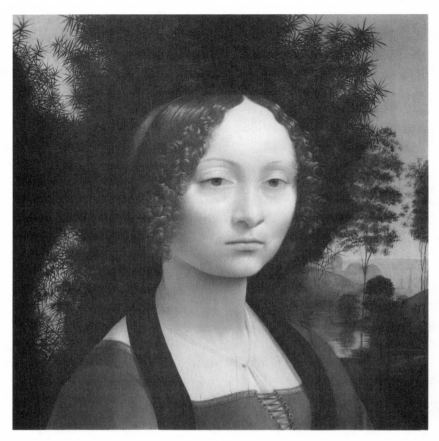

14. Leonardo da Vinci, *Ginevra de' Benci (obverse)* (1474). Ailsa Mellon Bruce Fund,
Image © 2005 Board of Trustees, National Gallery of Art, Washington, DC.

drooping mouth establishes a link between Sybilla, the painted lady,
and the famous marble hand.[12] Sybilla's hand—even though the woman
is often bent over needlework—is "cold and nerveless" (509, 525). Her
mother, an invalid who projects a "dull blue glance," has "swollen hands,"
implying a distortion that leads to uselessness (522, 528). And though
Sybilla wants out of the confined life to which she's been committed,
and to marry the count she loves, Wharton reminds us of the power her
hands will never know, despite the fact that the men around her cannot
understand it: "She [Miss Lombard] seemed hardly aware, the Count
said with a sigh, that the means of escape lay in her own hands, that she

was of age, and had a right to sell the picture, and to marry without asking her father's consent" (520). Here, Wharton uses the trope of the hand to a different end: the female hand is linked to commercial exchange. Sybilla could buy her freedom, at least as far as the count sees it. But because of her choice to obey the law of her patriarch, Sybilla will remain entrapped. Sybilla's role as custodian of her father's rule looks forward to that of Mrs. Clemm, the watchful administrator of her master's order in "Mr. Jones," discussed below. But the key difference in the later tale is that the figure of the custodian is finally eliminated, and that elimination means everything.

Despite the fact that Wyant has the power to assist Sybilla in her liberation from her father's house, he refuses to help. Like the count, Wyant has little compassion for this woman's entrapment: "She isn't walled in," he complacently remarks to himself, "she can get out if she wants to" (526). Men in this story seem blind to the fact that gender determines privilege and power. Their inability to recognize gender inequity, and their unwillingness to lift their own able fingers to help a woman confined, ultimately secures her imprisonment.

The same current of slipperiness between the spiritual and the secular that runs through Dr. Lombard's description of the Leonardo also informs Wyant's reading of a painting of Saint Catherine of Siena. Wharton here points to another kind of sacrilege manifest in the visual arts: the way in which images of religious women have been sexually charged. Early in the narrative, Wyant makes a pilgrimage to Siena's church of San Domenico in hopes of viewing a painting of Saint Catherine by the Italian Renaissance artist known as Sodoma (517).[13] He has timed the visit well, as he wishes to see the canvas bathed in the afternoon sun. Here is Wharton's description of Wyant's reading of the painting: "[T]he saint's figure emerged pale and swooning from the dusk, and the warm light gave a sensual tinge to her ecstasy. The flesh seemed to glow and heave, the eyelids to tremble" (517–18). Wharton refers to a painting by Sodoma (1526) housed at the church of San Domenico.[14] Sodoma's *Swooning* depicts Saint Catherine receiving the stigmata (figure 15). As Wharton has shown us in her allusion to Circe, Wyant is not a terribly trustworthy reader, as it is difficult to find "glowing, heaving flesh" or "trembling eyelids" in the Sodoma painting. Wyant's attraction to the painting seems more salacious than spiritual. Moreover, as Wharton

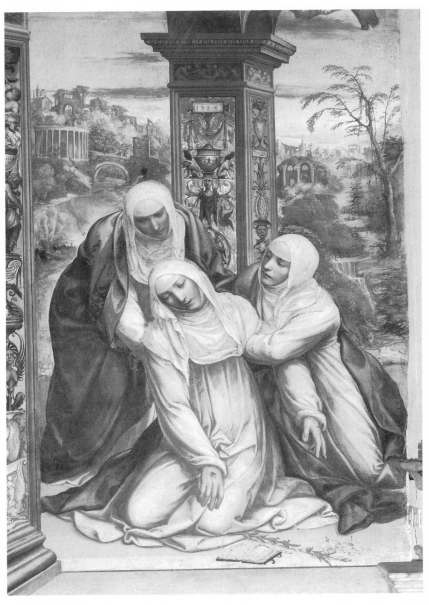

15. Giovanni Antonio Bazzi, called Il Sodoma, *Scenes from the Life of Saint Catherine of Siena: The Swooning of the Saint* (1526). Scala/Art Resource, NY.

surely was aware, Saint Catherine is not known for her ecstasy, and so her account of Wyant's reading taps into the way in which Italian Renaissance painters represented female religious authorities.[15] Butler's *The Lives of the Saints* describes the scene of Saint Catherine's swooning: "After making her communion in the little church of St. Christina, she had been looking at the crucifix, rapt in meditation, when suddenly there seemed to come from it five blood-red rays which pierced her hands, feet, and heart, causing such acute pain that she swooned" (Walsh 126).

Wharton's allusion to Sodoma's painting, which features the saint's bleeding palm, draws further attention to women's drooping, wounded hands. But Saint Catherine's case is different from that of Sybilla or the (imagined woman attached to the) drooping marble hand, as the saint's hand is ultimately empowered by Christ, who, with his hand raised, hovers above her in the background. Saint Catherine resembles the other women in these Wharton narratives insofar as she secures power from a male authority and is wounded in the exchange. Receiving the stigmata endows Saint Catherine with a special power. And yet, this saint— known for her letters and a treatise considered one of the most celebrated writings in the history of the Catholic church—is reduced, by Wyant's gaze and Sodoma's artistic interpretation, to a "pale and swooning" virgin sexually marked by her sensual ecstasy, her glowing, heaving flesh, and her trembling eyelids. The emphasis on her paleness, coupled with her drooping hand, links her to Leonardo's lady, Sybilla, and the "sallow marble hand" above the threshold of the house of Lombard.

By the end of the story, Wharton makes even more apparent the equation of women with art, as Sybilla is described as if she were a painted canvas. She is of course brought to us by a narrator who favors Wyant's perspective: "[T]he rose color of her cheeks had turned to blotches of dull red, like some pigment which has darkened in drying" (528). (Sybilla and her mother, faded with age, are not so fortunate as the Leonardo, which is compared to "some magical flower which had burst suddenly from the mold of darkness and oblivion" with "colors [that] had lost none of their warmth" [528]; the message seems to be that the beauty of women represented in art endures while the aesthetic value of real-life women diminishes.) It is as though Sybilla has been transformed into art and, like the Leonardo, locked up inside her father's

"chapel." This surprises us little, given that the narrative introduces her as "a slim replica" of her mother (510). Wharton's narrator describes Mrs. Lombard's fate, as if to suggest it is the most to which the daughter might aspire: "[H]er chair had been wheeled into a bar of sunshine near the window, so that she made a cheerful spot of prose in the poetic gloom of her surroundings" (522). The "bar" of sunlight suggests the (prison) bars encircling her Palace of Art. Even though this woman once dabbled in the creative arts and "did a view of Kenilworth which was thought pleasing" (523) the closest she can get to artistic endeavor is to create her "cheerful spot of prose" amid the "poetic gloom" of her husband's house of art, which he continues to govern in death as in life.

Before closing the door on "The House of the Dead Hand," we might consider Wharton's choice of the name "Sybilla," which again invokes Rossetti and the Pre-Raphaelites. Wharton's heroine may well have been named for Dante Rossetti's painting titled *Sybilla Palmifera* (1866–70), which inspired the Rossetti sonnet "Soul's Beauty." The picture, like the Leonardo Wharton describes, depicts a mysterious woman in red dress seated on a throne. As in the Leonardo, a skull appears in the backdrop and the painting blends the natural and the artificial. As William M. Rossetti noted, Dante Rossetti named the picture "beauty the Palm-giver, i.e., the Principle of Beauty, which draws all high-toned men to itself, whether with the aim of embodying it in art or only of attaining its enjoyment in life" (*Dante Gabriel Rossetti as Designer and Writer* 56). (The Rossetti poem and accompanying picture were presented as diametrically opposed to his sonnet "Body's Beauty" and the corresponding painting *Lilith*.) Swinburne, in his 1868 *Notes on the Royal Academy Exhibition*, enthusiastically celebrates the Rossetti painting. Given Swinburne's support of the principles of aestheticism, which resonate throughout "The House of the Dead Hand," and given also Wharton's apparent familiarity with Oscar Wilde's Sibyl Vane, who is admired for her aesthetically pleasing death, it seems likely that Wharton named her Sybilla with care.

The sibyls, of course, were the female figures of antiquity known for prophetic powers. Their "enigmatic prophecies in Classical mythology were realised as moments of fate that highlighted the futility of human endeavour" (Wilton and Upstone 263). In the same way that Wharton's exact contemporary, the British sculptor Henry Pegram (1862–

1937)—who exhibited his haunting *Sibylla Fatidica* the year Wharton's story was published—conveys something of the uselessness of struggling against the circumstances, Wharton's heroine suggests that the battle is not always worth the fight. It is a theme she would invoke with her angels at the grave who patiently, if not quietly, conduct their custodial work.

Ministering Angels

Like her "House of the Dead Hand," Wharton's "The Angel at the Grave" (1901) represents a woman imprisoned in a dark, depressing house and bound to the art of a dead master. Wharton's Paulina Anson is a pivotal character: in a line of progression, she falls between Sybilla Lombard and Mrs. Fontage, whom we meet in "The Rembrandt," discussed below. Like the victimized, ultimately defeated Sybilla, Paulina recognizes the staleness of the art that she guards. But what distinguishes her from Sybilla is that Paulina is dutifully devoted to the art and she seems to have dug her own titular "grave." Indeed, Paulina "bends her neck to the yoke" that ties her to an old, dead art (133). At the same time, Paulina resembles Mrs. Fontage of "The Rembrandt" insofar as she manages to reach a compromise that accords her power within the art world, albeit a power that is limited.

Wharton's Paulina, granddaughter of the once-formidable New England philosopher Orestes Anson, is described as the "solitary inmate of the Anson House" (129) and has been programmed for a career as a "guardian," "interpreter," "custodian," and keeper of the shrine of her grandfather's intellectual legacy (132, 134, 130). Wharton encourages us to read Paulina as a would-be woman writer and, with this story, she offers a kind of cautionary tale that resonates with one written a decade earlier by Mary Wilkins Freeman, much as Wharton would have resisted a comparison to a so-called New England authoress. Like Freeman's "A Poetess" (1891), Wharton's tale suggests that a woman writer ought to be prepared to defer to a man whose gender entitles him to preside over what Wharton called the Land of Letters. Like Freeman, Wharton implies that the female writer should expect to work behind the scenes for little, if any, credit.[16] Wharton's protagonist draws pleasure from her role as a "young priestess," "delight[ing] in her grand-

father's writings" (134). Admittedly, "[v]anity had a share in her subjugation," as she takes pride in her distinction as "the only person in the family who could read her grandfather's works" (133). Her aunts, for their part, are more taken with "needlework and fiction" (135) and the apparently unsophisticated poetry of Mrs. Hemans (130–31). Paulina's role as a custodian has its perks and it helps her to feel distinguished.[17]

Paulina becomes the acknowledged authority on Orestes Anson, consulted by historians and critics. And while the House of Anson, to which Paulina is all but married, represents "a monument of ruined civilizations," "[n]evertheless, the House did not immediately dominate her" (133). Paulina's opportunity to abandon the house comes in the form of a marriage proposal—an option quickly dismissed because her suitor, who is not humbled by Orestes' legacy, would remove her to New York and away from the house and the purpose for which fate seems to have fitted her. (Paulina thus represents a significant departure from Sybilla, who sought from men a means to escape her father's house.) Although rumor has Paulina rejecting Winsloe "because her aunts disapproved of her leaving them," the refusal seems to have been issued "from the walls of the House, from the bare desk, the faded portraits, the dozen yellowing tomes that no hand but hers ever lifted from the shelf" (136). Wharton's narrator notes that once Paulina rejects Winsloe, it is then that the house "possesses" her: "As if conscious of its victory, it imposed a conqueror's claims" (137). And, unlike Sybilla, Paulina seems to embrace captivity in a house that serves as both museum and shrine.

As a means to justify her having knelt, her whole life, before the altar of her patriarch—like the "votary of the arts" to which Sybilla is compared—Paulina passionately assumes the task of writing her grandfather's life. Driven by a "mystic conviction that she would not die till her work was accomplished" (137), she completes the biography by the time she reaches forty—the age Wharton approached as she published this tale. Wharton's narrator tells us it "was not so much her grandfather's life as her own that she had written" (138). But Paulina's "life" is callously rejected by the publishing house that represented her grandfather on the grounds that Orestes Anson is no longer fashionable. Feeling "like a wounded thing" (139), Paulina sets out to account for the decline of interest in Orestes.

The answer comes as she pores through Anson's works and those of

his contemporaries: "Death had overtaken the doctrines about which her grandfather had draped his cloudy rhetoric. . . . and he . . . lay buried deep among the obsolete tools of thought" (142). It is only when Paulina is awakened to the deadness of her grandfather's work that she recognizes, regrets, and wants to escape her cloistered life: "[I]t seemed to her that she had been walled alive into a tomb hung with the effigies of dead ideas. She felt a desperate longing to escape into the outer air. . . . It was the sense of wasted labor that oppressed her; of two lives consumed in that ruthless process that uses generations of effort to build a single cell" (142–43). Wharton's Poe-esque depiction of Paulina's live entombment resonates with the description of Mrs. Grancy's metaphorical burial in a portrait, thus emphasizing Miss Anson's status as disempowered in, and by, art. Yet Paulina is, in part, to blame for her live burial, as she relinquished an offer to escape the house and her role as its guardian when she rejected a marriage proposal.

Paulina's suffocation lifts when fate sends her a ticket to the literary world—a ticket that does not, however, grant her front-row access. At the door of the house appears George Corby who, in writing an article, hopes to reinvent Orestes as a scientist and thus renew his appeal—a goal that Paulina, as librarian of the Anson papers, can help him realize. Wharton captures Paulina's relationship to the world of letters with a clever reference to the woman's observance of "a fleck of dust on the faded leather of the writing-table and a fresh spot of discoloration" in Raphael Morghen's engraving *Parnassus* (145–46). The dusty, faded writing table points to the intellectual dust that has gathered on the grandfather's works and anticipates the cobwebs that promise to enshroud Paulina. The Morghen engraving reproduces Raphael Mengs's fresco by the same name, which features Apollo flanked by his muses atop the sacred mountain, which resonated powerfully for Wharton.[18] If we consider that Parnassus stood for Wharton as a symbol of the realm of art from which her women are repeatedly shut out, we see that Wharton's heroine literally eyes (a copy of) Parnassus as she agrees to assist George Corby in his scholarly endeavor. But Paulina notes the imperfection of this picture of Parnassus: first, it is discolored; second, it is not quite the real thing.

Corby's plan, to which Paulina consents, requires securing a pamphlet produced by Orestes that evidences his unacknowledged contri-

butions to the field of science. Dr. Anson, who originally studied medicine, had discovered a species that links vertebrates to invertebrates. With this detail, Wharton acknowledges her awareness of the museum's charge of making people aware of their place in the chain of being and giving them a sense of context to help shape identity. With this almost naturalistic gesture—reminding humans of their shared lineage with beasts, not gods—Wharton evidences her engagement with the literary naturalism and social Darwinism found in the works of Crane, Norris, Dreiser, London, and Upton Sinclair. Further, Corby will render Anson's philosophy more marketable by parlaying it into science. Paulina obliges Corby by producing the pamphlet—"a thin discolored volume" (148). The text's discoloration links it to the Parnassus engraving, thereby reminding us of Paulina's compromise. By publicizing this neglected material, Corby intends to revive interest in the great thinker by repackaging him as a scientist. Barbara A. White asserts that, consequently, Orestes' reputation will be resuscitated, and "Paulina can share in the work; as the story ends, she feels touched by youth" (54). Josephine Donovan reads Wharton's ending more pessimistically, claiming it demonstrates the author's "growing acceptance of patriarchal ideological hegemony, a sign, one could say, of Wharton's own ambivalent capitulation" (*After the Fall* 54). Donovan observes: "It should be pointed out . . . (and Wharton does not) that in the end Paulina has served as a vehicle for the transmission of a patriarchal tradition; her own work remains unpublished and therefore on the margins, silent" (53). White sees the ending altogether differently: "Fate finally allows Paulina to hold her grandfather and the House of Anson. Although it is true she will be transmitting a patriarchal tradition . . . , she is not really silenced. Clearly, with the reversal in her grandfather's reputation, her biography will become a hot item; Paulina will have work, will be published—and she controls the House of Anson" (55). White sees Paulina's story a bit rosier than Wharton seems to have painted it. Wharton offers no assurance that Paulina will find an audience for her work, which celebrates Anson in his outmoded identity as philosopher, not scientist. Further, it is no longer the case that Paulina "controls the House of Anson." On the contrary, she relinquishes that control to Corby when she hands over the pamphlet. Wharton offers little to encourage a reading of Paulina as "a professional writer," and though we are told she has, indeed, written her

own life in the process of recording her grandfather's, that life has been dismissed by a publishing house and by her own sense of regret.

Wharton's ending to the story is more complicated than White and Donovan suggest. Rather than reading the conclusion as Wharton's growing acceptance of patriarchy, it might be more useful to consider the ending as reflective of Wharton's *awareness* of patriarchy's stronghold and indicative of her idea of the futility of "struggling against the circumstances" (*Summer* 157). Wharton's stance here—as we might come to expect from her—is cautionary and realist. She suggests that society's sense of the most acceptable way for a woman to "scale the rugged heights of Parnassus," as she would refer to the publishing process in her mini-*Kunstlerroman* "Writing a War Story," is to attach herself to a male writer and assist him as *he* writes (359). Wharton proposes that Paulina's one option—if she wishes to set foot on Parnassus—is to serve as the kind of research assistant Mr. Corby seeks.

Wharton's tale may have been inspired by the real-life example of Mary Berenson. An overlooked detail of Mary's life is that she was an established art historian before her marriage to the esteemed Bernard Berenson. In 1894 Mary published *Guide to the Italian Pictures at Hampton Court,* which corrected some inaccurate attributions. Bernard's first book, *Venetian Painters* (1894), which helped establish his reputation as the leading authority on Italian painting, was for the most part a rewriting of Mary's notes. The Berenson example reminds us of the women who quietly work behind the scenes without proper acknowledgment.

A key to unpacking Wharton's message comes from a subtle pun employed at the story's end. Wharton suggests who will earn rights to authorship by cleverly repeating the phrase "by George." Once George Corby has articulated his intent to remake Orestes into an intellectual superstar—to transfuse into him the kind of new blood publishers crave—Wharton makes it clear that his name will be featured in the byline. Wharton does not promote the story as a victory for Paulina-as-writer. In his enthusiasm for the project at hand, George Corby thrice utters, like a punny refrain, "by George" (149) as if to point to the one whose voice will be considered authorial: George Corby. The story depicts a woman quietly laboring behind the scenes while two men—Orestes and George—are credited with the fruit of her work, even though the latter is marked by "the inadequacy of speech" (149). It seems fair to

assume that in the book's acknowledgments, George will thank Paulina, whose name derives from the Latin for "small," for her efforts to assist him with the Anson archives; but this amounts to all the thanks she likely will get.

With this early tale, then, Wharton offers a picture admittedly less bleak than what we find in the contemporaneous "Duchess at Prayer" or "The Moving Finger": art does not "enshrine" Paulina's body. And yet, like Sybilla Lombard, she remains trapped in a Palace of Art—a house that has come to serve as a kind of museum and mausoleum. Like the female muse in Wharton's last completed novels, *Hudson River Bracketed* and *The Gods Arrive,* Paulina serves as a support system for a male writer, reinforcing Gerard Manley Hopkins's notion that "the male quality is the creative gift." Corby needs Paulina's help in the way Vance relies on Halo, who patiently lingers in the background. Like the ministering angel of the story's title, Paulina keeps a watchful vigil at the grave of a patriarch.

Thus, in this tale, the value of art has shifted. Art seems to need transformation into science, and it is *research* rather than creativity that is redeeming. The emphasis here on art's evolution into a science further points to Wharton's engagements with aestheticism, given that the painter James McNeill Whistler, a key practitioner of the movement, insisted after 1878 on reading art as a science. Though his sometime peer and artistic confrere Swinburne thought this absurd, claiming that "the betrothal of art and science were a thing harder to bring about and more profitless to proclaim than 'the marriage of heaven and hell,'" Whistler was convinced of "the advantage of encouraging his audience to identify avant-garde art with current advances made in the sciences" (Spencer 78). First, it is Paulina's own research into the work of her grandfather and that of his contemporaries, once her manuscript is rejected, that allows her to recognize the deadness of her grandfather's work. Second, it is her grandfather's research that will be freshly packaged and will, it is hoped, draw a new audience. Though Paulina's manuscript has been rejected, Wharton identifies a role for her as a research assistant, and given that research now seems to be valued, Paulina likely will find a use for her skills, provided she is willing to work on unequal terms with her male counterparts.

Hands Tied

Wharton returns to rural New England, and to the theme of "the use-lessness of struggling against the circumstances," in her novella *Summer* (1917). Here, Wharton uses art—especially the kind of art that is translated and interpreted by a male authority—as an instrument of discipline. Art in fact serves to remind Wharton's heroine, another frustrated custodian, of her rightful place and ultimate disenfranchisement. The narrative tells the story of Charity Royall, a young woman born to a drunkard father and a renegade mother, who is adopted by the old, awkward Lawyer Royall. As Charity grows into a young woman, Royall makes clear his wish to marry her, notwithstanding her repeated rejections. He ultimately seizes the opportunity in Charity's weakened, defenseless state at the story's end. Much of the criticism devoted to *Summer* focuses on whether or not the marriage is a tragedy. Surprisingly, Cynthia Griffin Wolff and Candace Waid reconcile the marriage.[19] Elizabeth Ammons has perhaps put it best when she notes that the marriage, on the contrary, is "not merely depressing; it is sick," and the book is "Wharton's bluntest criticism of the patriarchal sexual economy" (*Edith Wharton's Argument with America* 133). As this novella is not an obvious choice for a discussion of female authority in relation to art in Wharton, the chapter offers a new context for reading *Summer*.

Through Lawyer Royall's influence, Charity is appointed "custodian of the village library" (3), and it is in this context that we can consider her one of Wharton's female stewards and keepers of the flame. Like "The Angel at the Grave" and "The House of the Dead Hand," *Summer* comes equipped with a kind of Palace of Art guarded by a young heroine, though Charity—more like Sybilla than Paulina—is a decidedly reluctant custodian. More strong-willed and outspoken than her predecessors, Charity considers the Hatchard Memorial Library, named for a man who was "the sole link between North Dormer and literature," a "vault-like" "prison-house" reminiscent of Sybilla's "dungeon" (5, 6, 5). It is a "temple of knowledge" and "mausoleum" (11, 34) that resonates with the "bleak temple of thought" that is the Anson house. Marked by dead air, the library's collection boasts old books that "mouldered undisturbed on the damp shelves" (4). Not surprisingly, Charity experi-

ences "joy" when released from the suffocating library, and she feels no
maternal pangs for the books it houses: "[S]he hated to be bothered
about books. How could she remember where they were, when they were
so seldom asked for? . . . no one asked for anything except, at intervals,
Uncle Tom's Cabin, or *Opening of a Chestnut Burr,* or Longfellow. She
had these under her hand, and could have found them in the dark; but
unexpected demands came so rarely that they exasperated her like an
injustice" (12). Books, for Charity, offer little enlightenment; in fact, she
puts them to more practical use, relying on "the buckram back of a dis-
integrated copy of *The Lamplighter*" as a handy tool around which to
wind lace (6). Although, like Paulina, she is likened to a kind of "solitary
inmate," Charity has no love for books in their intended function, and
she embraces her liberation from the dusty world of the library.

Charity's life alters permanently when into her library strolls Lucius
Harney, who initially represents the unfamiliar, unfriendly territory of
art and letters, projecting an "air of authority" (118). Young and dashing,
Harney instantly distinguishes himself as a preserver of old books. His
interest in their care and restoration is reflected in his fastidious dusting
of the "tall cobwebby volume[s]" and in his arranging for the Memorial
Library to be ventilated (7, 61). Harney's appreciation of the dark, dank
library harkens back to George Corby's admiration of the suffocation
one feels inside the Anson library. ("It's a hundred times better than I
could have hoped," Corby notes. "The seclusion, the remoteness, the
philosophic atmosphere—there's so little of that flavor left!" [145].) A
lover of old things, Harney "has such a feeling for the past" (122). For the
women in these Wharton tales, the past equals deadness; it is to be nei-
ther mourned nor yearned for. (If Wharton's Paulina Anson learns any-
thing, it is that only by looking ahead can one truly create. But then by
looking forward, one finds *science,* not art.) Harney has been hired by a
New York publisher to conduct in the village of North Dormer "a study
of the eighteenth-century houses in the less familiar districts of New
England" (52). As such, he resembles Wyant of "The House of the Dead
Hand," Corby of "The Angel at the Grave," and the curator of "The
Rembrandt"—each a male outsider on a mission to investigate the con-
tents of a house of art looked after by a female custodian. An architect,
Harney represents to Charity the esoteric world of art and letters. She
cannot understand his references, as he speaks a different language: she

feels "a sense of inadequacy" when Harney "plunge[s] into a monologue on art and life" (42). (Wharton's choice of the verb "to plunge" harkens back to the sexually charged rhetoric of Ruskin and his peers, who aligned art with penetration.) Harney resembles Wharton's archetypal male connoisseur whose access to the realm of art and experience alienates women who, like Charity, find themselves isolated by their ignorance.

But Charity, like Wharton's other custodians, has something to offer the connoisseur. He needs her help as a librarian and, like Sybilla and Paulina, Charity has in her possession the keys to an institution that houses art: the village library (31). Harney seeks literature on the history of North Dormer—"a book or pamphlet about its first settlement" (9). Charity knows the text to which he refers, and she harbors "a special grudge against it because it was a limp weakly book that was always either falling off the shelf or slipping back and disappearing if one squeezed it in between sustaining volumes" (9).[20] Intrigued by Harney from the start, Charity is glad to help this charming visitor from another world: "[S]he understood that he needed the help of books, and resolved to hunt up the next day the volume . . . and any others that seemed related to the subject" (25). Like Paulina, Charity embraces the opportunity to assist the acknowledged expert.

Charity immediately links Harney to an erudite lecturer she had heard in the neighboring town of Nettleton, and the connection pegs Harney as a visitor from a world that is to her off-limits, incomprehensible, and ultimately unfriendly. The town preacher had taken Charity and the other North Dormer children to see "an illustrated lecture on the Holy Land" (3). There she "listened to a gentleman saying unintelligible things before pictures that she would have enjoyed looking at if his explanations had not prevented her from understanding them. This initiation had shown her that North Dormer was a small place, and developed in her a thirst for information that her position as custodian of the village library had previously failed to excite" (3). Wharton here sets up a pattern that is replicated throughout her fiction: knowledgeable, worldly men indoctrinating women in need of experience and knowledge.

At the same time, Wharton speaks to the changing role of the museum: should it collect, interpret, educate, as well as discipline? Wharton's unintelligible lecturer calls to mind the origins of the museum as

institution: "[R]eliquaries, like the cabinets of curiosity, were similarly reliant not only upon display but upon *interpretation:* a guide narrated the religious importance of objects—objects often unseen (what was displayed was the cabinet holding the relics or a picture of it)" (Bann 15). For Charity, the unintelligible interpreter's explanations stand as an obstacle to her understanding and appreciation of the Bible images, and he serves as a representative—like Harney—of the museum-as-elite-temple-of-the-arts that so alienated working-class girls like Charity. The museum's purported potential to "teach the young child . . . to respect property and behave gently," lauded by Henry Cole at the end of the nineteenth century, seems not to have been actualized in the case of Wharton's heroine, as Charity is anything but gentle, respectful of property, or well behaved (356).

The lecture at Nettleton becomes a formative experience for Charity. The narrator notes that the presentation at once whet Charity's appetite to dip "feverishly and disconnectedly into the dusty volumes of the Hatchard Memorial Library," but after some time "the impression of Nettleton began to fade, and she found it easier to take North Dormer as the norm of the universe than to go on reading" (3). In the same way she had felt alienated by the language of the Nettleton lecturer, Charity, confronted with Harney's allusions and references, feels "the weight of her ignorance settl[ing] down on her again like a pall" (8). Even her tenderest moments with Harney are tainted by the division between their respective credentials to recognize good art: when Harney asks Charity to choose the jewel she likes best, he edits her choice by suggesting that the blue brooch is preferable to the pin that caught her eye. In response, Charity scolds herself for thinking the gilded lily of the valley pin beautiful, "colour[ing] at her want of discrimination" (94). (Harney's preference for the blue brooch may be less a mark of his discerning tastes than a sign of his cheapness, given his reluctance to spend money on their outings.)[21] Harney tells her what's beautiful, and his knowledge of art allows him to participate in an intellectual conversation whose allusions are lost on Charity. When the town preacher speaks to Harney of the impressionists, "[t]he names he cited were unknown to Charity" (64).

Harney's final letter to Charity, which thanks her for releasing him to "do right" and marry the society belle to whom he is betrothed, strikes Charity as difficult to read. Further, the letter links him to the Nettleton

lecturer: "It was so beautifully expressed that she found it almost as difficult to understand as the gentleman's explanation of the Bible pictures at Nettleton" (163). It was not the pictures that had troubled her, but rather the meaning he forged onto them. (The fact that Harney is linked in Charity's mind to a lecturer whose topic—the Holy Land—is drawn from the Bible, a text compiled by the earliest patriarchs, further connects Harney to the "established order," which yields "no place for her individual adventure" [166].) Wharton repeatedly invokes the Nettleton lecture as a reminder of Charity's sense of powerlessness in the face of art and scholarship. Like George Corby, this man wants to change the context around a particular subject, and that recontextualization is disempowering, particularly to women. *Summer* seems to reestablish or shore up these binaries: curator/male/active versus custodian/female/passive.

In *Summer*, then, Wharton uses the arts—literary as well as visual—as a means to remind her heroine of her ultimate "powerlessness" (140). The novella again alludes to the illustrated lecture at Nettleton the moment Charity discovers the unfortunate truth of Harney's liaison with another woman: "[T]he faces in the crowded hall began to dance like the pictures flashed on the screen at Nettleton" (140). Further, Charity's recollection of the *Surrender of Burgoyne* engraving that hangs in Mr. Royall's room anticipates her own resignation at the story's end when, in a daze of exhaustion marked by helplessness and voicelessness, she is cornered into marrying Lawyer Royall. Once she has given in to his relentless advances, what she has given up—a union with Harney, the father of her child, as well as whatever independence the culture might afford her—is mockingly reflected in a picture that hangs in the hotel room in which Mr. Royall has deposited his new, all but unconscious, bride: "It was a large engraving with a dazzling white margin enclosed in a wide frame of bird's-eye maple with an inner scroll of gold. The engraving represented a young man in a boat on a lake overhung with trees. He was leaning over to gather water-lilies for the girl in a light dress who lay among the cushions in the stern. The scene was full of a drowsy midsummer radiance, and Charity averted her eyes from it and, rising from her chair, began to wander restlessly about the room" (197–98).

Wharton encourages us to dwell a moment on this painting's relevance. The picture immediately invokes Charity's romantic boat ride

with Harney in chapter 10. But it is worth noting that, while the quaint pastoral painting depicts a pair of lovers in a boat, it comes to us through Charity's gaze as a "represent[ation of] a young man in a boat on a lake overhung with trees." The girl-in-light-dress is incidental and, what is more, her idle, recumbent pose invokes the countless Pre-Raphaelite and aesthetic renderings of languid, indolent women reclining for our visual consumption. William Reynolds-Stephens's *Summer* (1891), Albert Moore's *Midsummer* (1887) and *Dreamers* (1882), and Frederic, Lord Leighton's *Flaming June* (1895) come to mind. In fact, *Summer,* which Wharton has chosen to call her novella, would be a fitting title for the picture. The engraving is off-putting to Charity not only as a reminder of the proverbial boat that she has missed but also, perhaps, for its emphasis on the woman's status as secondary, passive, marginal. As Wharton's narrator makes clear, all Charity has the power to do at this point is wander restlessly and misguidedly, for in the universe in which she has been bred, she indeed finds no place for her individual adventure, and it is her inability to be autonomous that locks her into an incestuous marriage with a man who should have been her father. And though she once was marked by what Wharton calls "strong young hands" (155), willfully reaching out to tear up the natural order of things, her hands are ultimately tied behind her, "idle," "inert," and finally powerless (47, 153, 150).

Able Hands

Like "The House of the Dead Hand," Wharton's "The Rembrandt" (1900) documents the interactions between the female owner of an alleged masterwork (which represents the sum total of her wealth) and a male connoisseur brought in to assess the work. The story ostensibly underscores men's inherent authority with respect to art. Men are in charge of assessing the worth of art—they presumably know how to recognize a legitimate work by a seventeenth-century Dutch master—and have the ability to detect fraud. Women are expected to defer to male authority for said appraisal—*or at least feign deference*—and serve as custodians of great art. By withholding the perspective of the woman who owns the painting, Wharton asks us to consider that which remains unspoken. In other words, Wharton suggests that Mrs. Fontage manipulates the cura-

tor into liquidating a supposed Rembrandt in order to save her from bankruptcy. Thus, if Sybilla Lombard's story, which concerns an "undoubted" Leonardo, is "The House of the Dead Hand," then this tale could as easily be called "The House of the *Able* Hand," for Mrs. Fontage skillfully plays her hand and manipulates a system of exchange to her advantage.

Wharton's story comes to us by way of a nameless male narrator whose work as a museum curator identifies him as a connoisseur. In fact, he makes a career of serving the country's most formidable (and, at the time, male-dominated) Palace of Art, New York's Metropolitan Museum. The narrator's cousin has called on him to draw on his expertise: "Eleanor, in my presence, always admits that she knows nothing about art" (289). In fact, the narrative begins with Eleanor's gushy remark "You're *so* artistic" (287; Wharton's emphasis).[22] With such a statement, Wharton suggests that Eleanor simply professes, in his presence, to lack the expertise to attach a price to a work of art, relying on flattery to get what she wants. Wharton also implies that Mrs. Fontage feigns ignorance. Eleanor directs to the narrator's attention a painting owned by the elderly, once-wealthy Mrs. Fontage, whose fortune has dwindled to whatever capital the painting might yield. Amid her "unconcealably poor" surroundings, Mrs. Fontage notes that it is "always . . . a privilege to be in the presence of the great masters" (289). Here we have something of an inversion of gender roles, if we consider that the remark resonates with Dr. Lombard's insistence that no one can imagine the privilege of living with a masterpiece. After sharing the painting's colorful (but unconvincing) history, Mrs. Fontage explains to the narrator, as he studies the canvas, that the work's only drawback is its lack of a signature.[23] Although Mrs. Fontage asserts that "[n]o one . . . can know its value quite as well as I, who live with it," she nevertheless feels compelled to turn to the narrator to learn "what estimate would be put on it from the purely commercial point of view" (291). By asserting that "no one" can know its value as well as she, Mrs. Fontage suggests an intimacy with the painting that lends the artwork more than monetary value and she also credits herself with the kind of "discrimination" that Charity Royall had scolded herself for lacking. She puts an interesting spin on the (sexist) assertion made by the painter of "The Moving Finger" that "you don't know how much of a woman belongs to you after

you've painted her" (176). Mrs. Fontage is interested in using her owner-
ship of, and intimacy with, the painting to a different end. Mrs. Fon-
tage's stewardship allows her to parlay the painting into a passport out
of destitution.

The supposed Rembrandt invites a number of questions. Conspicu-
ously absent are the details of the painting's subject and genre. The clos-
est we get to a description is "a dusky canvas near the window" (289).
What W. J. T. Mitchell says of Wallace Stevens's poem "Anecdote of the
Jar," with its "apparent lack of visual representation," can also be said of
Wharton's "The Rembrandt," as it similarly "offer[s] us a blank space
where we might expect a picture, a piece of refuse or litter where we look
for art" (*Picture Theory* 166). And Wharton's act of withholding, like
Stevens's, tests the boundaries of the genre.

Mitchell also helps us understand what Wharton is up to when she
notes the narrator's displeasure with the painting. It is, to his mind, a
"lamentable canvas," "a damned bad picture" (291, 298). As Mitchell
notes, "If a woman is 'pretty as a picture,' (namely silent and available to
the gaze), it is not surprising that pictures will be treated as feminine
objects in their own right and that violations of the stereotype (ugliness,
loquaciousness) will be perceived as troublesome" (163). The supposed
Rembrandt, then, has fallen short of the aesthetic standards to which we
hold both pictures and women.

Not only is the "Rembrandt" neglecting its office insofar as it fails to
represent beauty, but it also is undermined by its lack of legitimacy,
for it bears no signature. At first glance, the narrator detects (what he
believes to be) the painting's fraudulence. So the "Rembrandt" of the
story's title is not—at least in the narrator's opinion—a Rembrandt at
all. The painting is believed—supposedly by Mrs. Fontage and (so she
says) by "[a]ll the connoisseurs who have seen it" (290) and, possibly, by
those who sold it to her—to be a Rembrandt.

Wharton subtly suggests there is more lurking beneath the surface of
Mrs. Fontage's trusting facade. She tells the narrator that "it might be
interesting to hear— . . . as a mere matter of curiosity—what estimate
would be put on it from the purely commercial point of view—if such a
term may be used in speaking of a work of art" (291). With this remark,
Mrs. Fontage suggests that she is interested in appraisal for reasons that
extend beyond curiosity; she seems more invested in the capital it might

yield, and with good reason, as she is all but broke. When the narrator, in a moment of weakness, offers Mrs. Fontage a thousand dollars for the picture—despite his assumption that it is not worth a penny—she refuses, insisting she "could never . . . under any circumstances whatever, consider, for a moment even, the possibility of parting with the picture at such a price" (292). But three weeks later, she follows up on his offer, suggesting that she intended to accept all the while: Mrs. Fontage ultimately responds with "the very flower of tact" (296), "disguising herself to the last," with "splendid effrontery" (297). Throughout the narrative, Mrs. Fontage gives herself away as cool, calculating, and deliberate.[24]

Wharton's curator ultimately purchases the painting for a thousand dollars from Mrs. Fontage as an act of charity; he wants to rescue her from a life of poverty and he hesitates to destroy the woman's "faith in the Rembrandt . . . the whole fabric of [her] past" and what he patronizingly calls "that lifelong habit of acquiescence in untested formulas that makes the best part of the average feminine strength" (291). And yet, her formulas seem to be more tested than he had imagined. The painting is relegated to the basement of the Metropolitan Museum, but with delicious irony, a colleague from the acquisitions committee hands the picture over to him in recognition of his recent procurement of a Reynolds painting. The "Rembrandt," of course, would be the last thing he would want.

Like the other narratives addressed in this chapter, this story interrogates the definition of art. Here, art has a strictly commercial value. We never find out what the supposed Rembrandt depicts, nor do we hear about the subject of the Reynolds painting that the narrator acquires for the Metropolitan.[25] Instead, we know that the (presumably fake) Rembrandt was acquired for a thousand dollars of the museum's funds and that the Reynolds was purchased at a steal (299). The narrator's colleague informs him at the end: "[A]s a slight recognition of your services in securing the Bartley Reynolds at a very much lower figure than we were prepared to pay, we beg you—the committee begs you—to accept the gift of Mrs. Fontage's Rembrandt" (300). The joke, of course, is on him.

Wharton's omissions, and the story's overall inconclusiveness, urge us to probe. Who is duping whom? Because we do not have access to Mrs. Fontage's thoughts, we cannot get the full picture, so to speak. Per-

haps she knows it is not a Rembrandt or, conversely, perhaps it is the real thing. Wharton suggests that the value of art comes to the female world mediated by male connoisseurs. Be that as it may, in the end this female custodian manipulates the system to her advantage. While men are the curators and museum directors, women underhandedly manipulate the system, dupe male authorities, and subtly run the show by determining the market value of a supposed Rembrandt.

By documenting women's lack of authority in relation to such formidable institutions as the Metropolitan Museum of Art, Wharton's story anticipates the real-life example of Giselda Richter, who would join the staff of the Metropolitan in 1905 and slowly work her way up the professional ladder. In her earliest position, Richter was not involved in purchasing objects but instead cared for them on their arrival, subsequently identifying and publishing them. Five years later she advanced to assistant curator, becoming associate curator in 1922 and full curator in 1925: the first woman to reach such a prominent position in a major American art museum (Sherman 284).

The Missing Lynke

Like each narrative discussed here, Wharton's late ghost story "Mr. Jones" (1928) features an unmarried woman tied to a "prison"-like house who ultimately finds her authority contested (175). As in "The House of the Dead Hand," here the hand of a dead patriarch metaphorically—and in this case literally—has the power to silence and strangle women. But Wharton's "Mr. Jones" departs in important ways from the earlier narratives addressed above. While in those works a male intruder brings his worldly experience to the woman's private sphere—Wyant, Corby, Harney, and the curator—here the heroine intrudes, as Lady Jane is a well-traveled visitor who feels "as intrusive as a tripper" (172).[26] In this story, a liberated, worldly woman enters the home of her ancestors—indeed inherits it, with all its secrets—to find that "her forebears were waiting for her" (171). She is an outsider looking in, rather than an insider cloistered in the dark, dusty world of her forebears.

While Wharton does not make it clear that her heroine, the spunky, spirited Lady Jane Lynke, can overcome the titular ghost and guardian of the old master's orders, she offers hope for the possibility. Wharton

thus turns a new spin on the theme of women's relationship to an old, "vault"-like house and the crippling tradition it represents (170). But if this woman is to overcome a legacy of oppression—the story ends before we know for sure—it will not be without struggle. The last thing the story shows us is a dead woman—a custodian strangled by a ghost for disobeying the orders of the original master of the house. And it is all the more significant a shift when we note that the protagonist in this tale is not the custodian who blindly follows the patriarch's orders. Indeed, the protagonist becomes a new sort of custodian, a woman in charge of her own house. Mrs. Clemm, a more sinister version of the Wharton custodian, is strangled for failing to prevent Lady Jane from purloining the lost letters of the late mistress of the house. So Mrs. Clemm is killed for failing to ensure the silence of the dead mistress. (Lady Jane, as a purloiner of these missives, will help unleash the silenced voice of the woman walled up in the house.) Wharton does not seem to promote the ending as entirely victorious or subversive: she compels us to note the ambiguities and avoid oversimplification. What seems key is that the elimination of the compliant female custodian—Mrs. Clemm— constitutes a kind of revisionary act on Wharton's part.

Houses in Wharton's fiction resonate powerfully with meaning, and this tale is no exception.[27] Here, the house named Bells serves as a metaphor for a structure or institution that is hard for women to enter: "Bells had always been known as harder to get into than any other house thereabouts" (174). Wharton suggests that Bells stands for the sort of establishment where women are not immediately welcome: a publishing house or the Palace of Art that assigned women secondary roles. The house to which Lady Jane ultimately gains access is also a place marked by deadness—"more dead than living" (176). Bells is shrouded in secrets: "There are a great many things in old houses that nobody knows about" (191), says Mrs. Clemm, the old custodian and housekeeper, to the younger Lady Jane, and as such it is linked to the "evil mystery" of "The House of the Dead Hand."

This supernatural tale tells the story of the acquisition of a stately English manor by Lady Jane, a British travel writer who has led "an active, independent and decided life," like Edith Wharton, who described herself in just these terms, and has, again like Wharton, written a few unsentimental travel narratives (171).[28] The manor named "Bells" in-

vokes Poe in name as well as in spirit.[29] Upon first seeing the house, the smitten Lady Jane claims she "'shall never leave it!' . . . her heart swelling as if she had taken the vow to a lover" (171). That Lady Jane is committed to a house by a vow recalls the examples of Paulina and Sybilla, women who, for various reasons, renounce life with a man to remain betrothed to a house and its treasures. But Jane's case is different in that she attempts to overtake a house rather than be sentenced to anguished imprisonment therein. She is both conquering and making a choice. The house in fact seems to replace the need for a lover, and she wears "a smile of ownership," finding that "the old walls . . . seemed to smile back, the windows . . . now looked at her with friendly eyes" (179). (The "friendly eyes" stand in sharp contrast to the sinister "eye-like windows" of Poe's "Fall of the House of Usher" [245].) As it was for Edith Wharton, here reclaiming a house seems to be analogous to reclaiming the self. (In her early adult years, Wharton "dreamed of having her own home, as though by taking possession of a house she could capture her own elusive self. The house as metaphor for woman became a dominant literary trope of her writing" [Benstock, *No Gifts* 59].) Excited by the promise of Bells, Lady Jane sounds more like Harney than Charity when she notes upon arrival that she is "interested in," and evidently not threatened by, "old houses" (173).

Notwithstanding the promise and possibility entailed in the house, Lady Jane quickly discerns that something is dangerously awry at Bells. The house's female custodians, Mrs. Clemm and her niece Georgiana, adhere to orders made by a conspicuously absent guardian named Mr. Jones, a ghost who carries out the wishes of one of the house's original patriarchs. As accomplices of Mr. Jones, these women complicitously "transmit" the "oracles" of the patriarch (180).

In the naming of the younger custodian, Wharton may have been invoking the flesh-and-blood example of Georgiana Burne-Jones, loyal wife to a "Mr. Jones," the second-generation Pre-Raphaelite painter Sir Edward Burne-Jones. Georgiana Burne-Jones transmitted the oracles of her artist-husband when she wrote *Memorials of Edward Burne-Jones*. "Georgie" (as she was known) was a friend to Lizzie Siddall, Jane Morris, and George Eliot, all of whose stories seem to have deeply concerned Wharton, and the friendship between Wharton's confidante, Sally Norton, and Mr. Burne-Jones (they met and subsequently exchanged several

letters) would have given her insight into the inner circle of the latter-day Pre-Raphaelites (Daly 304). Georgiana Burne-Jones poignantly wrote in *Memorials:* "It is pathetic to think how we women longed to keep pace with the men, and how gladly they kept us by them until their pace quickened and we had to fall behind" (Daly 413). The Pre-Raphaelite custodian, then, made compromises (*had to* fall behind) that were personal (given her husband's dalliances with younger women) as well as professional, and those compromises are mirrored in Wharton's art.

Lady Jane and her novelist friend Edward Stramer uncover the history of strangulation and suffocation of women that is associated with Bells. They are enticed by the mystery surrounding the former mistress of the house, who stares out from her early-nineteenth-century portrait "dumbly," "inexpressively" in her "frozen beauty" and is known to them by the marker on the crypt she shares with her husband ("Also His Wife," as in "his wife is *also* buried here"; she is an afterthought). The wife is eventually identified as the Viscountess Juliana. Lady Jane and Stramer find the missing pieces of Juliana's story in a packet of letters she wrote to her husband—letters that had been purloined and stashed away in Mr. Jones's desk. The missives reveal that Juliana had been deaf and dumb and, after having been married for her money, was shut up in her husband's house under the close watch of Mr. Jones, a kind of patriarch-by-proxy.[30] The letters bemoan her deplorable captivity in her husband's prison: "[T]o sit in this great house alone, day after day, month after month . . . , is a fate more cruel than I deserve and more painful than I can bear" (193). Lady Jane and Stramer discern that Juliana had been walled inside the parlor, à la Edgar Allan Poe, evidenced by "a rectangle of roughly plastered wall, where an opening had visibly been bricked up" (191). (Wharton here invokes Poe's "The Black Cat," in which the male narrator painstakingly describes concealing the body of his murdered wife within a brick wall.) Unfortunately, unraveling Juliana's story—and thus exposing her suffocation—precipitates the strangulation of another woman. Mrs. Clemm—whose name links her to Poe—is strangled by Mr. Jones's ghost for failing to prevent Lady Jane from tampering with "his papers," which were in fact Juliana's.[31]

Wharton encourages us to read Juliana's story as suggestive of a fate Lady Jane may escape. The fact that Juliana and Jane share a first initial points to their common lineage. Juliana is a kind of early Victorian pre-

cursor of Lady Jane. But the differences are key: Juliana lived a century ago; Jane lives in the 1920s, a time when British women had recently won the vote. Juliana had married; Jane has not. Juliana was mute and deaf; Jane is all voice, signaled by her profession as a writer. Juliana was sequestered for the duration of her adult life; as a globetrotter, Jane has seen and experienced the world. Juliana, compelled by situation and circumstance, was reliant upon her husband for economic support; Jane is financially independent. With the example of Juliana, Wharton suggests the fate Lady Jane might have known in an earlier day. Like Edith Wharton—so drawn to the design of houses and gardens—Lady Jane will transform a gloomy manor into her own rightful home.

"Mr. Jones," then, marks a notable shift in Wharton's treatment of the themes this chapter has discussed. Lady Jane Lynke is not buried alive like the New England nun of the Anson house, nor is she passive and paralyzed like the custodian of the house of Lombard. Her picture is very unlike the portrait of Juliana, whose face projects a look of "anguished participation in the scene" (192). Lady Jane will have no part in the sorry scenes sketched for Juliana, Mrs. Clemm, or Sybilla and her sisters. Jane is an independent travel writer and garden lover, like Wharton, who acquires a dark house and has a hand in transforming it. And, also like Wharton, Jane has forged entry into a territory that, like the Land of Letters, was "harder to get into" (174). There is the suggestion at the story's end that Lady Jane Lynke, through her ventilation and restoration of an old, sealed-up manor, will uncover and tell, as Wharton did, the stories of silenced women who, like the nineteenth-century Juliana, were locked up in patriarchal palaces and sentenced to voicelessness. Jane will become a happy custodian of the house, not just of the art and letters preserved therein. Her domestic stewardship is far more constructive than that of Paulina, Sybilla, or Charity. And, significantly, the previous keeper of Bells, the blindly obedient Mrs. Clemm—representing an older generation of female custodians—has been removed from office: Jane will take her place.[32] As Wharton tells us, Lady Jane recognizes in Bells the litany of "the unchronicled lives of the great-aunts and great-grandmothers buried there so completely that they must hardly have known when they passed from their beds to their graves" (175). Men here, as in the Wharton narratives discussed above, are linked to a dead past; they function as menacing ghosts, but there is

hope that the phantoms might be banished. There is also the suggestion in this 1928 tale that an empowered, Europeanized "New Woman" can expose crimes against women and tell their stories. Lady Jane is the "link" to those women artists who are able to claim their place and build up, as Wharton did, a home where their gardens, and their art, might flourish.

Ventilating the Palace of Art

Art for Art's Sake! Hail, truest Lord of Hell!
Hail Genius, Master of the Moral Will!
"The filthiest of paintings painted well
Is mightier than the purest painted ill!"
Yes, mightier than the purest painted well
So prone are we toward the broad way to Hell.

—Attributed to Alfred, Lord Tennyson

The fiction discussed in this chapter lays bare Wharton's interest not only in the function of the art museum and the spaces it failed to provide women but also in the changing definitions of art. Wharton evidently had some ambivalence about art as a cultural value and the meaning her world attached to it. The narratives addressed above pose many questions regarding the function of art: What does art signify? Does it always carry the same meaning? Who is entitled to serve as an authority on art? And who has the right to assess its value? In "The House of the Dead Hand," Dr. Lombard compares a supposed Leonardo painting to a "sacrament," suggesting art has become a religion that Wharton represents as a perversion of Ruskin's theories. Wharton questions the turn-of-the-century doctrine of "art for art's sake" touted by the aestheticism bemoaned in the above quoted verse. In "The Rembrandt," art has become a commodity that can be liquidated for money, and a painting can be a "Rembrandt" if someone says so. With "The Angel at the Grave," art reveals itself to be old, suffocating, and dead, and it must be transformed into science in order to attract a modern audience. In *Summer*, art and literature represent a world that is off-limits and incomprehensible to the underclass, underprivileged Wharton heroine. In "Mr. Jones," a female custodian conspires with patriarchy to prevent a be-

trayed woman's voice from being heard. It is not until the custodian her-
self is silenced that the voice of a mute woman can be released.

Wharton clearly was responding to the changing definitions of art at
the end of the nineteenth century, given the new appeal of art for art's
sake. Earlier in the century, Ruskin, art oracle for England from the
1840s until the 1860s and ardent champion of the Pre-Raphaelites, had
argued for the sanctification of art (Gillett 197). By the close of the cen-
tury, "[a]estheticism rejected both the mimetic and the didactic roles of
art and placed supreme emphasis on the intrinsic worth of formal val-
ues such as colour, line, tone, and pattern. It thus discarded the genre,
humour, narrative, and anecdote of the early Victorians, and also ran
counter to Ruskin's interpretation of art as an imitator of nature and
a means to convey moral and spiritual truths" (Treuherz 131). It was
the poet Algernon Charles Swinburne who, in 1867, had introduced the
term "art for art's sake" in his essay on William Blake. Pater made the
phrase famous in 1873 when he used it in his volume titled *The Renais-
sance,* drawing criticism for his apparent promotion of sensuality over
morality (Prettejohn, *After the Pre-Raphaelites* 3). So the end of the cen-
tury found Swinburne emphasizing, in his approval of a painting by
Albert Moore, that "[i]ts meaning is beauty; and its reason for being is
to be" (Treuherz 131). Art was becoming something of a cult that substi-
tuted for religion. Wharton perhaps best represents this transformation
in "The House of the Dead Hand."

When we juxtapose Sybilla Lombard's reluctant female custodian
and the able example of Lady Jane Lynke, we recognize some progress,
but there is ambivalence, as there ever is in Wharton. Wharton's 1928
story raises the question of why Lady Jane, a strong, empowered writer-
heroine—one of those rare Wharton women who secure for themselves
the role of happy, satisfied custodians of their houses and of their *selves*
—is not an American. Some of us have wondered why Wharton has not
created an American woman character as strong or formidable as Edith
Wharton herself—one who is as mobile, well traveled, and well read.
Why are her women so anguishedly imprisoned, in a way that is diamet-
rically opposed to Wharton's own example? In this late ghost story, as
in the earlier narratives discussed in this chapter, Wharton suggests a
rather hopeless prospect for the American woman artist. Reading these
stories in the context of the extraordinary leaps and bounds made by

women in the fields of museum development and art history enables us to see Wharton questioning the legitimacy of the term "Progressive Era." This so-called progress is called into question in the example of Paulina Anson who, like so many Wharton women, performs the rituals of nurturing, caretaking, keeping, and guarding—activities that have been socially inscribed as "feminine" and therefore secondary, incidental, and marginal, unworthy of equal credit, pay, or validation. And yet Wharton manages to find possibility for an American heroine who is arguably the most fulfilled of all Wharton women. She will unveil this promise in the figure of Ellen Olenska of *The Age of Innocence,* the novel that is the central focus of our fifth and final chapter. Olenska's hand, neither dead nor drooping, neither helplessly hanging nor crying out in "imprisoned anguish," is, on the contrary, decidedly "firm and free" (96).

5

"We'll look, not at visions, but at realities"

Women, Art, and Representation in *The Age of Innocence*

It's odd . . . that she should have kept such an ugly name as Ellen. I should have changed it to Elaine.

—Janey Archer
Edith Wharton, *The Age of Innocence*

[H]e had built up within himself a kind of sanctuary in which she throned among his secret thoughts and longings. Little by little it became the scene of his real life, of his only rational activities; thither he brought the books he read, the ideas and feelings which nourished him, his judgments and his visions.

—Edith Wharton, *The Age of Innocence*

Nineteenth-century culture was fascinated by the story of Elaine, the "Lily Maid of Astolat" from Arthurian legend. In Tennyson's "Elaine" (1859)—from the influential *Idylls of the King,* which Wharton and her protagonist, Newland Archer, knew well—Elaine loves Lancelot in vain and ultimately dies of grief. Elaine's narrative, like Tennyson's "The Lady of Shalott," projects the image of a beautiful dead woman drifting down the river to Camelot. Visual images of floating female corpses (the Lady of Shalott, Ophelia) made regular appearances at the Royal Academy of Art in the second half of the nineteenth century.[1] Homer Watson's *The Death of Elaine* (1877), which displays the lady's body on her bier for our visual consumption, is a case in point (figure 16). Elaine is invoked in *The Age of Innocence* (1920) in more than one way. Early in the novel, Newland's sister Janey cattily remarks that Ellen Olenska—the beautiful dark sheep of old New York—should have called herself "Elaine" (39). Further, there exists in New York a consensus that Ellen "ought to be

painted" (58). (In fact, her likeness was repeatedly captured by the best European portraitists.) Central here is the fact that Wharton does not have the heroine of her 1920 novel answer to the name Elaine, nor does she stretch the woman's body out on a bier, floating down to her metaphorical Camelot, subject to our gazes à la the corpse of Tennyson's "Lily Maid" or, for that matter, Wharton's Lily Bart. In fact, Wharton's later novel closes without affording the reader's eyes—or those of Newland Archer, through whose gaze we experience the narrative—the chance to dwell upon and in effect visually consume the body of its beautiful heroine. All we are left with is a memory of Ellen Olenska and the knowledge that she, like her creator, has transplanted herself to Paris and enjoyed there a rich, full, independent life.

Wharton offers her heroine as a kind of remedy to the problem of women, art, and representation in turn-of-the-century culture. True, Wharton's Ellen, like Tennyson's Elaine, has known love unrequited, but she neither withers nor dies, and her body does not become her art. She chooses a road not taken by her literary sisters—Lily Bart, Undine Spragg, and the like.[2] This woman is both a survivor and an artist. She makes art out of her *life,* not her body. Ellen is a woman who, like Edith Wharton, lives her final days enjoying a rich, artistic life in France. She is marked by what Wharton recognizes as a singular virtue of French culture—what she elsewhere admiringly calls "the seeing eye."[3] This *seeing eye* is for Wharton a kind of artistic sensibility, an intuitive ability to discern what is most artistic and least trendy, and it also endows an individual with the gift of recognizing, as Olenska does, the difference between "visions" and reality (*French Ways and Their Meaning*). Newland Archer's mother astutely observes that Ellen "looks at things quite differently" (319). But Ellen is brought to us by way of Archer, Wharton's untrustworthy reader, and by using this male reflector as a device, Wharton carries out her critique of a misguided gaze—an *unseeing eye*—that reads women as representations rather than as representers.

This fifth and final chapter serves as a culmination. Its approach departs from that of the other chapters, as it begins by focusing more on the male protagonist of *The Age of Innocence* (Newland Archer) than on the two women central to his world (Ellen Olenska, May Welland). Wharton offers the novel as a cautionary tale about the dangers of mis-

16. Homer Watson, *The Death of Elaine, 1877 (oil on canvas).* © Art Gallery of Ontario, Toronto, Canada, Gift of Mrs Mary King, Toledo, Ohio, 1937/Bridgeman Art Library.

guided reading and the detrimental ways in which women have been represented as works of art that are often overtly sexualized. Newland Archer is a spectator and a would-be connoisseur of (woman-as-) art. This chapter seeks not only to show how Archer's misreadings of Ellen and May are detrimental to the women themselves but also to demonstrate how they contribute to his own misfortune. Appearing as it does at the close of the book, the chapter connects and reemphasizes the themes that have been central throughout: the unseeing eye, with which so many of Wharton's men are marked; Wharton's intertextual project with nineteenth-century visual culture, especially the work of Rossetti and the Pre-Raphaelites; and Wharton's investment in locating a space for the American woman artist. Indeed, this novel affords us the occasion to revisit with Wharton some of the most subtly self-empowering ways in which her male protagonists misread creative women, even purposefully misconstruing them to the point that anything is preferable to having to share (creative) power with them.

Reading *The Age of Innocence,* most critics forgive Newland Archer his predilection for abstract, "enthroned" beauty and ignore Wharton's critique of him as a voracious but inept reader. R. W. B. Lewis, lamenting Newland's inability to act on his passion for Ellen Olenska, refers to him as "poor Archer" (introduction to *The Age of Innocence* xv). Cynthia Griffin Wolff, reading the book as a bildungsroman, claims that Archer learns the same lessons as Goethe's Wilhelm Meister: "acceptance of 'reality' and dedication to generativity." According to Wolff, Archer has been a "victim of [Society's] well-mannered brutalities" and is by the close of the novel "a man at peace with himself" (*"The Age of Innocence"* 644, 651, 655). Jeanne Boydston sees Archer emerging as a model citizen who after his wife's death ironically "becomes an emblem of motherhood . . . , a clearly sympathetic and victorious character" (35). In fact, Wharton's hero has been misread.[4] Wharton's "Archer" is much like the "wooden Cupid" atop the Newport summerhouse "who had lost his bow and arrow but continued to take ineffectual aim" (225). He is indeed a "poor archer" in a sense not consciously implied by Lewis's remark, and his reading disability contributes to, and indeed perpetuates, the cultural tendency to read women as representations and not as representers.

That Wharton wants us to view Archer in this particular way is suggested by the attention she draws to his reading habits. We learn a lot about a person by examining his or her bookshelves. Unshelving Archer's library facilitates a more accurate reading than the aforementioned critics offer. Several readers have commented on Archer's passion for anthropological books and scientific studies.[5] The novel itself has been likened to an "autopsy" of an age past (Ammons, "Cool Diana and the Blood-Red Muse" 211). What we have not seen is an in-depth focus on the works of "high literature" that Newland Archer devours. While many authors make cameo appearances in his library, Wharton's protagonist is especially taken with Dante Gabriel Rossetti, whose work, as we have seen, resonates throughout Wharton's fiction. In fact, Archer's life is informed by Rossetti's art in theory and in practice: he is profoundly influenced by his visual and verbal representations of women. Rossetti's sonnet sequence, *The House of Life* (1870), in the tradition of so many of the books Archer reads, offers him a fantasy world—a glimpse at "the beautiful things that could not possibly happen in real

life"; such texts in turn inform Archer's reading of the world around him (146).

But Archer is not a close reader, and Wharton's women continually expose him as such. Ellen Olenska and May Welland succeed in collapsing his readings of them and, what is more, they read him more accurately than he reads himself. Archer reads Ellen at times as a femme fatale, ultimately as "some imaginary beloved in a book or a picture" (347). He interprets May as an "artless," "blameless" bride incapable of surprising him (5, 37). In all cases, he reads these women as types; further, the attention he pays to their "pale" countenances underscores the lifelessness he attributes to them. By contrast, the books Ellen Olenska reads help her to analyze Newland Archer. Ellen's acquaintance with works of French naturalism—novels of disenchantment that offer a "slice of life"—helps her detect the signs of Archer's reading disability. She recognizes his status as a visionary and romantic. Wharton, then, offers Ellen as a kind of guide to help us understand the difference between Archer's "visions" and his realities.

Having consistently misread these women and misconstrued himself, Archer is consequently the "man to whom nothing was ever to happen" (227). Having read Ellen as a vision—an ideal who reigns high in his private, carefully constructed "sanctuary"—it follows that he never can be united with her, for such an object is necessarily inaccessible. Had he not misread both Ellen and May—had he looked, as Olenska asks, "not at visions, but at realities" (289)—he would perhaps not know the "vain regret" to which Rossetti gives voice in his sonnet sequence ("The One Hope," in Lang 129).

> [H]e had come up to his library and shut himself in.
> —Edith Wharton, *The Age of Innocence*

Newland Archer, self-professed dilettante of old New York, prides himself on being more well versed in the literary arts than the other members of his set: "In matters intellectual and artistic Newland Archer felt himself distinctly the superior of these chosen specimens of old New York gentility" (8). As a newly married man, Archer observes the ritual of "arranging his new library, which . . . had been carried out as he had dreamed" (206). It is the one room he has set up himself and he

can often be found there with his head "buried . . . in his book" (296). In a telling exchange with her mother, May explains Archer's habits by remarking that "when there's nothing particular to do he reads a book" (222). For Archer, his library always has been his refuge.

Wharton urges us to pay attention to the books he keeps in this library. Archer, like Ellen Olenska, reads the work of French authors—even writers who are linked with the naturalist school. But he does not read their so-called naturalist works, opting instead for their more romantic stories. For instance, he stocks his library with Alphonse Daudet, who was for a time a leading naturalist; but Archer reads "Daudet's brilliant tales" starring Tartarin, a quixotic character known for deluding himself with his own fictions (138). The similar vein of self-deception running through Archer's character explains his attraction to the book. Archer also reads Balzac who, like Daudet, was sometimes classed as a naturalist; but Archer chooses the author's fanciful tales ("a volume of the *Contes Drôlatiques*") crafted in the tradition of Rabelais (84). Additionally, Archer is taken with the works of French romantic writer Mérimée: one particular text of Mérimée's is for Archer among "his inseparables" (102). In similar fashion, Archer cannot "separate" himself from his romantic pursuit of the ideal.

Archer's fascination with the ideal explains his attachment to the art of the Italian Renaissance. He is drawn to the glorification of man that was basic to the Renaissance—not the imperfect, but instead a struggle for perfection. Archer reads all the writers of his day who treat the Renaissance; he was, for instance, raised on Ruskin, whose views Wharton herself had challenged in *The Decoration of Houses*. Ruskin writes in *Stones of Venice* that "the most beautiful things in the world are the most useless; peacocks and lilies for instance" (58). Archer is similarly enamored with beauty for its own sake. Archer likewise enjoys Vernon Lee ("Euphorion")[6] and John Addington Symonds, whose major work is *Renaissance in Italy*. A considerable fan of Walter Pater, Archer reads his "wonderful new volume called *The Renaissance*," (69) which voices the idea that life is modeled on the experience of art, "each mind keeping as a solitary prisoner its own dream of a world" (Buckler 551).[7] Much like Archer, Pater and the members of the aesthetic movement were fascinated by the ideal.

Wharton's Archer has a fondness for poetry that reaches for the ideal

and conceptualizes women as poetry. For both Dante and Petrarch—whose work Archer knows well—the woman is either the guiding muse or the poem itself; she is never the artist.[8] Dante's Beatrice is the muse while Petrarch's Laura is poetry. Archer keeps himself abreast of the latest developments in this genre. He owns a copy, for instance, of "Swinburne's *Chastelard*—just out," which is fitting, given the hero's all-consuming, unrequited passion for a dark, mysterious heroine, which Archer seems to script into his own life (84).[9] Archer's reading of Browning and Tennyson is also appropriate, given Browning's fascination with Renaissance Italy and Tennyson's penchant for myth and medievalism: both poets through their art retreated to an age that lent to their poetry an ideal subject matter.

But no poetry book mesmerizes Archer quite like Rossetti's *The House of Life*. In an especially revealing scene, Archer, alone in his dimly lit library, unpacks an order of books from London: a work by Herbert Spencer, the collection of Daudet's tales, and a copy of Eliot's *Middlemarch*.[10] Ever the bibliophile, Archer looks forward to "this feast"; curiously, none of these books is able to hold his attention (138). He reaches for "a small volume of verse which he had ordered because the name had attracted him: *The House of Life*" (138). Of the texts we find him reading, it is the one he most enjoys, providing him with "an atmosphere unlike any he had ever breathed in books" (138).

In Rossetti's sonnet sequence, the speaker mythologizes his beloved: she is throned high and worshiped as an idol. The image of the beloved is inspired by Rossetti's so-called stunner Jane Morris, an unattainable beauty married to sometime friend and Pre-Raphaelite peer William Morris. The young Jane was thus described by Rossetti's brother William, who became something of a chronicler for the Pre-Raphaelites: "Her face was at once tragic, mystic, passionate, calm, beautiful and gracious—a face for a sculptor and a face for a painter. . . . Her complexion was dark and pale, her eyes a deep penetrating grey, her massive wealth of hair gorgeously rippled, and tending to black, yet not without some deep-sunken glow" (Nicoll 105). Rossetti, like Archer, was bound by marriage to a fair-haired woman for whom he felt considerably less passion. As one scholar has put it, in marrying Elizabeth Siddall, Rossetti "married a woman he did not love, and loved a woman he could not marry" (Lang xvi). The semblance to Archer's situation is noteworthy.

In fact, the analogy further points to the way Archer models his own life on the experience of poetry, emulating Rossetti in theory and practice.

Wharton's Archer aligns Ellen Olenska with Rossetti's representations of the melancholy, pale, dark-haired, Bohemian-dressed Jane Morris. Pre-Raphaelite poet and painter Rossetti pictures his beloved Jane as ethereal and dreamy-eyed. Rossetti replicated the face of his unattainable Jane—dark-haired, pale, and unhappily married, like Archer's Olenska—throughout his art.[11] Rossetti described *The House of Life* as "life representative" concerned with "ideal art and beauty," and he seems to have rejected reality in the name of his innermost fantasies (Nicoll 23). Archer's predilection for identifying Ellen as a Jane Morris stand-in is evident in the following image of Ellen, seen through Archer's eyes: "She was excessively pale, and her pallor made her dark hair seem denser and heavier than ever. . . . she had wound several rows of amber beads around her neck" (333). Wharton's description might as easily have been extracted from the pages of Rossetti's journals, and we need only look to his painting of Jane Morris as Persephone for a visual counterpart (see figure 12 in chapter 3).[12] Archer finds Rossetti's sonnet sequence "so warm, so rich, and yet so ineffably tender, that it gave a new and haunting beauty to the most elementary of human passions. All through the night he pursued through those enchanted pages the vision of a woman who had the face of Ellen Olenska" (138).[13] Even if Wharton had not so clearly enunciated the correlation between Archer's Olenska and Rossetti's beloved, we would detect from her description that Archer immediately makes the link. The adjective "so rich" recalls the yellow roses he has had anonymously delivered to Ellen (79, 117). The "haunting beauty" that Rossetti's verse emits speaks to the phantomlike role to which he assigns Ellen Olenska. (She becomes to Archer "the most plaintive and poignant of a line of ghosts" and "some one long since dead" [208, 215].) Further, it is a "vision of a woman" (138) that Archer chases; because he reads Ellen as this "vision," she therefore can never be for him a reality.

Ah, I don't understand you!

—Newland to Ellen

Wharton lets us watch Archer imaging Olenska as a spectacle that titillates and shocks. When we first see Ellen, our image—as ever—is

filtered through Archer's eyes; we see what "Newland Archer, following
[the lecherous Lawrence] Lefferts's glance, saw with surprise" (9). By re-
cording this chain of glances, Wharton accentuates the gap between
Olenska as woman and Olenska as imaged woman. Here, Ellen is ren-
dered a work of art with high shock appeal: she wears "a narrow band
of diamonds [in her hair]. The suggestion of this headdress, which gave
her what was then called a 'Josephine look,' was carried out in the cut
of the dark blue velvet gown rather *theatrically* caught up under her
bosom by a girdle with a large old-fashioned clasp" (9; emphasis added).
Archer's gaze records Olenska as seemingly "*quite unconscious* of the
attention" her "unusual dress" was attracting, exposing "a little more
shoulder and bosom than New York was accustomed to seeing" (9; 14,
emphasis added). Her artistic sensibilities are undermined as she herself
is translated as "theatrical," "unusual," and "unconscious."

By making Archer contradict this earlier reading of Ellen, Wharton
calls attention to the unreliability of his gaze; his glance fails to pene-
trate the surface. Archer notices at a van der Luyden dinner that there is
little that is "theatrical" or "unconscious" about Ellen's eyes: "[T]here
was about her the mysterious authority of beauty, a sureness in the car-
riage of the head, the movement of the eyes, which, *without being in
the least theatrical,* struck his as highly trained and full of a *conscious*
power" (60–61; emphasis added). Wharton here uses the same terms to
bring to light Archer's inability to pin down a single, valid reading of
Olenska.

Wharton constantly directs our gaze to Archer's propensity for objec-
tifying and framing Ellen. Having heard that Olenska was once so at-
tractive that "people said . . . she 'ought to be painted,'" Archer seems to
have answered this call; he is happy to offer his renderings of Ellen (58).
In a wonderfully rich scene set in Olenska's drawing room, Archer ab-
sorbs the sight of Ellen decked out in "a long robe of red velvet bordered
about the chin and down the front with glossy black fur" (104). Archer's
fancy immediately carries him back to his most recent visit to Paris; he
recalls "a portrait by the new painter, Carolus-Duran, whose pictures
were the sensation of the Salon, in which the lady wore one of these *bold*
sheath-like robes with her chin nestling in fur. There was something
perverse and *provocative* in the notion of fur worn in the evening in a
heated drawing-room, and in the combination of a muffled throat and

bare arms; but the effect was undeniably pleasing" (104–5; emphasis added). Archer refers to *La dame au gant* (Lady with the Glove, 1869) by nineteenth-century French portraitist Emile-Auguste Carolus-Duran (figure 17).[14] In this painting, a woman dressed in black gazes at the viewer; it is fitting that Archer links this image to Olenska, given the attention he pays to Ellen's "conspicuous eyes" and her penchant for violating codes of etiquette (59, 62, 63).

By intertextually introducing this French painting into her own canvas, Wharton further highlights Archer's sexualizing of Olenska. Carolus-Duran's lady playfully tugs at her gloved hand, and the gesture acts as a tease for the implied male spectator: she seems to dare him to retrieve her fallen glove. (In nineteenth-century visual culture, the discarded glove often signified a woman's cast-off virtue; consider, for example, William Holman Hunt's *The Awakening Conscience,* which records a woman's epiphany of her status as fallen.) The lady in the painting, then, is undressing in a way that seduces the male viewer. To be sure, there is agency in the power to titillate and, in the form of a portrait, this lady is suspended in the act of undressing—fixed eternally in that pose, always teasing, never quite delivering. Archer seems determined to align Ellen with the woman in the painting because he wants her to be most fully what she always has represented for him: the seducer who will never quite finish disrobing and thus revealing herself to him—the object of desire who never actually becomes his lover, who is always kept eternally in a state of suspension.

Wharton also uses Carolus-Duran's *La dame au gant* to play with the iconic significance of hands. Specifically, Archer's constant fetishizing of Ellen's hands further accounts for his coupling her with the painting. Throughout the novel, Wharton makes it clear that Archer wants to suppress any agency invested in Ellen's hands. Olenska's hand is to him "a relic" (285). As Valerie Steele has noted, "Fetishism is a perversion or variation of the sexual instinct, involving a desire for only a part of the body or even an article of clothing that functions as a substitute for the loved person" (30). In a subsequent episode in Olenska's drawing room, Archer's "eyes fixed on the hand in which she held her gloves and fan, as if watching to see if he had the power to make her drop them" (168). When we spy the glove lying by the foot of Carolus-Duran's lady, we recognize Archer's attempt to model life on the experience of art—as if

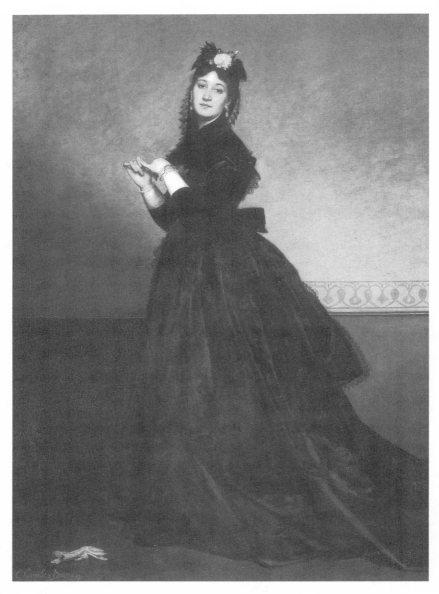

17. Emile-Auguste Carolus-Duran, *La dame au gant* (1869). Réunion des Musées Nationaux/Art Resource, New York.

to put Pater's theory into practice: he takes Ellen's hand, "softly un-
clasp[s] it, so that the gloves and fan f[a]ll on the sofa between them"
(168). There is for Archer something empowering in denying her hand
any usefulness. Moreover, given that a woman's discarded glove would
have signified her compromised virtue, the act of making Ellen drop her
glove suggests a metaphorical seduction. For Archer, all of Ellen's beauty
is concentrated in her hand; as he reflects on her "long pale fingers and
faintly dimpled knuckles" he muses to himself: "If it were only to see her
hand again I should have to follow her" (334). Worshiping her hand in
such a way undermines Ellen on at least two counts. First, it discounts
her hand as a useless relic worthy of a shrine, despite the fact that Whar-
ton will ultimately describe the woman's hand—which, for Wharton, re-
peatedly acts as a signifier for power and authority—as "firm and free"
(96). Further, associating Olenska with a painting that was "the sensa-
tion of the Salon" undermines her position as an agent. Ellen thus be-
comes for Archer an objet d'art whose office is to "please," even startle,
the spectator.[15]

A look at the Carolus-Duran painting shows that it is less scandalous
than Archer's heavily sexualized image of Olenska. Unlike Carolus-
Duran's *Dame*, which represents a matronly woman (the artist's wife)
whose body is concealed from neck to toe—she appears to be wear-
ing widow's weeds—Archer's portrait captures a woman who is "bold,"
"perverse," "provocative." And the description of the woman's "red vel-
vet bordered . . . with glossy black fur" is a sexually charged image that
suggests the female genitalia. The image also looks back to Wharton's
early story "The Duchess at Prayer," where fur is a signifier for a sexually
wayward, unattainable woman's nether regions. Wharton's duchess is
literally killed into art as punishment for out-of-wedlock sex; her body
is made her shrine. Olenska, to Archer, is more like John Singer Sargent's
Madame X (Madame Pierre Gautreau)—a painting of a femme fatale
who, like Archer's Olenska, is starkly pale, dark-haired, striking, and
rather worldly (figure 18). As "Madame X" is for Sargent (who, in fact,
studied under Carolus-Duran), Ellen is to Newland the prototypical
woman of experience. Further, Sargent's subject sports the "bare arms"
Archer finds so "pleasing" in Olenska. Like Archer's portrait of Olenska,
Sargent's is an American male's vision of an American-born woman
who married a European. Madame Gautreau's notoriety was only em-

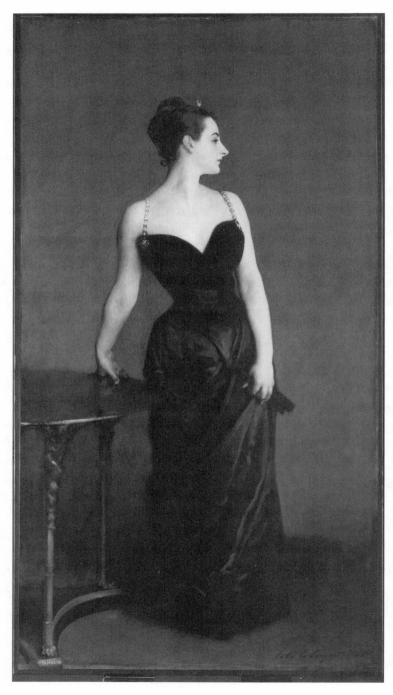

18. John Singer Sargent, *Madame X (Madame Pierre Gautreau)* (1883–84). The Metropolitan Museum of Art, Arthur Hoppock Hearn Fund, 1916 (16.53).

bellished by Sargent's bold, shocking representation of her. By encouraging such a comparison, Wharton highlights the American male's fetishizing of the Europeanized American woman.

Wharton's Archer perpetuates this myth of Olenska as a type of the "dark lady." At first it seems as though one of Archer's aims is to disprove the count's charges of Ellen's infidelities; this would help clear Ellen's name, allowing him to keep intact his untarnished, "enthroned" image of her. Archer keeps waiting for Olenska to prove her innocence, "intensely hoping for a flash of indignation, or at least a brief cry of denial" (110). But Ellen neither denies the allegations nor owns them. Archer reads her silence as a confession that she slept with the count's secretary. But Wharton offers no evidence to support his reading, and Archer never considers that Olenska deems the charges unworthy of rebuttal. His assumption of her infidelities, however, fits nicely with Archer's reading of Olenska as a femme fatale. When Archer discusses with journalist Ned Winsett the "dark lady" Ellen Olenska, Wharton's narrator, in a telling aside, remarks that Archer fosters "a secret pride in his own picture of her" (122).

Archer also aligns Olenska with a picture by James McNeill Whistler. It is telling, in fact, that this moment is staged at the Metropolitan Museum of Art, for Archer eventually will be involved with the planning and development of the great museum when we find him at the novel's close.[16] Archer thus proves himself to be the kind of institutional connoisseur Wharton critiques throughout her fiction. Here is Ellen at the Metropolitan, viewed through Archer's lens: "Archer, remaining seated, watched the light movements of her figure, so girlish even under its heavy furs, the cleverly planted heron wing in her fur cap, and the way a dark curl lay like a flattened vine spiral on each cheek above the ear. . . . As she stood there, in her long sealskin coat, her hands thrust in a small round muff, her veil drawn down like a transparent mask to the tip of her nose, and the bunch of violets he had brought her stirring with her quickly-taken breath, it seemed incredible that *this pure harmony of line and colour* should ever suffer the stupid law of change" (309–10; emphasis added). The "pure harmony of line and colour" is reminiscent of the musically inspired titles Whistler assigned to his paintings (for example, *Symphony in White, Harmony in Grey and Peach Colour*). Around the late 1860s Whistler began to rename his paintings, eliminating all references to the sitters themselves, emphasizing instead color and musi-

cal form. Thus Whistler's famous *White Girl* was retitled *Symphony in White, No. 1* and the well-known portrait of his mother was renamed *Arrangement in Grey and Black* (Prettejohn, *After the Pre-Raphaelites* 51). These Whistler titles in effect suppress content in the interest of pure form while they render the female subject increasingly abstract. Archer's description in fact strikingly recalls Whistler's *Arrangement in White and Black* (1876), which, produced at the cultural moment captured in Wharton's novel, depicts Whistler's mistress Maud Franklin.[17] Like Archer's Olenska, the lady is stylishly dressed in tones of white, silver, and black, complete with a fashionable feathered hat.

Wharton shows Archer viewing Ellen as if she were a nineteenth-century painting of a faceless woman—not a portrait but rather a representation of a type of fair lady. Take, for example, the scene at Newport where he silently gazes at Ellen on the pier. To Archer, Ellen resembles a kind of restless, Pre-Raphaelite lady-in-waiting, in the vein of the Lady of Shalott or Mariana, which Rossetti and his circle were fond of depicting: "[I]n the pagoda a lady stood, leaning against the rail, her back to the shore. Archer stopped at the sight as if he had waked from sleep. That vision of the past was a dream, and reality was what awaited him in the house on the bank overhead" (216). The positioning of Ellen's body recalls the visual representations of the writhing Lady of Shalott caught up in her loom, leaning out the window to her damnation (for example, by William Holman Hunt, Rossetti) and Mariana awaiting her perpetually absent lover (by Millais, Rossetti). Elsewhere, in a scene at Boston Common, Ellen is, to Archer, like a nameless, languid lady in a Monet painting: "[O]n the first bench, under a tree, he saw her sitting. She had a grey silk sunshade over her head. . . . As he approached he was struck by *her listless attitude:* she sat there *as if she had nothing else to do.* He saw her *drooping profile,* and the knot of hair fastened low in the neck under her dark hat, and the long wrinkled glove on the hand that held the sunshade" (230; emphasis added). The description bears a striking resemblance to Monet's images of well-dressed women of leisure shielded by parasols. At the same time, the emphasis on Ellen's listless, passive stance, and her "drooping profile"—the adjectives invoking the passive, drooping women of Wharton's "The House of the Dead Hand"—underscore the helpless, useless passivity with which Archer associates Olenska.

Wharton demonstrates that, in spite of the portraits Archer serves up, *Ellen* is in fact the artist. Early on we learn of Ellen's artistic bent as a child; it is suggested that she is a pianist (59, 78). As a young girl, Ellen was provided with an education that included "'drawing from the model,' a thing never dreamed of before," and her upbringing allowed her to become "a fearless and familiar little thing" who "possessed outlandish arts, such as dancing a Spanish shawl dance and singing Neapolitan love-songs to a guitar" (57). Several people recognize Olenska's inherent artistic sensibilities. Henry van der Luyden, for instance, applauds her "gift" for arranging her "cleverly" adorned apartment (88). A true artist, Olenska does not concern herself with what is "fashionable"; she is more a leader than a follower. When, for example, Archer remarks that living as she does in the "Bohemian" district of New York is "not fashionable," she replies: "Fashionable! Do you all think so much of that? Why not make one's own fashions?" (103, 73). Further, Ellen's cleverly decorated home is considered by the writer Ned Winsett to be an "oasis," and her aunt, Medora Manson, observes that "[p]oetry and art are the breath of life to her" (158). Even Archer is impressed with the way Ellen transforms "Medora Manson's shabby hired house" into an exotic, intriguing setting (70). But alas, he seems more interested in figuring her as another "delicate little Greek bronze" in her drawing room rather than an artist in her own right (69). And by leaving her husband, the Count Olenski, a man who "when he wasn't with women . . . was collecting china" and "[p]aying any price for both," Ellen resists transformation into an art object (13). In short, the men in her life want her to be art while she would rather make it.

Wharton's Archer is more comfortable with his "pictures" than the reality of Ellen Olenska. From Archer's perspective, we get several vintage Pre-Raphaelite renderings of Olenska. As Ellen enters the room, Wharton's narrator recounts Archer's vision: "Everything about her shimmered and glimmered softly, as if her dress had been woven out of candle-beams" (162). Archer seems to want to situate Ellen in a Pre-Raphaelite myth in which the woman, like an apparition, radiates an unearthly light: "So lambent, lady, beams thy sovereign grace / When the drear soul desires thee" (Rossetti, "Gracious Moonlight," in Lang 89). This fantasy is not only pleasurable but also preferable. When Archer steals a moment with the object of his desire, Wharton suggests that the

dream is more safe: "[T]he thought of her had run through him like fire; but now that she was beside him, and they were drifting forth into this unknown world, they seemed to have reached the kind of deeper nearness that a touch may sunder" (238). Ellen Olenska in the flesh problematizes Archer's fantastic image of her; to touch her would be to disrupt his fantasy.

An important part of this fantasy is the conviction that Olenska is necessarily a helpless "damsel in distress" in the medievalist tradition with which the Pre-Raphaelites were so enchanted. Though it is his sister Janey who voices the desire to cast Ellen as Elaine, Archer more or less reads her as such, despite Ellen's inherent independence and her resistance to the code that asks a woman to remain "immovable as an idol" (63). Having accepted the family's charge to discourage Ellen from seeking divorce, Archer imagines her "as an exposed and pitiful figure to be saved at all costs from farther wounding herself in her mad plunges against fate" (95). Archer's depiction of Ellen as fragile and frail is further enhanced by the attention he pays to her supposed paleness; he makes much of her "excessively pale" countenance (333). Archer, as is typical of Wharton's male leads (Lawrence Selden, Ralph Marvell), wants to play Perseus to his "lovely, rock-bound Andromeda" (*The Custom of the Country* 52).[18] Wharton makes a host of references to Archer's urge to "rescue" first May, then Ellen (15, 40, 42, 77, 138, 227). A telling passage makes this apparent: "A longing to enlighten [Ellen] was strong in him; and there were moments when he imagined that all she asked was to be enlightened" (138). But these women seem not to be interested in Archer's enlightenment; "imagined" is, of course, the operative term.

[W]e'll look, not at visions, but at realities.

—Ellen to Newland

Wharton shows us Ellen's bookshelves as a way of constructing a counterreading to Archer's "fictions." Though Wharton implies that her heroine is well read, we never see Olenska "buried in books." Further, while she does read fiction, Madame Olenska is no Madame Bovary: Wharton rewrites the script that has the female lead immersed in romance novels. On Ellen's coffee table, we find not the brothers Grimm but instead the Goncourts (103). Edmond and Jules de Goncourt, often

grouped with Zola, are considered the "founding fathers" of French naturalism; the Goncourt brothers are known for a refusal to idealize experience and, as Edmond de Goncourt expressed it, an aim to write "history which might have happened," to paint life as it is (189).[19] In fact, they viewed painting as something that was meant to delight the eye and appeal to the senses "and not to aspire to much beyond the recreation of the optic nerve."[20] But also of interest is the fact that the Goncourts had a penchant for viewing women "almost exclusively as sexual objects," and this would suggest Ellen's awareness of, and sensitivity to, a kind of sexualizing male gaze (Steele 103). Olenska also reads J. K. Huysmans—novelist and follower of the Goncourts, Zola, and Flaubert—who similarly aligned himself with the school of *naturalisme* (103). Huysmans's *A rebours*[21] is considered a handbook to modern times—a picture of disillusionment with the natural world; as Charles Bernheimer has noted, this work "fetishizes the female body with . . . violence" (373). By showing that Ellen has read Huysmans and the Goncourts, Wharton suggests Olenska's awareness of an objectifying, fetishizing male gaze. Ellen's understanding of the human psyche is further suggested by her reading of Paul Bourget, the French writer of psychological novels whom Wharton knew well (103). A common thread running through these authors is a knowledge of life—interior and exterior—and a refusal to live in fantasy—except, of course, for a fantasy that positions women almost exclusively as sex objects. Naturalism, unlike the escape we find in romanticism, captures the bleakness of the human experience. These books endow Olenska with a more realistic lens for observing herself, the world around her, and the way in which that world insists on viewing her.

Another important feature of Olenska's books is that they are written by men.[22] Wharton seems to be saying that Ellen understands the male perspective from which these books are written. Olenska's novels are "scattered about her drawing-room (a part of the house in which books were usually supposed to be 'out of place')" (103). Wharton here makes an important distinction: unlike Archer—who, in shelving his books in his private library, suggests that the knowledge he draws from them is not compatible with the outside world—Olenska fuses her inner world with the exterior by keeping her books in the space where she accepts visitors.

Wharton gives Ellen ample chance to apply her literary studies to her everyday life; often, Archer thinks he has secured a controlling gaze on Ellen, but she overrules it by having found him out. Take, for instance, the scene at Newport where Archer, summoned to fetch Ellen from the shore, finds her with her back to him, facing the water. Archer watches Ellen and, in a typically romantic vein, links the moment to his favorite episode from Boucicault's *The Shaughraun*.[23] He fancies himself the hero stealing a last look at his beloved "without her knowing" he is in her presence (217). Following Boucicault's script, Archer resists calling out to her and retreats to the house. We later learn that not only has he misread Ellen but she has—without his knowing—read him; she makes it clear that she had all the while detected his presence: she "didn't look round on purpose," she says, explaining, "I knew you were there" (234).

Ellen proves herself a far more deft reader than Archer, and she brings this skill to their every exchange. In an important episode in May's brougham, Archer tells Olenska he's been desperately clinging to the dream of their one day being together, "just quietly trusting it to come true" (289). Ellen, showing little patience for Archer's romantic notions, responds with laughter: "Your vision of you and me together?" Then, in one of Wharton's most poignant lines, Ellen tries to correct his "near-sightedness": "[W]e'll look, not at visions, but at realities" (289). She recognizes the futility of Archer's solution to run off somewhere, forgetting all responsibilities. She asks if he is suggesting that she become his "mistress"; recoiling from the word's ugliness, he replies: "I want somehow to get away with you into a world where words like that—categories like that—won't exist. Where we shall be simply two human beings who love each other . . . , and nothing else on earth will matter." Archer, then, would like to find the "new land" implied by his first name. Olenska's rejoinder proves that she knows such a prospect exists only in storybooks: "Oh, my dear—where is that country? Have you ever been there?" Ellen Olenska knows that the "words" and "categories," from which Archer claims to want to escape, are written indelibly on society's consciousness; she knows the folly of trying to live "in the blessed darkness" (290). Ellen has "had to look at the Gorgon" and had her eyes forced open (288). So Olenska has read Archer like a book. And what is Archer's response? As if in rehearsal for his final act in the novel (that is, his reso-

lution *not* to act), he abruptly stops the carriage and gets out. Ellen Olenska's voice of reality complicates his fictions.

> But I really don't see.
>
> —Newland to May

Ellen Olenska also complicates Archer's original translation of May Welland as his "enthroned" beauty. Archer had aligned May with this role before Ellen's appearance forced him to rethink his cast of characters. When we first see Archer, May is the object of his gaze; and his misconstruction of her is anticipated by the novel's opening scene: Wharton begins by giving stage to Christine Nilsson playing Marguerite in Gounod's *Faust*. The connection between Nilsson and May is apparent when we consider that the prima donna has "yellow braids" while May's are "fair" (6, 5). The opera singer is described as the "artless victim" of her Faustian costar; this is precisely how Archer reads May (5). To Archer, she is "the ingenuous May," a genuine naïf (120). The soprano in this opening scene "listened with downcast eyes to M. Capoul's impassioned wooing, and affected a guileless incomprehension of his designs" (6). This charade of "guileless incomprehension" underscores an alliance between May—who at this point is identified as "a young girl in white with eyes ecstatically fixed on the stagelovers"—and the singer (5). The scene effectively sets the stage for Archer's misguidedness, warning us not to invest confidence in the assertion he's about to make: "The darling! . . . She doesn't even guess what it's all about" (6). That the prima donna here sings "the Daisy Song" further suggests the association with *Archer*'s innocent May. Wharton suggests a comparison to Henry James's "Daisy Miller" (1879), one of the most popular renderings of the "American Girl"—the archetypal pretty, charming, innocent sweetheart of America (5).[24] As Wharton demonstrates, in direct opposition to Archer's rendering, May is more *ingenious* than "ingenuous."

Wharton shows Archer constantly "photographing" May as this virginal emblem of innocence. While critics make much of the novel's Diana-May comparisons, we are wise to discern that it is always Archer who draws the connection. Wharton's phrasing elucidates this distinction: "Archer saw May Welland entering with her mother. In her dress

of white and silver, with a wreath of silver blossoms in her hair, the
tall girl looked like a Diana just alight from the chase" (65). She looks,
to Archer, like a Diana—goddess of the hunt, an archetype pervading
nineteenth-century renderings of women. Diana is the "archer" with
"effectual aim." (And May, a winning archeress, ultimately proves her
aim to be more effectual than Archer, or any of the men in her circle,
had imagined.) Archer's imaging of May as an icon is more striking
when we learn that, to him, May's face has "the look of representing a
type rather than a person; as if she might have been chosen to pose for
a Civic Virtue or a Greek goddess" (189). Howard Chandler Christy's
early-twentieth-century renderings of "The American Girl" offer a nice
visual analogue to Archer's pictures of May.[25] Christy typically captures
the upper-class lady's demurely downcast eyes, her regality of posture,
her impossibly slim waistline. Further, the throne upon which Christy
positions his subjects recalls the pedestal from which Archer eventu-
ally demotes May. By documenting Archer's imaging of May, Wharton
voices a critique of the types that were assigned to, and in effect con-
tained, American women.

> Sometimes she is a child within mine arms.
> —Dante Gabriel Rossetti, "Heart's Haven"

An important and especially damaging part of the myth of the Ameri-
can Girl is that she is, of course, a perpetual child. Wharton's Archer
makes no effort to disguise his promotion of the imaging of woman-as-
child. When, for instance, Archer appeals to May to hasten their engage-
ment, ridding her of the suspicion that his urgency is triggered by un-
certainty, "she seemed to have descended from her womanly eminence
to helpless and timorous girlhood; and he understood that her courage
and initiative were all for others, and that she had none for herself . . .
she had dropped back into the usual, as a too-adventurous child takes
refuge in its mother's arms" (150). Wharton's readers need to account for
the capital difference between what May "seemed" to him—what Archer
"understood"—and the reality of May Welland; Wharton repeatedly
makes use of such qualifiers to draw attention to this gap. It is always
through Archer's eyes that we see May.[26]
 Even after they are wed, May, to Archer, remains "the simple girl of

yesterday" (188). Archer's reading of May as an infantalized woman is underscored by the Reynolds painting from which Wharton takes the title of her novel.[27] As we saw in *The House of Mirth*, Sir Joshua Reynolds figures prominently in Wharton's oeuvre. Reynolds's *The Age of Innocence* is the profile of a small girl seated barefoot in a pastoral setting with bow in hair, eyes open and unquestioning, and hands demurely crossed over her breast. The lesson here is twofold: the woman, to Archer, is like a child, and her hands are not to be applied to active endeavors; she is to be manipulated, not manipulative.

Wharton's May, in the final chapters of the novel, explodes this reading with an unanticipated move that defines her as considerably manipulative. We recall that Archer has been confident that May would remain predictable, that "he would always know the thoughts behind [her clear brow], that never, in all the years to come, would she surprise him by an unexpected mood, by a new idea, a weakness, a cruelty or an emotion" (295). Further, he has convinced himself that his wife "would always be loyal, gallant and unresentful" (196). As if Wharton wants to deconstruct Archer's reading of this woman as "artless" and "guileless," May shows that she is in fact artful; she stuns him with the news that she told Ellen she was pregnant "a fortnight" before she was certain (150, 343). May knows that word of a pregnancy will force Ellen out of the picture—she has kept hidden from Archer the details of their "really good talk"—but May reports, in a remark that means more than Archer can read: "I think she understands everything" (315, 326).

> To be a sweetness more desired than Spring;
> A bodily beauty more acceptable
> Than the wild rose-tree's arch that crowns the fell;
> .
> To be all this 'neath one soft bosom's swell
> *That is the flower of life:*—how strange a thing!
> —Dante Gabriel Rossetti,
> "True Woman" (emphasis added)

Situating Archer in his library at the start of the final chapter, Wharton encourages a reading of him as a man engrossed in his fictions. Twenty-six years have passed; Archer has lived an honorable life and af-

ter bearing him three children, May has died. Archer has just attended a reception in the very room at the Metropolitan Museum where, almost a lifetime ago, he shared a secret meeting with the Countess Olenska. Archer's fancy leads him back to that moment: "[I]nstantly everything about him vanished, and he was sitting alone on a hard leather divan against a radiator, while a slight figure in a long sealskin cloak moved away down the meagrely-fitted vista of the old Museum" (344). For Archer, Ellen Olenska remains a "vision" that represents the quintessential missed opportunity: "Something he knew he had missed: *the flower of life.* But he thought of it now as a thing so unattainable and improbable. . . . When he thought of Ellen Olenska it was *abstractly,* serenely, *as one might think of some imaginary beloved in a book or a picture:* she had become the composite vision of all that he had missed" (344, 347; emphasis added).

Wharton's Archer has assumed the persona of Rossetti's sonnet sequence—the text through whose pages he had chased visions of the Countess Olenska. Ellen Olenska has become for Archer—who draws from Rossetti's rhetoric—this "flower of life," the "imaginary beloved" for which he had strived, with the misguided "aim" of the bowman ill equipped to claim his target. In his private library, Archer is up to his old tricks: he is still "picturing" both Ellen and May. Though May has collapsed his reading for us—proving her artfulness and intuition—he continues to misread her. Studying a photograph of May, he remarks that, as he had remembered her, "so she had remained . . . so lacking in imagination" and characterized by "blindness" (348). And yet it is Archer who has "unseeing eyes" (332).

May's vision has remained intact, and she has the last word here. May collapses his construction of her as "blind" and bereft of imagination. In the final pages of the novel, Archer's grown son discloses that on her deathbed May had revealed her awareness of his father's passion for Olenska: "[S]he knew we were safe with you, and always would be, because once, when she asked you to, you'd given up the thing you most wanted" (356). And now that his wife is dead, we may recall a promise Archer once made to himself: he fancied that May's death would "set him suddenly free" and clear the path to the woman of his dreams (296). At the novel's end, he is given that hoped-for chance; Ellen Olenska is

an available woman: "There was nothing now to keep her and Archer apart" (357).

> I have loitered in the vale too long
> And gaze now a belated worshipper.
>
> —Dante Gabriel Rossetti,
> "The Hill Summit"

In the last moments of her epilogue, Wharton takes us to the Parisian quarter where Ellen Olenska has made her home. Like her creator, Olenska has secured for herself a home in France where she can enjoy the intellectual and artistic freedom that America failed to afford her. Ellen's body, in fact, remains withheld from view—an editorial move that spares Wharton's heroine the consuming gaze to which the earlier heroines were subjected. But we do learn something of Ellen's new-found life, and this intelligence is filtered, naturally, through Archer: "For nearly thirty years, her life—of which he knew so strangely little—had been spent in this rich atmosphere that he already felt to be too dense and yet too stimulating for his lungs. He thought of the theatres she must have been to, the pictures she must have looked at, the sober and splendid old houses she must have frequented, the people she must have talked with, the incessant stir of ideas, curiosities, images and associations thrown out by an intensely social race in a setting of immemorial manners" (359). It should come as no surprise that Ellen would find respite in Paris, for her fate is aligned with that of Monsieur Rivière, her husband's secretary, who similarly enjoys "intellectual liberty" abroad.[28] Paris represents freedom for both Ellen and Rivière; it is for them, as it was for Wharton, "a world in which . . . no one who loved ideas need hunger mentally" (200). Rivière remarks to Archer: "You see, Monsieur, it's worth everything, isn't it, to keep one's intellectual liberty, not to enslave one's powers of appreciation, one's critical independence? . . . And when one hears good talk one can join in it without compromising any opinions but one's own; or one can listen, and answer it inwardly. Ah, good conversation—there's nothing like it, is there? The air of ideas is the only air worth breathing. . . . *Voyez-vous*, Monsieur, to be able to look life in the face: that's worth living in a garret for, isn't it?"

(200–1). Rivière's privileging of the ability to look life in the face is simpatico with Ellen's staring down the Gorgon and adopting the eyes-wide-open approach to life. When Monsieur Rivière asks Archer about the possibility of working in New York, the latter is struck by the disparity between France (artistic freedom) and New York (limitation): "New York, for a young man who had frequented the Goncourts and Flaubert, and who thought the life of ideas the only one worth living! He continued to stare at M. Rivière perplexedly, wondering how to tell him that his very superiorities and advantages would be the surest hindrance to success. . . . the more Archer considered it the less he was able to fit M. Rivière into any conceivable picture of New York as he knew it" (201). New York for Archer and Olenska, as it evidently was for Wharton, is diametrically opposed to artistic and intellectual freedom. For that alone, Wharton was compelled to transplant herself to the very Parisian neighborhood where Olenska now lives.

Loitering in the district that is now home to his "imaginary beloved" and invited to ascend the stairs to her apartment, Archer resists. He "pictures" the scene of his grown son advancing into Ellen's drawing room finding "a dark lady, pale and dark, who would look up quickly, half rise, and hold out a long thin hand with three rings on it" (361). We witness his final resolution, as he sits on a bench opting instead to "gaze at the awninged balcony": "'It's more real to me here than if I went up' . . . and the fear lest that *last shadow of reality* should lose its edge kept him rooted to his seat" (361–62; emphasis added). Newland Archer relinquishes his last chance to see Ellen Olenska, nearly thirty years later, preferring instead to protect his picture of her.

An "acceptance of 'reality,'" as Cynthia Griffin Wolff would have it? The only reality that Newland Archer accepts is his "vision" of Ellen Olenska, which he labors desperately to preserve. Moreover, the reason he ultimately does not climb up to her level is that he refuses to adulterate the vision he mistakes for reality. If Newland Archer is a "victim" at all, as so many readers have suggested, then he is a victim of his own illusions. In the final analysis, he is the "Archer" with "ineffectual aim." So very much like Rossetti's speaker in the sonnets with which he most identifies, Archer knows "Life-thwarted . . . / Love shackled with Vain-longing" ("Love's Fatality," in Lang 106). Because he has cast Ellen Olenska in the role of the untouchable beloved one finds only "in a book or

a picture," it follows that he must play out the part of Rossetti's "belated worshipper":

> Look in my face; my name is Might-have-been;
> I am also called No-more, Too-late, Farewell. ("A Superscription," in
> Lang 127)

> He had to deal all at once with the packed regrets and stifled memories
> of an inarticulate lifetime.
>
> —Edith Wharton, *The Age of Innocence*

Wharton's own "lifetime" was of course very articulate. Her novel closes at the beginning of the last century, and, as we dwell at the start of the next, our theoretical concerns reflect hers. Contemporary theory continues to address the representation of women in Western culture; we are ever reminded of the fixed types that are still imposed on women—modified though they may be. Important new studies in gender and the visual arts build on the foundation laid by Gilbert and Gubar, Showalter, Banta, Dijkstra, and Suleiman.

Wharton's 1920 novel compels us to ask what, finally, is gained by exposing Newland Archer as a poor reader. By depicting Archer as an untrustworthy reader with poor analytical skills,[29] as blind, "inarticulate," and "ineffectual," Wharton implies that a good, close reader (with eyes "meditative," "fasten[ed] . . . open," and "highly trained" like Ellen's, or "widening" eyes marked by "clearness" like May's—and not eyes "unseeing," "hidden," "blank," and "staring into utter darkness" like Archer's) would recognize these types as the myths they are and collapse these constructions of femininity.

Ellen and May, in fact, work together to dismantle Archer's world in ways similar to Wharton, who deflates the myth of the American woman and challenges the tradition that assigns her to types: either woman-as-artless (ingenue, angel, Diana, American Girl) or woman-as-art (femme fatale, dark lady, imaginary beloved, Pre-Raphaelite stunner). As Elizabeth Ammons persuasively argues in *Edith Wharton's Argument with America,* there was, in Wharton's America, no room for the American woman as *artist*. Wharton's own expatriation to France—as well as her description of herself as an "exile" in America—would

imply just that.[30] The women artists embraced by the world of Whar-
ton's novel—Christine Nilsson, Ada Dyas, Adelaide Neilson, Mrs. Scott-
Siddons[31]—are not American. Wharton suggests that, in the same way
that America is "distrustful and afraid" of Ellen Olenska, it is similarly
averse to the American woman artist (352).

The body of Wharton's work would strongly suggest it. One searches
Wharton's fiction in vain for the figure of the fully realized, well-rounded
American woman artist who is at once happy, satisfied, and *alive,* living
a life without serious compromise or subjection to ridicule, resentment,
and exile. We might, for instance, consider Wharton's early novella *The
Touchstone* (1900), whose female protagonist, an American expatriate
writer who found "London offered more scope than New York to her
expanding personality" (23), is dead at the start of the narrative, after a
life of loneliness and exile—a move on Wharton's part that speaks to her
sense of the possibilities for female creative power and the measure of
joy that can accompany it.[32] Margaret Aubyn, like Ellen Olenska, comes
to us by way of a narrative perspective that, like Newland Archer's, is
"unseeing." (In fact, we recognize in this novella the seeds of *The Age
of Innocence,* given the analogous love triangle and the way in which a
male reflector misreads and undermines the two women in his life—a
creative woman who expatriates herself and a seemingly blameless wife
who, like May Welland, is read by her husband as "a throned Justice by
some grave Florentine painter" [12].) Meanwhile, Margaret Aubyn be-
comes to Glennard, as Olenska is to Archer, "the mere abstraction of a
woman" (115).

By the time we arrive at the novel *Twilight Sleep* (1927), Wharton un-
veils Lita Wyant, who seems to embrace, rather than resist, her status as
"[an] idol . . . made to be worshipped." Lita's disempowerment (along
with her married name, "Wyant") looks back to the early "House of
the Dead Hand": Lita possesses "drooping hands," "slim yet dimpled,"
which have "never grown up," and which "drooped from her wrists as if
listlessly waiting to be kissed" (16–17). The spoiled, drowsy, "indolent"
Lita, who assumes "the immemorial attitude of sleeping beauty" (240),
is the tragic consequence of an American culture that elevates women to
pedestals only to deny them power and voice (17). And yet she is de-
scribed, through the gaze of a male reflector, as an *artist:* "Lita was first
and foremost an artist, born to live in the world of art" (165). Lita's is

"the gift of posing" (176), and she is courted by an opportunistic Holly-wood filmmaker named Klawhammer who recognizes her star power (166). Her identity as an "artist," then, is a ruse, as Lita has been raised, like her literary cousin Lily Bart, to be art rather than an art *maker,* and so it comes as no surprise that she is compared to a painting by Crivelli (233). And in the same way Lily's mother hopes to transform her daugh-ter's beauty into capital, Lita's aunt sees "a gold mine in the exploita-tion of her niece's gifts" (165). If Lita signifies a kind of new woman artist, Wharton suggests that there is very little that is "new" about this Jazz Age vixen's story. In fact, when we consider one of Lita's real-life counterparts, the American screen star Louise Brooks, it becomes in-creasingly clear that the new medium of the moving picture, with such vehicles as *The American Venus* (1926) and *Pandora's Box* (1929), pre-sented women with a limited choice of roles that resound all too famil-iarly with the options presented by the Pre-Raphaelites (consider Ros-setti's paintings *Venus Verticordia* [1864–68] and *Pandora* [1869]). Lita Wyant and Wharton's other modern sirens, like Rossetti's stunners, are rather all sexed up with nowhere to go. Lita's hand is not a *speaking hand* but instead a *drooping* hand that hauntingly reaches back to Wharton's early gothic tale and interrogates the idea of the "progressive" age.

Yet, amid these depressing spectres, Wharton offers the example of a woman empowered, whose hand asserts a certain measure of artistic agency: the shrewd, spirited Miss Adelaide Painter who, though a minor character, exerts extraordinary influence in Wharton's 1912 novel *The Reef*. This Massachusetts spinster lives in Paris and, as Wharton and Ellen Olenska eventually would do, enjoys there her status as unmar-ried, mobile, and autonomous. The "omniscient" Miss Painter is one of Wharton's most respected women, and, because her "gimlet gaze" pene-trates "the heart of any practical problem," her counsel is sought on delicate family affairs (203, 291). Knowing "all their destinies were in Miss Painter's grasp," everyone in the novel "yield[s] to the tremendous impact of [this woman's] determination" (206–7). When Miss Painter waves her "vigorous hand," people take notice (280). In christening her "Miss Painter," Wharton offers this woman as an allegorical example of the transplanted, thus liberated, American woman artist (a woman painter, not a woman painted). Like Wharton and like Olenska, she has left her native land and enjoys independence in her adopted European

milieu. When she lifts her hand—not a *drooping* hand, not a *dead* hand, but a speaking hand—and waves her "wand of expression," she effects change. And, like Edith Wharton's, her hand wields authority as an agent of change and speaks from a subjectivity traditionally sentenced to silence.

Wharton's Archer, whose conception of life is fundamentally literary, habitually brings his books to his daily experiences. As is his custom, we find him, in a scene at Newport, with Olenska on his mind: anticipating seeing her after more than a year's time, he wistfully remembers her "fire-lit drawing-room." His memory leaps to "a story he had read, of some peasant children in Tuscany lighting a bunch of straw in a wayside cavern, and revealing old silent images in their painted tomb" (215). Wharton, through her own art, also illuminates the "old silent images" entombed in painted spaces, though her light is decidedly free of the idealistic haze of Archer's perspective. As we have seen, her fiction exposes and problematizes debilitating patterns of representing women and exhorts us to look not at visions but at realities. It also casts a clarifying light on these troubling "visions"—old silent images, indeed—and manages to locate power and agency for women despite the politics of misrepresentation.

Wharton continued her engagement with Dante Rossetti and the Pre-Raphaelites through to her last novel. In *The Buccaneers,* which Wharton left unfinished at her death, the American woman novelist paints the Pre-Raphaelite artist as an aged, ailing troublemaker. Rossetti as he appears in *The Buccaneers* is, as he was at the end of his life, woefully in debt and "addicted to chloral mixed with whisky" (306). His poison is the very drug that took Lily Bart's life. In this final novel, Laura Testvalley, Dante Rossetti's (fictional) younger cousin, ushers in a new era of post-Pre-Raphaelitism, for the Rossetti line will be succeeded by this no-nonsense, worldly-wise "great old adventuress"—an empowered "spinster" the likes of which we have seen in Miss Adelaide Painter. In revising Elizabeth Siddall and Lily Bart's stories in the later fiction—by letting the muse live and live *well*—and by reframing the Pre-Raphaelites in her final novel, Wharton manipulates the politics of representation perhaps more than has been previously acknowledged. Indeed, it is as if she has listened attentively to the (muted) voice of

Lizzie Siddall, Rossetti's tragic muse, who boldly critiques the politics of nineteenth-century visual art when she speaks for the male painter in her poem titled "The Lust of the Eyes":

> I care not for my Lady's soul
> Though I worship before her smile;
> I care not where be my Lady's goal
> When her beauty shall lose its wile.[33]

Wharton's fiction is mindful of the damage incurred by countless pairs of lustful eyes, and she reverses the visual vectors in her later work. Though she paints Undine Spragg and her modern sisters in less flattering colors than those with which she sketched Lily Bart, Wharton sets them up in more livable homes, banishes their phantoms, and decorates their respective houses with mirth as well as life.

Wharton continued to revise the Pre-Raphaelite script throughout her career, as is powerfully evident in an unpublished poem titled "The 'Beata Beatrix' of Rossetti." In ekphrastic verse, Wharton appropriates the story of Beatrice, the muse of Dante and Rossetti, and retells it in her own voice. Her speaker speaks for the painted woman from whom we cannot take our eyes away:

> And when his gaze, that thought to meet the sun,
> Had pierced the olive-cinctured veil she wore,
> Methinks she smiled upon his travail done,
> Whispering, "What matter though the way was sore?
> Look on me, Poet, till our souls be one
> For I am Beauty, thou my servitor."[34]

Wharton thus deconstructs Rossetti's *Beata Beatrix* (see figure 3 in chapter 2) by speaking for Beatrice—and for Lizzie Siddall, who posed for the picture, and Jane Morris, who modeled as Beatrice in his art and imagination. In place of Rossetti's narrator who had compelled us, in *The House of Life*, to "look in my face" and ponder what "might have been," Wharton's first-person speaker prods us to acknowledge that what is true philosophically is true materially: beauty enshrined will become

beauty enthroned. Indeed, more like Undine Spragg than Lizzie Siddall, she assures the artist, whose travail is now done, that if she must embody Beauty, then he will be her servant. And though "the way was sore," Wharton's modern beauties, with their body art, will, at long last, be served.

Notes

Introduction

1. In *The Age of Innocence*, Newland Archer, gazing at May Welland, is charged by "the simple joy of possessorship" (80), while Waythorn of "The Other Two" finds himself "yielding again to the joy of possessorship" (386) as he contemplates his new bride.

2. Edith Wharton (1862–1937) left behind an impressive body of work to discuss: twenty-five novels and novellas, eighty-six short stories, three books of poetry, an autobiography, a book on fiction writing, eleven pamphlets of nonfiction, and several articles, reviews, and translations; at her death she left an unfinished novel, not to mention several unpublished poems that deserve attention. She enjoyed commercial and critical success, especially with *The House of Mirth* (1905) and *The Age of Innocence* (1920), for which she won the Pulitzer Prize. At the height of her career Wharton was recognized as one of the leading, and highest grossing, American writers of her time. But she was often dismissed, particularly toward the end of her life, as an old-fashioned, class-bound Victorian and mere disciple of Henry James—only more depressing. And while Wharton conceded in a 1925 letter to F. Scott Fitzgerald that she had become "the literary equivalent of tufted furniture and gas chandeliers," she took no pleasure in hearing the verdict voiced by others. Critics came to deride "Mrs. Wharton's icy restraint," the implication being that her reading public expected the warmth of the hearth from an American "authoress" (see a review of *Summer*, quoted in Bell, *Cambridge Companion* 3). At the time of her death in 1937, Wharton's star had faded, outdone by trends in literature that gave preference to what she despairingly called, in *A Backward Glance*, "the man with the dinner pail" (206) and the vulgarity she equated with naturalism and modernism. Percy Lubbock's *Portrait of Edith Wharton* (1947) helped further inscribe Wharton as a stuffy chronicler of a bygone era. Wharton's place in the classroom and in critical dia-

logue was reassessed as a result of two major events: the 1967 opening of the Wharton papers at Yale's Beinecke Library and the advent of feminist scholarship. R. W. B. Lewis's 1975 biography unveiled Wharton as an accomplished writer. Wolff's 1977 psychobiography helped deconstruct the perception of Wharton as a rigid Victorian, focusing on her realistic analysis of circumscribed female experience. Wharton's readers owe a great debt to the Edith Wharton Society, organized by Annette Zilversmit in 1983, which for nearly three decades has hosted conferences on Wharton and provided a printed forum in the *Edith Wharton Review,* both of which have attracted scholars from around the world. Though Wharton would not have called herself a feminist, modern readers have felt she expressed a poignant understanding of women's place in American culture.

3. In 1992, responding to a resurgence of interest in Wharton, Peggy Noonan's article titled "My Own Private Edith" appeared in *Vogue* magazine.

4. Wharton's final, unfinished novel, *The Buccaneers,* was made into a 1995 BBC miniseries, and a film adaptation of the novella *Summer* is reportedly in the works. Given the recent successes of such films as *Shakespeare in Love* and *The Hours,* a biopic of Wharton's life seems a promising project for a twenty-first-century filmmaker.

5. For the most part, Wharton scholarship has tended to be psychologically or biographically informed and/or has attempted either to defend her from attacks or to classify her. An incest thread runs through much of the recent biographically inspired scholarship—a subject first addressed by the Lewis biography, later by Adeline Tintner. Barbara A. White, David Holbrook, and Gloria Erlich contend that the now-famous "Beatrice Palmato" fragment—Wharton's fictional account of a father-daughter sexual encounter—suggests Wharton was a survivor of incest.

6. Among such critics are Dijkstra, Pollock, Warner, and Van Hook. *Edith Wharton and the Visual Arts* also draws from such inspired studies of Pre-Raphaelitism and aestheticism as Prettejohn, *After the Pre-Raphaelites;* Watson; and Harding. Finally, this book relies heavily on the extraordinary contributions to Pre-Raphaelite studies made by Jan Marsh and Jerome McGann.

7. Wharton did not decorate her drawing room with the kind of art produced by the painters she critiques in her fiction. According to Judith Fryer, "Although the house she was building while writing *The House of Mirth* was artfully planned . . . and Wharton paid a great deal of attention to the details of decoration, from interior furnishings and their placement to the plantings of the gardens, no paintings adorned the walls" ("Reading" 41–42). While Fryer uses this detail to support a different point, it contributes to our understanding of Wharton's impression of—or lack of regard for—the kind of art that embellishes and romanticizes women as decorative objects. Photographs from the Wharton archive at the Beinecke Library speak to Wharton's preference for hanging floral tableaux on her walls. Wharton acquired an impressive collection of paintings in her lifetime, including Paul Cezanne's *The Avenue at the Jas de Bouffan* (1874–75; now at the Tate), Allan Ramsay's portrait of William Sutherland (now at the Louvre), and works by Odilon Redon.

8. Several studies have enabled this analysis of Wharton's cultural critique. Judith Fetterley early on recognized in Wharton's fiction a powerful condemnation of patriar-

chal culture. *Edith Wharton and the Visual Arts* also builds upon the efforts of Elizabeth Ammons's important *Edith Wharton's Argument with America* (1980), which takes a feminist approach to Wharton as a writer who argued that American patriarchy had robbed women of control of their own lives. While Ammons traces the evolution of Wharton's views up to and through the 1920s, her study does not examine in depth the early fiction, which remains a vital part of Wharton's oeuvre that deserves attention.

9. Donovan cites as examples "April Showers," "Copy," "Expiation," and "Writing a War Story" (175n2).

10. The new two-volume Library of America edition, which gathers sixty-seven of Wharton's stories, should have a hand in making this part of her work more accessible.

11. Dale Bauer's *Edith Wharton's Brave New Politics* (1994) makes an early, convincing case for turning to the neglected fiction—especially that of the 1920s and 1930s—for a fuller sense of Wharton's evolution as an artist and social critic (9).

12. While this study examines Wharton's links to several traditions in the visual arts, it places special emphasis on the palpable presence of the Pre-Raphaelites, and particularly Dante Gabriel Rossetti, in Wharton's work. Only Adeline Tintner has discussed Wharton's engagement with the Pre-Raphaelites, addressing *The Buccaneers, The Glimpses of the Moon,* and *False Dawn.* Tintner does not read in Wharton a critique of the rhetoric and repertoire of the PRB. As Sophia Andres has recently shown, "Pre-Raphaelite art captivated literary artists, inspired them, and compelled them to reconfigure some of the most notable and popular Pre-Raphaelite paintings in their own ways into narrative images of intense emotions, emotions that reflected multifarious cultural and social issues" (xvi). Andres's 2005 study considers the underexamined interdisciplinary relationship between Pre-Raphaelite painting and the British Victorian novel and thus does not discuss the American writer Edith Wharton. The excellent collection *Worldwide Pre-Raphaelitism,* edited by Thomas J. Tobin, examines the PRB's far-reaching influence during the nineteenth and twentieth centuries. (While the collection makes mention of such distinguished American voices as Henry James, William Dean Howells, and Charles Eliot Norton—all of whom were important to Edith Wharton—Wharton is not among them.) No less a figure than Jerome McGann has shown that, while Dante Rossetti would not be called a "master," nevertheless, "the [Victorian] age's two most imposing critics, Ruskin and Pater, both saw Rossetti as the period's central artistic presence. . . . Though not much now remembered, the truth is that between approximately 1848 and 1912 Rossetti was, in Whistler's final phrase, 'a king'" (2).

13. Philip Stevick in his study of the American short story has shown that early-twentieth-century American writers like Wharton kept up with the painting world, particularly impressionism, postimpressionism, and cubism, and also the art of film and camera (19).

14. Maureen Honey also recognizes Wharton's interventions in visual culture, but she does not discuss what I see as the writer's dialogue with the sexually charged work of the Pre-Raphaelites. Further, while the cultural critic Camille Paglia has devoted a section of her provocative *Sexual Personae* to the Pre-Raphaelites, the commentary suffers from historical inaccuracies (for example, Paglia claims the artists wanted to retreat

to the style of Raphael when in fact they were attempting just the opposite) as well as what seems a missed opportunity to open up a discussion of an oversexed impulse in the works of these artists.

15. Wharton's library included Dante Rossetti's *Ballads and Sonnets* (1881) and *Collected Works* (1886) and three volumes of Christina Rossetti's poetry: *Poems, 1875; Poems, New and Enlarged Edition, 1890; and Poems, 1895* (Ramsden, *Edith Wharton's Library*). Further, Wharton quotes Dante Rossetti's poem "The Woodspurge" in the last paragraph of *A Backward Glance,* and she published a story titled "A Cup of Cold Water" (1899) that resonates with Rossetti's story "The Cup of Water," written in the early 1870s. Perhaps most relevant to the present study is an ekphrastic poem Wharton wrote in response to a Dante Rossetti painting—"The 'Beata Beatrix' of Rossetti" (the Lilly Library, Indiana University, Bloomington, box 8, notebook 2: poems)—which lays bare her close familiarity with the picture and her awareness of its troubling politics of representation; for more on this unpublished poem, see chapter 5. My deepest thanks to Clare Colquitt for bringing the poem to my attention.

16. Carol Christ sees Rossetti's paintings figuratively imposing the phallus onto women's bodies: "Rossetti at once exaggerates all the signs of female sexuality—the full, slightly parted lips, the cascading hair, the fruits and boxes so prominently and temptingly held—while he distorts the female body so that it becomes phallic, in the elongated and muscular neck, the enlarged hands placed prominently at the picture's center, and the massive shoulders" (145). So Rossetti has put to practice what Laura Mulvey has theorized: "The true exhibit is always the phallus. Women are simply the scenery onto which men project their narcissistic fantasies" (13). The male artist has figuratively forced the phallus onto his images of women, as if to suggest anxiety about the mysteries of female biology and creative power.

17. Wharton may have seen Rossetti's work in person at the Royal Academy of Art in 1883 or 1906 as well as in the private collections of Winthrop, Norton, and their peers.

18. *The Rossetti Archive* at the University of Virginia is a lavishly illustrated electronic companion to the catalogue raisonné edited by Virginia Surtees.

19. Not everyone sang the praises of the Pre-Raphaelites. In a famous essay in the *Contemporary Review* called "The Fleshly School of Poetry: Mr. D. G. Rossetti" (1871), Rossetti's first published collection of poems was lambasted by the poet Robert Buchanan in a rather puritanical attack on its "sensuality." In general, the art of the Pre-Raphaelites was subjected to various epithets, among them "revolting," "objectionable," "unhealthy," "perverse" (Nicoll 54).

Mary Elizabeth Braddon's sensational novel, *Lady Audley's Secret* (1862), with which Wharton likely was familiar, shares with her fiction an engagement with the Pre-Raphaelites. The scene cited in my epigraph above describes the portrait of Braddon's heroine, Lady Lucy Audley, painted by an artist of the Pre-Raphaelite persuasion (Braddon 72). Henry James, whose reading list regularly overlapped with Wharton's, reviewed Braddon's novel in the November 1865 the *Nation*. Like Wharton, Braddon drew inspiration from Balzac and alludes in her fiction to the stage actress (Madame) Rachel (Eliza Felix), who enjoyed success in London in the mid-nineteenth century. I thank Bill Cohen for introducing me to *Lady Audley's Secret.*

20. Readers interested in biography will find it especially revealing that Ruskin would use the sexually laden verb "to penetrate" in speaking of artistic production when, in fact, his wife demanded an anulment because of his failure to consummate their marriage (Des Cars 58). This piece of biography suggests a displacement of the sexual act onto the creative process—as if artistic penetration might substitute for sexual penetration.

21. In Wharton's novel *The Reef* (1912), the male protagonist reads his fiancée as "a fine portrait kept down to a few tones" (126). Wharton's pun points to the ways in which a pernicious artistic tradition works to suppress and disempower women.

22. Rossetti's predilection for the dead bodies of beautiful women manifests not only in his painting and poetry but also his translations. For instance, he translated a poem by Francois Villon titled "The Ballad of Dead Ladies" (*Collected Writings* 253).

23. D'Annunzio is well represented on Wharton's reading list (Killoran, "Edith Wharton's Reading" 379).

24. The 1866 Browning poem begins "Beautiful Evelyn Hope is dead!" and goes on to catalogue the young girl's beauty, praising her "mouth of geranium's red" and her "hair's young gold." The speaker reveals himself to be a man several years her senior who had loved, and, it seems, sexualized, the sixteen-year-old. He closes the poem with the following plea to the dead girl: "hush . . . I will give you this leaf to keep,— / See, I shut it inside the sweet cold hand." The gesture eerily echoes Rossetti's burial, earlier that decade, of his manuscript with the body of Elizabeth Siddall. For further manifestations of the trope of the female corpse see Hawthorne's *Blithedale Romance* ("the grass grew all the better . . . for the decay of the beautiful woman who slept beneath" [243–44]), Flaubert's *Madame Bovary,* James's "Daisy Miller," Hardy's *Tess,* Crane's *Maggie: Girl of the Streets,* and renderings of such doomed damsels as Beatrice, the Lady of Shalott, and Ophelia by Pre-Raphaelite painters Rossetti, Waterhouse, and Millais.

25. I am convinced that the Harlem Renaissance writer Nella Larsen (1891–1964) knew well, and admired deeply, Edith Wharton's fiction. For instance, the title of Wharton's 1904 story looks forward to Larsen's 1928 novel *Quicksand.* Wharton's novella *Sanctuary* (1903) anticipates Larsen's story of the same name. Larsen, like Wharton, works within the genre of the novel of manners, exposing the contradictions and hypocrisies of the upper classes; the chief difference, of course, is Larsen's commitment to issues of race as well as gender and class. Like Wharton, Larsen relies on the trope of the "unseeing eye." In Larsen's *Passing,* Irene Redfield's sense that no one weeps as beautifully as Clare Kendry echoes Selden's notion, in *The House of Mirth,* that "even [Lily's] weeping was an art" (72). In Larsen's *Quicksand,* the narrator describes Helga Crane's loss of "confidence in the fullness of her life" (47), which echoes the early Wharton story "The Fullness of Life." A provocative scene in *Quicksand,* which records Helga's disenchantment with Axel Olsen's painted picture of her—and his assumption that in painting her he might seduce her—not to mention the shared focus on such naturalistic themes as female suffocation and entrapment, betrays a profound literary kinship with Wharton that deserves further exploration.

It seems likely that Mary Austin also read Wharton's tale "The Quicksand," which looks forward to the Austin sketch titled "The Walking Woman." In Austin's tale,

the protagonist shares with the narrator the three main objectives in life: work, the love of a child, and the love of a man: "taken as it came, not picked over and rejected if it carried no obligation of permanency; and a child; any way you can get it, a child is good to have, say nature and the Walking Woman; to have it and not to wait upon a proper concurrence of so many decorations that the event may not come at all" (262).

Chapter 1

1. *Washington Post,* January 14, 2001, G6.

2. Bourget's short story "The Portrait" features a character evidently based on Wharton. The tale seems to have been inspired by Wharton's "The Moving Finger."

3. In response to a request for a book shot, Wharton writes to William Crary Brownell "I hate to be photographed," playfully citing as a reason that "the results are so trying to my vanity" (February 14, 1902, *Letters* 57). Benstock notes that Wharton's husband, Teddy, arranged for the newly married Edith to sit for a painted portrait by Julian Story during the couple's 1886 visit to Paris. The painting of Wharton's face was later lost. Wharton did not enjoy the long hours posing for the picture (*No Gifts* 63.) Wharton had been painted on at least two previous occasions by Edward Harrison May while abroad: in 1870, at the age of five, and in 1881, at age nineteen. The 1870 and 1881 Edward Harrison May images are available for viewing at the National Portrait Gallery, Smithsonian Institution, Washington, DC, and at the American Academy of Arts and Letters, New York City, respectively.

4. In a 1908 letter to Sara (Sally) Norton, Wharton acknowledges Taine (1828–93), French philosopher, historian, and critic, as "one of the formative influences of my youth" (*Letters* 136). He is well represented in Ramsden's catalogue of her library.

5. After Siddall's funeral, Rossetti not only burned her letters, to protect the privacy of the deceased and her relations, he also destroyed all photographs of her in his possession (Daly 93). This gesture, intentionally or no, in effect controlled for some time the way in which Lizzie would be represented in visual culture, compelling us to go through him to reach her. Today, Rossetti's renderings are complemented by the strikingly austere and rather haunting self-portrait and poetry Siddall left behind. Contrary to convention, I refer to Siddall by the original spelling of her name.

6. The founding members of the Pre-Raphaelite Brotherhood established a list of heroes they deemed "Immortals." At the top of the list was Jesus (though Rossetti had voted for Shakespeare); other designees included Homer, Dante, Chaucer, Leonardo, Goethe, Keats, Shelley, Thackeray, Robert Browning, Boccaccio, and Newton (Daly 17). Elizabeth Barrett Browning seems to have been one of the few women included in this canon. Not coincidentally, Wharton's own list of favorite writers and historical personages overlapped considerably with that of the PRB.

Wharton, too, admired Poe, writing that he and Whitman, "with Emerson, are the best we have—in fact, the all we have" (Lewis, *Edith Wharton* 236). Carole Shaffer-Koros has discussed Wharton's use of Poe as inspiration in her ghost tales, specifically "Kerfol." She compellingly suggests there is strong evidence—in spite of the destruction

of much of her library during the blitz—that Wharton was familiar with his complete works (12–15). Shaffer-Koros does not discuss the tales addressed here.

7. If Wharton draws her curious title from *The Rubaiyat of Omar Khayyam,* it seems the "moving finger"—the hand of the artist—is clearly attached to a man. The stanza in full reads: "The Moving Finger writes, and, having writ, / Moves on; nor all your Piety nor Wit / Shall lure it back to cancel half a Line, / Nor all your Tears wash out a Word of it" (stanza 71). The verse speaks to art's permanence, which carries a note of irony, given that the artist in Wharton's tale is asked to "wash out" some of the details of Mrs. Grancy's portrait. In *The House of Mirth,* Lily Bart, "who prided herself on her broad-minded recognition of literature . . . , always carried an Omar Khayyam in her travelling-bag," but evidently spent little time reading it (65).

8. Other such heroines who are dead at the story's start include Margaret Aubyn of *The Touchstone* and Emily Morland of "The Temperate Zone," both of whom are writers.

9. By invoking the trope of the "magic picture," Wharton situates herself within a popular trend in Victorian fiction found in Mary Elizabeth Braddon's *Lady Audley's Secret,* H. Savile Clarke's "The Portrait's Warning" (1867–68), and Oscar Wilde's fin-de-siècle *Picture of Dorian Gray.* In Clarke's short story, a portrait envisions the tragedy that befalls its subject; the story was published in Braddon's *Belgravia* 4 (November 1867–February 1868, 429–37). Wharton seems to be engaging Wilde's novel, given Dorian's fear that his youthful portrait might someday mock him.

10. I thank Cathy Romagnolo for pointing my attention to *The Stepford Wives* and *M. Butterfly.*

11. For one of the many nineteenth-century representations of the myth, see Sir Edward Burne-Jones's *Pygmalion and the Image,* a series drawn from William Morris's retelling of the story in Ovid's *Metamorphoses.*

12. In the unpublished, undated Wharton poem originally titled "The Ghost Wife" and renamed "The Dead Wife," a woman's ghost expresses to her husband the wish to look into the home they once shared. This fragment, with the stories discussed here, suggests Wharton was concerned with who will speak for, and faithfully represent, the wife who is no more (the Lilly Library, Indiana University, Bloomington, box 8, notebook 2).

13. The reference to "keep[ing] watch beside a corpse" also reminds one of Poe's "Ligeia" (1838), in which a male narrator keeps a vigil beside his dead wife.

14. Enshrined beauty also surfaces as a motif in Wharton's *The Touchstone.* Glennard likens the body of his beloved Alexa to a "temple" and a "shrine" (105–6). He also associates the formidable Margaret Aubyn with a shrine (24). Wharton's emphasis on Glennard as a gazer with eyes "unseeing" serves to collapse and critique this reading. Wharton's Alexa may have been named for one of Rossetti's most recognizable models, Alexa Wilding, whose image was permanently enshrined in such works as *The Blessed Damozel* and *Monna Vanna.*

15. An unfinished tale by Rossetti suggests the Pre-Raphaelite read, and found a source in, Poe's "Oval Portrait." Rossetti's "St. Agnes of the Intercession" was begun in the late 1840s and partially revised in 1870. Rossetti's narrator is a poet-painter who,

charmed by the exquisite young Mary Arden, makes her his model and proposes marriage to her. The narrator describes the process of painting his beloved in a way that harkens back to Poe: "At this picture I laboured constantly and unwearily, my days and my nights; and Mary sat to me for the principal figure" (*Collected Writings* 402). The narrator's portrait of Mary is a dead ringer for a painting of Saint Agnes by the Italian artist Bucciuolo Angiolieri. The narrator travels to Bologna to see the painting, at which point he learns its unhappy history, which ties it to the Poe story: the model, whom the artist had adored, was, like Poe's heroine, dying as he painted her. In spite of her failing health, she insisted that he finish the portrait: "[F]or two days, though in a dying state, she sat with wonderful energy to her lover. . . . On the third day, while Bucciuolo was still at work, she died without moving. After her death, Bucciuolo finished the portrait" (415). After learning of this sorry fate, Rossetti's narrator sees a self-portrait of the Italian artist and identifies his own features in the picture. It is hard to say in what direction Rossetti intended to take this story, but we can speculate that, given the narrator's identification with the story of Bucciuolo and his beloved, his Mary may have been headed for a fate similar to that of the woman who posed as Saint Agnes.

16. Although Bronfen in her splendid *Over Her Dead Body* discusses the Poe tale, she does not address the sexual dimensions I cite.

17. In its treatment of female power, "The Moving Finger" looks forward to Wharton's "The Daunt Diana" (1909). In both tales men function as art connoisseurs and women as subjects of art. The stories are also connected by the fact that they recount a work of art's travels through various pairs of (male) hands and ultimate return to its owner. In "The Daunt Diana," a statue of a goddess presides in a similar way over an art collector, as the male narrator observes: "[S]he rules there at last, she shines and hovers there above him, and there at night, I doubt not, comes down from her cloud to give him the Latmian kiss" (60). Just as the mortal Endymion cannot be united with the moon goddess in Keats's telling of the myth (1818), so Wharton's men will never be joined with their mythologized beauties, for the women are not real.

18. Wharton's frigid duke may have been inspired by George Eliot's Casaubon from *Middlemarch,* a novel Wharton admired. For instance, he is a scholar "forever closeted in his library, talking with learned men" (10).

19. See, for example, 18, 21.

20. Evidently "since the Duchess had been left to herself, it was observed she *affected* a fervent devotion" to the relics of Saint Blandina, a second-century martyr and patroness of young girls (16; emphasis added). Wharton's duchess seems to rely on her faith as a pretext, and she dresses for her devotions as though she were welcoming a lover (22).

21. The story invites connections to Wharton's "Beatrice Palmato" fragment, a piece of erotica likely written between 1918 and 1919, subsequently marked "unpublishable" by Wharton, and ultimately discovered by Wolff in the Yale archives (Wolff, *Feast of Words* 407–15). The fragment, with its accompanying plot summary, narrates the tragic consequences of father-daughter incest. Wharton's Beatrice, a victim of incest, is described as "a musical and artistic child, full of intellectual curiosity," and it is instructive to note how many "artistic" Wharton heroines find themselves sexualized or made into art.

Given that Rossetti's ghost lingers throughout Wharton's fiction, the name "Beatrice Palmato" seems to have been inspired by Beatrice Portinari, the muse of Dante Alighieri with whom Elizabeth Siddall and Jane Morris are identified in Rossetti's work.

22. Jan Marsh has noted that in the nineteenth century, women's hair, traditionally kept up or braided, was let down only in the privacy of the home, and as such it instantly suggests intimacy (*Pre-Raphaelite Women*, 23, 48). Marsh's contributions to the study of the Rossettis, the PRB, and especially Pre-Raphaelite women (artists and models), are unmatched.

23. Like Browning's duchess, who had a "heart . . . too soon made glad," Wharton's duchess had been vibrant—"she was all for music, play-acting and young company," "always laughing" (10–11)—and she arouses the duke's jealousy and contempt. Browning's duchess becomes a painting concealed beneath curtains; Wharton's duchess is turned into a statue tucked away in the duke's chapel. Readers interested in Wharton's use of the gothic will want to consult Kathy A. Fedorko's excellent *Gender and the Gothic in the Fiction of Edith Wharton*.

Chapter 2

1. Maureen Montgomery notes that it was at the start of the twentieth century, when Wharton's novel is set, that photographs became a popular means of disseminating images of women in the press (59).

2. Insofar as she steps into, and not out of, a painting, Lily does precisely the opposite of what Terence Davies says of Gillian Anderson, cited at the start of chapter 1.

3. Smith, "The Academy and the Professional Model" (27). Smith also notes that the short supply of models' testimonies about their profession has compelled historians to rely on the memoirs and recollections of artists, "which collectively have reinforced assumptions about the link between models and prostitutes. Ford Madox Brown, for instance, used Julia Wyld, who was 'celebrated as a model and prostitute, also for her black eyes.' Whistler's Finette was described as a 'coquette,' and Ellen Smith, who sat for Rossetti and George Price Boyce, was known as 'a laundress of uncertain virtue'" (28).

4. Maureen Montgomery uses the example of Lizzie Hazeldean to point to Wharton's critique of a culture that compels women to prostitute themselves: "The ramifications of such a critique are to call into question the nature of marriage in such a society. Is not marriage itself a form of prostitution when so little choice is afforded women? . . . a society that prides itself on honor and respectability but that allows women little opportunity to provide for themselves bears responsibility for the prostitution of women" (37).

5. Wolff, "Lily Bart"; Fetterley; Lidoff; Showalter, "The Death of the Lady (Novelist)."

6. McCullough traces the history of this term by pointing to the advertisements for Dr. Collyer's series of tableaux that debuted in New York at the Apollo Rooms in 1847: "When he opened at the Apollo Rooms, the term, 'model personifications,' was used to designate his performances. As the run progressed the newspapers used 'living statuary,' 'model impersonations,' and 'living models' to describe the production. In his

advertising, Collyer consistently used the term, 'model artistes.' . . . When editors and other writers picked up the term, they dropped the last 'e,' stripping away the hint of French. 'Model artists' then became the common title for this kind of production and for the performers themselves. Furthermore, these entertainments were looked upon as 'exhibitions' rather than as acts or performances or shows" (23). Living pictures appear in nineteenth-century American fiction by Hawthorne (*The Blithedale Romance*), Oliver Wendell Holmes (*The Guardian Angel*), and Louisa May Alcott (*Behind a Mask* and *A Modern Mephistopheles*). For an excellent discussion of tableaux vivants in nineteenth-century American fiction and culture, see Chapman.

7. See McCullough 43–44 for a reproduction of the playbill. Special thanks are due to Jack McCullough for pointing my attention to Madame Warton.

8. Maureen Montgomery quotes the response that these "living pictures" on Bowery stages evoked from the *Town Topics* columnist known as "the Saunterer": "At present the youth of New York may gaze each night in the year upon female nakedness presented in the most tempting and sensual shape that ingenious men can devise. Under the name of art the most amazing visions of living, breathing, palpitating nudity . . . is deliberately spread before innocent eyes, and the moral damage thereby is, I maintain, beyond computing" (2).

9. William Merritt Chase, quoted in Fryer, "Reading," 31; originally quoted in the *Illustrated American,* October 1895.

10. *Miniature Stories of the Saints, Book Two* (New York: Francis J. Spellman, D.D. Archbishop, n.d).

11. Readers are enthusiastically encouraged to look for Susan Elizabeth Sweeney's forthcoming work on the Sleeping Beauty fairy tale and its compelling links to Wharton's Lily.

12. *To slosh* means to splash or spill, as in to (sloppily) slosh paint on a canvas.

13. George Ramsden lists Reynolds's *Fifteen Discourses* (1820) among the surviving texts in Wharton's library, and Wharton refers to the discourses in her novella *False Dawn*. The discourses preached many of the principles rejected by the PRB. Reynolds asserted that the "genuine painter . . . , instead of endeavoring to amuse mankind with the minute neatness of his imitations . . . , must endeavor to improve them by the grandeur of his ideas; instead of seeking praise, by deceiving the superficial sense of the spectator, he must strive for fame, by capturing the imagination" (Penny 30). Like William Blake before him, Rossetti "found himself profoundly out of sympathy with the murky tones and contrived highlights of the imitation [of] old masters which Reynolds's advocacy of the 'grand style' had popularized" (Nicoll 22).

14. This Reynolds painting captures a fancily dressed young girl with hands crossed demurely over her chest. Like the painting Lily reenacts in her tableau, this portrait of a (young) lady also depicts the female in profile and it places her in a natural setting that seems to have served Reynolds as a comfortable, liberating space for females. Reynolds's *The Age of Innocence* is reproduced in my article on Wharton's 1920 novel.

15. Reynolds's *Mrs. Lloyd* was exhibited at the Royal Academy in 1776 under the title *Portrait of a Lady, whole length*. It commemorates the marriage of Joanna Leigh, daugh-

ter of John Leigh of England's Isle of Wight, to Richard Bennett Lloyd of Maryland (1775) and was painted c. 1775–76 (Mannings 309). Nicholas Penny notes that "[t]he lady he depicted writing the name Lloyd on a tree was Mrs. Lloyd by the time the painting was exhibited but surely still Miss Leigh when she sat to Reynolds" (29); Mannings, however, claims that the portrait was painted after the engagement if not after the wedding. (One cannot be sure, as Reynolds's pocket books for 1774–76 are missing.) During Wharton's lifetime, the painting was exhibited at the Royal Academy in 1873 and 1887; it is possible she viewed it in person then or had access to it by way of its numerous copies (Penny 275–76). Terence Davies's recent film adaptation departs from the novel when his Lily enacts a tableau vivant of Watteau's *Summer*. To the (otherwise beautifully adapted) film's detriment, the camera focuses but a fleeting moment on this scene despite the fact that it is the literal and metaphorical center of Wharton's novel.

16. The term was Rossetti's. It was Rossetti who first used *stunner* to describe a pretty woman worth painting, with the other Pre-Raphaelites following suit. As Val Prinsep reflected, "we copied his very way of speaking. All beautiful women were 'stunners' with us" (Marsh, *The Pre-Raphaelites* 113).

17. See, for example, Whistler's *The Artist's Model Maud Reading in Bed* (1886) or *Note en rouge: La sieste* (Harmony in Red: The Siesta) (1884), both of which depict the artist's mistress, Maud Franklin (Walters Art Museum and Daniel J. Terra collection, respectively).

18. John Atkinson Grimshaw's *Elaine* (1877) and *The Lady of Shalott* (1878) serve as illustrative examples. Though not a card-carrying member of the Pre-Raphaelite Brotherhood, Grimshaw's paintings share with his contemporaries a fascination with the idea of a recumbent dead lady. For more on this trope, see Herndl.

19. Art historians have called the *Portrait of a Flemish Lady* a traditional Van Dyck. As a possible source for the Van Dyck, Fryer ("Reading *Mrs. Lloyd*") reproduces his *[Queen] Henrietta Maria with Her Dwarf* (1633), which is in fact a Van Dyck in *blue* satin. With the great exception of Fryer, heretofore the scholarship on this novel has not pursued the sources for the other paintings Wharton has carefully chosen for this scene nor has it considered them in contrast to Lily's tableau. Killoran's *Edith Wharton* briefly examines Lily's tableau but does not discuss the other living pictures (26). Fryer reproduces several images as possible sources but does not at length discuss them in contrast to Lily's tableau ("Reading" 34).

20. Meisler notes that there is little evidence of a consummated affair between Goya and the duchess, though for centuries their relationship was grist for the rumor mill, and it seems safe to infer from his paintings that he was in love with her. For all the numerous paintings of the duchess and other alluring women, there exists but one documented drawing by Goya of his wife, Josefa, and it captures her as a fifty-eight-year-old woman, "fleshy, weary and domesticated" (50). As the curator Francisco Calvo Serraller has noted, "Woman is goddess and witch for Goya, sinner and saint, lover and procurer, worker and aristocrat, mysterious and enigmatic, tender and maternal, greedy and, when necessary, as tough as a man" (Meisler 48).

21. The images of archery and youthfulness in this excerpt from George Eliot also

anticipate Wharton's May Welland, who is repeatedly aligned with Diana in *The Age of Innocence,* particularly in the archery scene. We find, then, in *Daniel Deronda,* more evidence of the intertextuality of Wharton's oeuvre. Judith Fryer also recognizes a literary precedent in *Daniel Deronda,* noting that Gwendolen impersonates Saint Cecilia for her tableau vivant; Fryer does not discuss Gwendolen's pose as Hermione, nor does she point to the scenes here invoked ("Reading" 29).

22. After the tableaux are complete, Lily "read, too, in his answering gaze the delicious confirmation of her triumph, and for the moment it seemed to her that it was for him only she cared to be beautiful" (220). Selden had seated himself as a spectator at the Welly Brys' home, "surveying the scene with frank enjoyment" (212).

23. Wharton offers ample material to support a reading of Lily as an artist. Selden, for instance, tells her, "You are an artist and I happen to be the bit of colour you are using today" (105). See Kaplan's discussion of Lily's artistic sensibilities.

24. Giovanni Battista Tiepolo, Italian rococo artist of the eighteenth century, painted several images of Cleopatra, the most famous of which is *The Banquet of Cleopatra,* in which she slips a pearl into her drink (1743–44, oil on canvas, National Gallery of Victoria, Melbourne).

25. Waid argues that Lily becomes a writer when she impersonates Mrs. Lloyd. Showalter, "The Death of the Lady (Novelist)"; Michaels; and Fryer, "Reading *Mrs. Lloyd*" focus on the detail of the pen-in-hand as support for their readings.

26. Wharton may have seen the 1871 oil painting exhibited at the Royal Academy in 1883 and the 1856 watercolor at the Burlington Fine Arts Club in 1881, the New Gallery in 1897, or more likely at the Tate in 1923 (source of provenance: *The Rossetti Archive*). *The Rossetti Archive,* edited by Jerome McGann, notes that Jane Morris sat for Beatrice in the 1871 version.

27. Rossetti's poem "Jenny," an interior monologue that concerns a golden-haired prostitute, is spoken in the voice of her most recent client, who watches her as she sleeps. The reader, then, joins the speaker in subjecting the woman to a voyeuristic gaze while her own eyes are unseeing.

28. Prostitution was considered by the mid-nineteenth century "the great social evil" that threatened to destroy society. As Jan Marsh notes, "It is difficult to find a rational explanation for this moral panic, since in reality prostitutes—vulnerable, outcast women from the lowest economic rank—posed no threat to the power structures of the day, but were indeed society's victims, at risk themselves from violence and disease. Nevertheless, the anxiety of the age was turned on the supposed hordes of 'circulating harlotry' that gathered on the streets, particularly in London's fashionable West End, in search of clients" (*Pre-Raphaelite Women* 77).

29. The source of the story's title and, apparently, the word *potboiler,* is found in Stanwell's remark: "Why can't a man do two kinds of work—one to please himself and the other to boil the pot?" (671). Late in her career, Wharton revealed in a letter to her agent Rutger B. Jewett (October 26, 1933) that she had difficulty appealing to the American reading public's tastes. She noted that it was beyond her "capacity" to "write down to the present standard" of the American pictorial magazines: "If I could turn out a se-

ries of pot-boilers for magazine consumption I should only be too glad to do so; but I really have difficulty imagining what they want" (quoted in Benstock, *No Gifts* 439). Although Wharton's comment suggests an inability to stoop to the level of potboiler fiction, her story seems to beg the question of why a *woman* can't do two kinds of work: one to please herself, the other to boil the pot. Clearly she produced many a story under the pressure of financial restraint. (See Benstock, *No Gifts* on the misconception that Wharton lived on a trust fund; in fact, the writer found herself writing to support not only herself but also some two dozen dependents.)

30. Wharton's audience likely would have recognized Sargent in Mungold. Sargent was at the top of his game at the time Wharton was writing, and there was ample opportunity for Wharton's set to interact with him. As Barry Maine has recently noted, Sargent painted some of Wharton's friends, including Margaret Rutherford White, wife to America's ambassador to England (*Mrs. Henry White*, 1883) and Mrs. Edward Boit and her four children, whom Sargent captured in a famous group portrait (8). In Wharton's "Autre Temps" (1911), being painted by Sargent signifies the highest social rank. Wharton seems to want to discourage her readers from thinking Mungold a stand-in for Sargent by alluding to Sargent elsewhere in the story. The gesture recalls Hawthorne, who in *The Blithedale Romance* models his unsympathetic Zenobia on Margaret Fuller but compares her sister, Priscilla, to the author of *Woman in the Nineteenth Century.*

31. Wharton would continue her engagement with the topic of prostitution in her novella *New Year's Day*, in which Lizzie Hazeldean, a married society woman, takes up with a rich man in order to support her dying husband, whom she loved. She candidly admits to her lover: "You thought I was a lovelorn mistress; and I was only an expensive prostitute" (*Old New York* 292).

32. This textual moment looks forward to Wharton's last completed novel, *The Gods Arrive*, in which the male protagonist examines his beloved "like an unfinished picture" (122).

Chapter 3

1. Other popular illustrators of the period include Charles Dana Gibson, famous for the "Gibson girl," and W. T. Smedley.

2. Doane has made sense of women's desire to commodify their own image. Doane argues that female narcissism is a consequence of the changes taking place in capitalist society, noting that commodity fetishism is "more accurately situated as a form of narcissism" (32).

3. A little-known detail about Josephine is that her real name was Rose until she met Napoleon: according to Erickson, Bonaparte renamed her Josephine when he took her for his own. Unlike the fictional Mary Anerton (whom the poet Rendle immortalizes as Silvia) or the real-life Elizabeth Siddall (whom Rossetti rechristens Siddal), Undine cannot be renamed by her admirer.

4. The issue of women's failure to procreate surfaces in Wharton. A good number of Wharton's heroines do not produce children for various reasons: consider the

childless Mary Anerton, the duchess at prayer, Mrs. Grancy, and Lily Bart. Undine Spragg reproduces but her son is a hindrance and she all but disowns him. The childless women stand diametrically opposed to Halo Tarrant, who appears at the end of Wharton's career—a woman who becomes the ultimate producer (of the male poet's child).

5. Wharton elaborates on these values in her remarks on women in *French Ways and Their Meaning* and also in her guarded autobiography *A Backward Glance*. Undine's failure on this score is clear, for example, in a scene wherein her new husband, Raymond de Chelles, reads in her presence: "At first he tried—as [her previous husband] Ralph had done—to tell her about what he was reading or what was happening in the world; but her sense of inadequacy made her slip away to other subjects, and little by little their talk died down to monosyllables" (317). Even after she scores her final victory and finds herself remarried to Elmer Moffatt, Undine "was not always happy. She had everything she wanted, but she still felt, at times, that there were other things she might want if she knew about them" (368–69). And once she discovers that what she really wants—"the one part she was really made for"—is to be an ambassador's wife, she learns that her status as a divorcée disqualifies her from the running (370).

6. Ralph Marvell and others ridicule "the egregious Popple" for his excesses and his posturing (23, 45, 63, 119). Mrs. Fairford calls his painting "chafing-dish art." Additionally, Popple enjoys the same kind of popular contemporary fiction that Undine prefers: "The mastery with which Mr. Popple discussed the novel of the day, especially in relation to the sensibilities of its hero and heroine, gave Undine a sense of intellectual activity which contrasted strikingly with Marvell's flippant estimate of such works" (119).

7. Undine's red-gold hair is more than once described as having been captured "rippingly" by Popple's brush (118); the adverb's violence recalls the aggressive nature of the male artist's creative process in "The Duchess at Prayer" (a statue functions as a means to contain a woman's too-liberal sexuality) and "The Potboiler" (a painting serves to "block in" a woman's face).

8. Wolff (*Feast of Words* 113) and others have drawn a link between Popple and the most widely sought society portraitist of Wharton's day.

9. Popple lays out an impressive spread for his guests when he offers a viewing of Undine's portrait: "an elaborately furnished tea-table flanked by the most varied seductions in sandwiches and pastry" (117); further, Popple shamelessly compares his work to a seduction: he tells Peter Van Degen that "the artist, you understand, sees all this as a pure question of colour, of pattern; and it's a point of honour with the *man* to steel himself against the personal seduction" (118). But Popple seems to concede that his (artistic) seduction takes the place of romancing women: "'Passion,' the artist implied, would have been the dominant note of his life, had it not been held in check by a sentiment of exalted chivalry, and by the sense that a nature of such emotional intensity as his must always be 'ridden on the curb'" (119).

10. Undine is responsible for commissioning her portrait and for providing her wardrobe. Once the portrait is unveiled, Undine remarks, with utter disbelief: "'*I* have to pay for being painted! He'll [Popple] tell you he's giving me the picture—but what do you suppose this cost?' She laid a finger-tip on her shimmering dress" (118).

11. Admiring Popple's work, Peter Van Degen seems to speak for Undine's circle when he categorically dismisses realism as a mode of representation: "Those big chaps who blow about what they call realism—how do *their* portraits look in a drawing-room? Do you suppose they ever ask themselves that? They don't care—they're not going to live with the things!" (122).

12. For instance, Rossetti translated the work of Fazio degli Uberti (1326–60) for his *Early Italian Poets* (1861). One poem, which inspired Rossetti's sensuous painting titled *Fazio's Mistress* (1863), catalogues a lady's beauty, celebrating each lovely part: "I look at her *white easy neck,* so well / From shoulders and from bosom lifted out" (quoted in Wilton and Upstone 100; emphasis added). Like Undine, Fazio's mistress is an auburn-haired vixen who ensnares men by her beauty: "Not one can have display'd / More power upon all hearts than this one doth; / Because in her are both / Loveliness and the soul's true excellence" (99–100). And yet Undine, named, perhaps, for the beautiful but soulless water nymph of classical mythology, lacks the soul that is celebrated in the Fazio poem and the Rossetti painting.

13. Rossetti's *La Pia de' Tolomei,* for which Jane Morris modeled, depicts a scene from Canto V of Dante's *Purgatorio,* in which Dante relates his meeting with Pia de' Tolomei of Siena, a woman sentenced by her husband to "a fortress of the Maremma, where she pined and died of malaria, or, as some say, by poison. . . . On her features are no signs of animation, or hope, or care for existence, still less of a desire to battle for life" (F. G. Stephens, quoted in Lang 530–31, note on plate 6). Thus, Rossetti's image captures another woman bereft of agency relegated to a patriarchal trap. The story of Pia de' Tolomei is linked to this discussion in another important way: in "The Muse's Tragedy," one of the Rendle poems inspired by Silvia is titled "Pia Tolomei" (67).

14. For Ralph, Undine's hand weighs heavily with meaning: "It was small and soft . . . , a puff-ball of a hand—not quick and thrilling, *not a speaking hand,* but one to be fondled and dressed in rings. . . . Ralph had never before felt more convinced of his power to write a great poem; but now it was Undine's hand which held the magic wand of expression" (88–89; emphasis added). To him, Undine's hand can hold the male artist's "wand of expression"—can endow him, as any good muse would, with the "power to write a great poem"—but for her own pursuits they remain useless. The mythological figure of Undine was prominent in the visual arts of the turn of the century and came to be identified with the trope of the castrating female: "Figures such as Lorelei and Undine completed this gallery of marine enchantment. These predatory mythological females must be placed in the context of a world in which physicians advised against too frequent intercourse because women robbed men of their sperm during copulation" (Kestner 44). But, much to his detriment, Ralph misreads the significance of Undine's name. Just as he's been musing on its appropriateness—he reads her as the water sprite for which he assumes she has been named—he learns from her mother that she in fact was named for "undoolay," French for crimping hair (50).

15. Beauty enthroned also manifests as a theme in Wharton's *The Touchstone.* In an early scene, Glennard in his sitting room reads a photo of his beloved Alexa Trent in a frame—the very frame where a picture of Margaret Aubyn, the woman who had unsuc-

cessfully loved him, "had so long throned in its stead," a displacement that suggests the ease with which Glennard demotes one woman at the expense of another (11): "She looked like a throned Justice by some grave Florentine painter" (12). Glennard's conception of his enthroned beloved resonates with the popular renderings of time-honored American values (for example, "Columbia," "Liberty," "Justice") at the turn of the twentieth century. Banta examines American history from the 1870s through the 1920s, a period during which "a canon of types remained prominently in view" (xxxi): " 'Woman' and 'American' coalesced around the types of desire and fear that underlay the very formation of that culture" (xxviii–xxix).

16. For purposes of consistency, this chapter refers to Wharton's protagonist as Bessy Paul, even though Wharton's narrative frequently interchanges the name with "Mrs. Fingall" and "Mrs. Paul." Before she was Mrs. Fingall or Mrs. Paul, she answered to the name of Miss Bessy Reck.

17. Josephine Withers notes that these sorts of academies were "an extension of the 'female accomplishments' cultivated by the middle and upper (white) classes, and not at all intended for professional development" (letter to the author, September 28, 2002).

18. Christina Rossetti knew something of the artist-model relationship as an observer and as a participant, having posed as the Virgin Mary for her brother Gabriel early in his career. Her poems "Beauty Is Vain," "After Death," and "Sleeping at Last" suggest an acute awareness of the destructive power of representation.

19. In addition to Siddall and Morris, Rossetti's models include Fanny Cornforth, Annie Miller, Alexa Wilding, and Marie Spartali who, like Siddall, was an accomplished painter.

20. Among the entrapped or disempowered female figures for which Jane Morris modeled are the following: Pandora (1869), Silence (1870), La Pia de' Tolomei (1868–81), Beatrice (1859), Desdemona (1881), and Mariana (1870).

21. James visited Rossetti's studio in 1869, was impressed by his artwork, and eventually made his home on the same historic Chelsea street where Rossetti lived after Siddall's death in 1862. Rossetti lived at number 16 Cheyne Walk and died in 1882; James lived at number 21 Carlyle Mansions on Cheyne Walk from 1913 until his death in 1916. James had lived in London since 1886. Wharton's frequent visits to England would have afforded her many an occasion to wander in the footsteps of the Pre-Raphaelites.

22. In the Tennyson ballad to which James refers, Oriana is described as having a "pale, pale face so sweet and meek. . . . Thou smilest, but thou dost not speak." This seems to be the only reference to the "mouth like the 'Oriana' " to which James compares Jane Morris. James's point, then, is to compare the quiet, melancholy Jane to the silent, meek maiden of Tennyson's ballad. James further noted that, in meeting Jane Morris in the flesh, he found it difficult to distinguish her painted image from her actual self: "It's hard to say whether she's a grand synthesis of all the Pre-Raphaelite pictures ever made—or they a 'keen analysis' of her—whether she's an original or a copy." Regardless, he confessed: "In either case she is a wonder" (quoted in Mancoff 62). James, then, taps into the tension between being an original and a copy that Wharton describes in her discussions of Undine Spragg and Lily Bart.

23. Rossetti romanced and worshiped Jane Morris through his art. Despite (or because of) the fact that she was married to William Morris, his artistic peer, Rossetti desired to possess her. Jane Morris dominated Rossetti's art from 1866 until his death in 1882. "Although it was regarded as strange, her beauty became a sensation. Knowing her only through Rossetti's portraits, women began imitating her style, her manner of dress, her languid grace and sultry expression. . . . Even today, we see Jane Morris through the enhancement of Rossetti's painting. She has remained an icon of romantic beauty: enigmatic and distant, evocative and strange" (Mancoff 3).

24. Provenance history available at *The Rossetti Archive* online.

25. For more on Wharton's admiration of Paget, who published under the name Vernon Lee, see Wharton, *Edith Wharton* (Wegener's edition).

26. For further discussion of the trope of the nineteenth-century female invalid, see Herndl.

27. Discussing Rossetti's *Beata Beatrix* (1864–70), Pearce draws the important connection between this image of a woman who has been denied ("death disguised as romantic denial") and its modern-day analogue, anorexia nervosa, "not simply in the sense of becoming thin, but of becoming less; becoming less, psychologically as well as physically, so that we end up as simply a flattened outline, a romantic shape in which to pour the requisite dreams. Because it is the hazy, two-dimensional outline of Rossetti's Beatrice that post-1960s consumerism has aspired to; it is the cleanness of line, the flatness of flesh, that women are encouraged to desire for, and of, themselves. To this extent Beatrice is no more and no less than a fashion plate in *Vogue;* it is simply that she comes in poster form that she is suitable to hang on walls" (51–52).

28. See Olin-Ammentorp's excellent essay titled "Edith Wharton's Challenge to Feminist Criticism."

29. By naming him Mr. French, Wharton begs the question of whether this character represents something she recognizes in French culture. Quite possibly he is so named because he embodies that which Wharton ultimately disliked about the 1920s Paris scene—the crowds, the noise, the (much younger) "lost generation" whose presence pushed her to retreat to the country.

30. Waid notes that "A Moment's Ornament" and "The Year of the Rose" were considered as titles for the novel. Discussing *The House of Mirth,* Goodwyn observes that the phrase "a moment's ornament" takes its origin from the Wordsworth poem "She Was a Phantom of Delight" (57). Though critics have noted the poem's connection to the 1905 novel, they do not discuss its relevance to "The Temperate Zone."

31. Woman as an inexhaustible reservoir looks back to Wharton's Mrs. Grancy of "The Moving Finger" who "acquired the charm which makes some women's faces like a book of which the last page is never turned. There was always something new to read in her eyes" (156). The comparison also recalls the derisive comment made by Harold Harbard to Ivy Spang in Wharton's "Writing a War Story," which likens women to "inexhaustible" subjects for poetry.

32. The *Pictorial Review* was a slick, widely circulating American women's magazine that paid contributors well. It was founded in 1899 as a house organ of Albert McDow-

ell's System of Dressmaking and Tailoring, which would explain the emphasis on fashion in the illustrations discussed (Wright, *Edith Wharton A to Z*). Wharton published several stories and serialized novels in the magazine after World War I (for example, *Age of Innocence, Glimpses of the Moon, The Mother's Recompense, Twilight Sleep, The Children*).

33. Latham's excellent study reproduces a popular cartoon mimicking what came to be understood as "proper" flapper posture which, essentially, is a glorified slouch.

34. The editors of the *Pictorial Review* collaborate with Wharton's text in pointing to the commodification of women, even creative women. Alongside Wharton's story appears an advertisement for the latest scent from Parfumerie Rigaud, located on the fashionable Rue de la Paix in Paris, which Bessy Paul is known to frequent. The ad features a photo of Mary Garden, "the famous opera artiste" whose popularity has been commemorated by a "seductively fascinating" perfume deemed "utterly irresistible to men." So this celebrated artist's name and face are being used to help (American) women seduce men.

35. Wharton depicts Halo as a smart woman who appreciates and understands good art (she introduces Weston to Coleridge) and recognizes a sham. For instance, in the example of Mr. Alders, Halo identifies a "roving American with a thin glaze of culture over an unlettered origin, and a taste for developing in conversation theories picked up in random reading, or evolved from an imperfect understanding of art and history" (45–46). Because this chapter's discussion is concerned with the representation of Halo as Vance's muse, it focuses primarily on the second of the two-part series, *The Gods Arrive*, which grants us access to their rapport and carries us through to its destination.

36. Vance cannot stomach Halo's suggestion that he may have been overly influenced by current literary trends (343). It seems Halo's reading of the book's inadequacy is on the mark: when his *Colossus* comes out, the consensus is that "it was much too long, nothing particularly happened in it, and few people even pretended to know what it was about" (355), a review that bears a striking resemblance to the criticisms leveled at James's later novels, which Wharton found unbearably dull. Readers interested in Wharton's response to James will likely appreciate her playful story, "Velvet Ear Pads" (itself a jab at "the Master" for his literary unkindnesses in his "The Velvet Glove").

37. The second paragraph of *The Gods Arrive* notes that Halo Tarrant, who is married to, but estranged from, Lewis Tarrant, has "unseeing eyes" and a "short-sighted gaze" (3); elsewhere she is described as having "short-sighted eyes" (36).

38. Unlike Wharton, some women writers have imagined an empowered Eurydice who talks back. For example, the twentieth-century poet H.D., from the perspective of Eurydice, renounces Orpheus. The contemporary poet named alta finds inspiration and affirmation in the figure of Eurydice. In Rachel Blau DuPlessis's poem "Eurydice" (1980), the muse rejects Orpheus in the interest of exploring her own creativity (DeShazer 37).

39. Vance reads Halo as both a toy and a work of art: "[W]hen I go away anywhere I always shut up the idea of [Halo] in a box, as if she were a toy; or turn her to the wall, like an unfinished picture" (122). Vance's equation of Halo with an "unfinished picture" suggests that there is something in Halo, as there is in Kate Arran ("The Potboiler"), that

prevents her from being killed into art. Vance also reads Floss Delaney as a "marble statue" (390); here he is gazing at Floss at a dinner: "She wore a dress of some thin silver tissue, against which her arms and shoulders looked like sun-warmed marble" (241). Elsewhere he reflects on "her statue-like calm" (379). In *Hudson River Bracketed*, Wharton's narrator playfully describes Vance musing on the memory of a brief fling with Floss, thinking "big manly thoughts about her, and about Woman in general" (21). This kind of editorial remark makes it difficult to imagine that Wharton endorses Vance's sexist attitudes toward women.

40. Ramsden's catalogue of Wharton's library provides an interesting insight into the meaning of pegs and books for Wharton. In a copy of Hazlitt's essay "On Reading Old Books," Wharton marked the following passage as significant: "[Books] are landmarks and guides in our journey through life. They are pegs and loops on which we can hang up, or from which we can take down, at pleasure, the wardrobe of a moral imagination, the relics of our best affections, the tokens and records of our happiest hours" (xiii).

41. Wharton here looks forward to what Singley and Sweeney compellingly identify as "anxious power" in women's writing.

42. The final scene of Alcott's novel celebrates a female community charged by the promise of a new generation, signified by the protagonist's young daughter. Cather's "Old Mrs. Harris" similarly looks forward to a new era in which women, in the example of the young Vickie Templeton, will forge into the male-dominated sphere of achievement and intellect.

43. James's heroine is described as follows: "It was in her nature to be easily submissive, to like being overborne"; she is "the sweetest flower of character . . . that ever bloomed on earth" (*Bostonians* 337, 108).

44. In *Emile; or, On Education* (1762), Jean-Jacques Rousseau emphasized the innate passivity and weakness of females. In his section on the education of Emile's female counterpart, Sophie, he asserted that "[i]f woman is made to please and be subjugated to man, she ought to make herself pleasing to him rather than to provoke him; her particular strength lies in her charms; by their means she should compel him to discover his own strength and put it to use" (44). Wharton, then, seems to be directly engaging Rousseau insofar as Halo's charm evidently invigorates Vance's art. I thank Jaime Osterman Alves for bringing the Rousseau passage to my attention.

45. In *French Ways and Their Meaning*, Wharton notes that in France, "no woman can force her way into the talk by mere weight of book-learning" (and surely Undine Spragg learns this lesson). "She has no place there unless her ideas, and her way of expressing them, put her on an equality with the men; and this seldom happens" (25). Clearly Halo possesses the intellectual gifts to class herself among that select circle of women.

46. Although Wharton alludes to a Poussin painting called *Poet and the Muse*, Killoran helpfully notes that Wharton likely refers to his *Inspiration of the Poet* (1636). Killoran identifies and reproduces the painting but does not discuss its details (*Edith Wharton* 163).

Chapter 4

1. Beatrice Winser directed the Newark Museum after the death of its director (John Cotton Dana) in 1929 (Taylor 15). This museum in particular was unusual in that from Winser onward, all of its directors were women. The Baltimore Museum of Art also has a long history of female directors. Women have, of course, become more prominent in art museums over the past century. In the year 2004, for instance, Susan Edwards was appointed executive director of Nashville's Frist Center for the Visual Arts.

2. Edith Wharton, of course, was *not* of the middle class but rather of the upper class, old New York society, and so writing was anathema to her family's set.

3. Jane Mitchell Thompson Walters, quoted in gallery guide to Walters Art Museum, formerly the Walters Art Gallery, 2001.

4. Wharton closely examines this ritual in the novella *False Dawn*.

5. De Morgan (1855–1919), born Evelyn Pickering, was influenced by the work of Rossetti, Burne-Jones, and George Frederic Watts, with whom she had a close friendship. Watts described her as being "a long way ahead of all the women and considerably ahead of most of the men," adding, "I look upon her as the first woman-artist of the day—if not of all time" (quoted in Wilton and Upstone 231). The image is found in Marsh, *Pre-Raphaelite Women* (153).

6. Consider the examples of Elizabeth Siddall and Marie Spartali Stillman, both of whom served as Pre-Raphaelite models and painters in their own right. Of the young Marie Spartali, who studied under Ford Madox Brown and exhibited at the Dudley Gallery, Swinburne reportedly said, "She is so beautiful that I want to sit down and cry" (Spencer 84n44). Stillman's 1895 painting titled *Beatrice*, in which the subject appears contemplative, with book in hand, might be read as a feminist revision of Rossetti's *Beata Beatrix;* Stillman's painting *Mariana* (1867–69) similarly suggests a reworking of Millais' well-known picture by the same name.

7. The trope of the hand surfaces elsewhere in Wharton. Since her youth, Wharton was known for having restless hands. Her most recent biographer notes that she "never outgrew this physical restiveness; in adulthood, she knitted, tatted, or fussed with a cigarette while others talked" (Benstock, *No Gifts* 33). It is thus understandable that she would weave into her art the hand as a signifier for (female) power and authority.

8. In chapter 2 of his study of William Blake, Swinburne notes that the "result of having good art about you and living in a time of noble writing and painting" is that the "spirit and mind of men" should receive "a certain exaltation and insight caught from the influence of such forms and colours of verse or painting" (Spencer 61).

9. Pater praised Rossetti as the most original poet of his age. See Pater's "Dante Gabriel Rossetti" (1883; available online at *The Rossetti Archive* <http://www.rossettiarchive. org>. 1889).

10. John Ruskin, whose work Wharton knew well, weighed in on the meaning of Circe. Ruskin noted that the "power of Circe . . . is that of frank, and full vital pleasure, which, if governed and watched, nourishes men; but, unwatched, and having no 'moly,'

or bitterness or delay, mixed with it, turns men into beasts, but does not slay them. . . . She is herself indeed an Enchantress;—pure Animal life" (Kestner 29).

11. National Gallery of Art curator David Alan Brown notes that for Leonardo, "hands were a central means of expression. Look at *The Last Supper,* with the apostles gesturing. For him, hands were as important as the face to create expression, and that element was missing from [Leonardo's painting of] Ginevra" (*Smithsonian,* September 2001, 68).

12. As such, Sybilla looks forward to Judith of Wharton's *The Children,* who is described, through Martin Boyne's gaze, as bearing a "dull droop of [the] mouth" and a "pale complexion which looked dead when unlit by gaiety" (38). Judith is ultimately sexualized and objectified by Boyne, who is of the age to be her father.

13. Wharton's reference to the Renaissance painter (Giovanni Antonio Bazzi) who answered to the name "il Sodoma," Italian for "the Sodomite," stands as further indication of Wharton's engagement with aestheticism in this tale. Sodoma was championed by the poet Swinburne and by the homosexual painter Simeon Solomon, both key figures in the aesthetic movement. Prettejohn discusses the Victorian "homosexual code" associated with Pater, Solomon, and Swinburne (*Art of the Pre-Raphaelites* 46).

14. The church displays at least two of his Saint Catherines, and Wharton seems to refer to the more esteemed *Swooning of Saint Catherine,* aka *Saint Catherine Supported by Her Sisters;* Wharton invokes its companion, *The Ecstasy of Saint Catherine,* in *The Touchstone.*

15. Saint Catherine was known as a woman of letters, given her active correspondence with Pope Gregory XI (she urged him to work for Italy's peace) and with various princes and leaders and was known for her own "celebrated mystical work, written in four treatises, known as the 'Dialogue of St. Catherine'" (Walsh 127). She died at age thirty-three, was canonized in 1461, and was made a doctor of the church in 1970. Thank you to Theresa Coletti for her insight into Saint Catherine.

16. Donovan draws important links between this Wharton tale and Mary Wilkins Freeman's "A New England Nun," reading it as a "negative version" of the Freeman tale (*After the Fall* 53). Donovan also alludes to Freeman's "A Poetess" (1891), with which "The Angel at the Grave" begs comparison: "Like Betsey Dole's work in Freeman's 'A Poetess' . . . , Paulina's book is rejected by patriarchal authorities" (53). But in contending that the Wharton tale "ends, however, on a twist that the local colorists would never have entertained," Donovan overlooks a rich opportunity to note the similarities between the message of "A Poetess" and that of "The Angel at the Grave." In both cases, attaching oneself to a male authority figure is the closest an aspiring woman writer gets to publication. Although White duly notes that Paulina resembles such cloistered women as the duchess at prayer, Wharton makes it clear Paulina does not at first feel as constricted as she might in her "bleak temple of thought" (133). Paulina feels both free and restricted at various points in the story.

17. This tale may have been inspired by Wharton's reading of George Eliot's *Romola,* which similarly documents a daughter's allegiance to her father's legacy.

18. Thanks are due to the staff at the library of the National Gallery of Art, Washington, DC, for assistance in tracking down the Morghen engraving.

19. Waid reads the union as "an affirmation of the benevolence of paternal authority" (*Edith Wharton's Letters from the Underworld* 115). Wolff argues that Royall "*does* offer a finite but attainable form of fulfillment. . . . Royall is willing to assist Charity in the transition from a love that is extra-social . . . to a love that contains both passion and affection—both some element of freedom and some appropriate component of mutual dependency. In short, he offers her maturity and the only kind of happiness that can span a lifetime" ("Cold Ethan" 112–13).

20. Wharton's hypersexualized description of the text (limp, weakly) anticipates Harney's exposure as a man who lacks the courage of his convictions to break his engagement in order to be with Charity, whom he professedly loves. Further, the book's tendency to slip back and disappear looks forward to Harney's abandonment of Charity, in the Old Home Week episode, the duration of which he spends hidden behind a screen, shielding himself from Charity's discovery of his attachment to Annabel Balch.

21. Thank you to the students of my Wharton, Larsen, Hurston course for their insightful observations on Harney's spending habits.

22. The comment anticipates May Welland's fawning deference to Newland Archer's connoisseurship in *The Age of Innocence*: "I do love you, Newland, for being so artistic!" (83). The allusion suggests that, like May, Eleanor knows how to feign awe in order to get what she wants from men. The narrator observes that Eleanor's "calling me artistic fatally connotes the request to visit, in her company, some distressed gentlewoman whose future hangs on my valuation of her old Saxe or of her grandfather's Marc Antonio's. . . . It is not always easy for the curator of a museum to abandon his post on the plea of escaping a pretty cousin's importunities" (287).

23. Mrs. Fontage tells the narrator that the painting was previously owned by an old Belgian countess and before that, a wealthy English duke who was "a great collector and had a famous Highland castle, where somebody had been murdered" (290).

24. Mrs. Fontage further manipulates when she encourages others to sympathize with her unfortunate circumstances: "I shall have to leave here, you know . . . if nobody cares to have it" (294).

25. The narrator secures for the Met the "Bartley Reynolds"; the most recent catalogue of Reynolds's work makes no mention of such a painting.

26. See Moers, especially her chapter on traveling heroism, which discusses female travel in gothic texts.

27. In "The Fullness of Life" (1893), Wharton's protagonist observes, "I have sometimes thought that a woman's nature is like a great house full of rooms: there is the hall, through which everyone passes in going in and out; the drawing room, where one receives formal visits; the sitting room, where the members of the family come and go as they list; but beyond that, far beyond, are other rooms, the handles of whose doors perhaps are never turned; no one knows the way to them, . . . and in the innermost room, the holy of holies, the soul sits alone and waits for a footstep that never comes" (14).

28. Toward the end of her life, Wharton saw herself as an "incorrigible life-lover and

life-wanderer and adventurer" (1936 letter to Mary Berenson, quoted in Benstock, *No Gifts* 449).

29. The allusions to Poe are many. First, the house's name recalls the Poe poem titled "Bells." And the secret kept within—concerning a woman's live interment in a house— looks back to Poe's "The Fall of the House of Usher" and "The Premature Burial." The tale involves "letters purloined"—an obvious nod to Poe's "The Purloined Letter." The portrait of Juliana, whose "long fair oval looked out dumbly, inexpressively, in a stare of frozen beauty," calls to mind Poe's "The Oval Portrait" (184). Finally, Wharton draws an allusion to Poe's aunt (and the mother of his consumptive young bride, Virginia Clemm) in naming her custodian "Mrs. Clemm."

30. Wharton's tale makes several noticeable allusions to Charlotte Brontë's *Jane Eyre* (1847): (1) the socially unfit, unsuspecting woman married for her money and shut up in her husband's house recalls Bertha Mason Rochester; (2) the name Edward Stramer invokes Edward Rochester, the last name a partial anagram for "master," by which Rochester is known to Jane; (3) in naming her heroine Jane, Wharton instantly summons up the most famous governess of Western literature; and (4) the gothic elements that resonate throughout Wharton's tale pay homage to Brontë's novel. Importantly, Wharton makes a rather progressive and unromantic twist on the "Reader, I married him" plot, thus reinscribing her status as an intertextual realist.

31. By weaving in the theme of female strangulation, Wharton connects her project to the work of her contemporaries Charlotte Perkins Gilman ("The Yellow Wallpaper," 1892) and Susan Glaspell (*Trifles,* 1916). (Gilman's narrator recognizes on her papered walls "a broken neck and two bulbous eyes," suggestive of the strangulation of her creativity. In Glaspell's play, two women discover that a neighbor's husband has strangled her pet bird in an act of cruelty that mirrors the breaking, and suffocation, of the wife's spirit.) The strangulation of women—at a time when they were increasingly present in the workforce and in higher education—was evidently a topic that carried much currency. In D. H. Lawrence's novel *Women in Love,* published eight years before Wharton's tale, Gerald attempts to strangle his artist-lover Gudrun (allegedly a stand-in for Katherine Mansfield), which we can read as a gesture to suffocate and silence the increasingly powerful New Woman—in this case, a New Woman artist. Wharton's project anticipates the recent Robert Zemeckis film *What Lies Beneath* (2000), which tells the story of a woman's acquisition of a house that had belonged to her husband's scholar-father. Michelle Pfeiffer's Claire Spencer, like Lady Jane, has a hand in uncovering the story of a woman betrayed and drowned by her lover (Claire's husband) in a way that suggests the timelessness of Wharton's story. At the film's end, Madison Elizabeth Frank gets a proper burial. Like Juliana's, her voice is channeled by another woman and her story can at last be told.

32. Showalter makes a similar point about Lily Bart's death in her essay "The Death of the Lady (Novelist)." Showalter reads Lily's passing as symbolic of Wharton's death as a "lady novelist," which led to her transformation into an artist who would "create the language of feminine growth and mastery in her own work" (7). Showalter sees the ending as suggestive of "a new world of female solidarity" (20).

Chapter 5

An earlier version of this chapter appeared in *American Literary Realism (1870–1910)* 30 (Winter 1998).

1. Images of beautiful female corpses were produced by such painters as Homer Watson, Edmund Blair Leighton, Briton Riviere, Robert Gibb, Walter Crane, Arthur Hughes, John William Waterhouse, Atkinson Grimshaw, Edward Henry Corbould, Henry Wallis, and Robert Scott Lauder. For more on this topic, see Poulson.

2. The stark contrast between Ellen Olenska and the early-twentieth-century "material girl" Undine Spragg is noteworthy. Ellen's aunt, Medora Manson, conveys privately to Archer her utter disbelief that Ellen would sacrifice the financial perks of her marriage to a count: "[O]n the material side, Mr. Archer, if one may stoop to consider such things; do you know what she is giving up? . . . Jewels—historic pearls: the Sobieski emeralds—sables—but she cares nothing for all these! . . . And she had it all; and the homage of the greatest. She tells me she is not thought handsome in New York—good heavens! Her portrait has been painted nine times; the greatest artists in Europe have begged for the privilege. Are these things nothing? And the remorse of an adoring husband?" (160–61). While "these things" would surely satisfy Undine, they are not enough to lure Ellen back to a loveless, lifeless marriage.

3. Wharton notes: "The difference is that in France almost every one has the seeing eye, just as almost every one has the hearing ear. It is not a platitude, though it may be a truism, to say that the French are a race of artists. . . . The gift of the seeing eye is, obviously, a first requisite where taste is to prevail. And the question is, how is the seeing eye to be obtained?" (52–53). Wharton discredits any attempts at acquiring this finer sensibility through higher education, and it is here that we can begin to understand (if not accept) her disdain for college instruction and her distrust of university education for women: "As long as America believes in short-cuts to knowledge, in any possibility of buying taste in tabloids, she will never come into her real inheritance of English culture. . . . It is the pernicious habit of regarding the arts as something that can be bottled, pickled and absorbed in twelve months (thanks to 'courses,' summaries and abridgments) that prevents the development of a real artistic sensibility in our eager and richly endowed race" (55).

4. For an enlightened discussion of Wharton's Archer, see Kress, chapter 6 ("The Price of a Conscious Self in Edith Wharton's *The Age of Innocence*").

5. Moseley writes that Archer "has a Faustian thirst for knowledge; he reads all the new books on anthropology which enable him to see his own society in its proper perspective of time, but there is no faculty for translating his relativistic attitudes into action" (157).

6. The extended title is "Euphorion: Being Studies of the Antique and the Medieval in the Renaissance"; Vernon Lee is the pseudonym of Violet Paget, essayist and novelist. Henry James, Wharton's close friend and colleague, did not respect this writer's work. Although Wharton of course held opinions independent of James, the latter's disdain for

Lee's work is useful to our understanding of Wharton's intertextual project. Wharton praises Paget's work in her letters and memoirs.

7. While Ruskin and the Pre-Raphaelites, in the 1840s, had sounded a cry for "truth to nature," Walter Pater and the proponents of aestheticism appealed for "art for art's sake" (Asleson 115). See chapter 4 for Wharton's subtle critique of Pater and aestheticism.

8. In chapter 9, Archer draws on his command of Dante and Petrarch to speak with Ellen's Sicilian housekeeper.

9. Like all of Wharton's intertextual moments, the placement of Swinburne's *Chastelard: A Tragedy* (1865) in Archer's hands is no accident. The links to Archer's obsession with Olenska are noteworthy: "Dramatic tension in the play is generated almost exclusively by the dynamic and suicidal passion of the hero for the dark and capricious heroine. . . . When the object of his passion proves inaccessible and viciously changeable, his commitment to the ideal supersedes his passion for the beloved" (Anthony H. Harrison, *Swinburne's Medievalism: A Study in Victorian Love Poetry* [Baton Rouge: Louisiana State UP, 1979], 43). Swinburne's verse was considered quite scandalous, often engaging the trope of the femme fatale: "His female figures are sensual and desired, but they are also lamias, exquisite tormentors, and penal hierophants" (Pat Rogers, ed., *The Oxford Illustrated History of English Literature* [New York: Oxford UP, 1990], 362). Some contemporary critics labeled him "Sin-burn" in light of the salacious nature of his poetry. He was closely associated with Rossetti and the Pre-Raphaelite circle at Oxford and shared a home with Rossetti, George Meredith, and William Rossetti after the death of Lizzie Siddall (Daly 345). See also the discussion of Swinburne in chapter 4.

10. Wharton very much admired George Eliot's *Middlemarch,* as evidenced by her review of Leslie Stephen's biography of Eliot (1902), but Archer doesn't seem terribly impressed by it. Perhaps he would not have liked what he found in its pages. In chapter 22, for instance, Eliot's knowing narrator remarks: "The remote worship of a woman throned out of their reach plays a great part in men's lives, but in most cases the worshipper longs for some queenly recognition, some approving sign by which his soul's sovereign may cheer him without descending from her high place" (199). Archer, "the worshipper," as we shall see, does not get the "approving sign" that he seems to seek from his respective "throned" woman.

11. As Mancoff notes in her recent study of Jane Morris, "Through his art, Rossetti courted her and worshiped her. Despite the fact that she was married to another man, he sought to possess her. From 1866 until his death in 1882, Jane Morris was the dominant subject of Rossetti's art. He painted her as medieval queens and classical goddesses. Her sultry features graced his portraits of the beautiful women of poetry, theater, and ancient mythology. . . . Like Shakespeare's captive *Mariana* . . . , she appeared before him as the spirit of desire denied" (3).

12. Here is another noteworthy moment in which Archer reads Ellen as a kind of Pre-Raphaelite stunner: "[F]or a moment they continued to hold each other's eyes, and he saw that her face, which had grown very pale, was flooded with a deep inner radi-

ance. His heart beat with awe: he felt that he had never before beheld love visible"
(313). Wharton's description invokes Rossetti's image of Jane Morris titled *Water Willow*
(1871).

13. Daniel Day-Lewis, in Scorsese's (superb) 1993 film adaptation, demonstrates
Archer's relationship to books by stroking the Rossetti text as he sits in his library. For
a fleeting moment, Scorsese's camera zooms in as Archer reads a note from Olenska
(Michelle Pfeiffer) against the backdrop of his copy of *The House of Life*. Scorsese clev-
erly has Archer read the missive as he holds the book open to display the sonnet titled
"Supreme Surrender."

14. In his film of *The Age of Innocence*, Martin Scorsese hangs this painting on the
wall as a backdrop to Newland and May's farewell dinner for Ellen Olenska (chapter 33).

15. For Newland, women are conceptualized as works of art: Mrs. van der Luyden,
for instance, calls to his mind "a Cabanel," while his own mother is to him "an Isabey
miniature" (61, 62). The reference to a Cabanel carries with it an especially sexual con-
notation. Van Hook acknowledges the "decidedly erotic charge" to his paintings. "His
Birth of Venus . . . has perhaps more than any other painting come to signify the deca-
dence of the Second Empire style. Its blatant eroticism, pin-up pose, and hooded ex-
pression, as well as its waxen drawing and candy-box coloring make it an obvious tar-
get" (28).

16. At the start of the final chapter, which is set at the turn of the century, Archer
has just returned from "a big official reception for the inauguration of the new galleries
at the Metropolitan Museum, and the spectacle of those great spaces crowded with the
spoils of the ages, where the throng of fashion circulated through a series of scientifically
catalogued treasures, had suddenly pressed on a rusted spring of memory" (344). As
an older gentleman, Archer, known as "a good citizen," is regularly consulted on such
matters as "reorganising the Museum of Art, founding the Grolier Club, inaugurating
the new Library," and the like (347). For a discussion of museums as male spaces, see
Duncan.

17. The description also recalls Whistler's *Mother of Pearl and Silver: The Andalu-
sian* (1888?–1900, National Gallery of Art), which was exhibited in Paris in the early part
of the twentieth century (1900, 1905) and may well have caught Wharton's eye. See also
Whistler's *Arrangement en noir: La dame au brodequin jaune—Portrait de Lady Archibald
Campbell* (1882, Philadelphia Museum of Art).

18. That one of Wharton's original names for Newland was Lawrence further dem-
onstrates the connection between these male protagonists who come up short.

19. Steele notes that "[t]he Goncourt brothers . . . associated male beauty primarily
with intelligence, and female beauty . . . with animality: 'All the physical beauty, all the
strength, and all the development of a woman is concentrated in . . . the pelvis, the but-
tocks, the thighs; the beauty of a man is to be found in the upper, nobler parts, the pec-
toral muscles, the broad shoulders, the high forehead'" (103). The Goncourts' frank de-
scription of upper and lower social classes and their clinical analysis of social relations
contributed to the development of naturalism.

20. "Goncourts," *Oxford Companion to Art*, 1999 ed.

21. The work was published in 1884; this is an anachronism in *The Age of Innocence*.

22. Here, then, is another link between Olenska and her creator, for one of the puzzling elements of Wharton's biography is that the people she read, and with whom she kept company, were almost exclusively men. Some critics have read this as indicative of Wharton's dislike of women, but Wharton's predilection for things male suggests to me more a wish to be taken seriously as a professional (and not dismissed as a "scribbling woman") than an affirmation of her disregard of women.

23. *The Oxford English Dictionary* defines *shaughraun* as "a wandering, a straying, an error"; the phrase *to go a shaughraun* means "to go wrong" (*OED Online*, 2nd ed., 1989). The link Archer makes between Boucicault's play (translation: "a straying") and his connection with Olenska anticipates his resolution that a romance with Ellen is too deviant and thus can never be realized.

24. For a rich, insightful discussion of the type of the American Girl, see Banta.

25. See Christy, *Liberty Belles* and *The American Girl*.

26. That May is not real to Archer is underscored by his obsession with her alleged paleness, which he also sees in Ellen (318).

27. Wolff identifies this painting as the source for Wharton's title (*The Age of Innocence* 642).

28. Ellen and Rivière's respective fates are intertwined in more than one way. There has been talk of an inappropriate relation between them, though the rumors are never substantiated. Further, Olenska and Rivière are drawn to the same writers (for example, the Goncourt brothers, 200).

29. He is rarely "in an analytic mood" (229).

30. "Life and I," unpublished Wharton manuscript (c. 1919), quoted in Joslin and Price (8).

31. In an amusing scene, the "blowsy" Blenker girl tells Archer that Ellen reminds her of "Mrs. Scott-Siddons when she reads 'Lady Geraldine's Courtship' "; the reference is lost on Archer (227). Wharton likely refers to the celebrated British tragedienne Sarah Siddons, who redefined the role of Lady Macbeth on stage and posed for Reynolds's portrait *The Tragic Muse*. Siddons gave readings at the end of her career and may have read from the 1844 Elizabeth Barrett Browning poem of which Miss Blenker speaks.

32. Wharton's litany of frustrated and/or humiliated American women artists includes Mrs. Amyot of "The Pelican" (1898), Mrs. Laura Birch of *The Reef* (1912), Miss Ivy Spang of "Writing a War Story" (1919), Mrs. Emily Morland of "The Temperate Zone" (1924), and both Mrs. Churley and Miss Margot Crash of *The Gods Arrive* (1932), the latter a journalist the likes of which we find in James's Henrietta Stackpole (*Portrait of a Lady*) whom Osmond disparagingly claims reminds him of "a new steel pen—the most odious thing in nature. She talks as a steel pen writes" (491).

33. Elizabeth Siddall, "The Lust of the Eyes," published in *Poems and Drawings of Elizabeth Siddal*, ed. Roger C. Lewis and Mark Samuels Lasner (Wolfville, N.S.: Wombat Press, 1978), 14.

34. Wharton, "The 'Beata Beatrix' of Rossetti," unpublished poem (the Lilly Library, Indiana University, Bloomington, box 8, notebook 2: poems). The poem, though undated, seems to have been composed between 1889 and 1893. My hearty thanks to Clare Colquitt for bringing the poem to my attention, and to Erika Dowell of the Lilly Library for her assistance with the Wharton manuscripts.

Works Consulted

Altick, Richard D. *The Shows of London.* Cambridge: Belknap Press of Harvard UP, 1978.

Ammons, Elizabeth. "Cool Diana and the Blood-Red Muse: Edith Wharton on Innocence and Art." *American Novelists Revisited: Essays in Feminist Criticism.* Ed. Fritz Fleischman. Boston: G. K. Hall, 1982.

———. *Edith Wharton's Argument with America.* Athens: U of Georgia P, 1980.

Andres, Sophia. *The Pre-Raphaelite Art of the Victorian Novel.* Columbus: Ohio State UP, 2005.

Asleson, Robyn. "Nature and Abstraction in the Aesthetic Development of Albert Moore." Prettejohn, *After the Pre-Raphaelites.*

Austin, Mary. *Stories from the Country of Lost Borders.* New Brunswick: Rutgers UP, 1987.

Balzac, Honoré de. *Tales from Balzac.* London: Eveleigh Nash and Grayson, 1927.

Bann, Stephen. "Shrines, Curiosities, and the Rhetoric of Display." Cooke and Wollen.

Banta, Martha. *Imaging American Women: Idea and Ideals in Cultural History.* New York: Columbia UP, 1987.

Barnes, Rachel. *The Pre-Raphaelites and Their World.* London: Tate Gallery, 1998.

Barreca, Regina. *Sex and Death in Victorian Literature.* Bloomington: Indiana UP, 1990.

Bauer, Dale M. *Edith Wharton's Brave New Politics.* Madison: U of Wisconsin P, 1994.

Beer, Janet. *Kate Chopin, Edith Wharton, and Charlotte Perkins Gilman: Studies in Short Fiction.* New York: St. Martin's, 1997.

Bell, Millicent, ed. *The Cambridge Companion to Edith Wharton.* Cambridge: Cambridge UP, 1995.

———. *Edith Wharton and Henry James: A Story of Their Friendship.* New York: George Braziller, 1965.

Bendixen, Alfred, and Annette Zilversmit. *Edith Wharton: New Critical Essays.* New York: Garland, 1992.

Bennett, Tony. *The Birth of the Museum: History, Theory and Politics*. New York: Routledge, 1995.

Benstock, Shari. "Landscape of Desire: Edith Wharton and Europe." *Wretched Exotic: Essays on Edith Wharton in Europe*. Ed. Katherine Joslin and Alan Price. New York: P. Lang, 1993.

———. *No Gifts from Chance: A Biography of Edith Wharton*. New York: Scribner's, 1994.

Bentley, Nancy, *Ethnography of Manners: Hawthorne, James, Wharton*. New York: Cambridge UP, 1995.

Berger, John. *Ways of Seeing*. Harmondsworth: Penguin, 1972.

Bernheimer, Charles. "Huysmans: Writing against (Female) Nature." *The Female Body in Western Culture: Contemporary Perspectives*. Ed. Susan Rubin Suleiman. Cambridge: Harvard UP, 1985.

Boydston, Jeanne. " 'Grave Endearing Tradition': Edith Wharton and the Domestic Novel." *Faith of a (Woman) Writer*. Ed. Alice Kessler-Harris and William McBrien. New York: Greenwood, 1988.

Braddon, Mary Elizabeth. *Lady Audley's Secret*. New York: Penguin, 1998.

Bronfen, Elisabeth. *Over Her Dead Body: Death, Femininity, and the Aesthetic*. New York: Routledge, 1992.

Brooks, Peter. *Body Work: Objects of Desire in Modern Narrative*. Cambridge: Harvard UP, 1993.

Browning, Robert. *Lyrics of Life*. Boston: Ticknor & Fields, 1866.

Buckler, William E. *Prose of the Victorian Period*. Boston: Houghton Mifflin, 1958.

Bullen, J. B. *The Pre-Raphaelite Body: Fear and Desire in Painting, Poetry, and Criticism*. Oxford: Clarendon, 1998.

Butler, Judith, and Joan W. Scott, eds. *Feminists Theorize the Political*. New York: Routledge, Chapman & Hall, 1992.

Carpenter, Lynette. "Deadly Letters, Sexual Politics, and the Dilemma of the Woman Writer: Edith Wharton's 'The House of the Dead Hand.'" *American Literary Realism* 24.2 (Winter 1992): 55–69.

Chadwick, Whitney. *Women, Art, and Society*. New York: Thames & Hudson, 1990.

Chafe, William Henry. *The Paradox of Change: American Women in the 20th Century*. New York: Oxford UP, 1991.

Chapman, Mary. " 'Living Pictures': Women and Tableaux Vivants in Nineteenth-Century American Fiction and Culture." *Wide Angle* 18.3 (1996): 22–52.

Childers, Joseph, and Gary Hentzi, eds. *Columbia Dictionary of Modern Literary and Cultural Criticism*. New York: Columbia UP, 1995.

Christ, Carol. "Painting the Dead: Portraiture and Necrophilia in Victorian Art and Poetry." *Death and Representation*. Ed. Sara Webster Goodwin and Elisabeth Bronfen. Baltimore: Johns Hopkins UP, 1993.

Christy, Howard Chandler. *The American Girl as Seen and Portrayed by Howard Chandler Christy*. New York: Moffat, Yard, 1906.

———. *Liberty Belles: Eight Epochs in the Making of the American Girl*. Indianapolis: Bobbs-Merrill, 1912.

Cole, Sir Henry. *Fifty Years of Public Work of Sir Henry Cole, K.C.B., Accounted for in His Deeds, Speeches, and Writings.* 2 vols. London: George Bell & Sons, 1884.

Colquitt, Clare, Susan Goodman, and Candace Waid, eds. *A Forward Glance: New Essays on Edith Wharton.* Newark: U of Delaware P, 1999.

Conn, Steven. *Museums and American Intellectual Life, 1876–1926.* Chicago: U of Chicago P, 1998.

Cooke, Lynne, and Peter Wollen. *Visual Display: Culture Beyond Appearances.* Seattle: Bay, 1995.

Crawford, Mary C. *The Romance of the American Theatre.* New York: Halcyon House, 1940.

Daly, Gay. *Pre-Raphaelites in Love.* New York: Bookspan, 1989.

de Lauretis, Teresa. *Alice Doesn't: Feminism, Semiotics, Cinema.* Bloomington: Indiana UP, 1984.

Des Cars, Laurence, *The Pre-Raphaelites: Romance and Realism.* New York: Harry N. Abrams, 2000.

DeShazer, Mary K. *Inspiring Women: Reimagining the Muse.* New York: Pergamon, 1986.

Dijkstra, Bram. *Idols of Perversity: Fantasies of Feminine Evil in Fin-de-Siècle Culture.* New York: Oxford UP, 1986.

Doane, Mary Ann. *The Desire to Desire: The Woman's Film in the 1940s.* Bloomington: Indiana UP, 1987.

Donovan, Josephine. *After the Fall: The Demeter-Persephone Myth in Wharton, Cather, and Glasgow.* University Park: Pennsylvania State UP, 1989.

———. *Feminist Theory: The Intellectual Traditions.* 3rd ed. New York: Continuum, 2000.

Doughty, Oswald. *Dante Gabriel Rossetti: A Victorian Romantic.* New Haven, Yale UP, 1949.

Downs, Linda. "A Recent History of Women Educators in Art Museums." Glaser and Zenetou.

Duncan, Carol. *Civilizing Rituals: Inside Public Art Museums.* New York: Routledge, 1995.

Edgell, George Harold. *A History of Sienese Painting.* New York: Dial, 1932.

Eliot, George. *Daniel Deronda.* New York: Penguin Classics, 1986.

———. *Middlemarch.* New York: Bantam, 1992.

Erickson, Carolly. *Josephine: A Life of the Empress.* New York: St. Martin's, 1999.

Erlich, Gloria C. *The Sexual Education of Edith Wharton.* Berkeley: U of California P, 1992.

Ettlinger, L. D. *The Complete Paintings of Leonardo da Vinci.* New York: Penguin, 1986.

Fedorko, Kathy A. *Gender and the Gothic in the Fiction of Edith Wharton.* Tuscaloosa: U of Alabama P, 1995.

Fetterley, Judith. "'The Temptation to Be a Beautiful Object': Double Standard and Double Bind in *The House of Mirth.*" *Studies in American Fiction* 5 (1977): 199–211.

Flint, Kate. *The Victorians and the Visual Imagination.* Cambridge: Cambridge UP, 2000.

Fryer, Judith. *Felicitous Space: The Imaginative Structures of Edith Wharton and Willa Cather.* Chapel Hill: U of North Carolina P, 1986.

——. "Reading *Mrs. Lloyd.*" Bendixen and Zilversmit.

Gardiner, Judith Kegan, ed. *Provoking Agents: Gender and Agency in Theory and Practice.* Urbana: U of Illinois P, 1995.

Gilbert, Sandra M., and Susan Gubar. *No Man's Land: The Place of the Woman Writer in the Twentieth Century.* 2 vols. New Haven: Yale UP, 1988.

Gillett, Paula. *Worlds of Art: Painters in Victorian Society.* New Brunswick: Rutgers UP, 1990.

Glaser, Jane R., and Artemis A. Zenetou, eds. *Gender Perspectives: Essays on Women in Museums.* Washington: Smithsonian Institution P., 1994.

Goncourt, Edmond de. *The Goncourt Journals, 1851–1870.* New York: Greenwood, 1968.

Goodman, Susan. *Edith Wharton's Women: Friends and Rivals.* Hanover: UP of New England, 1990.

Goodwin, Sara Webster, and Elisabeth Bronfen. *Death and Representation.* Baltimore: Johns Hopkins UP, 1993.

Goodwyn, Janet. *Edith Wharton: Traveller in the Land of Letters.* New York: St. Martin's, 1990.

Harding, Ellen, ed. *Re-Framing the Pre-Raphaelites: Historical and Theoretical Essays.* Brookfield: Ashgate, 1995.

Hares-Stryker, Carolyn. *An Anthology of Pre-Raphaelite Writing.* New York: New York UP, 1997.

Hawthorne, Nathaniel. "The Birth Mark." *Norton Anthology of American Literature.* 6th ed. New York: W. W. Norton, 2003.

——. *The Blithedale Romance.* New York: Penguin, 1986.

Herndl, Diane Price. *Invalid Women: Figuring Feminine Illness in American Fiction and Culture, 1840–1940.* Chapel Hill: U of North Carolina P, 1993.

Hoeller, Hildegard. *Edith Wharton's Dialogue with Realism and Sentimental Fiction.* Gainesville: UP of Florida, 2000.

Holbrook, David. *Edith Wharton and the Unsatisfactory Man.* New York: St. Martin's, 1991.

Hollander, John. *The Gazer's Spirit: Poems Speaking to Silent Works of Art.* Chicago: U of Chicago P, 1995.

Honey, Maureen. "Erotic Visual Tropes in the Fiction of Edith Wharton." *A Forward Glance: New Essays on Edith Wharton.* Ed. Clare Colquitt, Susan Goodman, and Candace Waid. Newark: U of Delaware P, 1999.

Hooper-Greenhill, Eilean. "The Museum in the Disciplinary Society." *Museum Studies in Material Culture.* Ed. J. Pearce. Leicester: Leicester UP, 1989.

Howe, Irving, ed. *Edith Wharton.* New York: Prentice-Hall, 1962.

Hudson, Kenneth. *Museums of Influence.* New York: Cambridge UP, 1987.

Huf, Linda. *A Portrait of the Artist as a Young Woman: The Writer as Heroine in American Literature.* New York: Ungar, 1983.

Isaacson, Robert. *William-Adolphe Bouguereau.* London: Lund Humphries, 1975.

James, Henry. *The Bostonians.* New York: Penguin, 1984.

——. *The Portrait of a Lady.* New York: Penguin Modern Classics, 1978.

Jiminez, Jill Berk, ed. *The Dictionary of Artists' Models*. Chicago: Fitzroy Dearborn, 2001.

Joslin, Katherine, and Alan Price, eds. *Wretched Exotic: Essays on Edith Wharton in Europe*. New York: Peter Lang, 1993.

Kaplan, Amy. *The Social Construction of American Realism*. Chicago: U of Chicago P, 1988.

Kestner, Joseph. *Mythology and Misogyny: The Social Discourse of Nineteenth-century British Classical-Subject Painting*. Madison: U of Wisconsin P, 1989.

Killoran, Helen. *Edith Wharton: Art and Allusion*. Tuscaloosa: U of Alabama P, 1996.

———. "Edith Wharton's Reading in European Languages." *Wretched Exotic: Essays on Edith Wharton in Europe*. Ed. Katherine Joslin and Alan Price. New York: Peter Lang, 1993.

Kostenevich, Albert. *Bouguereau to Matisse: French Art at the Hermitage, 1860–1950*. London: Booth-Clibborn, 1999.

Kress, Jill M. *The Figure of Consciousness: William James, Henry James, and Edith Wharton*. New York: Routledge, 2002.

Krieger, Murray. *Ekphrasis: The Illusion of the Natural Sign*. Baltimore: Johns Hopkins UP, 1992.

Lambourne, Lionel. *The Aesthetic Movement*. London: Phaidon, 1996.

Lang, Cecil Y. *The Pre-Raphaelites and Their Circle*. Chicago: U of Chicago P, 1975.

Larsen, Nella. *Quicksand and Passing*. New Brunswick: Rutgers UP, 1986.

Latham, Angela. *Posing a Threat: Flappers, Chorus Girls, and Other Brazen Performers of the American 1920s*. Hanover: Wesleyan UP, 2000.

Lauer, Kristin O., and Margaret P. Murray. *Edith Wharton: An Annotated Secondary Bibliography*. New York: Garland, 1990.

Lauer, Kristin O., Margaret P. Murray, and James Tuttleton, eds. *Edith Wharton: The Contemporary Reviews*. New York: Garland, 1992.

Lee, Vernon [Violet Paget]. *Miss Brown*. Vol. 1. Whitefish: Kessinger, 2004. Feb. 17, 2006 <http://books_google.com/books>.

Lewis, R. W. B. *Edith Wharton: A Biography*. New York: Harper & Row, 1975.

———. Introduction. *The Age of Innocence*. By Edith Wharton. New York: Scribner's, 1968.

Lidoff, Joan. "Another Sleeping Beauty: Narcissism in *The House of Mirth*." *American Quarterly* 32 (1980): 519–39.

Lubbock, Percy. *Portrait of Edith Wharton*. New York: Appleton-Century, 1947.

Maine, Barry. "Reading 'The Portrait': Edith Wharton and John Singer Sargent." *Edith Wharton Review* (Spring 2002): 7–14.

Malcolm, Janet. "The Woman Who Hated Women." *New York Times Book Review* Nov. 16, 1986: 11.

Malraux, André. *Museum without Walls*. New York: Doubleday, 1967.

Mancoff, Debra N. *Jane Morris: The Pre-Raphaelite Model of Beauty*. San Francisco: Pomegranate, 2000.

Mannings, David. *Sir Joshua Reynolds: A Complete Catalogue of His Paintings*. New Haven: Yale UP, 2000.

Marsh, Jan. *The Pre-Raphaelites: Their Lives in Letters and Diaries.* London: Collins & Brown, 1996.

——. *Pre-Raphaelite Women: Images of Femininity in Pre-Raphaelite Art.* London: Weidenfeld & Nicolson, 1987.

Marsh, Jan, and Pamela Gerrish Nunn. *Pre-Raphaelite Women Artists.* Manchester: Manchester City Art Galleries, 1997.

Marshall, David. *The Figure of Theater: Shaftesbury, Defoe, Adam Smith, and George Eliot.* New York: Columbia UP, 1986.

——. *The Surprising Effects of Sympathy: Marivaux, Diderot, Rousseau, and Mary Shelley.* Chicago: U of Chicago P, 1988.

McCullough, Jack W. *Living Pictures on the New York Stage.* Ann Arbor: UMI Research, 1981.

McGann, Jerome. *Dante Gabriel Rossetti and the Game That Must Be Lost.* New Haven: Yale UP, 2000.

McNay, Lois. *Foucault and Feminism: Power, Gender, and the Self.* Boston: Northeastern UP, 1992.

Meisler, Stanley. "Goya and His Women." *Smithsonian Magazine* Apr. 2002: 47–54.

Messer-Davidow, Ellen. "Acting Otherwise." *Provoking Agents: Gender and Agency in Theory and Practice.* Ed. Judith Kegan Gardiner. Urbana: U of Illinois P, 1995.

Michaels, Walter Benn. *The Gold Standard and the Logic of Naturalism: American Literature at the Turn of the Century.* Berkeley: U of California P, 1987.

Millais, John Guille. *The Life and Letters of Sir John Everett Millais.* Vol. 1. London: Methuen, 1899.

Miller, Lillian B. "The Impact of Women and Museum Work: A Historical Perspective, Introduction." Glaser and Zenetou.

Mitchell, W. J. T. *Iconology: Image, Text, Ideology.* Chicago: U of Chicago P, 1986.

——. *Picture Theory: Essays on Verbal and Visual Representation.* Chicago: U of Chicago P, 1994.

Moers, Ellen. *Literary Women.* New York: Anchor, 1977.

Montgomery, Maureen E. *Displaying Women: Spectacles of Leisure in Edith Wharton's New York.* New York: Routledge, 1998.

Moscovici, Claudia. *From Sex Objects to Sexual Subjects.* New York: Routledge, 1996.

Moseley, Edwin M. "*The Age of Innocence:* Edith Wharton's Weak Faust." *College English* 21 (Dec. 1959).

Mulvey, Laura. *Visual and Other Pleasures.* Bloomington: Indiana UP, 1989.

Nelson, Elizabeth. "Pictorial Interpretations of 'The Lady of Shalott': The Lady in her Boat." *Ladies of Shalott: A Victorian Masterpiece and Its Contexts.* Ed. George P. Landow. Providence: Brown UP, 1979.

Nettels, Elsa. "Gender and First-Person Narration in Edith Wharton's Short Fiction." Bendixen and Zilversmit.

Nicholson, Linda J., ed. *Feminism/Postmodernism.* New York: Routledge, 1990.

Nicoll, John. *Dante Gabriel Rossetti.* New York: Macmillan, 1976.

Nochlin, Linda. *Representing Women.* London: Thames & Hudson, 1999.

——. *Women, Art, and Power and Other Essays.* New York: Harper & Row, 1988.

Nochlin, Linda, and Thomas B. Hess, eds. *Woman as Sex Object: Studies in Erotic Art, 1730–1970.* New York: Newsweek, 1972.

Olin-Ammentorp, Julie. "Edith Wharton's Challenge to Feminist Criticism." *Studies in American Fiction* 16.2 (1988): 237–44.

——. "Wharton through a Kristevan Lens: The Maternality of *The Gods Arrive.*" *Wretched Exotic: Essays on Edith Wharton in Europe.* Ed. Katherine Joslin and Alan Price. New York: P. Lang, 1993.

Orlando, Emily J. "Re-reading Wharton's 'Poor Archer': A Mr. 'Might-have-been' in *The Age of Innocence.*" *American Literary Realism* 30 (Winter 1998): 56–76.

Ormond, Richard. "John Singer Sargent: A Biographical Sketch." National Gallery of Art Exhibition Catalogue: Sargent. Washington: Smithsonian Institution, 1999.

Paglia, Camille. *Sexual Personae: Art and Decadence from Nefertiti to Emily Dickinson.* New Haven: Yale UP, 1990.

Parrington, Vernon L. "Our Literary Aristocrat." *The Age of Innocence.* By Edith Wharton. Ed. Candace Waid. New York: W. W. Norton, 2004.

Pater, Walter. *The Renaissance. Prose of the Victorian Period.* Ed. William E. Buckler. Boston: Houghton Mifflin, 1958.

Pearce, Lynne. *Woman/Image/Text: Readings in Pre-Raphaelite Art and Literature.* Hemel Hempstead: Harvester Wheatsheaf, 1991.

Penny, Nicholas, ed. *Reynolds.* London: Royal Academy of Arts in association with Weidenfeld & Nicolson, 1986.

Poe, Edgar Allan. *The Portable Poe.* Ed. Philip Van Doren Stern. New York: Penguin, 1977.

Pollock, Griselda. *Vision and Difference: Femininity, Feminism, and Histories of Art.* New York: Routledge, 1988.

Poulson, Christine. "Death and the Maiden: The Lady of Shalott and the Pre-Raphaelites." *Re-Framing the Pre-Raphaelites: Historical and Theoretical Essays.* Ed. Ellen Harding. Brookfield: Ashgate, 1995.

Preston, Claire. *Edith Wharton's Social Register.* New York: St. Martin's, 2000.

Prettejohn, Elizabeth, ed. *After the Pre-Raphaelites: Art and Aestheticism in Victorian England.* New Brunswick: Rutgers UP, 1999.

——. *The Art of the Pre-Raphaelites.* Princeton: Princeton UP, 2000.

Psomiades, Kathy Alexis. *Beauty's Body: Femininity and Representation in British Aestheticism.* Stanford: Stanford UP, 1997.

Ramsden, George. *Edith Wharton's Library.* Settrington: Stone Trough, 1999.

Raven, Arlene, Cassandra L. Langer, and Joanna Frueh, eds. *Feminist Art Criticism: An Anthology.* Ann Arbor: UMI Research, 1988.

Richardson, Edgar P. "The Museum in America 1963." *Museum News* 42.4 (Sept. 1963): 20–28.

Robertson, W. Graham. *Time Was.* London: Quartet, 1981.

Robinson, Hilary, ed. *Feminism-Art-Theory: An Anthology, 1968–2000.* Malden: Blackwell, 2001.

Rosenberg, Rosalind. *Divided Lives: American Women in the Twentieth Century.* New York: Hill & Wang, 1992.

Rosenblum, Robert. *19th-Century Art.* New York: Abrams, 1984.

Rossetti, Christina. *Complete Poems*. New York: Penguin Classics, 2001.

Rossetti, Dante Gabriel. *Collected Writings of Dante Gabriel Rossetti*. Ed. Jan Marsh. Chicago: New Amsterdam, 2000.

———. *The Poetical Works of Dante Gabriel Rossetti*. Ed.William M. Rossetti. New York: A. L. Burt, 1886.

———. *The Rossetti Archive*. Ed. Jerome McGann. 2000. U. of Virginia. Sept. 8, 2005 <http://www.rossettiarchive.org>.

Rossetti, William Michael. *Dante Gabriel Rossetti as Designer and Writer*. London: Cassell, 1889.

———. *Dante Gabriel Rossetti: His Family Letters with a Memoir by William Michael Rossetti*. 2 vols. New York: AMS, 1970.

Rousseau, Jean-Jacques. *Emile; or, On Education*. *Women, the Family, and Freedom: The Debate in Documents*. Vol. 1, *1750–1880*. Ed. Susan Groag Bell and Karen M. Offen. Stanford: Stanford UP, 1983. Feb. 11, 2006 <http://chnm.gmu/revolution/d/470>.

Rugoff, Ralph. "Beyond Belief: The Museum as Metaphor." Cooke and Wollen.

Ruskin, John. "Sesame and Lilies, Lecture II, Lilies: Of Queens' Gardens." *Essays: English and American*. Ed. Charles W. Eliot. Harvard Classics 28. New York: P. F. Collier & Son, 1909–14. 2001 <http://www.bartleby.com/28/>.

———. *The Stones of Venice*. Vol. 1. Boston: Dana Estes, 1900.

Seltzer, Mark. *Bodies and Machines*. New York: Routledge, 1992.

Shaffer-Koros, Carole M. "Edgar Allan Poe and Edith Wharton: The Case of Mrs. Mowatt." *Edith Wharton Review* (Spring 2001): 12–15.

Sheets, Robin. "Pornography and Art: The Case of 'Jenny.'" *Critical Essays on Dante Gabriel Rossetti*. Ed. David G. Riede. Boston: G. K. Hall, 1992.

Sherman, Claire Richter, with Adele M. Holcomb, eds. *Women as Interpreters of the Visual Arts, 1820–1979*. Westport: Greenwood, 1981.

Showalter, Elaine. "The Death of the Lady (Novelist): Wharton's *House of Mirth*." Bendixen and Zilversmit.

———. "Piecing and Writing." *Poetics of Gender*. Ed. Nancy K. Miller. New York: Columbia UP, 1986.

———. *Sister's Choice: Tradition and Change in American Women's Writing*. Oxford: Clarendon, 1991.

Simon, Rita James. *Women's Movements in America: Their Successes, Disappointments, and Aspirations*. New York: Praeger, 1991.

Singley, Carol J. *Edith Wharton: Matters of Mind and Spirit*. New York: Cambridge UP, 1995.

Singley, Carol J., and Susan Elizabeth Sweeney. *Anxious Power: Reading, Writing, and Ambivalence in Narrative by Women*. Albany: State U of New York P, 1993.

Smith, Alison. "The Academy and the Professional Model in 19th-Century Britain." *The Dictionary of Artists' Models*. Ed. Jill Berk Jiminez. Chicago: Fitzroy Dearborn, 2001.

———. "The Pre-Raphaelite Nude." *Collecting the Pre-Raphaelites: The Anglo-American Enchantment*. Ed. Margaretta Frederick Watson. Brookfield: Ashgate, 1997.

Sonstroem, David. *Rossetti and the Fair Lady*. Middletown: Wesleyan UP, 1970.

Spencer, Robin. "Whistler, Swinburne, and Art for Art's Sake." Prettejohn, *After the Pre-Raphaelites.*

Springer, Marlene. *Edith Wharton and Kate Chopin: A Reference Guide.* Boston: G. K. Hall, 1976.

Steele, Valerie. *Fashion and Eroticism: Ideals of Feminine Beauty from the Victorian Era to the Jazz Age.* New York: Oxford UP, 1985.

Steiner, Wendy. *Pictures of Romance: Form against Context in Painting and Literature.* Chicago: U of Chicago P, 1988.

Stevick, Philip. *The American Short Story, 1900–1945: A Critical History.* Boston: G. K. Hall, 1984.

Stewart, Susan. "Death and Life, in That Order, in the Works of Charles Willson Peale." Cooke and Wollen.

Suleiman, Susan Rubin, ed. *The Female Body in Western Culture: Contemporary Perspectives.* Cambridge: Harvard UP, 1985.

Sullivan, Robert. "Evaluating the Ethics and Consciences of Museums." Glaser, and Zenetou.

Surtees, Virginia. *The Paintings and Drawings of Dante Gabriel Rossetti (1828–1882): A Catalogue Raisonné.* 2 vols. Oxford: Oxford UP, 1971.

Taylor, Kendall. "Pioneering Efforts of Early Museum Women." Glaser and Zenetou.

Tintner, Adeline R. *Edith Wharton in Context: Essays on Intertextuality.* Tuscaloosa: U of Alabama P, 1999.

Tobin, Thomas J., ed. *Worldwide Pre-Raphaelitism.* Albany: SUNY Press, 2005.

Treuherz, Julian. *Victorian Painting.* New York: Thames & Hudson, 1993.

Treuherz, Julian, Elizabeth Prettejohn, and Edwin Becker, eds. *Dante Gabriel Rossetti.* London: Thames & Hudson, 2003.

Upstone, Robert. *The Pre-Raphaelite Dream: Paintings and Drawings from the Tate Collection.* London: Tate, 2003.

Van Hook, Bailey. *Angels of Art: Women and Art in American Society, 1876–1914.* University Park: Pennsylvania State UP, 1996.

Vita-Finzi, Penelope. *Edith Wharton and the Art of Fiction.* New York: St. Martin's, 1990.

Waid, Candace. *Edith Wharton's Letters from the Underworld: Fictions of Women and Writing.* Chapel Hill: U of North Carolina P, 1991.

Waldmann, Susann. *Goya and the Duchess of Alba.* New York: Prestel, 1998.

Walker, Nancy A. *The Disobedient Writer: Women and Narrative Tradition.* Austin: U of Texas P, 1995.

Walsh, Michael, ed. *Butler's Lives of the Saints.* Concise rev. ed. San Francisco: Harper-Collins, 1991.

Warner, Marina. *Monuments and Maidens: The Allegory of the Female Form.* New York: Atheneum, 1985.

———. "Waxworks and Wonderlands." Cooke and Wollen.

Watson, Margaretta Frederick, ed. *Collecting the Pre-Raphaelites: The Anglo-American Enchantment.* Brookfield: Ashgate, 1997.

Weber, Jean. "Changing Roles and Attitudes." Glaser and Zenetou.

Weinberg, H. Barbara. *John Singer Sargent*. New York: Rizzoli International, 1994.

Werlock, Abby. "Edith Wharton's Subtle Revenge? Morton Fullerton and the Female Artist in *Hudson River Bracketed* and *The Gods Arrive*." Bendixen and Zilversmit.

Wharton, Edith. *The Age of Innocence*. New York: Collier, 1992.

——. "The Angel at the Grave." *Roman Fever and Other Stories*.

——. *A Backward Glance: An Autobiography*. New York: Scribner's, 1964.

——. *The Buccaneers*. Completed by Marion Mainwaring. New York: Penguin, 1993.

——. *The Children*. New York: Scribner's, 1997.

——. *The Collected Short Stories of Edith Wharton*. Ed. R. W. B. Lewis. 2 vols. New York: Scribner's, 1968.

——. *Crucial Instances*. New York: Scribner's, 1901.

——. *The Custom of the Country*. New York: Signet Classic/Penguin, 1989.

——. "The Duchess at Prayer." *Crucial Instances*.

——. *Edith Wharton: The Uncollected Critical Writings*. Ed. Frederick Wegener. Princeton: Princeton UP, 1996.

——. *French Ways and Their Meaning*. Lee: Edith Wharton Restoration at the Mount and Berkshire House, 1997.

——. "The Fullness of Life." Lewis. Vol. 1.

——. *The Ghost Stories of Edith Wharton*. New York: Scribner's, 1973.

——. *The Gods Arrive*. New York: Scribner's, 1960.

——. *The House of Mirth*. New York: Penguin, 1985.

——. "The House of the Dead Hand." Lewis. Vol. 1.

——. *Hudson River Bracketed*. New York: Appleton-Century-Crofts, 1962.

——. *The Letters of Edith Wharton*. Ed. R. W. B. Lewis and Nancy Lewis. New York: Scribner's, 1989.

——. "The Moving Finger." *Crucial Instances*.

——. "Mr. Jones." *The Ghost Stories of Edith Wharton*.

——. "The Muse's Tragedy." Lewis. Vol. 1.

——. *Old New York: Four Novellas by Edith Wharton*. New York: Scribner's, 1995.

——. "The Potboiler." Lewis. Vol. 1.

——. "The Quicksand." Lewis. Vol. 1.

——. *The Reef*. New York: Scribner's, 1993.

——. "The Rembrandt." Lewis. Vol. 1.

——. *Roman Fever and Other Stories*. New York: Collier, 1987.

——. *Summer*. New York: Bantam, 1993.

——. "The Temperate Zone." Lewis. Vol. 2.

——. *The Touchstone*. New York: Scribner's, 1900.

——. *Twilight Sleep*. New York: Scribner's, 1997.

——. "Writing a War Story." Lewis. Vol. 2.

——. *The Writing of Fiction*. Touchstone/Simon & Schuster, 1997.

Wharton, Edith, and Ogden Codman, Jr. *The Decoration of Houses*. New York: Scribner's, 1901.

White, Barbara A. *Edith Wharton: A Study of the Short Fiction*. New York: Twayne, 1991.

Wilde, Oscar. *The Picture of Dorian Gray.* New York: Penguin, 2003.

Wildman, Stephen. *Visions of Love and Life: Pre-Raphaelite Art from the Birmingham Collection, England.* Alexandria: Art Services International, 1995.

Williams, Deborah Lindsay. *Not in Sisterhood: Edith Wharton, Zona Gale, and the Politics of Female Authorship.* New York: Palgrave, 2001.

Wilton, Andrew, and Robert Upstone, eds. *The Age of Rossetti, Burne-Jones, and Watts: Symbolism in Britain, 1860–1910.* New York: Flammarion, 1997.

Wolff, Cynthia Griffin. "*The Age of Innocence:* Wharton's 'Portrait of a Gentleman.'" *Southern Review* 12 (1976):640–58.

———. "Cold Ethan and 'Hot Ethan.'" Bendixen and Zilversmit.

———. *A Feast of Words: The Triumph of Edith Wharton.* New York: Oxford UP, 1977.

———. "Lily Bart and the Beautiful Death." *American Literature* 46 (1974): 16–40.

Wright, Sarah Bird, ed. *Edith Wharton Abroad: Selected Travel Writings, 1888–1920.* New York: St. Martin's, 1995.

———. *Edith Wharton A to Z: The Essential Guide to the Life and Work.* New York: Facts on File, 1998.

Index

aestheticism, 7, 9, 13, 63, 110, 136, 138, 146, 152, 158, 167, 168, 175, 202n6, 221n13, 225n7

Alcott, Louisa May: *Behind a Mask,* 209n6; *A Modern Mephistopheles,* 209n6; *Work,* 122, 219n42

Alighieri, Dante, 11, 16, 47, 74, 77, 78, 119, 176, 199, 206n6, 208n21, 215n13, 225n8

Alma-Tadema, Sir Lawrence, 140

Altick, Richard, 60

Alves, Jaime Osterman, 219n44

Ammons, Elizabeth, 119, 153, 173, 195, 202n8

Anderson, Gillian, 27, 78, 209n2

Anderson, Ross, 21

Andres, Sophia, 203n12

Asleson, Robyn, 225n7

Auden, W. H., 7

Austin, Mary, 205n25

Avery, Myrtella, 128

Balzac, Honoré de, 4, 22, 28, 204n19; *Contes Drôlatiques,* 175; "La grande bretèche," 51

Bancroft, Samuel, 15

Bann, Stephen, 156

Banta, Martha, 87, 195, 215n15, 227n24

Barnes, Rachel, 13, 14

Barrymore, Ada Adams, 60

Bartholdi, Frederic, 61

Baudry, Paul, 62

Bauer, Dale, 203n11

Bazzi, Giovanni Antonio. *See* Sodoma

Bell, Millicent, 33, 201n2

Bellini, Giovanni, 8

Benstock, Shari, 8, 164, 206n3, 212n29, 220n7, 222n28

Berenson, Bernard, 8, 128, 141, 151

Berenson, Mary, 8, 128, 151, 222n28

Berger, Florence Paull, 130

Berger, John, 70, 71

Bernheimer, Charles, 187

Bernini, Gian Lorenzo, 13, 46, 47, 49, 51; *Damned Soul,* 49; *Ecstasy of Saint Theresa,* 49

Bingham, George Caleb, 96

Blake, William, 210n13, 220n8

Blunt, Wilfred Scawen, 117

Boccaccio, Giovanni, 14, 206n6
La Bohème (Puccini), 84, 85
Boit, Mrs. Edward, 213n30
Bonaparte, Josephine, 91, 93, 178, 213n3
Botticelli, Sandro, 8, 66, 70
Botticini, Francesco, 8
Boucicault, Dion, *The Shaughraun,* 188,
 227n23
Bougeureau, William-Adolphe, 97, 98
Bourget, Paul, 6, 27, 187, 206n1
Boydston, Jeanne, 173
Braddon, Mary Elizabeth, 204n19; *Lady
 Audley's Secret,* 12, 204n19, 207n9
Breakspeare, William A., 20
Bronfen, Elisabeth, 21, 40, 42, 208n16
Brontë, Charlotte, 141, 223n30
Brooks, Louise, 197
Brooks, Peter, 18
Brown, David Alan, 221n11
Brown, Ford Madox, 13, 17, 111, 209n3,
 220n6
Brownell, William Crary, 206n3
Browning, Elizabeth Barrett, 206n6,
 227n31
Browning, Robert, 4, 21, 22, 28, 176,
 206n6; "Evelyn Hope," 21, 205n24;
 "My Last Duchess," 40, 51, 52, 137,
 209n23
Buchanan, Robert, 204n19
Bullen, J. B., 13, 14
Burne-Jones, Sir Edward Coley, 5, 13, 17,
 164, 207n11, 220n5; *Briar Rose,* 63;
 Pygmalion and the Image, 207n11
Burne-Jones, Georgiana, 164, 165
Burton, Tim, 85

Cabanel, Alexandre, 63, 226n15
Carolus-Duran, Emile-Auguste, 178;
 La dame au gant, 179, 181
Carpaccio, Vittore, 8
Carracci, Annibale, 8
Casteras, Susan P., 14, 17
Castleman, Riva, 130

Cather, Willa, 122, 219n42
Cezanne, Paul, 202n7
Chapman, Mary, 209n6
Chase, William Merritt, 62, 95, 210n9
Chaucer, Geoffrey, 206n6
Chopin, Kate, 86
Christ, Carol, 20, 204n16
Christy, Howard Chandler, 87, 227n25;
 The American Girl, 87–88, 190
Clark, Kenneth, 8, 19
Clarke, H. Savile, 207n9; "The Portrait's
 Warning," 207n9
Codman, Ogden, Jr., 8
Cohen, William A. (Bill), 204n19
Cole, Henry, 156
Cole, Thomas, 95, 96
Coleridge, Samuel Taylor, 218n35
Coletti, Theresa, 221n15
Collinson, James, 13
Colquitt, Clare, 204n15, 228n34
Corbould, Edward Henry, 224n1
Corcoran Gallery of Art, 5, 130
Cornforth, Fanny, 14, 15, 16, 216n19
Correggio (Antonio Allegri), 60
Cosimo, Piero di, 8
Crane, Stephen, 86, 50; *Maggie,* 205n24
Crane, Walter, 224n1
Crewdson, Gregory, 37
Crivelli, Carlo, 197

Daly, Gay, 15, 17, 20, 34, 164–165, 206n5,
 206n6, 225n9
D'Annunzio, Gabriele, 205n23; *Il trionfo
 della morte,* 1, 4, 21, 85, 99
Daudet, Alphonse, 175, 176
Davies, Terence, 27, 78, 85, 209n2, 210n15
da Vinci, Leonardo. *See* Leonardo
Day-Lewis, Daniel, 226n13
De Lauretis, Teresa, 18
Delaware Art Museum, 5, 15
della Robbia, Giovanni, 8
De Morgan, Evelyn, 131, 220n5
Des Cars, Laurence, 13, 16, 205n20

DeShazer, Mary K., 119–120, 218n38

Dewing, Thomas, 95

Dijkstra, Bram, 17, 21–22, 29, 36, 37, 98, 111, 195, 202n6

Doane, Mary Ann, 213n2

Donovan, Josephine, 9, 150, 203n9, 221n16

Dossi, Dosso, 137, 138; *Circe and Her Lovers in a Landscape,* 138–139

Dowell, Erika, 228n34

Downs, Linda, 128, 129

Dreiser, Theodore, 150

Duncan, Carol, 226n16

DuPlessis, Rachel Blau, 218n38

Dyas, Ada, 196

Edith Wharton Society, 201n2

Eliot, George (Mary Ann Evans), 4, 22, 28, 164; *Daniel Deronda,* 49, 50, 60, 62, 68, 211n21; "Margaret Fuller and Mary Wollstonecraft," 27; *Middlemarch,* 46, 131, 176, 208n18, 225n10; *Romola,* 221n17

Eliot, T. S., 7

Emerson, Ralph Waldo, 206n6

Erickson, Carolly, 93, 213n3

Erlich, Gloria, 202n5

Ettlinger, L. D., 141

Eytinge, Sol, Jr., 21

Fedorko, Kathy A., 209n23

Felix, Eliza (Madame Rachel), 204n19

Fetterley, Judith, 202n8, 209n5

Fitzgerald, F. Scott, 201n2

Flaubert, Gustave, 187, 194; *Madame Bovary,* 86, 186, 205n24

Fogg Museum of Art, Harvard University, 15

Folk Art Museum at Colonial Williamsburg, 127

Fowler, Frank, 97

Freeman, Mary Wilkins, 147, 221n16

Frist Center for the Visual Arts, Nashville, 5, 220n1

Frith, William Powell, 137

Fryer, Judith, 6, 60, 61, 70, 202n7, 210n9, 211n19, 211n21, 212n25

Fuller, Margaret, 27, 213n30

Garden, Mary, 218n34

Gibb, Robert, 224n1

Gibson, Charles Dana, 213n1

Gilbert, Sandra M., and Susan Gubar, 28, 51, 123, 195

Gillett, Paula, 12, 168

Gilman, Charlotte Perkins, 141, 223n31

Glaspell, Susan, 223n31

Goethe, Johann Wolfgang von, 173, 206n6

Goncourt, Edmond, and Jules de, 186–187, 194, 226n19, 227n20, 227n28

Gonnelli, 8

Goodwyn, Janet, 217n30

Gounod, Charles, *Faust,* 189

Goya (Francisco de Goya y Lucientes): *Duchess of Alba,* 66, 68, 211n20

Grimshaw, John Atkinson, 20, 211n18, 224n1; *Elaine,* 211n18; *Lady of Shalott,* 211n18

Grosvenor Gallery, 15

Guardi, Francesco, 8

H. D. (Hilda Doolittle), 218n38

Hacker, Arthur, 139

Hamilton, Emma (Lady), 60

Harding, Ellen, 202n6

Hardy, Thomas, 86; *Tess,* 205n24

Harper's Magazine, 88

Harrison, Anthony H., 225n9

Hawthorne, Nathaniel, 4, 22, 28; "The Birth Mark," 37, 45; *Blithedale Romance,* 205n24, 209n6, 213n30

Hazlitt, William, 219n40

Herndl, Diane Price, 45, 68, 211n18, 217n26

Herrmann, 30

Hill, Emma, 17

Holbrook, David, 202n5

Holcomb, Adele, 128

Hollander, John, 137
Holmes, Oliver Wendell, 209n6
Homer, 206n6
Honey, Maureen, 203n14
Hopkins, Gerard Manley, 152
The Hours (Daldry), 202n4
Howell, Charles, 20
Howells, William Dean, 203n12
Hughes, Arthur, 224n1
Hughes, Edward Robert, 20
Hunt, William Holman, 13; *The Awakening Conscience,* 179; *The Lady of Shalott,* 184
Huntington, Daniel, 96
Huysmans, J. K., *A rebours,* 187

Isabella Stewart Gardner Museum, 127
Isabey, Eugène, 226n15
Isham, Samuel, 6

James, Henry, 30, 32–33, 108, 114, 122, 201n2, 203n12, 204n19, 216n21, 216n22, 218n36, 224n6; *The Bostonians,* 123–124, 219n43; "Daisy Miller," 189, 205n24; *Portrait of a Lady,* 94, 227n32; "The Velvet Glove," 218n36
Jameson, Anna, 7
Jewett, Rutger B., 212n29
Jones, Allen, 29–30
Jones, Mary, 16
Joslin, Katherine, 227n30

Kaplan, Amy, 212n23
Kauffman, Angelica, 60, 66, 70
Keats, John, 206n6, 208n17
Kestner, Joseph, 40, 140, 215n14, 220n10
Kidman, Nicole, 55, 85
Kilianyi, Edward, 62
Killoran, Helen, 6, 7, 205n23, 211n19, 219n46
Kress, Jill M., 224n4
Krieger, Murray, 7
Kugler, Franz, 7

La Farge, John, 20
Lambourne, Lionel, 63, 132
The Lamplighter (Cummins), 154
Lang, Cecil, 176, 185, 194, 195, 215n13
Larsen, Nella, 205n25; *Passing,* 205n25; *Quicksand,* 205n25; "Sanctuary," 205n25
Latham, Angela, 218n33
Lauder, Robert Scott, 224n1
Lawrence, D. H., 223n31
Lee, Vernon (Violet Paget), 8, 175, 217n25, 224n6; *Miss Brown,* 109–110
Leighton, Edmund Blair, 224n1
Leighton, Frederic, Lord, 63, 158
Leonardo, (Leonardo da Vinci), 13, 134, 135, 136, 137, 138, 141, 206n6, 221n11; *Ginevra de' Benci,* 141–142; *The Last Supper,* 221n11; *Mona Lisa,* 113; *St. John,* 138
Lewis, R. W. B., 6, 173, 201n1, 202n5, 206n6
Lidoff, Joan, 209n5
London, Jack, 150
Longfellow, Henry Wadsworth, 154
Longhi, Pietro, 8
Lubbock, Percy, 27, 30, 201n2
Lucas, George, 85
Lurman, Baz, 55, 85

M. Butterfly (Hwang), 37, 38, 207n10
Maine, Barry, 213n30
Malcolm, Janet, 9
Mancoff, Debra, 15, 107, 108, 110, 114, 117, 216n22, 217n23, 225n11
Mannings, David, 73, 210n15
Mansfield, Katherine, 223n31
Marsh, Jan, 17, 21, 107, 109, 202n6, 209n22, 211n16, 212n28, 220n5
Marshall, David, 50
May, Edward Harrison, 206n3
McClure's Magazine, 88
McCullough, Jack, 60, 61, 62, 209n6, 210n7

McGann, Jerome, 202n6, 203n12, 212n26

Meisler, Stanley, 211n20

Mengs, Raphael, 149

Meredith, George, 225n9

Mérimée, Prosper, 175

Metropolitan Museum of Art, 127, 133, 159, 161, 162, 183, 192, 226n16

Michaels, Walter Benn, 212n25

Michelangelo (Michelangelo di Lodovico Buonarroti), 63

Millais, Sir John Everett, 13, 43, 64, 75, 85, 99; *Mariana in the Moated Grange,* 99, 184, 205n24, 220n6; *Ophelia,* 43, 75, 99

Millard, Emily, 130

Miller, Annie, 216n19

Miller, Dorothy Canning, 130

Miller, Lillian B., 127

Millet, Frank, 95

Miner, Dorothy, 130

Mitchell, W. J. T., 160

modernism, 7, 210n2

Moers, Ellen, 222n26

Monet, Claude, 184

Montgomery, Maureen, 89, 91, 100, 209n1, 209n4, 210n8

Moore, Albert, 63, 158, 168

Morghen, Raphael, 149

Morris, Frances, 130

Morris, Jane (Burden), 16, 17, 31, 74, 89, 105, 106, 107, 108, 110, 113, 114, 117, 119, 164, 176, 177, 199, 208n21, 212n26, 215n13, 216n19, 216n20, 216n22, 217n23, 225n11, 225n12

Morris, William, 13, 17, 107, 176, 207n11, 217n23

Moseley, Edwin, 224n5

Mulvey, Laura, 18, 19, 29, 71, 204n16

Museum of Modern Art (MoMA), 127, 130

museums, birth and development of, 7, 24, 150, 155; women and, 11, 126–169, 226n16

Myers, Frederick William Henry, 16

National Gallery, London, 5

National Gallery of Art, Washington, 5, 221n11, 222n18, 226n17

naturalism, 150, 174, 175, 187, 201n2, 205n25, 226n19

Neilson, Adelaide, 196

Newton, Sir Isaac, 206n6

New Woman, 11, 23, 111, 115, 116, 117, 118, 167, 197, 223n31

Nicoll, John, 34, 74, 75, 76, 176, 177, 204n19, 210n13

Nilsson, Christine, 189

Nochlin, Linda, 39

Noonan, Peggy, 202n3

Norris, Frank, 150

Norton, Charles Eliot, 8, 15, 203n12, 204n17

Norton, Sara (Sally), 164, 206n4

Olin-Ammentorp, Julie, 217n28

Paget, Violet. *See* Lee, Vernon

Paglia, Camille, 203n14

Parrington, Vernon L., 29

Pater, Walter, 138, 168, 175, 181, 203n12, 220n9, 221n13, 225n7

Pearce, Lynne, 89, 112, 217n27

Pegram, Henry, 146–147

Penny, Nicholas, 210n13, 210n15

Petrarch (Francesco Petrarca), 176, 225n8

Pfeiffer, Michelle, 223n31, 226n13

Philadelphia Museum of Art (formerly Pennsylvania Museum), 128, 226n17

Pictorial Review, 115, 217n32, 218n34

Poe, Edgar Allan, 4, 22, 28, 33, 76, 99, 133, 149, 206n6, 223n29; "The Black Cat," 165; "The Fall of the House of Usher," 41, 164; "Ligeia," 207n13; "The Oval Portrait," 42, 43, 44, 207n15, 208n16; "The Raven," 34

Pollock, Griselda, 22, 109, 202n6

Portinari, Beatrice, 16, 208n21. *See also* Alighieri, Dante; Rossetti, Dante;

Wharton, "The 'Beata Beatrix' of
 Rossetti"
Portman, Natalie, 85
Poulson, Christine, 224n1
Pound, Ezra, 7
Poussin, Nicolas, 60, 125, 219n46
Poynter, Sir Edward, 63
Pre-Raphaelite Brotherhood (PRB), 6, 7,
 22, 23, 25, 34, 56, 63, 64, 72, 74, 99, 102,
 105, 106, 108, 109, 111, 114, 115, 117, 132,
 146, 158, 164, 165, 168, 172, 176, 184,
 185, 186, 195, 197, 198, 202n6, 203n12,
 203n14, 209n22, 210n13, 225n7, 225n9;
 attacked by critics, 204n19; founding
 of, 13–16; "Immortals" celebrated by,
 34, 206n6; models, 57, 209n22, 209n3,
 216n18, 216n19, 220n6. See also Corn-
 forth, Fanny; Jones, Mary; Morris,
 Jane; Siddall, Elizabeth; Wilding,
 Alexa; Zambaco, Maria
Pre-Raphaelite representations (of
 women), 4, 14, 20, 99, 102, 106, 108,
 115, 158, 184, 216n22, 225n12. See also
 Burne-Jones, Edward; Hunt, William;
 Millais, Sir John Everett; Rossetti,
 Dante; Rossetti, William; Ruskin,
 John; Swinburne, Algernon Charles
Prettejohn, Elizabeth, 138, 168, 184, 202n6,
 221n13
Price, Alan, 227n30
Prinsep, Val, 211n16
Prud'hon, Pierre-Paul, 91; Portrait of
 Josephine at Malmaison, 1805, 91–93
Pygmalion theme, 34, 39, 40, 50, 125. See
 also Burne-Jones, Edward

Rabelais, François, 175
Ramsay, Allan, 202n7
Ramsden, George, 204n15, 206n4, 210n13,
 219n40
Raphael (Raffaello Sanzio), 13, 63, 203n14;
 Parnassus, 125; Transfiguration, 13.

See also Pre-Raphaelite Brotherhood,
 founding of
realism, 4, 9, 151, 201n2, 215n11. See also
 realist revision
realist revision, 4, 22, 44, 51, 223n30
Redon, Odilon, 202n7
Reid, Robert, 37
Rembrandt (Rembrandt Harmensz van
 Rijn), 159
Renaissance, Italian, 8, 134–147, 175, 176,
 224n6. See also Pater, Walter
Reynolds, Sir Joshua, 4, 5, 13, 23, 38, 56,
 60, 63, 64, 68, 70, 72, 73, 74, 79, 83, 102,
 161, 191, 222n25; The Age of Innocence,
 191, 210n13, 210n14; Discourses on Art,
 63; Portrait of Joanna Lloyd of Mary-
 land, 64–66, 70, 72, 73, 102, 210n15;
 The Tragic Muse, 227n31
Reynolds-Stephens, William, 158
Richter, Giselda, 162
Riviere, Briton, 224n1
Robertson, W. Graham, 113
Rogers, John, 62
Rogers, Pat, 225n9
Romagnolo, Catherine, 207n10
Romanino, Girolamo, 8
Rossetti, Christina, 28, 216n18; "In an
 Artist's Studio," 1, 2, 12, 14, 22, 30–31,
 38, 44, 96, 106–107; "Who Shall De-
 liver Me?" 131–132; works collected in
 Wharton's library, 204n15
Rossetti, Dante Gabriel, 4, 5, 6, 13, 14,
 20, 21, 22, 25, 28, 32, 34, 41, 49, 56, 59,
 64, 74, 75, 76, 77, 79, 80, 87, 88, 90,
 99, 105, 106, 107, 108, 109, 110, 111, 112,
 114, 117, 119, 138, 146, 172, 173, 177, 198,
 199, 203n12, 204n16, 205n22, 205n24,
 207n15, 209n22, 211n16, 220n5, 225n11;
 Astarte Syriaca, 16; Beata Beatrix,
 47, 74, 199, 217n27, 220n6; Beatrice,
 216n20; The Blessed Damozel, 15, 34,
 76, 99, 207n14; Bocca Baciata, 14;

"The Cup of Water," 204n15; *Dante's Dream at the Time of the Death of Beatrice*, 74, 77, 212n26; *The Day Dream*, 64, 74; *Desdemona*, 216n20; *Fazio's Mistress*, 215n12; *The House of Life*, 20, 31, 59, 74, 75, 87, 88, 90, 107, 109, 113, 146, 173, 174, 176, 177, 185, 190, 191, 192, 193, 194, 195, 199, 226n13; "Jenny," 79–80, 212n27; *Lady of Shalott*, 184; "Love-Lily," 76; *Love's Mirror; or, A Parable of Love*, 53–54, 75; *Mariana*, 184, 216n20, 225n11; *Monna Vanna*, 207n14; *Pandora*, 197, 216n20; *La Pia de' Tolomei*, 99, 215n13, 216n20; "The Portrait," 19, 31, 39, 41, 42, 50; *Proserpine*, 109; residence of, 216n21, 225n9; response to death of Elizabeth Siddall, 20, 75–76, 205n24, 206n5; *Sancta Lilias*, 76; *Silence*, 216n20; "St. Agnes of the Intercession," 207n15; *Sybilla Palmifera*, 146; *Venus Verticordia*, 197; *Water Willow*, 225n12; "The Woodspurge," 204n15; works collected in Wharton's library, 204n15

Rossetti, William Michael, 13, 32, 105, 111, 114, 146, 176, 225n9

Rossetti Archive, 15, 204n18, 212n26, 217n24

Rousseau, Jean-Jacques, 124, 219n44

Royal Academy of Art, 13, 15, 89, 109, 146, 170, 204n17, 210n15, 212n26

Royal Museums, Florence, 8

Rubaiyat of Omar Khayyam, 207n7

Rugoff, Ralph, 129

Ruskin, John, 4, 7, 8, 16, 36, 127, 136, 155, 167, 168, 175, 203n12, 205n20, 220n10, 225n7

Sandys, Frederick, 16, 63

Sargent, John Singer, 5, 81, 82, 94, 95, 99, 213n30, 214n8; *Madame X* (Madame Pierre Gautreau) 100, 181; *Mrs. Ralph Curtis, 1898*, 100, 102, 115

Scorsese, Martin, 226n13, 226n14

Scribner's Magazine, 8, 88

Serraller, Francisco Calvo, 211n20

Shaffer-Koros, Carole, 206n6

Shakespeare, William, 43, 50, 73, 206n6, 225n11

Shakespeare in Love (Madden), 202n4

Shelley, Percy Bysshe, 206n6

Sherman, Claire Richter, 8, 128, 130

Shields, Frederic, 17

Showalter, Elaine, 195, 209n5, 212n25, 223n32

Siddall, Elizabeth, 15, 17, 20, 32, 43, 47, 54, 74, 75, 76, 89, 99, 106, 107, 111, 112, 117, 119, 164, 176, 198, 199, 200, 205n24, 206n5, 208n21, 213n3, 216n19, 220n6, 225n9; *Clerk Saunders*, 15; "The Lust of the Eyes," 199, 227n33

Siddons, Sarah, 50, 227n31

Signorelli, Luca, 8

Sinclair, Upton, 150

Singley, Carol, 219n41

Smedley, W. T., 213n1

Smith, Alison, 16, 17, 209n3

Sodoma (Giovanni Antonio Bazzi), 143, 221n13; *Scenes from the Life of Saint Catherine of Siena: The Swooning of the Saint*, 143, 221n14

Solomon, Simeon, 221n13

Spartali, Marie (later Marie Spartali Stillman), 216n19, 220n6

Spencer, Herbert, 176

Spencer, Robin, 152, 220n6, 220n8

Steele, Valerie, 179, 187, 226n19

The Stepford Wives (Forbes), 37, 38, 207n10

Stephen, Leslie, 225n10

Stephens, F. G., 215n13

Stephens, Frederick, 13

Stevens, Alfred, *The Painter and His Model*, 1, 2

Stevens, Alfred George, 63
Stevens, Wallace, 160
Stevenson, Sara Yorke, 128
Stevick, Philip, 203n13
Stillman, Marie Spartali. *See* Spartali, Marie
Stoker, Bram, *Dracula*, 111
Stolz, Eric, 78
Story, Julian, 27, 206n3
Strudwick, J. M., 63
Suleiman, Susan, 195
Surtees, Virginia, 204n18
Sweeney, Susan Elizabeth, 210n11, 219n41
Swinburne, Algernon Charles, 136, 146, 152, 168, 176, 220n6, 220n8, 221n13, 225n9n
Symonds, John Addington, 175
Symons, Arthur, 20

tableau vivant, 23, 38, 59, 60, 61, 62, 63, 64, 65, 66, 67, 68, 69, 70, 71, 82, 209n6, 210n7, 210n8, 210n15, 211n19, 211n21, 212n22
Taine, Hippolyte, 27, 28, 206n4
Tate Gallery, 5, 15, 43, 64, 212n26
Taylor, Kendall, 127, 129–130, 220n1
Tennyson, Alfred, Lord, 167, 176; "Elaine" (*Idylls of the King*), 170–171; "Lady of Shalott," 170; "Oriana," 108, 216n22; "Palace of Art," 132
Thackeray, William Makepeace, 206n6
Thayer, Abbott Handerson, 21, 35, 95
Tiepolo, Giovanni Battista, 8, 72, 212n24
Tintner, Adeline, 7, 8, 202n5, 203n12
Tintoretto (Jacopo Robusti), 8
Titian (Tiziano Vecellio), 66
Tobin, Thomas J., 203n12
Treuherz, Julian, 136, 168

Uberti, Fazio degli, 215n12
Uncle Tom's Cabin (Stowe), 154
Upstone, Robert, 14, 34, 47, 48, 63, 78, 146, 215n12, 220n5

Van Dyck, Anthony, 66, 68, 70, 211n19; *Portrait of a Flemish Lady*, 66–68
Van Hook, Bailey, 15, 19, 21, 35, 63, 95–96, 97, 98, 202n6, 226n15
Vanity Fair Magazine, 55, 85
Veronese, Paolo, 66
Villon, Francois, 205n22
Vogue Magazine, 5, 116, 202n3, 217n27

Wadsworth Atheneum, 130
Waid, Candace, 153, 212n25, 217n30, 222n19
Walker, Nancy A., 52
Walker Art Gallery, Liverpool, 5
Wallis, Henry, 224n1
Walsh, Michael, 145, 221n15
Walters, Jane Mitchell Thompson, 129, 220n3
Walters, William T., 129
Walters Art Museum (formerly Walters Art Gallery), 129, 130, 211n17
Warner, Marina, 99, 202n6
Warton, Madame, 60, 61, 71, 210n7
Waterhouse, John William, 5, 22, 62, 64, 205n24, 224n1; *Circe Offering the Cup to Ulysses*, 139; *The Lady of Shalott*, 99; *The Shrine*, 22
Watson, Homer, 224n1; *The Death of Elaine, 1877*, 170
Watson, Margaretta, 14, 15, 17, 202n6
Watteau, Antoine, 66, 210n15
Watts, George Frederic, 140, 220n5
Weber, Jean, 127
Wegener, Frederick, 217n25
Wharton, Edith, command of art history, 7–8; paintings owned by, 202n7; *The Age of Innocence*, 5, 10, 25, 29, 39, 49, 58, 61, 64, 73, 94, 169, 170–200, 201n1, 201n2, 210n14, 211n21, 217n32, 222n22; "The Angel at the Grave," 24, 126, 131, 133, 147–152, 153, 154, 157, 162, 164, 166, 167, 169; "April Showers," 203n9; "Autre Temps," 213n30; *A Back-*

ward Glance, 8, 201n2, 204n15, 214n5; "The 'Beata Beatrix' of Rossetti," 199, 204n15, 228n34; "Beatrice Palmato," 135–136, 202n5, 208n21; *The Buccaneers,* 11, 14, 15, 25, 198, 202n4, 203n12; *The Children,* 115, 123, 217n32, 221n12; "Copy," 109, 203n9; "A Cup of Cold Water," 204n15; *The Custom of the Country,* 9, 11, 15, 23, 28, 29, 40, 58, 59, 73, 79, 80, 82, 86, 87, 88, 90–105, 112, 114, 115, 116, 117, 118, 122, 123, 171, 186, 199, 200, 213n4, 216n22, 224n2; "The Daunt Diana," 208n17; "The Dead Wife," 207n12; *The Decoration of Houses,* 7, 8, 64, 175; "The Duchess at Prayer," 4, 22, 24, 28, 29, 40, 45–52, 73, 81, 90, 95, 97, 102, 112, 117, 118, 124, 133, 137, 152, 181, 213n4, 214n7, 221n16; *Ethan Frome,* 5; "Expiation," 203n9; *False Dawn,* 203n12, 210n13, 220n4; *French Ways and Their Meaning,* 171, 214n5, 219n45, 224n3; "The Fullness of Life," 205n25, 222n27; *The Glimpses of the Moon,* 203n12, 217n32; *The Gods Arrive,* 6, 11, 24, 49, 58, 59, 88, 117–125, 152, 213n32, 213n4, 227n32; *The House of Mirth,* 5, 6, 11, 23, 27, 28, 29, 38, 39, 49, 52, 54, 55–79, 82, 83, 84, 86, 88, 89, 90, 91, 100, 102, 103, 105, 111, 112, 113, 116, 132, 171, 186, 191, 197, 198, 199, 201n2, 202n7, 205n25, 207n7, 209n2, 213n4, 216n22, 217n30, 223n32; "The House of the Dead Hand," 6, 24, 133, 134–147, 152, 153, 154, 158, 159, 162, 163, 164, 166, 167, 168, 184, 196; *Hudson River Bracketed,* 23, 88, 117, 120, 152, 218n39; *Italian Backgrounds,* 8; *Italian Villas and Their Gardens,* 8; "Kerfol," 206n6; "Life and I," 227n30; *The Mother's Recompense,* 217n32; "The Moving Finger," 1, 22, 28, 29, 33–45, 46, 50, 81, 88, 90, 95, 97, 100, 102, 112, 113, 117, 118, 121, 122, 133, 149, 152, 159, 206n2, 207n7, 208n17, 213n4, 217n31; "Mr. Jones," 24, 134, 143, 162–167, 168; "The Muse's Tragedy," 21, 22, 28, 29, 30, 31–33, 34, 35, 36, 50, 58, 81, 84, 88, 95, 97, 113, 114, 117, 119, 120, 121, 123, 124, 137, 213nn3–4, 215n13; *New Year's Day,* 58, 80, 209n4, 213n31; "The Other Two," 201n1; "The Pelican," 227n32; "Pomegranate Seed," 109; "The Potboiler," 23, 28, 40, 52, 56, 57, 58, 59, 80, 81, 82, 83, 84, 85, 86, 94, 103, 112, 113, 122, 123, 212n29, 214n7, 218n39; "The Quicksand," 26, 58, 122, 123, 205n25; *The Reef,* 122, 197, 205n21, 227n32; "The Rembrandt," 24, 133, 134, 147, 154, 158–162, 167; *Sanctuary,* 205n25; *Summer,* 24, 126, 133, 151, 153–158, 159, 162, 164, 166, 167, 201n2, 202n4; "The Temperate Zone," 11, 23, 31, 40, 80, 88, 89, 91, 105–117, 118, 122–123, 207n8, 217n30, 227n32; *The Touchstone,* 109, 196, 207n8, 207n14, 215n15, 221n14; "A Tuscan Shrine," 8; *Twilight Sleep,* 80, 118, 123, 196, 217n32; "Velvet Ear Pads," 218n36; "The Vice of Reading," 6; *The Writing of Fiction,* 10, 51; "Writing a War Story," 3, 151, 203n9, 217n31, 227n32

What Lies Beneath (Zemeckis), 223n31

Whistler, James McNeill, 5, 64, 183, 184, 203n12, 209n3, 211n17, 226n17

White, Barbara A., 10, 150, 202n5, 221n16

White, Margaret Rutherford, 213n30

Whitman, Walt, 206n6

Whitney Museum of American Art, 127

Wilde, Oscar, 138; *The Picture of Dorian Gray,* 85, 146, 207n9

Wilding, Alexa, 207n14, 216n19

Wildman, Stephen, 34

Wilton, Andrew, 14, 34, 47, 48, 146, 215n12, 220n5

Winser, Beatrice, 220n1
Winthrop, Egerton, 5, 8, 204n17
Winthrop, Grenville L., 15
Withers, Josephine, 216n17
Wolff, Cynthia Griffin, 153, 173, 194,
 201n2, 208n21, 209n5, 214n8, 222n19,
 227n27
Woolner, Thomas, 13

Wordsworth, William, 113, 217n30
Wright, Sarah Bird, 217n32

Yeats, W. B., 7

Zambaco, Maria, 17
Zilversmit, Annette, 201n2
Zola, Emile, 187

PS 3545 .H16 Z756 2007
Orlando, Emily J. 1969-
Edith Wharton and the visual
arts

DATE DUE

Brodart Co. Cat. # 55 137 001 Printed in USA